MEDIEVAL ARCHITECTURE
IN WESTERN EUROPE

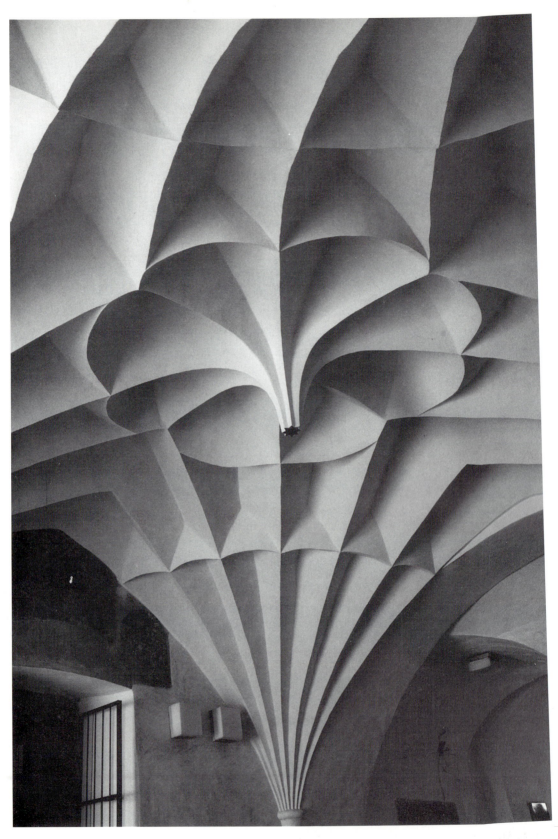

Slavonice (Bohemia), burgher house, circa 1500: entrance hall vault. (R. G. Calkins.)

MEDIEVAL ARCHITECTURE
IN
WESTERN EUROPE

FROM A.D. 300 TO 1500

ROBERT G. CALKINS

New York Oxford
OXFORD UNIVERSITY PRESS
1998

Oxford University Press

Oxford New York
Athens Auckland Bangkok Bogota Bombay Buenos Aires
Calcutta CapeTown Dar es Salaam Delhi Florence Hong Kong
Istanbul Karachi Kuala Lumpur Madras Madrid Melbourne
Mexico City Nairobi Paris Singapore Taipei Tokyo Toronto Warsaw

and associated companies in
Berlin Ibadan

Published by Oxford University Press, Inc.
198 Madison Avenue, New York, New York 10016

Cover photograph of Beauvais Cathedral by Robert G. Calkins.

Library of Congress Cataloging-in-Publication Data
Calkins, Robert G.
Medieval architecture in Western Europe: from A.D. 300 to 1500/Robert G. Calkins
p. cm.
Includes bibliographical references and index.
ISBN 0-19-511241-5
1. Church architecture—Europe, Western. 2. Architecture, Medieval—Europe, Western.
I. Title.
NA 5453.C35 1998 97-8135
726.5'09'02—dc21 CIP

1 3 5 7 9 8 6 4 2
Printed in the United States of America on acid-free paper

In memory of my Father
Robert D. Calkins

CONTENTS

PREFACE

This book is intended as an introductory survey of the architecture of the Middle Ages in western Europe from circa A.D. 300 to 1500, from the early Christian period through the late Gothic in Europe. It aims to fill a gap between the very selective and cursory mention of major medieval buildings in general surveys of art or architectural history and the in-depth books on particular periods or regions, so that the interested reader can find in one volume what has previously been scattered through myriad expensive books.

Given the extent of the period covered and the number of important monuments, however, not every medieval building can be discussed, neither can all of the architectural details and complete contextual background of each of those chosen. Nevertheless, beginning with structural antecedents in Roman architecture, and referring to a few representative types of Byzantine churches that had a particular impact on the West, I have tried to select major examples of representative traditions and innovative solutions, particularly those that influenced contemporary or later developments throughout the Middle Ages. Realistic expectations of what a student might encounter in an academic semester or what an interested traveler might find useful to consult also determined the number and selection of buildings discussed.

Sometimes specific themes have a life of their own that dictate being followed through at the expense of strict chronology. Therefore, the section on monasticism extends from its beginnings through Cluny III; a section in the same early chapter on timber construction, ubiquitous to northern Europe throughout the Middle Ages, spans several centuries and encompasses some secular buildings. The chapter on Ottonian architecture comes immediately after that on Carolingian in order to follow the developing imperial tradition, before backtracking to Visigothic and Asturian Spain, contemporary with the Merovingian and Carolingian periods. Also for this reason, Anglo-Saxon buildings serve as a preface to the changes wrought in England by the invading Normans after 1066, even though these buildings are again contemporary with the Carolingian. Innovations appearing in secular architecture, particularly the diamond or cellular vault of the late fifteenth century, might appropriately be discussed in the chapter on secular buildings, but since these vaults were also adapted to ecclesiastical structures, both uses are examined together. The chapter on medieval building practices, though appearing at the end as a summary of monuments discussed, can just as easily be read as an introduction. Many of these structures were built and revised over long periods of time, but where particularly relevant, I have tried

to indicate the development of their form and structure even in their protracted evolutionary process.

Throughout the Middle Ages, the church represented the dominant unifying political and economic power, thus resources and architectural know-how were directed to producing the most spectacular innovations in ecclesiastical architecture. However, in the late Gothic period, less grandiose projects in the form of parish churches, civic, and secular buildings provided greater freedom and possibility for architectural expression; therefore, a chapter discusses these secular developments: castles, public halls, town halls, and commercial buildings.

The limited selection of bibliographic sources presented here, broken down by chapter and topic, is intended only as a starting point for further investigation by the interested reader. More detailed references exist in books devoted to specific periods or regions, and in books and articles on specific monuments. In order to keep the footnotes to a minimum, I acknowledge my debt to those sources listed under each chapter.

Adequate visual presentation of architecture usually requires a ground plan, section, exterior and interior views, and probably some salient details. However, the economic realities of publishing illustrations has severely limited their number and resulted in combinations of plans and sections, although I hope with instructive results. The high cost of permissions dictated that I use many of my own photographs, but I am grateful to those photographic agencies that were responsive to this situation.

Apologies are due to the memory of Kenneth J. Conant. Although I already had photographs of some of his drawings, I did not of others. Some of his drawings and negatives have been lost. Attempts to resurrect these from printed sources by a variety of means have resulted in harsher images, but even without his sensitive touch, I still felt it important to present at least a shadow of his relevant reconstructions.

Inconsistencies abound in published ground plans of medieval buildings. Therefore many plans and sections have been revised insofar as possible to maintain a uniform convention within this book: groin vaults are indicated by dotted lines and entablatures, arches and ribs by solid ones.

I would like to thank my students at Cornell University over the years who have provoked me to think through many of the issues covered here. Special thanks are due the 105 participants in seven Summer Seminars for School Teachers funded by the National Endowment for the Humanities that I have directed on the topic of *The Gothic Cathedral as a Mirror of Medieval Culture*, for their reactions to many of these buildings, their lively discussions of the issues, their good company on many field trips to investigate them. Many thanks to Tony DeCamillo and Sheryl Sinkow of Art Science Studio Lab of Ithaca and to Bill Staffeld for their perseverance and care in extracting usable prints from a mountain of photographic material. David Greenbaum relentlessly pursued the lost Conant drawings, and I thank him for his persistence in the face of frequent negative responses: he managed at least to locate Conant's Cluny drawings. I am indebted to William Clark for his insights and kind advice over the years. I am particularly grateful to my editor, Joyce Berry, for her faith in this project. Special thanks are also due to my wife and children.

Finally, this book is dedicated to the memory of my father, Robert D. Calkins, who encouraged me to go to graduate school after I had done time in the commercial world and the army. He did not mind that I chose art history over business school; he would have liked this subject.

Robert G. Calkins

Ithaca, New York
Sunday, July 20, 1997

1

Classical Antecedents

Medieval architecture evolved from many of the building forms and construction techniques that the classical world developed before the Christian era. In particular, the Romans had perfected arches, various forms of vaulting, intricate sequential layouts of buildings, and a repertoire of symbolic architectural forms. These provided the basis for plan, structure and meaning adapted to Christian usage in the simplest to the most complex medieval buildings throughout the Middle Ages.

The simplest and oldest structural device is the post and lintel system, where two upright posts support a horizontal member, or lintel. It has been used since time immemorial, in timber and in stone. Stonehenge (ca. 2750–1500 B.C.), with its huge horizontal blocks of granite placed upon even more massive rough-hewn upright supports, exemplifies an early and monumental form of this structural system. Colonnaded peristyles in the Hypostyle Hall of the Temple of Amun at Karnak in Egypt (ca. 1290 B.C.) and around the Parthenon (447–438 B.C.) on the Acropolis in Athens, provide more sophisticated examples of these forms. But the post and lintel system has its limitations. The length relative to the thickness and tensile strength of the timber or stone lintel limits the possible span between the columns, for if the supports are too far apart the lintel will sag and then crack.

The perfection of the semicircular arch allowed a greater span between posts, but required adequate buttressing in the form of thick supports or additional flanking arches to counter the diagonal thrusts generated by the accumulated wedge-shaped voussoirs that made it up (fig. 1.1). The Romans perfected the arch and used it in the construction of massive aqueducts such as the **Pont du Gard** (fig. 1.2) in Provence (first century B.C.). Used decoratively, such arches alternate with entablatures in the free-standing peristyle around the reflecting pool of the **Canopus** at Hadrian's Villa at Tivoli outside of Rome (after A.D. 130; fig. 1.3).

When an arch is extended three-dimensionally it forms a tunnel, or barrel vault (fig. 1.1). The Romans used this device in the Cloaca Maxima in Rome, an underground sewer vaulted with brick voussoirs, as early as 200 B.C. The surrounding earth countered the outward forces while the wedge-shaped voussoirs prevented internal collapse. Aboveground, however, barrel vaults need massive walls to absorb the outward thrusts generated by the vault, although arched openings could penetrate the wall and channel the forces above them into the mass of the flanking structure.

The intersection of two barrel vaults at right angles (one longitudinal and one transverse) forms a groin vault (fig. 1.1). The groin vault channels the forces of the vault down onto the corner supports,

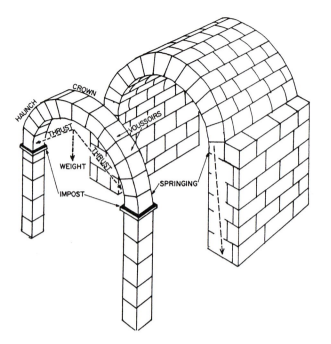

1.1 *Left:* arch and barrel vault; *Right:* groin vault. (R. G. Calkins.)

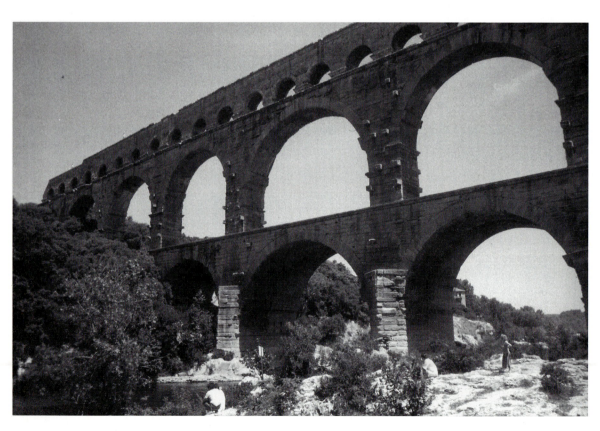

1.2 Pont du Gard, late first century B.C. (R. G. Calkins.)

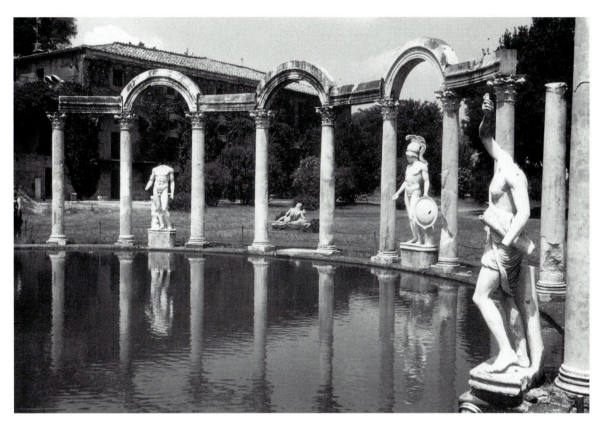

1.3 Tivoli, Hadrian's Villa, Canopus, after 130. (R. G. Calkins.)

leaving open both the lateral and the longitudinal sides. This vault forms a creased, sometimes domical, canopy that forms the structural unit known as the bay. The corner supports need buttressing, preferably at a forty-five-degree angle, unless abutted by similar bays, in which case some form of lateral buttressing must brace the supports against the outward thrust. In Rome, the main halls of huge baths constructed of bricks and concrete, such as the Baths of Caracalla (A.D. 212–16), the Baths of Diocletian (298–306), or the colossal **Basilica of Maxentius and Constantine** (ca. 307–12; fig. 1.4), also used this same system over their main halls consisting of a longitudinal barrel vault intersected by three transverse ones that formed three groin vaulted bays. In the Basilica of Maxentius, three massive transverse barrel vaults covered the aisle bays on each side and the walls between them absorbed the lateral forces generated by the groin vaults.

When an arch is rotated around a center point, it forms a dome. The dome requires a hefty supporting system around its complete circumference because it transmits its forces radially outward. The Romans not only perfected the use of the hemispherical dome in the **Pantheon** in Rome (ca. 118–28; figs. 1.5–1.6), but also wrought exotic and structurally sound variations on it. The huge coffered dome of the Pantheon—a monolithic mass like a giant saucepan lid, 142 feet in diameter and constructed of concrete reinforced with interlocking brick arches—sits on a thick cylindrical wall eroded on the inside by square and semicircular niches screened by columns. The mass and weight of this dome is not immediately apparent, however, because the diminishing coffering of its surface gives the illusion of converging ribs and the classical orders and entablature of the drum give it a logical, visual supporting base. However, in the vault of the **Serapheum** (fig. 1.7) opening onto the Canopus of Hadrian's Villa at Tivoli, built at approximately the same time, a half dome composed of triangular segments alternating between wedged shaped barrel vaults and flat upward curving elements, echoes the lively undulation of arches and entablatures around the Canopus.

1.4 Rome, Basilica of Maxentius, 307–12, completed by Constantine after 312: cutaway reconstruction, plan.

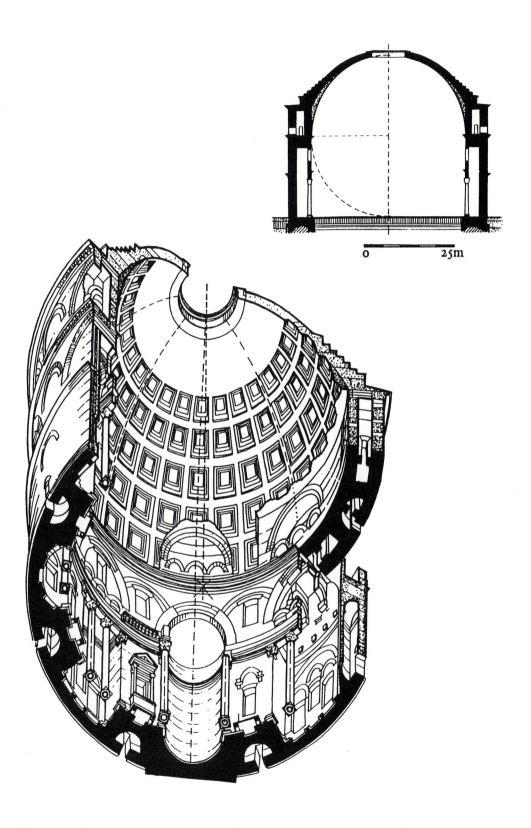

1.5 Rome Pantheon, circa 118–128: section and axonometric view. (After J. B. Ward-Perkins:
Yale University Press Pelican History of Art.)

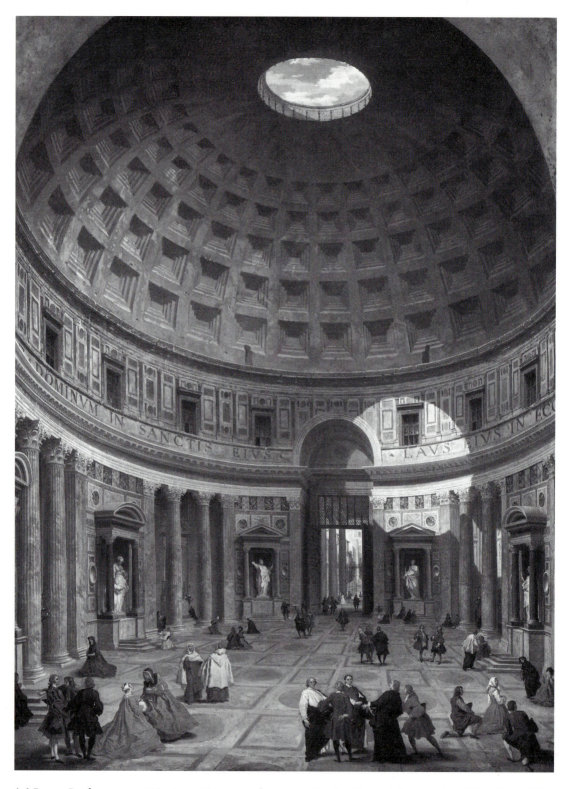

1.6 Rome, Pantheon, circa 118–circa 128: interior from a painting by Giovanni Pannini, circa 1734. (Samuel H. Kress Collection. © 1996, Boad of Trustees, National Gallery, Washington D.C.)

A domical vault over the vestibule of the entrance to the Piazza d'Oro at Hadrian's Villa forms a melon vault composed of a succession of upward arching wedge-shaped barrel vaults. Hadrian's builders used another variation of this system in the vault of the **State Hall of the Piazza d'Oro** (fig. 1.8), where alternating concave and convex surfaces flowed upward into an undulating dome penetrated by an oculus as in the Pantheon.

The domed structure known as the Temple of Minerva Medica or Nymphaeum in the Licinian Gardens in Rome, of the early fourth century, also exemplified this tradition (fig. 2.21). It consisted of a decagon with emanating apsidal spaces: those on the cross axes contained open colonnades providing a view into the surrounding gardens. The dome above emulated that of the Pantheon in Rome, but in the Nymphaeum it created a much more dynamic space, with the lower wall surfaces curving away from the center and even dissolving into distant lighted vistas as opposed to the closed, static cylinder of the Pantheon.

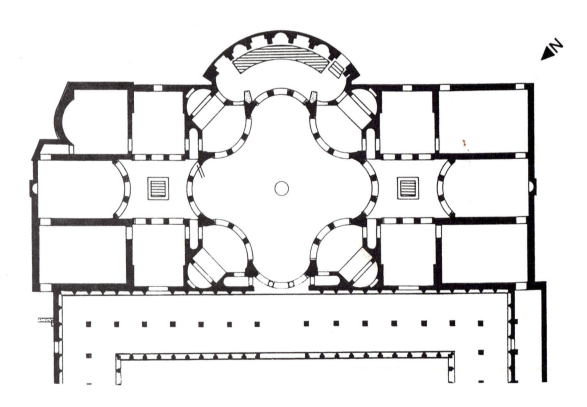

1.8 Tivoli, Hadrian's Villa, Piazza d'Oro, 125–133: isometric reconstruction and plan. (After Kähler.)

PLAN AND AESTHETIC EFFECTS

The Romans' exuberant manipulation of various forms of vaulting and their self-assurance in creating massive structures that would last for all time, and some almost have, were also manifested in the plans of the buildings and their interior lighting effects. These, in turn, influenced the plans and interior effects of many medieval buildings. For instance, at Hadrian's Villa, the **Treconch Dining Hall** (fig. 1.9) exhibits a more distinctive plan than structure: three open semicircular areas emanated away from a timber-roofed square core, providing lighted screened vistas beyond a shadowed interior. The State Hall of the Piazza d'Oro developed the exotic interior effect even further: its central core, a four-lobed space that undulated in and out, gave rise to the billowing vault mentioned above. Lit both by a central oculus and by open corner aediculae screened by the weaving colonnade, the shadowy interior space became elusive and intangible. These

screened, multilobed, backlit spaces became a key feature in some medieval imperial chapels.

The Romans also developed complex plans on a large scale, creating ensembles of buildings with a relational sequence of volumes and spaces, resulting in a series of experiences and perspectives for the visitor. The Romans drew from a long tradition of similar complexes, as such plans had been prevalent in the preclassical and classical worlds; however, they became a Roman forte. They transformed an entire hillside at the **Sanctuary of Fortuna Primigenia** (ca. 80 B.C.) at Praeneste (Palestrina) into a series of stairs, ramps, and temples set on terraces, requiring frequent changes in the processional route (fig. 1.10). A similar though axial manipulation of sequential experiences characterized the great **Sanctuary of Jupiter Heliopolitanus at Baalbek** (fig. 1.10) in Lebanon (early first century to ca. 250), where after mounting a monumental stairway, the visitor would enter through a propylaeum, pass through an octagonal atrium, and finally

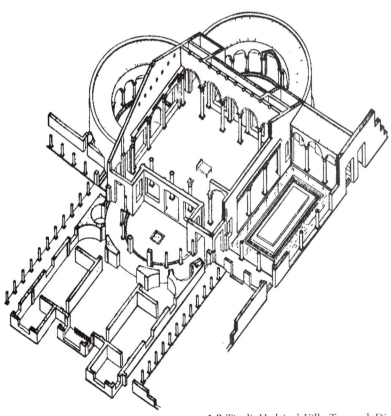

1.9 Tivoli, Hadrian's Villa, Treconch Dining Hall, 125–133: reconstruction. (After Kähler.)

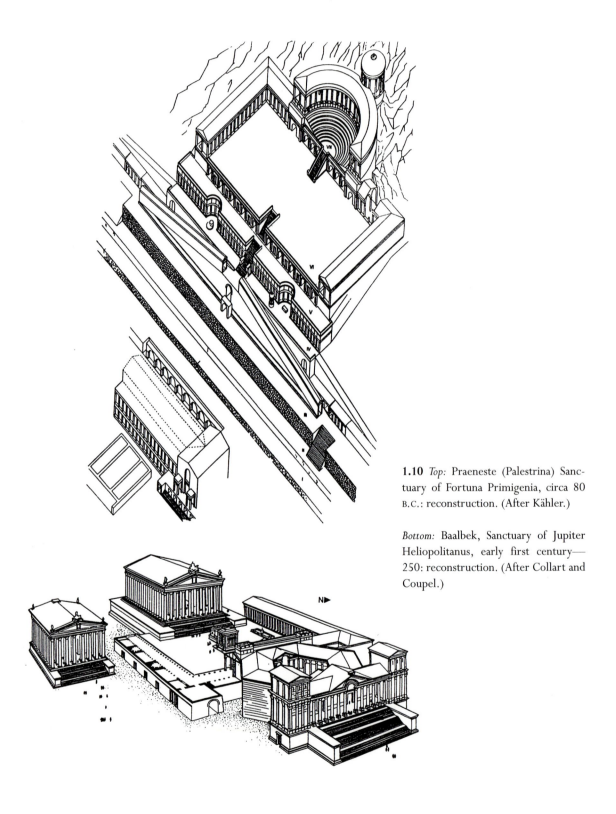

1.10 *Top:* Praeneste (Palestrina) Sanctuary of Fortuna Primigenia, circa 80 B.C.: reconstruction. (After Kähler.)

Bottom: Baalbek, Sanctuary of Jupiter Heliopolitanus, early first century—250: reconstruction. (After Collart and Coupel.)

arrive in a large space in the middle of which stood freestanding altars and the large Parthenon-like Temple of Jupiter.

A less exotic plan, but with a similar axial emphasis, dominated the Roman military camp, laid out in many sites throughout Europe and northern Africa. It usually consisted of a large rectangle with two main axial streets, the Cardo and Decumanus, and a grid system for the organization of the four sections defined by them. The palace complex built for Diocletian (300–306) on the shore of the Adriatic at **Spalato** (present-day Split) formalized this plan (fig. 1.11). Fortified gateways in the city wall provided access to the two major streets. A pair of monumental octagonal towers flanked the principal entrance, the **Porta Aurea** (fig. 1.12), giving access

to the axial street that led to the facade of Diocletian's Palace at the opposite end.

ARCHITECTURAL DETAILS AND SYMBOLIC FORM

One consequence of the post and lintel system in the classical world was the development of standardized combinations of proportions and ornament for the columns and their capitals, the classical orders,[1] that has been the source of classicizing architecture ever since. The heavy, fluted, strongly tapered Doric column was topped by a slightly bulging, pillowlike capital; the Ionic column was more slender and surmounted by a capital of shell-like volutes and egg-and-dart molding; and the tallest proportioned was

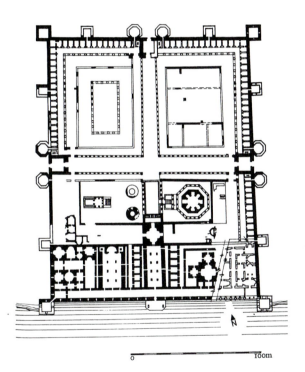

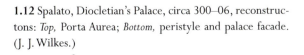

1.11 Spalato, Diocletian's Palace, circa 300–06: plan. (After J. B. Ward-Perkins: *Yale University Press Pelican History of Art.*)

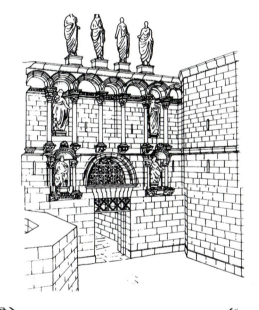

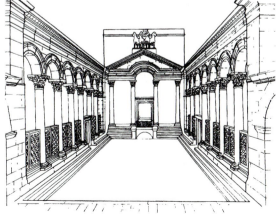

1.12 Spalato, Diocletian's Palace, circa 300–06, reconstructons: *Top,* Porta Aurea; *Bottom,* peristyle and palace facade. (J. J. Wilkes.)

the Corinthian column with capitals surrounded by bands of sculpted acanthus leaves. The Romans varied these forms, creating Tuscan Doric, with smooth, unfluted columns set on a base, but with Doric capitals, and a Composite order combining Ionic volutes and Corinthian acanthus on a capital above an even more slender shaft. They also developed the engaged column, one that appears in relief emerging from the wall, and the pilaster, a flat rather than semicircular projection from the wall to which they applied the above orders. The four-story elevation of the Coliseum (finished 12 B.C.) consists of four layers of these orders: Tuscan Doric, Ionic, and Corinthian engaged columns frame the exterior arcades, and Corinthian pilasters articulate the attic, a formula that served as a continuing model for medieval and Renaissance builders.

The Romans also developed a repertoire of symbolic architectural forms that were to influence the builders of subsequent centuries. Hadrian's Pantheon in Rome—probably the ultimate domed centralized Roman structure (figs. 1.5–1.6)— embodied a cosmic significance in its dedication to the Olympian gods. Its proportions, perhaps only

subliminally perceptible, undoubtedly enhanced its symbolic impact for the interior encompasses the entire height of a sphere, 142 feet high, that equals the full diameter of the dome. The open oculus in the crown of the dome allows a spotlight of sunlight to circulate through the building during the day and in different positions during the year as a constant reminder of the passage of cosmic time.

As freestanding monumental arches became commemorative symbols of military triumphs, so the gateway became the symbol of the Roman city. At Spalato, the Porta Aurea served primarily as a fortified entrance. Nevertheless, as a decorative embellishment to the fortifications with blind arcades and niches for statuary above the entrance, it also symbolized the strength of the city and emperor (fig. 1.12). This gate preceded a processional route flanked by a mounting crescendo of architectural elements that led to the facade of Diocletian's Palace: a low trabeated peristyle preceded the main intersection, then a taller arcade passed Diocletian's Mausoleum and ultimately led to a stairway and the facade. Flanking the entrance, columns supported a triangular pediment contain-

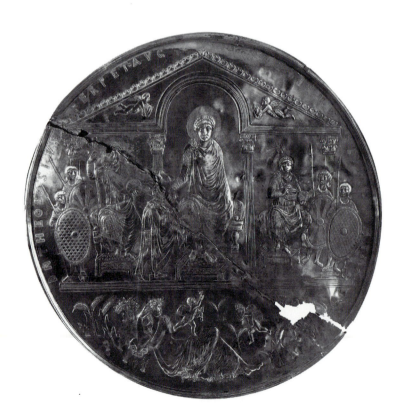

1.13 Missorium of Theodosius, 388. Madrid, Real Academia de la Historia. (Photo: P. Witte; Deutsches Archäologishes Institut, Madrid.)

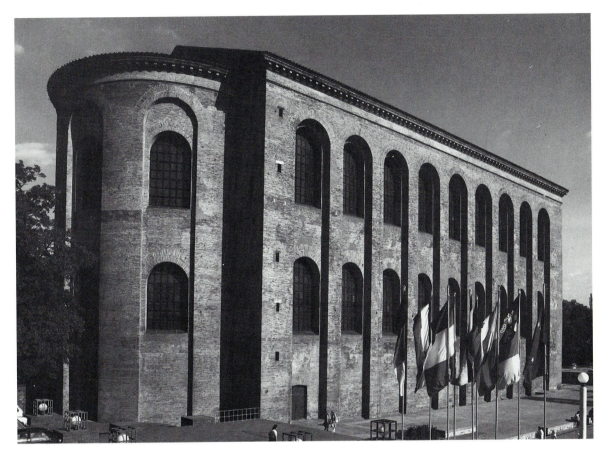

1.14 Trier, Aula Palatina, early fourth century: exterior. (Photoarchiv, Landesmuseum, Trier.)

ing a central arch over the doorway. This pediment-ed arch became a frequent framework for authorita-tive representations, surrounding the enthroned fig-ures of the Emperor Theodosius and his sons on the Missorium in Madrid (fig. 1.13), on ivory plaques showing Byzantine consuls, and later representa-tions of the Virgin Mary and Christ.

The imperial audience hall, whether in monu-mental scale, as in the Basilica of Maxentius, or inferred by architectural details, as in the facade of Diocletian's Palace, became the source of imperial symbolism in medieval architecture. Such sources also survived in northern Europe. Trier, situated on the Moselle River in modern-day Germany, was an important Roman administrative, military, and cul-tural capital between 293 and 395. The huge audi-ence basilica at Trier, the **Aula Palatina** (fig. 1.14), attached to Constantine's palace of the early fourth century, is a vast timber-roofed structure built of

brick. Its interior consists of a spacious single nave and beyond a transverse arch, a timber roofed apse, made to appear even larger than it is by the use of smaller windows and a lower ceiling in the apse. Massive two-story wall arcades frame two layers of windows and articulate its vigorous aqueduct-like exterior. Similar arcades were to reappear in various forms in later structures, some with imperial pre-tensions.

The early Christians inherited this full repertoire of structural devices, varied plans, and symbolic architectural vocabulary, whether for buildings or for larger complexes, yet they chose, at first, other structural systems. Not until after the Edict of Milan in 313, which extended religious tolerance to Christians, and the institution of the de facto patron-age of Emperor Constantine himself, did some of the splendid effects of Roman architecture begin to reappear in buildings designed for Christian use.

2

Early Christian Buildings to A.D. 500

Early Christian Meeting Places

In the two centuries before the Edict of Milan in 313, many structures used by early Christians for the practice of their faith had little in common with the grandiose and complex vaulted buildings erected under Roman imperial patronage. During the first three centuries, Christianity was only one of several religious cults originating in the Near East competing for the attention of the Romans: the Cult of Isis, emanating from Egypt, and particularly Mithraism, attracted many believers. Fear of persecution discouraged ostentation and the creation of easily identifiable structures. As Christianity appealed more to the intellegensia and lower classes than to the wealthy and powerful, only limited financial resources were available for even moderate projects. And finally, the early Christians had not yet standardized either the liturgy of their religious services or the requirements for specific places of worship. Therefore, they simply used pre-existing structures that were indistinguishable from other Roman buildings. As their influence and power grew, they adapted existing spaces to their usage and began to develop uniquely Christian structures.

At first, the early Christians met in small groups, perhaps in a room of a dwelling in the Roman equivalent of our apartment blocks, or *insulae*. Vestiges of such buildings of the second century A.D. still sur-

vive at **Ostia**, the port city of Rome at the mouth of the Tiber (fig. 2.1). A room with three couches surrounding a table was referred to as a *triclinium*; if it occupied an upper floor open to the light, it was referred to as an *anageon* or *hyperoon*. Meetings held here required no special furnishings or arrangements.

One form of the early Christian meeting place, however, was distinctive: the extensive catacombs excavated for the burial of the dead. In spite of their belief in the resurrection of the soul, early Christians rejected the practice of cremation and preferred to inter their dead. Lack of available space for surface cemeteries led early worshippers to dig vast networks of underground passages, sometimes on several layers, linked by stairs. The Caecilli family began one of the oldest, the Catacomb of Callixtus, during the reign of Marcus Aurelius (161–180). Some forty feet below ground, it expanded into a vast network of intersecting corridors on several levels by the fourth century. These passageways frequently had narrow horizontal niches for the placement of bodies of poor people; a wealthy family might have excavated a square chamber, a *cubiculum,* with a domical vault and three niches to hold sarcophagi as in the **Catacomb of the Via Latina** in Rome of the third century (fig. 2.2). These *cubicula,* which functioned as family mausolea, could be used for funeral banquets and

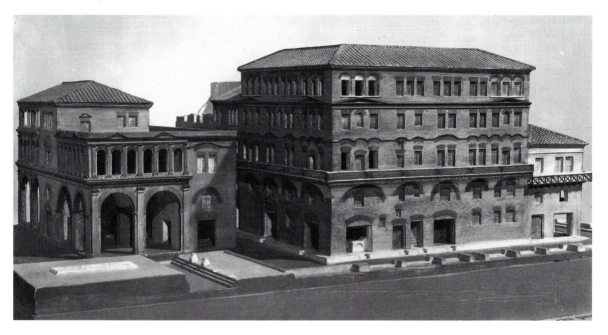

2.1 Model of an *Insula,* Ostia, second century A.D. Rome, Museo della civiltà, Ostia (Mansell). (Alinari/Art Resource, N.Y.)

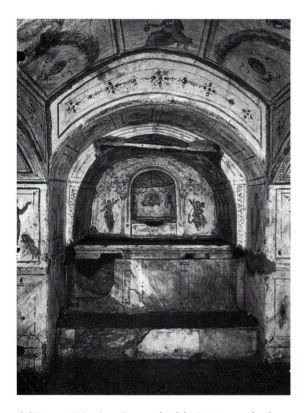

2.2 Rome, *Cubiculum,* Catacomb of the Via Latina, third century. (Pontifica Commissione di Archaeologia Sacra, Rome.)

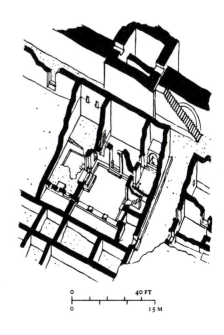

2.3 Dura Europas, Christian Meeting House, 231: isometric reconstruction. (Lampl, after J. W. Crowfoot, *Early Churches in Palestine,* fig. 1.)

memorial services on the anniversary of a death. The decoration of these chambers divided wall and vault surfaces into geometric frames centered with figural representations, following similar but more elaborate decorative schemes found in Roman tombs such as the Tomb of the Pancratii or the ceiling painting at the Isola Sacra at Ostia. The representations combined classical, Old Testament, and Christian motifs, demonstrating the early and tentative growth of a specific Christian iconography with emphasis on themes of ultimate resurrection and salvation.[1]

By the third century, Christian congregations had grown larger, and worshippers had adapted a variety of buildings for their specific activities. These small meeting places or chapels for private worship, known as a *domus ecclesiae,* or a *titulus,* served as Christian community centers. Often such structures contained no identifiable element that could be related to any certain religious usage. Sometimes, however, renovations were made for specific liturgical purposes. One of the earliest surviving examples is a house at **Dura Europas** in Syria, begun circa 200 and altered for Christian usage in 231 (fig. 2.3). The building resembled any other dwelling at the time, with rooms surrounding an interior atrium. The Christians expanded one of the chambers to hold about fifty persons and added a raised platform, perhaps for a bishop's throne. This room may have been a *consignatorium* or chamber for confirmations. In another room they placed a tublike basin within an altar niche, or baldachin, for baptisms. Frescoes of Adam and Eve denoting the Fall of Man, and of the Good Shepherd, a motif found in the catacombs suggesting the theme of salvation, decorated the room as appropriate themes to accompany the rite of baptism.

THE EARLY CHRISTIAN BASILICA

Not until after the Battle of the Milvian Bridge in 312, in which Constantine defeated his rival and co-emperor Maxentius, did a distinctive Christian architecture begin to appear. Reputedly, Constantine attributed his victory to a vision of the true cross upon which Christ was crucified, which he beheld the night before the battle. As a result, he promulgated the Edict of Milan in 313, which decreed tolerance and gave the cult of Christianity equal status with other religions in the Roman Empire. In addition, Constantine gave his direct

imperial patronage to vast building programs for the Christians.

Although Constantine completed the massive bathlike Basilica of Maxentius (fig. 1.4), its huge scale, brick and concrete barrel and groin vaults, and lavish marble veneer did not inspire the Christians. As Richard Krautheimer pointed out, early Christians deliberately turned away from the splendor of imperial buildings, and from forms of temples that evoked the pagan worship of previous eras.[2] This aversion ultimately affected the nature of the first major Christian buildings, which avoided the vaulted splendor of imperial buildings and turned for inspiration to structures more deeply rooted in the popular heritage. In ancient Rome, "basilica" referred to public meeting halls. Such a structure at **Cosa** (second century B.C.; fig. 2.4) consisted of colonnades supporting timber truss roofs, open on the sides and ends, and sometimes with a high middle area containing a clerestory above the colonnade with openings to let in the light. At Pompeii, a basilica of circa 100 B.C. had a walled exterior, interior colonnades defining two side aisles, and a clerestory lighting the middle section. These buildings were longitudinal, and depending on their use, sometimes had a semicircular apse at one end. Such buildings had a long tradition in the classical world going back more than five centuries before Christ, as the precursors of the covered market places or stoas of ancient Greece. An elaborate two-story version of this structure, the Basilica Ulpia, with an apse at each end and a gallery level above the aisles, was erected in the Forum of Trajan in Rome in A.D. 112. This type of building, neither the huge vaulted halls nor the Roman variants of the temple with a peristyle, became the preferred structure that the Christians adapted to their use in the first early Christian basilicas.

The first of these was the **Basilica of St. John the Lateran** (fig. 2.5), that Constantine began next to a palace he donated to the pope, who also held the office of bishop of Rome, after his victory at the Battle of the Milvian Bridge in 312. Although completely rebuilt by Borromini between 1646 and 1649, it reveals the basic characteristics that became the standard followed faithfully in later basilican structures: a cruciform plan (250 feet long and 180 feet wide) with a nave flanked by two aisles on each side; a large semicircular apse covered by a half dome at the west end; and low projecting transverse spaces, or transepts, close to the apse. The interior

C. 320 AD

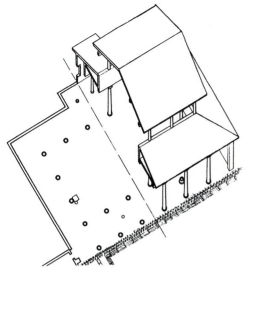

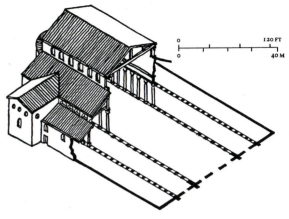

2.5 Rome, Basilica of St. John the Lateran, begun circa 320: reconstruction. (After Lampl, based on E. Jos, R. Krautheimer, and S. Corbett, *R.A.C.* 34 (1958), 70,71.)

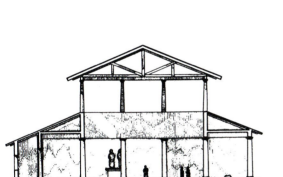

2.4 Cosa, Basilica, second century B.C.: reconstruction and section. (American Academy in Rome.)

elevation consisted of trabeated colonnades—a series of columns surmounted by an entablature—that supported the nave walls adorned with pictorial mosaics, and, above, a clerestory with windows. A timber roof covered the entire space.

This formula was essentially repeated in the other great Roman Basilicas: **Old St. Peter's,** begun about 325; St. Paul's Outside the Walls, begun about 330; S. Sabina, 422–32; and S. Maria Maggiore, circa 432–40. Old St. Peter's (fig. 2.6) featured a huge, complex interior space, 391 feet long and 208 feet wide, generally following the same layout as at St. John the Lateran with transepts and a five-aisled interior defined by multiple colonnades. The

transepts and nave formed a cruciform volume on the exterior that mirrored the distinct screened-off spaces for different liturgical uses inside. Since St. Peter's served as a martyrium, with its apse to the west over the tomb of St. Peter, transepts were used for liturgical purposes, but the nave and aisles became a virtual covered cemetery for the congregation until the practice was finally stopped because of the disturbances caused by funerals. At St. Paul's, however, the orientation was reversed, with the apse to the east in the direction of the Holy Land, and this became the practice for most Christian churches thereafter. Both these buildings were preceded by a colonnaded atrium.

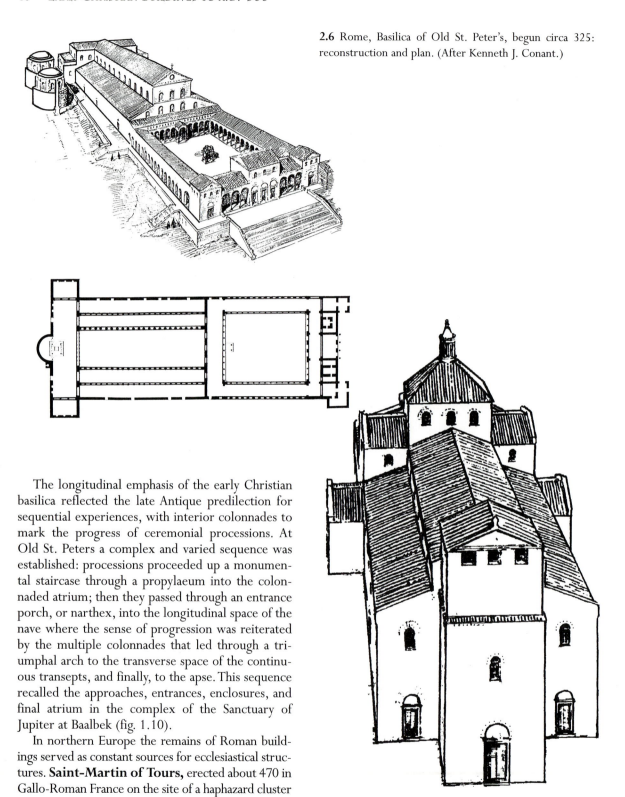

2.6 Rome, Basilica of Old St. Peter's, begun circa 325: reconstruction and plan. (After Kenneth J. Conant.)

The longitudinal emphasis of the early Christian basilica reflected the late Antique predilection for sequential experiences, with interior colonnades to mark the progress of ceremonial processions. At Old St. Peters a complex and varied sequence was established: processions proceeded up a monumental staircase through a propylaeum into the colonnaded atrium; then they passed through an entrance porch, or narthex, into the longitudinal space of the nave where the sense of progression was reiterated by the multiple colonnades that led through a triumphal arch to the transverse space of the continuous transepts, and finally, to the apse. This sequence recalled the approaches, entrances, enclosures, and final atrium in the complex of the Sanctuary of Jupiter at Baalbek (fig. 1.10).

In northern Europe the remains of Roman buildings served as constant sources for ecclesiastical structures. **Saint-Martin of Tours,** erected about 470 in Gallo-Roman France on the site of a haphazard cluster of earlier monastic buildings, manifests a northern variation of the basilican form (fig. 2.7). However, it

2.7 Tours, Saint-Martin, as of circa 470: reconstruction. (After Kenneth J. Conant.)

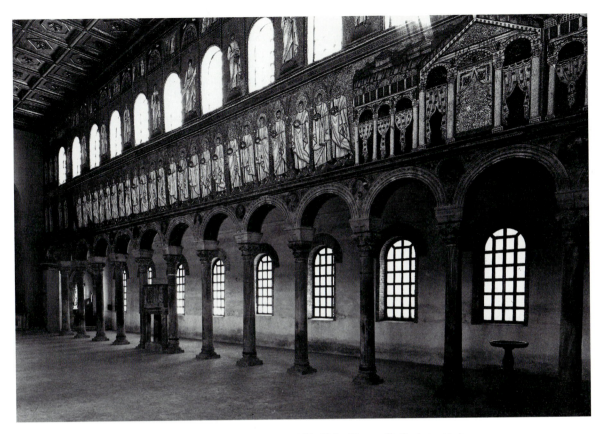

2.8 Ravenna, Basilica of S. Apollinare Nuovo: nave interior (495–504). (Antonello Perissinotto.)

had a square lantern tower over the eastern transept crossing and a projecting tower porch on the west facade, thereby introducing new vertical and balancing accents to the horizontal mass of the building. As Kenneth Conant pointed out, this new volumetric massing would later have a profound effect on both Carolingian and Romanesque churches.[3] Huge basilican structures, perhaps also with western towers, continued to be built into the fifth and sixth centuries in Merovingian France, such as in the large five-aisled basilica dedicated to St. Étienne on the Île-de-la-Cité in Paris, on the site now occupied by Notre-Dame.

In many of these buildings, the restraint and simplicity of decoration of earlier Christian spaces were abandoned in favor of marble veneer, lavishly carved Corinthian capitals on marble columns, and shimmering pictorial mosaics of biblical scenes on the nave walls and in the apse, all seen in the suffused soft golden light coming through the thin alabaster sheets covering the clerestory windows. Perhaps nowhere

was the unity of processional space, interior decoration, and interior lighting so aptly fused as in the **Basilica of S. Apollinare Nuovo** in Ravenna (495–504), where mosaic processions of male and female martyred saints echo the sequence of arcaded colonnades and the movement of visitors down the nave (fig. 2.8). This return to decorative ostentation resulted from the desire to depict instructional Old and New Testament narratives and symbolic scenes that emphasized the precepts of the faith and educated the worshippers. The lavishness of the decor was considered appropriate for several reasons: in recognition of the sanctity of the buildings, as an evocation of the heavenly kingdom, and as a manifestation of the newfound power of the church.

CENTRALIZED BUILDINGS

In addition to adapting the longitudinal basilica to their uses, early Christians also modified the various

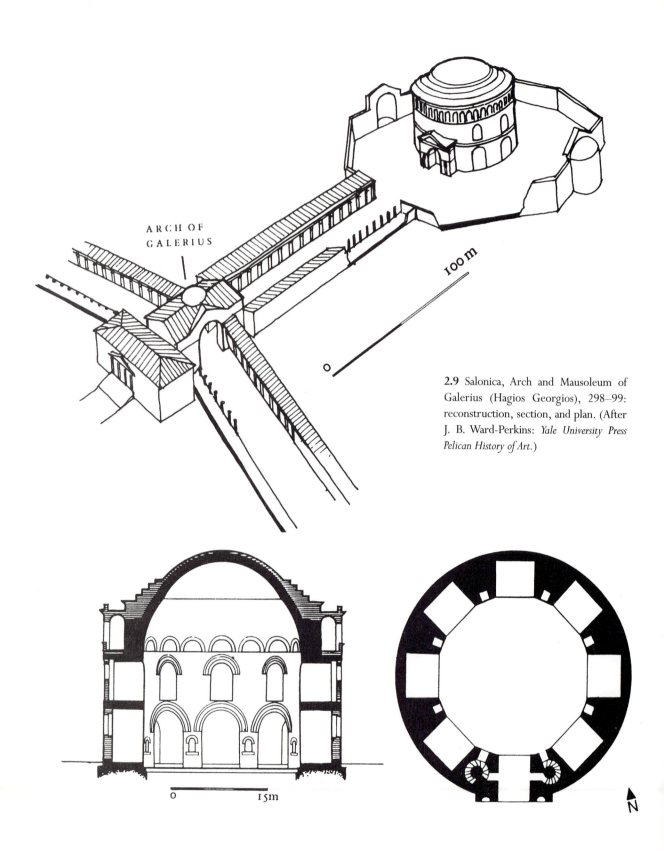

ARCH OF
GALERIUS

100 m

0

2.9 Salonica, Arch and Mausoleum of
Galerius (Hagios Georgios), 298–99:
reconstruction, section, and plan. (After
J. B. Ward-Perkins: *Yale University Press
Pelican History of Art.*)

0 15m

N

forms of traditional centralized buildings. Circular structures were often considered to embody cosmic significance and were used for cult sanctuaries and as tombs since prehistory, either underground, as in the beehive tomb, or tholos, such as the Treasury of Atreus in Mycenae, Greece (fourteenth century B.C.), or above ground as in the Castel S. Angelo in Rome, originally the tomb of the Emperor Hadrian, dating from A.D. 138. Although not a funereal monument, Hadrian's Pantheon in Rome, intended as a temple dedicated to the Olympian gods, epitomizes the cosmos in its shape and proportions based on a sphere, culminating the tradition of centralized buildings in the classical world.

Varied forms of centralized funerary structures appeared in the late Roman Empire. The **Mausoleum of Galerius** (now known as Hagios Georgios) in Salonica, Greece (298–99), reused the massive domed cylinder of the Pantheon, but eroded the interior with large rectangular niches (fig. 2.9). Galerius's Mausoleum formed part of an imperial complex, connected to a triumphal arch by an avenue flanked by two peristyles near the imperial palace. The Emperor Theodosius later converted it into a Christian palace chapel about 395, adding an apse and mosaics in the dome depicting saints standing in architectural niches. Diocletian's Mausoleum (ca. 305–313) at Spalato in the eastern Adriatic represents one of the most elaborate surviving centralized funerary structures. An open peristyle surrounds its octagonal core. Freestanding columns articulate the interior and support projecting entablatures, a second story of columns, and then a dome.

Christian members of the imperial court continued to vary these funerary structures. Ravenna became the capital of the western empire after the imperial court moved there from Milan in the early fifth century. Galla Placidia, who served as regent of the empire after the death of her husband, Constantius III, in 421, built a small cruciform structure originally attached to the church of S. Croce, now destroyed. Intended as an oratorio dedicated to St. Lawrence, who is depicted in a mosaic inside, it was converted to a mausoleum to contain her tomb as well as that of her husband, her brother Honorius, and her son, Valentinian III. Within the **Mausoleum of Galla Placidia** (fig. 2.10, *top*; figs. 2.11–2.12) superb decorative and pictorial mosaics cover the four barrel vaulted arms of the cross. At the intersection, a crossing tower contains a small domical "pendentive" vault rising from four corbelled arches. A blind arcade articulates the brick exterior: its recessed panels between pier buttresses and rhythmic arches may have inspired the decorative arched corbel tables that began to appear in the ninth century.

The tradition of cylindrical mausolea was continued in the **Tomb of Theodoric** also in Ravenna (fig. 2.13). Theodoric, an Ostrogoth who at the behest of the Byzantine emperor Zeno, defeated the Herulians in northern Italy and killed their leader Odovacar, ruled the Western Empire from Ravenna from 493 until his death in 526. His solid sepulchral tomb was built of massive blocks of stone in two stories. The bottom decagon-shaped level contains a cruciform chamber with intersecting barrel vaults; the top octagonal story contains a circular chamber capped by a single monolithic stone forming a dome 35 feet in diameter and ten feet thick. This tomb combines three diverse traditions: the Roman tradition of solidity implying permanence; a Christian tradition in the twelve handles on the capstone symbolic of the apostles; and a barbarian tradition of Ostrogothic metalwork in the incised decoration on the cornices.

As early Christians varied the form of the centralized mausoleum, they also varied its function. An octagonal structure was built as a **baptistery** in conjunction with the Basilica of St. John the Lateran (fig. 2.10). Begun in 312 under the patronage of Constantine, it was restored under Pope Sixtus III (430–40) and again in the Baroque period.

It originally consisted of an octagonal external shell wrapped around an internal octagonal core. Two stories of columns supported entablatures and separated the central space from the surrounding ambulatory. The building therefore forms a double shell in which a passageway surrounds an interior octagonal baldachin. Since a timber roof covered both interior spaces, the inner core and enveloping ambulatory were not visible from the exterior. The appropriation of a building type most commonly used for mausolea for a baptistery also had symbolic relevance, for baptism in the Christian faith was considered to be a rebirth to a new life after casting off the old pagan ways. The octagonal plan also denoted the symbolism of the Resurrection, for Christ's Resurrection occurred eight days after his entry into Jerusalem.

The simple octagonal form was also used with slight variations at the **Baptistery of the Orthodox** in Ravenna by Bishop Neon between 449

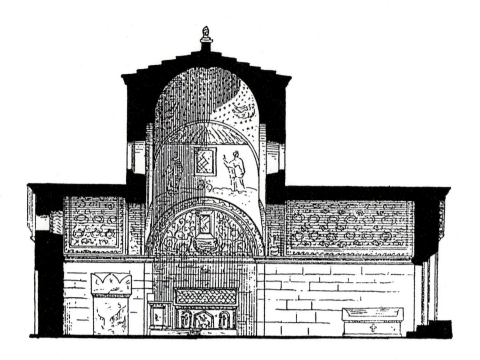

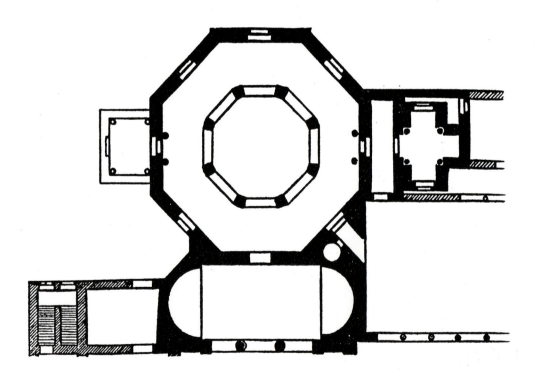

2.10 *Top:* Ravenna, Mausoleum of Galla Placidia, circa 425: section. (After Dehio and Bezold.) *Bottom:* Rome, Baptistery of St. John the Lateran, circa 313: plan. (After Dehio and Bezold.)

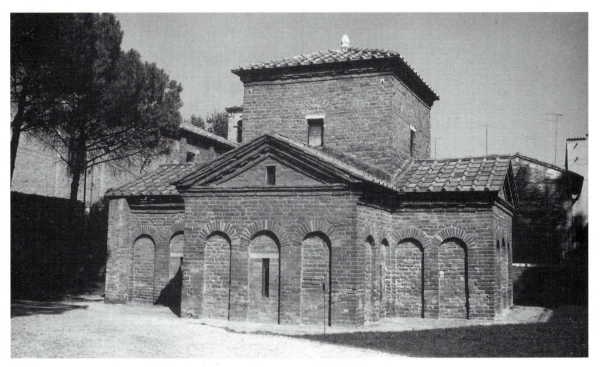

2.11 Ravenna, Mausoleum of Galla Placidia, circa 425: exterior. (R. G. Calkins.)

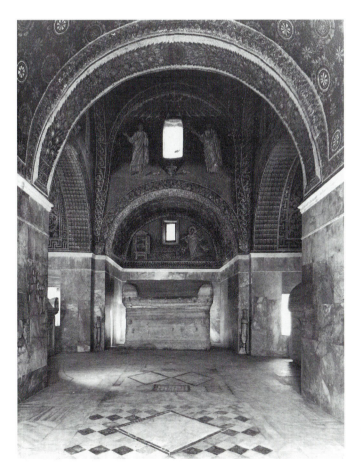

2.12 Ravenna, Mausoleum of Galla Placidia, circa 425: interior. (Deutsches Archäologisches Institut, Rome.)

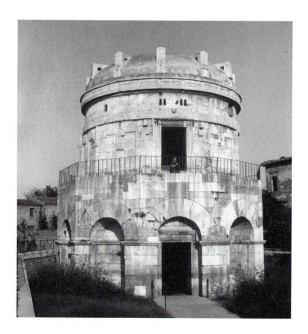

2.13 Ravenna, Mausoleum of Theodoric, circa 526: exterior. (R. G. Calkins.)

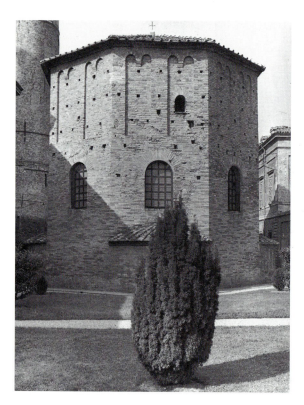

2.14 Ravenna, Baptistery of the Orthodox (Baptistery of Neon), 449–452: exterior. (Deutsches Archäologisches Institut, Rome.)

and 452 (fig. 2.14). In plan, the bottom story appears almost square because four rounded chapels emanate from alternate sides. A dome caps the unified interior space without an ambulatory. Built of hollow tiles, the dome rises from continuous pendentives between eight arches layered inward from the walls. Marble veneer and rich mosaics cover the entire interior. The brick exterior with recessed panels, projecting pilaster strips at the corners, and series of arched corbels may be an addition of the ninth or tenth century. This decoration is significant because it exemplifies an early arched corbel table, or Lombard decoration, that evolved from the decorative arcading on the Mausoleum of Galla Placidia and became prevalent later in Romanesque architecture.

S. Costanza (end of the fourth or beginning of the fifth century, figs. 2.15–2.16) and S. Stefano Rotunda (ca. 468–83) in Rome most clearly reveal the essential characteristics of the double shell structure. S. Costanza has a cylindrical outer shell containing a curving barrel (annular) vault, over an ambulatory, wrapped around a higher cylindrical core that is surmounted by a dome. Twelve pairs of columns define the central core. They are set on the radii, with slightly higher and wider arches articulating the main and transverse axes forming a subtle equal-armed Greek cross. The high drum with twelve windows beneath the dome floods the central space with light, beyond which the shadowy ambulatory creates a dramatic visual effect reminiscent of that achieved at Hadrian's Villa. Originally attached to the covered cemetery of S. Agnese, it had an open external peristyle and oblong entrance vestibule, or narthex. Archaeological evidence suggests that it replaced an earlier trefoil structure, a martyrium of St. Agnese, and became a combined martyrium and mausoleum for Constantina, the daughter of Constantine (she died in 354), and for his mother, Helena.[4] Mosaics in the vault of the ambulatory combine pagan and Christian motifs with funerary portraits of Constantina, and specifically Christological mosaics occupied the north and south apsidal niches. The emphasis in this building has shifted from the structural prowess of Roman architecture to one of symbolic form: the twelve pairs of columns and windows refer to the Twelve Apostles, the implied cruciform plan to the Crucifixion, and the lighting effects of the interior to a more etherial rather than terrestrial world.

Centralized plans perhaps derived from complex designs found in Roman imperial palaces were also

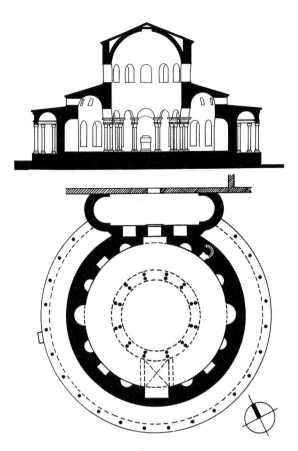

2.15 Rome, S. Costanza, end of fourth, beginning of fifth century: section and plan. (Leland Roth.)

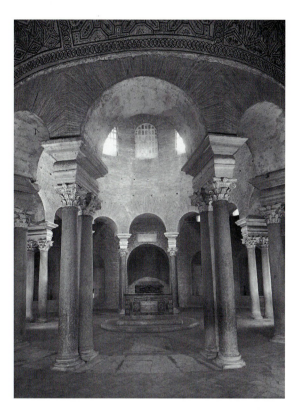

2.16 Rome, S. Costanza, end of fourth, beginning of fifth century: interior. (Deutsches Archäologisches Institut, Rome.)

were adapted for churches and chapels with imperial associations. One of the buildings that borrowed from late antiquity and set the stage for future Byzantine developments was the church of **S. Lorenzo** in Milan (figs. 2.17–2.20) that combined the double shell with the multilobed plans evolving out of late imperial palaces. It was completed just before A.D. 378, at a time when Milan served as the capital of the western Roman Empire. Since S. Lorenzo was erected in the proximity of the imperial palace in Milan, it exemplified an early palatine chapel and used architectural forms with appropriate imperial connotations. Thus, a monumental colonnade before a large atrium preceded the whole ensemble, a variation of the peristyles linking Galerius's arch and mausoleum at Salonica, and leading to the imperial palace of Diocletian at Spalato. A pediment over a large arch interrupts the heavy entablature along the top of the

columns, the same motif also appearing on the facade of Diocletian's palace and frequently serving as an architectural frame for imperial images.

Permutations of centralized interior spaces occur in the octagonal chapels surrounding the complex structure of S. Lorenzo. The little chapel of S. Sisto appended to the north has alternating rectangular and semicircular niches enclosed in an octagon. The same format repeats on a larger scale in the chapel of S. Aquilino to the south, and an octagonal shell encloses an interior Greek cross in the chapel S. Ippolito to the east.

The components of S. Lorenzo itself are difficult to discern from the ground plan: essentially the building forms a double shell tetraconch or four-lobed building. It consists of a central octagon contained within a square, off of which emanate segmental exedrae on all four sides. Cruciform piers

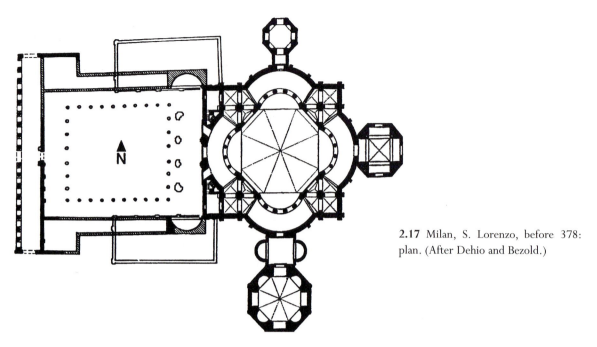

2.17 Milan, S. Lorenzo, before 378: plan. (After Dehio and Bezold.)

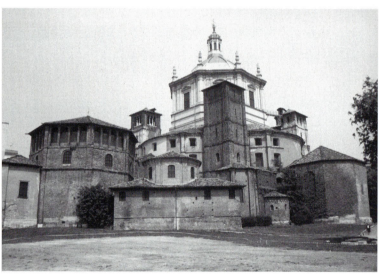

2.18 Milan, S. Lorenzo, before 378: exterior. (R. G. Calkins.)

define the corners of the interior square. An ambulatory envelopes this central core, and its exterior walls reiterate the corners of the square and four apsidal lobes echo the interior exedrae. Inside, curved screens of columns billow out from the central space, defining the interior quatrefoil plan and penetrating the undulating ambulatory that surrounds it. The intrusion of these apsidal spaces into the ambulatory becomes particularly evident as one circulates around this passage, as one can see past the

inside of the columns to other areas of the ambulatory. The interior core supports an octagonal dome, or cloister vault, with flat sides curving upward to its apex. This forms the octagonal central core of the building clearly visible on the exterior.

Although the interior was also reworked in the late Renaissance and baroque periods, its previous decoration stripped away and replaced by austere pilasters and heavy entablatures, the shifting vistas and evasive colonnades create an ephemeral interior

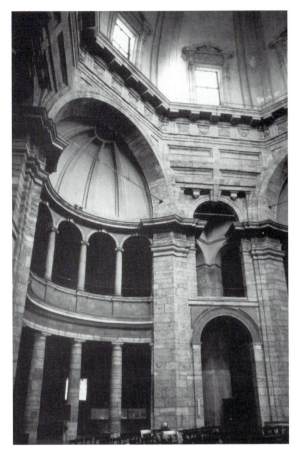

2.19 Milan, S. Lorenzo, before 378: interior. (R. G. Calkins.)

2.20 Milan, S. Lorenzo, before 378: ambulatory. (R. G. Calkins.)

of light-filled core and shadowy surrounds. This effect, although less elusive and flowing, may ultimately derive from the undulating quatrefoil plan of the Piazza d'Oro at Tivoli (fig. 1.8). Even the residual corner spaces were repeated at S. Lorenzo, where the corners provide a shadowed foil for the lighter central space.

Centralized buildings used as baptisteries and mausolea were also erected throughout France and Germany. Octagonal baptisteries at Fréjus in southern France, Albenga in northern Italy—both dating from the late fifth century—and the Orthodox Baptistery in Ravenna, had corner niches forming a square plan out of the octagonal core, each with a dome on a drum pierced by windows. Roman imperial mausolea may have inspired **St. Gereon** in Cologne (ca. 380), an exotic oval building surrounded by eight semicircular niches with an apse

on one end and a narthex on the other (fig. 2.21, *bottom*). Its many-lobed plan recalls that of the Nymphaeum in Rome. Now embedded in later structures, it was built in a cemetery and probably served as a martyrium, although its original dedication is unknown.

The plan of the **Cathedral of Bosra,** built in A.D. 512, carried the manipulation of complex interior spaces within a relatively simple exterior shell even further (fig. 2.22). The plan consisted of a square with prolongations on the east side for projecting chapels. Two small chapels flanked a large central one, in effect turning the square plan into a rectangular one. The simple boxlike configuration of the exterior revealed nothing of the dynamic interior space. Projecting piers and alternating semicircular and rectangular niches eroded the interior wall surface and defined an interior circu-

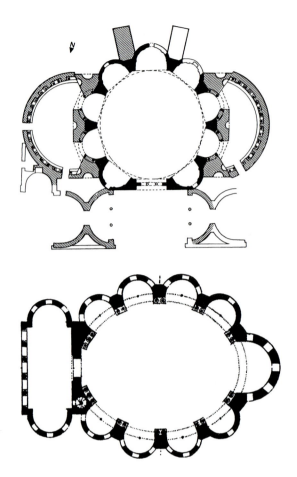

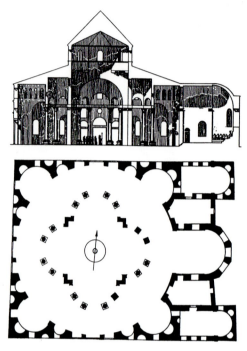

2.22 Bosra, Cathedral, 512: section and plan. (After Detweiler.)

2.21 *Top:* Rome, Pavillion in the Licinian Gardens (Temple of Minerva Medica), early fourth century: plan. (After J. B. Ward-Perkins, *Yale University Press Pelican History of Art.*) *Bottom:* Cologne, St. Gereon, circa 380: plan. (After A. von Gerkan, *Spätantike und Byzance Neue Beiträge zur Kunstgeschichte des Jahrhunderts.* Baden Baden, 1952, fig. 20.)

lar ambulatory. The interior core of the building consisted of a square defined by L-shaped corner piers that supported a timber pyramidal roof above the central space. Curved screens of columns emanated out from the central square on all four sides, intruding into the space of the surrounding circular ambulatory, creating an elusive, weaving corridor of space, especially in contrast to the clarity of the annular aisle that surrounded the central core of S. Costanza. This variety and complexity of interior spaces, fusing variegated centralized spaces within simple, usually rectilinear, shells became the basis for many of the most innovative buildings

erected during the reign of the Emperor Justinian between A.D. 527 and 565.

COMBINED STRUCTURES

In addition to using the longitudinal and centralized types of buildings for ecclesiastical purposes, early Christians combined these forms to achieve ensembles of remarkable complexity. An early example of such a combined structure in the Near East was created haphazardly as the result of two building campaigns. The Praetorium church at Musmiyeh in Syria (figs. 2.23–2.24) was originally constructed in A.D.

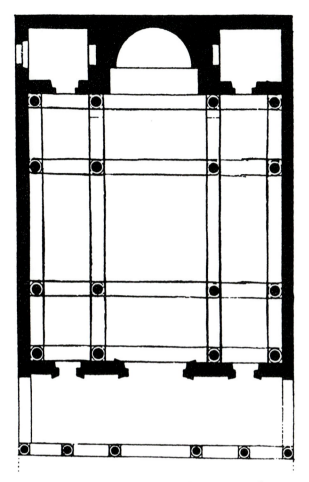

2.23 Musmiyeh, Praetorium church, 160, revised circa 400: plan after alterations. (After de Vogüé.)

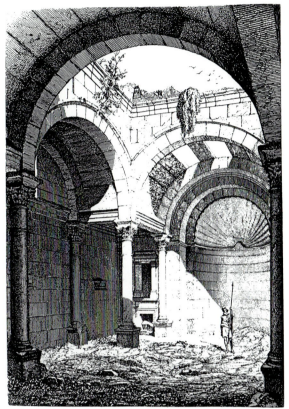

2.24 Musmiyeh, Praetorium church, 160, revised circa 400: reconstruction of interior after alterations. (After de Vogüé.)

160 as a simple building with a square nave prolonged into a rectangle by an apse and two side chambers. About A.D. 400 this building was converted to Christian use, and four columns were placed in the interior to form a central square baldachin surmounted by a four-sided cloister vault. Four barrel vaults extended to the outer walls from the central square, creating an inscribed Greek cross within the confines of the structure. Thus, a centralized space was created within a longitudinal one, a variation of the subtle inscribed crosses found in the rotundas of S. Constanza and S. Stefano Rotunda in Rome.

Larger combined structures resulted from the simple combination of the two forms. The emperor Constantine founded the **Church of the Holy Sepulcher** in Jerusalem (fig. 2.25, *top*) over the reputed site of the tomb of Christ. Contained with-

in a rectangular perimeter, by A.D. 350 the church consisted of a succession of spaces, buildings, and holy sites. A monumental stairway led up to a propylaeum, affording entrance to a narrow atrium surrounded by a colonnaded covered walk. This space, like that of Old St. Peter's in Rome, afforded the pilgrim a chance to pause before entering the martyrium basilica. This five-aisled, timber-roofed basilica had a single apse at the end of the nave. An exit to the left side of the apse led to a hillock within the complex, the rock of Calvary where Christ was crucified. Beyond another courtyard surrounded by a colonnade loomed a large circular double shell structure: the Rotunda of the Anastasis, a martyrium situated over the grotto tomb of Christ and the site of his Resurrection. About 110 feet in diameter, it was preceded by a circumferential colonnaded portico. The interior consisted of an ambulatory sur-

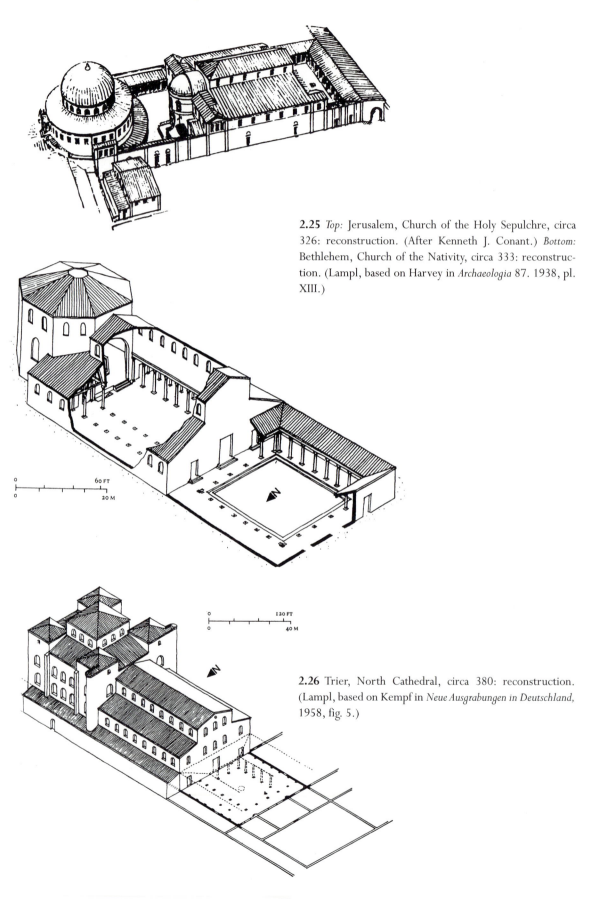

2.25 *Top:* Jerusalem, Church of the Holy Sepulchre, circa 326: reconstruction. (After Kenneth J. Conant.) *Bottom:* Bethlehem, Church of the Nativity, circa 333: reconstruction. (Lampl, based on Harvey in *Archaeologia* 87. 1938, pl. XIII.)

60 FT

20 M

120 FT

40 M

2.26 Trier, North Cathedral, circa 380: reconstruction. (Lampl, based on Kempf in *Neue Ausgrabungen in Deutschland*, 1958, fig. 5.)

rounding the site of the tomb and a three-story colonnade with gallery and clerestory that supported a conical dome. The variety of external and internal spaces, the sequence of a longitudinal, processional basilica and a centralized, focused martyrium reflect a similar penchant for an ordered sequential experience found in earlier Roman temple complexes such as that at Baalbeck of the second century A.D.

A more subdued but more innovative combination of the longitudinal and centralized structures occurred at the nearly contemporaneous **Church of the Nativity** in Bethlehem (fig. 2.25, *bottom*). This was another Constantinian commission, dating from about A.D. 330. Erected over the reputed site of the grotto of the Nativity, the church consisted of a five-aisled, timber-roofed basilica with an octagon covered by a pyramidal wooden roof added onto the longitudinal structure and situated over the sacred grotto. Thus, the centralized and longitudinal buildings were tightly pulled together, and the four side-aisles of the basilica flowed easily into the ambulatory of the octagon, providing for the unencumbered circulation of pilgrims to the site without the intervention of additional courtyards as at Jerusalem.

At Trier, Constantine's palace and nearby Roman baths provided the imperial setting against which a large double cathedral was built. This structure, consisting of two parallel basilicas, echoes a simpler plan of a double cathedral built at Aquelia at the beginning of the fourth century in which the spaces of both buildings may have been devoted to different liturgical rites. About 380, Emperor Gratian had the **North Cathedral** at Trier rebuilt (fig. 2.26), creating a five-aisled basilica joined to a complex, centralized cruciform structure within a square at the east end. Four corner towers flanked the square crossing lantern tower, evoking the clustered towers and central drum of the nearly contemporaneous S. Lorenzo in Milan. This fusion of centralized and longitudinal plans resembled the combined form of the Church of the Nativity at Bethlehem. Because this impressive structure at Trier had twelve niches, reflecting the number of the Apostles, Richard Krautheimer wondered if it might have housed a relic of Christ as a *memoria*.[5]

In contrast to the detached axial arrangement of the Church of the Holy Sepulcher or the additive ensembles of the Church of the Nativity and the North Cathedral at Trier, the monastic complex at **Qalat Siman** (ca. 480–90) in Syria achieved a complete integration of the centralized and longitudinal plans over a century later (fig. 2.27). In this region east of Antioch, situated on main trade routes between Rome and the Eastern Empire, there flourished an accomplished school of architecture versed in the construction of monumental buildings built of fine ashlar masonry, carefully squared blocks of stone. The Syrians were experts at cutting precise stereometric blocks to form half-domes over apsidal spaces.

The great monastic complex built at Qalat Siman commemorated the site and the remains, until they were stolen, of St. Simeon in Stylites (ca. 390–459), an ascetic monk who lived on and preached from the top of a column for thirty-six years. After his death, a vast martyrium was built around the base of his column. Four three-aisled basilican structures radiated out of a central octagon with corner niches. The north, west, and south arms had seven consecutive bays. The east arm had ten bays and terminated in three apses with half-domes of carefully cut stone blocks. The exterior of the central apse was decorated with two stories of engaged columns surmounted by an arched corbel table frieze, perhaps another early example of an exterior decorative feature that became prominent in later Romanesque architecture in western Europe. The basilican arms had timber roofs above the clerestory, while a timber octagonal dome surmounted the crossing. Originally, each of the transeptal basilicas may have had an entrance portico like that of the facade of the western basilica, with a triple gable and large richly decorated central arch framing an entrance porch. Measuring 260 feet on the north-south axis and 295 feet on the east-west axis, this was the most grandiose example of Syrian architecture. But it also exemplified the developing innovation of combining the centralized and longitudinal plans, now making the martyrium/memorium the core of an intersection of processional spaces.

The penchant for monumental entrance facades and building with sophisticated masonry techniques at Qalat Siman prevailed in other Syrian buildings. Although not combined types, three-aisled basilican churches at Qalb Louzeh of about 500, and **Der Tourmanin,** of about the same date, may represent the genesis of the two-tower facade that later developed in western European medieval architecture. Qalb Louzeh was a simple, three-aisle basilica with a timber roof and a half-domed apse of well-shaped ashlar masonry.[6] The aisles were separated from the nave by three wide nave arcades on rectangular stone piers,

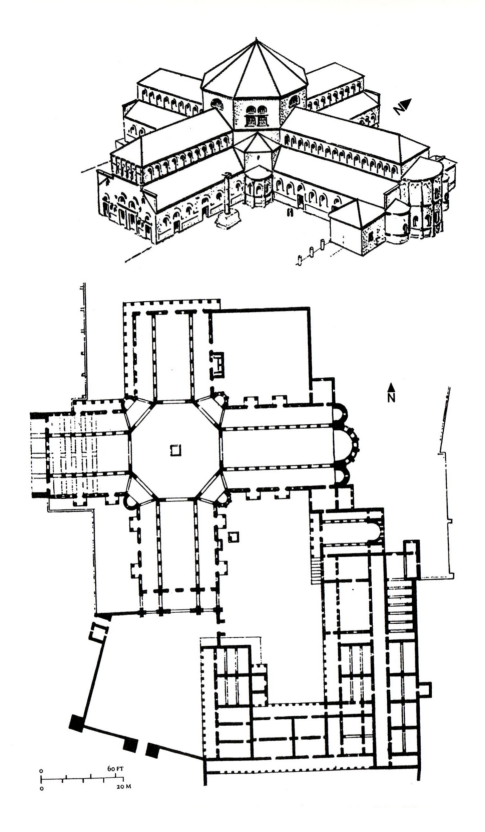

2.27 *Top:* Qalat Siman, St. Simeon in Styletes, Syria, circa 480–90: reconstruction. (After Lampl, based on Lassus, *Sanctuaires,* fig. 46.) *Bottom:* plan. (Butler, *Early Churches,* fig. 53.)

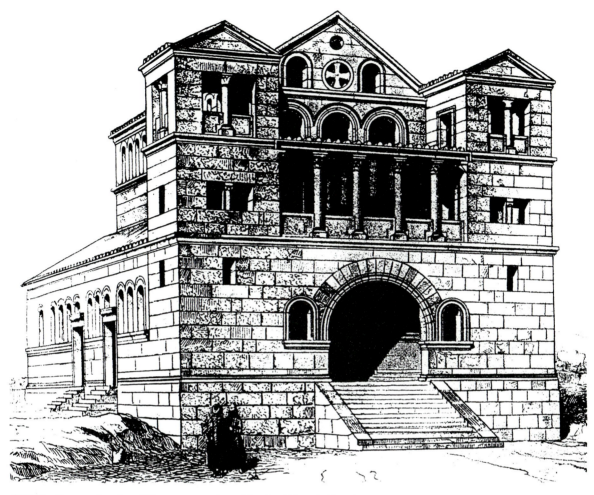

2.28 Der Tourmanin, circa 500: reconstruction of facade. (After de Vogüé.)

and above, small attached columns flanking clerestory windows supported the roof timbers. A facade with an entrance porch flanked by two low towers projected in front of the nave. A wide arch leading to the entrance porch voided the space between the twin towers, making the volumes of the towers seem more independent than they really were, resulting in a nascent two-tower facade. This same device was also used at the now destroyed sixth-century monastery church at Der Tourmanin (fig. 2.28).

Thus, once the early Christians had the resources and patronage to build structures for their own liturgical purposes in the fourth century, they borrowed a variety of forms from their Roman heritage, the longitudinal basilica and variations of the centralized plan. Nevertheless, they usually avoided the heavy Roman vaults, opting for timber-roofed buildings. The resulting configuration became the basis for the development of subsequent medieval buildings. At the same time, they built innovative combinations of the longitudinal and centralized forms, and this fusion of dual interior spaces ultimately led to the grandiose buildings constructed under Justinian.

3

JUSTINIAN'S BUILDINGS

Whereas the early Christians developed basic centralized and basilican forms from which much of later medieval architecture in the West evolved, in the East the Byzantines turned to more exotic combinations of forms. These buildings were inspired by rich late Roman traditions, as exemplified by the complexities of Hadrian's Villa at Tivoli, and were often closely tied to imperial patronage. They drew on the intricacies of late antique plans, the form of the double-shell structures, and the growing early Christian predilection for the combined ensemble. This tradition culminated in Justinian's Haghia Sophia. Some of its precursors, and Haghia Sophia itself, in scale and complexity expressed the magnificence and power of empire and church.

Constantinople, founded by the Roman emperor Constantine in 325 on the shores of the Bosporus, was intended as the new capital of the empire closer to the eastern border. But the establishment of an eastern capital effectively robbed Rome of its monopolistic power and thus eventually undermined it, giving rise to the split of the empire into a Greek East and Latin West. The resulting schism between the Greek Orthodox, or Byzantine, Church and the Latin-speaking Roman Catholic Church was also reflected in the different evolution of their architecture. This split became virtually codified by the death of Theodosius in 395 and the concomitant division of the empire between Honorius in the West and Arcadius in the East. By the time of Justinian in the sixth century, the locus of power firmly resided in the East, and the division between Byzantium and the Latin West had become irrevocable.

Large imperial projects abounded in Constantinople: Constantinian and Theodosian fortifications, the imperial palace complex, and the Hippodrome, all befitting the capital of the eastern Empire. Some of these structures used innovative designs, particularly extensive underground cisterns constructed in the fourth and the sixth centuries to store water for the populace of Constantinople. These consisted of myriad small brick groin vaults supported on a forest of columns. Theodosius also built a great basilica, dedicated to Holy Wisdom (Haghia Sophia) on the highest ground of the peninsula separating the Bosporus from the Sea of Marmara.

HAGHIA SOPHIA AND ITS PRECURSORS

When Justinian succeeded to the imperial throne in 527 he started a major construction campaign in the capital. He began the first of his projects in that year, the Church of **SS. Sergius and Bacchus** as a palace chapel, now known as Kuçuk Aya Sofya Çamii (figs. 3.1–3.4). The complex plan of this building closely follows the interior plans of Bosra (fig. 2.22),

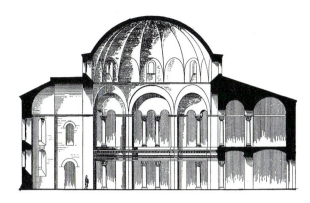

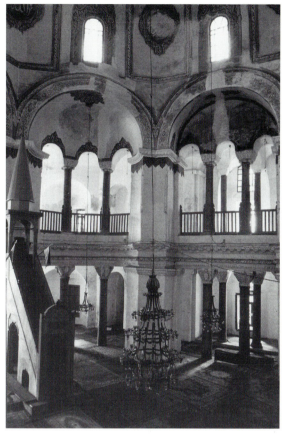

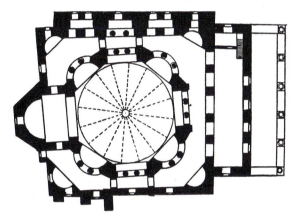

3.1 Constantinople, SS. Sergius and Bacchus, begun 527: section and plan. (After Dehio and Bezold.)

3.2 Constantinople, SS. Sergius and Bacchus, begun 527: interior from gallery. (R. G. Calkins.)

S. Lorenzo (figs. 2.17–2.20), and their Roman prototypes. Like Bosra, this double-shell building masks the interior octagon with a simple rectilinear exterior. Its square exterior shell with a protruding, faceted, eastern apse contains an interior octagon within a square as at S. Lorenzo. The interior square is not obvious, however, implied only by the four corner exedrae that alternate with the four flat sides. From the interior octagon, flat pie-shaped segments curve upward to form an eight-faceted dome similar to that of S. Lorenzo. The space of the interior flows into the expanding corner exedrae and past the curving screens of columns into the darker, residual space of the ambulatory.

The screening effect is reversed, however, in the gallery by the light wraparound space contrasting with the shadowy interior core. The upward rhythm

of arcades and enclosing arch enhances the undulating interior and leads the eye to the dome rising above. Drilled and undercut windblown acanthus leaves weaving across undulating surfaces of capitals create a similar diaphanous effect. The carving creates a lacelike foreground hovering above indeterminate depths that in a microcosm mirrors the spatial flow and screening effect of the interior colonnades of the entire building.

A virtually contemporary building similar to SS. Sergius and Bacchus, is the centralized archiepiscopal chapel of **S. Vitale in Ravenna** (figs. 3.5–3.7). Archbishop Ecclesius founded S. Vitale in 527 after a visit to Constantinople in 525, and obtained financing for it from Julius Argentius, a Ravenna merchant. However, S. Vitale was not completed until 548, well after Ecclesius's death in 532, the Byzantine occupa-

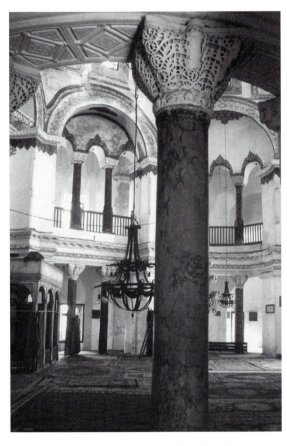

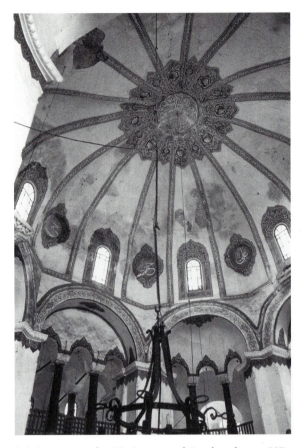

3.3 Constantinople, SS. Sergius and Bacchus, begun 527: interior from ambulatory. (R. G. Calkins.)

3.4 Constantinople, SS. Sergius and Bacchus, begun 527: dome. (R. G. Calkins.)

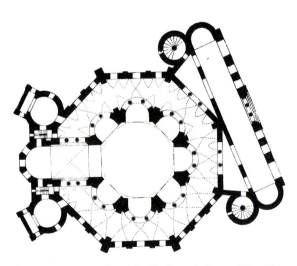

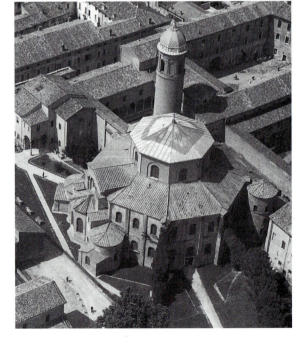

3.5 Ravenna, S. Vitale, 527–48: plan. (Dehio and Bezold.)

3.6 Ravenna, S. Vitale, 527–48: air view. (Fotocielo.)

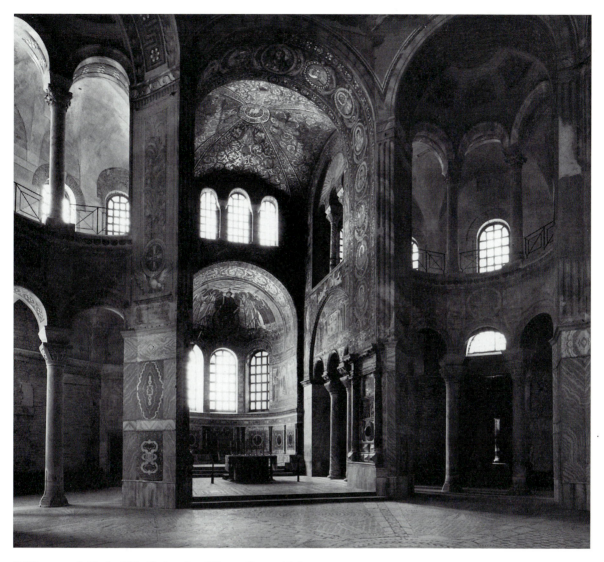

3.7 Ravenna, S. Vitale, 527–48: interior. (Hirmer Fotoarchiv.)

tion of 540, and the enstatement of Archbishop Maximian, Justinian's direct representative.

The plan and exterior volumes of S. Vitale are more directly discernible than in the buildings just considered. Its double shell consists of two concentric octagons, one side of which extends into a sanctuary flanked by two side chambers that interrupts the ambulatory. These elements give the building a longitudinal emphasis within its centralized design. The center octagon rises above the ambulatory and gallery levels and supports a dome on squinches (arches bridging the angles of intersecting walls) that effectively double from eight to sixteen the

number of sides tangent to and supporting the circular rim of the dome. Thin Roman bricks form the lower stories, but the semispherical dome was constructed of innovative materials: terra-cotta amphorae were set with the feet of the upper placed into the neck of the lower, to create a rigid, lightweight fabric.

The interior amplifies the screening effect of Saints Sergius and Bacchus with welling exedrae and rising arches on seven of its sides. Visitors enter through a narthex, oddly abutted at an angle to the building because of the adjacent episcopal palace, requiring an angled route into the building. An awk-

ward series of groin vaults, basically the result of an annular vault penetrated by cross vaults, covers the ambulatory. Nevertheless, the effect is similar to that at S. Lorenzo and SS. Sergius and Bacchus: semi-circular exedrae intrude upon this residual space resulting in the same interpenetration of spaces and glimpses of screened vistas. Seven semi-circular exedrae well out from the octagonal core with curved arcades screening the ambulatory and gallery spaces, and rising to half domes and arches beneath the dome. Although the interior manifests a similar lateral expansion to that at SS. Sergius and Bacchus in Constantinople, the arcades in both the ground and gallery levels create a more emphatic vertical emphasis, reiterated by the half dome and the enclosing arch above.

In addition, color and light contribute to the insubstantial effect. The central space is surrounded by piers and surfaces once covered with rich marble veneer, polychromed capitals and mosaics. Much of this original decoration has been lost; in the dome it was replaced by baroque embellishments. Rich marble and gold mosaic surfaces would have created a glowing, even glistening interior, but the substance of the windows, covered with thin sheets of translucent alabaster, cast a warm, suffusive, creamy glow in the interior. Lit by candles that would have flickered on the reflective surfaces, this interior would have seemed immaterial and insubstantial. Here too, the carved capitals echo the characteristics of the entire space but in a subdued manner. Squared rather than undulating capitals with windblown acanthus, though less undercut than at SS. Sergius and Bacchus, repeat the openwork and screening effect of the interior space.

The mosaics of the sanctuary supplement the spatial experience with representations of sacrificial offerings echoed by themes of episcopal and imperial donations: Abel and his Lamb; Melchizedek with his chalice; Abraham and Isaac in side mosaics; even St. Vitalis receiving his crown of martyrdom and Bishop Ecclesius presenting a model of S. Vitale to Christ in Majesty in the apsidal mosaic. Below, Justinian, on the left, and Theodora, on the right, proffer a bowl and a chalice, respectively, toward the apse and altar, virtual icons of an imagined imperial presence offering gifts and participating eternally in the celebration of the mass. All elements of S. Vitale—architectural, iconographical, pictorial, liturgical, and even emotive—work upon the

beholder to create a spiritual ambience that evokes far more than the mere sum of its physical parts.

Meanwhile, in Constantinople, the early years of Justinian's reign (527–65) were tumultuous. During the Nika Riots of 532 the Theodosian basilica of Haghia Sophia burned down. The riots were so severe that the emperor wished to flee, but his wife, Theodora, prevailed upon him to stand firm, and he weathered the uprising. As part of the campaign to reestablish the image of a magnificent empire and to reaffirm his rule, Justinian set about having the church of **Haghia Sophia** rebuilt in a more grandiose form (figs. 3.8–3.15). Construction began on February 23, 532, and was completed by its dedication on Christmas Day, 537. Anthemios of Tralles and Isidorus of Miletus—two sixth-century equivalents of civil engineers who understood the theories of vaulting, parabolic curves, statics, and mathematics—designed it and directed its construction.

In the tradition of earlier Near Eastern double-shell buildings, the exterior of Haghia Sophia stands a hulking mass that reveals little about its interior arrangement (fig. 3.11). The addition of later medieval pier buttresses on the north and south flanks of the building make it even more difficult to read. But even without them, the exterior would still remain enigmatic. The slopes of two half-domes on the east-west axis flank the shallow curve of the dome atop a massive cube. Below that, the volumes of the exedrae blend into the rectangular mass of the lower part of the building, while the faceted apse on the east supports a series of ambiguous curved walls. Nevertheless, the exterior of Haghia Sophia so impressed Procopius, the court historian of Justinian, that he wrote:

> So the church has become a spectacle of marvelous beauty, overwhelming to those who see it, but to those who know it by hearsay, altogether incredible. For it soars to a height to match the sky, and, as if surging up from amongst the other buildings, it stands on high and looks down upon the remainder of the city, adorning it . . . glorifying in its own beauty . . . [1]

The simplified but obfuscating exterior hides the interior complexity of Haghia Sophia's double shell in the same way as the exteriors of Bozra and SS. Sergius and Bacchus. The ground plan (fig. 3.8),

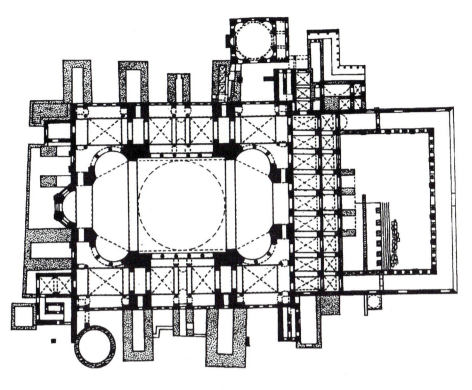

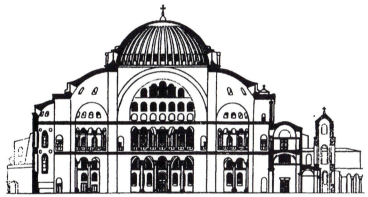

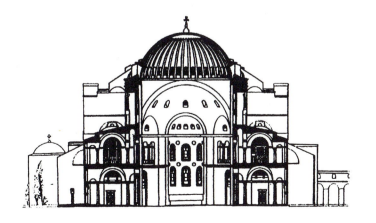

3.8 Constantinople, Haghia Sophia, 527–32: plan, longitudinal and transverse sections. (After A. M. Schneider.)

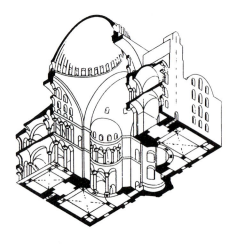

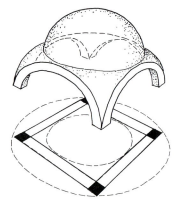

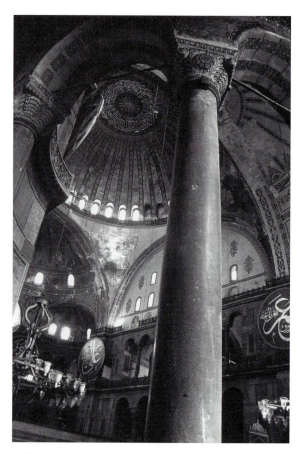

3.9 *Top:* Constantinople, Haghia Sophia, 527–32: isometric view. (After MacDonald) *Bottom:* Dome and pendentives. (After Leland Roth.)

3.10 Constantinople, Haghia Sophia, 527–32: dome from exedra. (R. G. Calkins.)

however, clearly reveals the components of the double-shell: a huge exterior rectangle 230 by 250 feet long contains a square in the center (100 feet a side) defined by four massive piers that support the dome. Two flanking half-domes prolong the central square, creating a rectangular nave equal to two of the central squares that in turn expand into curving corner exedrae. Two side aisles with galleries above flank the central space and penetrate the four massive piers. Haghia Sophia represents the ultimate combined-type building, integrating the longitudinal three-aisled plan of the Basilica of Maxentius (fig. 1.4) with a domed centralized core in a grandiose double-shell structure, a magnification and refinement of the arrangement at SS. Sergius and Bacchus.

The construction of the central core of the building proved difficult, and its dome required later revisions. The four great piers support massive arches that in turn support the dome above. But because the piers were not oriented along the radius of the dome—or at a forty-five-degree angle to the intersecting arches they receive—they twisted sideways and outward during their construction. Procopius records how Anthemios and Isidorus went in great fear to Justinian, who told them not to worry, but to press on and complete the construction of the arch that was causing the problem, "For when it rests upon itself," he said, "it will no longer need the props beneath it." While the arch in fact survived, the piers had to be strengthened with lead sheets to distribute the load, and the dome encircled by a huge chain to contain its lateral thrusts.

To make matters worse, the original dome probably was a "pendentive dome," semicircular only from corner to corner, therefore exerting severe diagonal thrusts onto the inner corner of the piers, while the lateral and longitudinal profiles formed flat segmental curves discharging even more out-

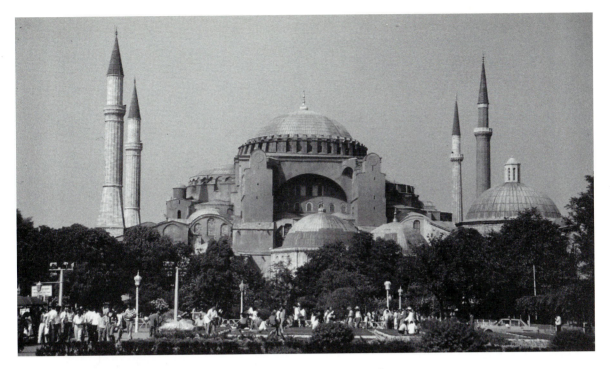

3.11 Constantinople, Haghia Sophia, 527–32: dome from exterior. (R. G. Calkins.)

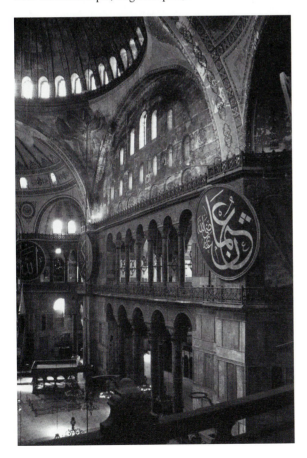

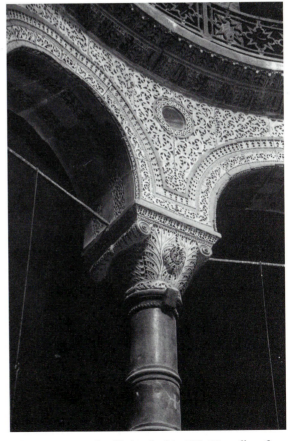

3.12 Constantinople, Haghia Sophia, 527–32: side elevation from west gallery. (R. G. Calkins.)

3.13 Constantinople, Haghia Sophia, 527–32: wall surface and capital. (R. G. Calkins.)

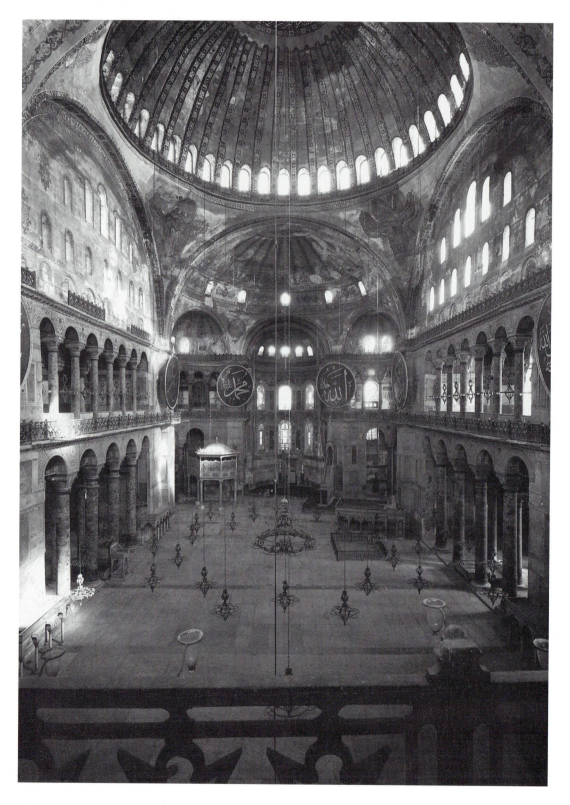

3.14 Constantinople, Haghia Sophia, 527–32: interior from west gallery. (Hirmer Fotoarchiv.)

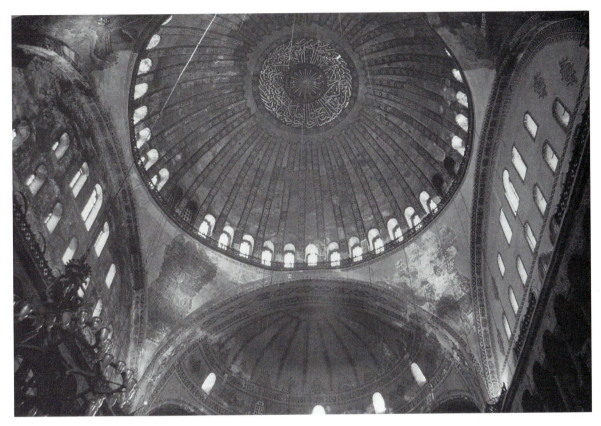

3.15 Constantinople, Haghia Sophia, 527–32: dome from west gallery. (R. G. Calkins.)

ward thrusts upon the supporting arches. This dome resembled a vast enlargement of the dome found in the crossing tower of the Mausoleum of Galla Placidia. Thus, probably no proper pendentives existed as we see them now.

The present dome with pendentives may result from a collapse of the original dome after an earthquake in 557 and its restoration by Isidorus the Younger between 558 and 562. He evened out the top edge of the remnants of the former dome, creating a circumference at a point tangent to the apex of the major arches that serves as a support for the dome placed above it. The remnants of the previous dome in the corners, curved triangular panels linking the arches, became pendentives that in turn supported the new hemispherical dome above (figs. 3.9–3.10).

Haghia Sophia works on the beholder in an experiential way, first by the sequence of spaces and shifting vistas, and second by its masking of its structural viability. First of all, the structure invites move-

ment. The visitor enters from the atrium into the low, dark exonarthex, and then into the higher, lighter transverse space of the narthex proper. A person not a member of the imperial party or the clergy would have been relegated to the aisles and side galleries. From the ambulatory space behind the exedrae the beholder has shifting furtive glimpses through the screening colonnade to similar screens on the other side (fig. 3.10). Ample side aisles offer similar views constantly screened by the nearest colonnades. From these positions the visitor cannot experience the totality of the building. Even if the beholder should venture out into the central nave, the vast scale of the space overwhelms and its fabric eludes comprehension: exedrae and walls are voided by multiple arcades and windows (fig. 3.12). From the north and south galleries, the changing vistas become even more fragmentary. Only from the ample arcade of the western loggia above the narthex, facing down the length of the nave to the

eastern apse, can a visitor comprehend the totality of the entire interior space (fig. 3.14).

But even the complete vista of the interior creates an illusion, for the building conceals its structural elements. In contrast with the palpable unity and reassuringly articulated interior space of the Pantheon in Rome (fig. 1.6), with a concrete dome resting on a massive cylinder, the interior of Haghia Sophia reveals only ambiguous structural components, resulting in a diaphanous, insubstantial material fabric. Unlike the obvious visual clues of columns, piers, and rising vertical and horizontal ribs in the dome that state convincing, though erroneous, tectonics of the Pantheon, the major elements of structure at Haghia Sophia are obscured. The four massive piers, sheathed in marble veneer, barely project beyond the wall surface, simply blending in with it (fig. 3.12). Nowhere do they state their massiveness or supporting function. The four enormous arches are also invisible: those on the eastern and western sides of the central square blend smoothly into the curve of the half-domes (fig. 3.14), and even the strip of later painted decoration does not convince one that they exist. The arches to the north and south appear only as a thin rim above the semicircular wall, their massive bulk only visible from the outside. Numerous arcades and windows penetrate walls, dome, and half-domes. Contrasting effects of shadowed areas, backlit vaults, hovering domes, and coronas of windows under them accentuate the effect of the dematerialized fabric: the whole interior surface forms a latticework before indeterminate voids in the same way that the undercut, windblown acanthus on the capitals found throughout the building hovers before the shadowed background (figs. 3.12–3.15). These capitals mirror the diaphanous effect of the building in the same way as those at SS. Sergius and Bacchus. It is no wonder then, that Procopius marveled about the structure and interior effect of Haghia Sophia:

And it exults in an indescribable beauty. For it proudly reveals its mass and the harmony of its proportions. . . . Both its breadth and its length have been so carefully proportioned that it may not improperly be said to be exceedingly long and at the same time unusually broad. . . . The upper part of this structure ends in the fourth part of a sphere and above it another crescent shaped structure rises, fitted to the adjoining parts of the building. . . . All

of these details fitted together with incredible skill in midair and floating off from each other and resting only on the parts next to them, produce a single and most extraordinary harmony in the work, and yet do not permit the spectator to linger much over the study of any one of them, but each detail attracts the eye and draws it on irresistibly to itself. So the vision constantly shifts suddenly, for the beholder is utterly unable to select which particular detail he should admire more than all the others. . . . [It is] marvelous in its grace, but by reason of the seeming insecurity of its composition, altogether terrifying. . . . [It] seems somehow to float in the air on no firm basis, but to be poised aloft to the peril of those inside it. . . . Yet [the dome] seems not to rest upon solid masonry, but to cover the space with its golden dome suspended from Heaven.

Writing of the effect of the light within this miraculous space, Procopius summed up the purpose and essence of the building as a whole:

. . . It abounds exceedingly in sunlight and in the reflection of the sun's rays from the marble. Indeed, one might say that its interior is not illuminated from without by the sun, but that the radiance comes into being within it, such an abundance of light bathes this shrine. . . . The whole ceiling is overlaid with pure gold, which adds glory to the beauty, yet the light reflected from the stone prevails, shining out in rivalry with the gold. . . . Or who could recount the beauty of the columns and the stones with which the church is adorned? One might imagine he had come upon a meadow with its flowers in full bloom. For he would surely marvel at the purple of some, the green tint of others, and at those on which the crimson glows and those from which white flashes, and again at those which Nature, like some painter, varies with the most contrasting colors. And whenever anyone enters this church to pray, he understands at once that it is not by any human power or skill, but by the influence of God that this work has been so finely turned. And so his mind is lifted up toward God and exalted, feeling that He cannot be far away, but must especially love to dwell in this place which He has chosen.

Overwhelming in size and exterior mass, yet ambiguous in apparent interior structure, Haghia Sophia stands magnificent, elusive, glittering, and immaterial in fabric, a fitting symbol of the rejuvenation of Byzantium under Justinian. No such overwhelming interior and exterior effects would be achieved again in medieval architecture until the great Gothic cathedrals of the thirteenth century.

OTHER BUILDINGS UNDER JUSTINIAN

In contrast to the complex domed double-shell buildings built under Justinian, the basilican form also prevailed in early Byzantine architecture: H. Demetrios at Salonica (late fifth century), S. Apollinare Nuovo in Ravenna (ca. 495) (fig. 2.8), S. Apollinare in Classe (549), and basilican cathedrals at Poreč (ca. 550) and Grado (571–79). **H. Demetrios** (figs. 3.16–3.17) burned in 1917, but

it has been restored. It has five aisles, an eastern transept, a single semicircular apse around which an angled ambulatory extends from one transept end to the other. An ample gallery with windows above the aisles and numerous clerestory windows under a timber roof create a well-lit spacious interior. In contrast, the two above-named basilicas in Ravenna are simple three-aisled structures without transepts or galleries. Nevertheless, these buildings, along with H. Demetrios and other Eastern basilicas in general, have a characteristic amplitude of space and light.

However, variations of the domed cruciform plan, combined with elements derived from the elevation of Haghia Sophia, provided sources for the development of later major types of Byzantine churches. In Constantinople, the design of Haghia Sophia had an immediate effect on the church of **St. Irene** (figs. 3.18–3.19). Built on the site of a nearby church destroyed by the Nika Riots, it was begun in the same year as Haghia Sophia. Fire partially destroyed it in 564 and an earthquake in 740 damaged it considerably; thus the present building, now with two domes, reflects its eighth-century reconstruction. It is possible that the western, lower dome is a result of this rebuilding. Two nave bays in

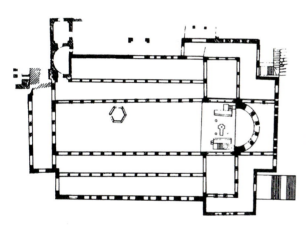

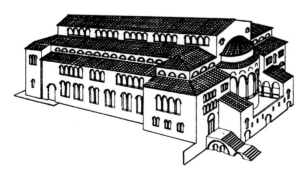

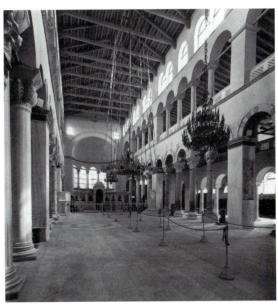

3.16 Salonica, H. Demetrios, late fifth century: plan and exterior reconstruction. (After Soteriou and Orlandos.)

3.17 Salonica, H. Demetrios, late fifth century: nave interior. (Hirmer Fotoarchiv.)

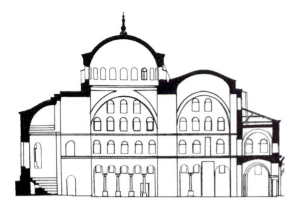

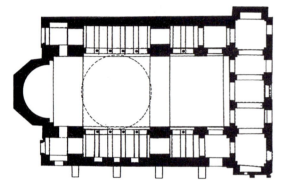

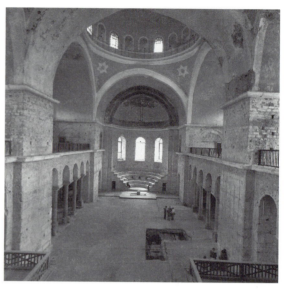

3.19 Constantinople, St. Irene, 527 with revisions of 564 and after 740: nave interior. (Josephine Powell.)

3.18 Constantinople, St. Irene, 527 with revisions of 564 and after 740: section and plan. (After W. S. George.)

succession emulate the characteristics of the central bay at Haghia Sophia and are covered by domes on pendentives. It is a brick structure, a three-aisled basilica with a semicircular apse on the inside and faceted on the outside. Narrow aisles with galleries above flank the nave. Although in a more subdued fashion, the colonnades separating the nave from the aisles and the semicircular wall pierced with windows above reflect the elevation at Haghia Sophia. Because the semicircular wall is set back to allow a gallery passage before it, the mass of the supporting piers and great lateral arches are clearly revealed, emphatically stating the working structure.

This same configuration, a square bay with a dome on pendentives supported by massive piers, became the basic unit repeated six times in the large cruciform basilica of **St. John at Ephesus** in Asia Minor which Justinian rebuilt over the grave of St. John the Evangelist (fig. 3.20). This monumental building, completed in 565, replaced a cruciform

basilica of Constantinian origin. Four bays with domes on pendentives covered the nave, while an additional dome constituted each arm of the projecting transepts, forming a Latin cross with the crossing dome higher than the others. The interior wall elevation with a nave arcade, gallery arcade, and semicircular wall with windows copied the basic design of Haghia Sophia even more closely than St. Irene, and as in the latter church, piers and arches were more apparent.

The **Church of the Holy Apostles** in Constantinople, rebuilt by Justinian in 540 and destroyed by the Ottoman Turks in 1461, used a different variation of the multiple-dome configuration (fig. 3.21, *left*). Four equal arms formed a Greek cross, centralizing the longitudinal arrangement at St. John at Ephesus. The nave and each of the two transept bays were covered by domes, interspersed with short connecting barrel vaults. According to Procopius, the central dome rose from a drum pen-

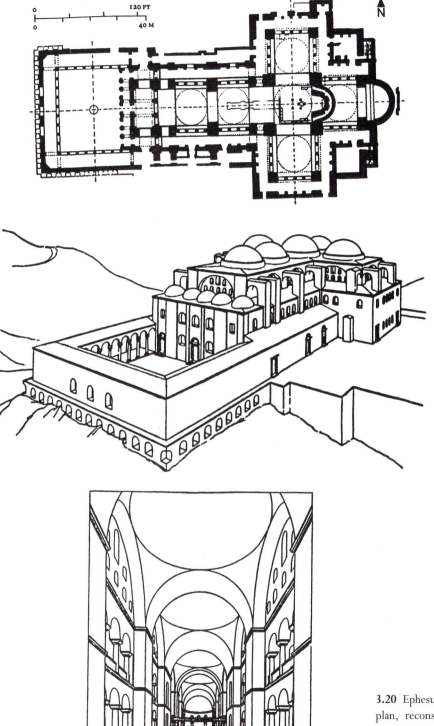

3.20 Ephesus, St. John, before 565: plan, reconstruction of exterior and interior. (H. Hörmann.)

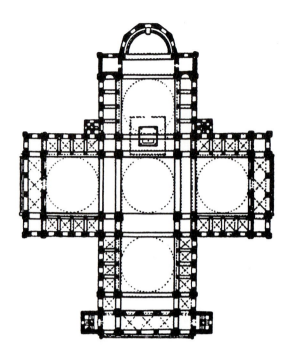

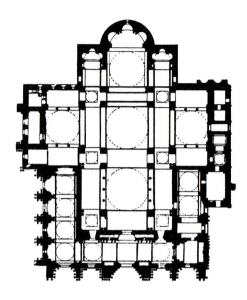

3.21 *Left:* Constantinople, Church of the Holy Apostles, 540: plan. *Right:* Venice, S. Marco, begun 1063: plan. (After Dehio and Bezold.)

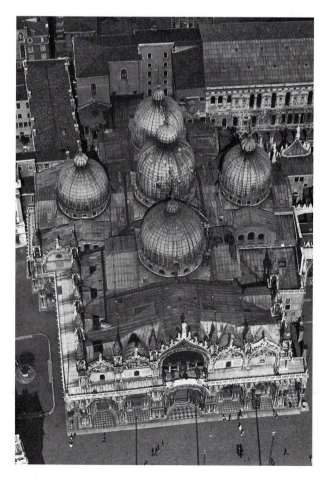

3.22 Venice, S. Marco, begun 1063: air view. (Fotocielo.)

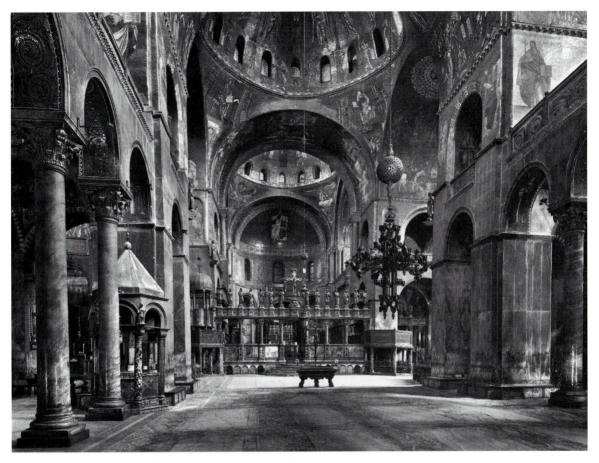

3.23 Venice, S. Marco, begun 1063: nave interior. (Anderson/Alinari/Art Resource, N.Y.)

etrated by windows like Haghia Sophia. This five-domed cruciform plan with the domes arranged on the longitudinal and transverse axes became one of the most widely used configurations in Byzantine architecture.

Although built over four hundred years later, **S. Marco in Venice** (fig. 3.21, *right;* figs. 3.22–3.23) best exemplifies the splendor and layout of the Church of the Holy Apostles and St. John at Ephesus, complete with interior marble veneer and resplendent mosaic decoration. Begun in 1063, and directly influenced by the Church of the Holy

Apostles, it consists of a similar five-dome cruciform plan but with the addition of some surrounding structures. Although the exterior has been changed by the later addition of onion-shaped coverings for the domes and decorative Gothic veneer on the facade, the interior, with every inch of its surface covered by marble and mosaic, captures the shimmering effect of its earlier prototype. Domes and barrel vaults also cover the preceding narthex. These domed cruciform buildings established the basic form from which one of the major types of later Byzantine churches evolved.

4

LATER BYZANTINE VARIATIONS

Although Byzantine builders continued to use the basilican form, they also varied the complex cruciform plans. The richness of these Byzantine designs after Justinian cannot be underestimated. A multitude of various forms developed, but for impact on western European architecture three distinctive types gained paramount importance. Several of the resultant configurations became virtually standard forms in later Byzantine and Greek Orthodox churches from the sixth century to the collapse of the Byzantine Empire in 1453 with the invasion of the Ottoman Turks. These "typical" Byzantine churches, with infinite small variations, were prevalent in southern Italy, Sicily, Greece, the Near East, the Balkans, and Russia as far east as the Ural Mountains. Most of these are beyond the scope of this survey of western European medieval architecture, but several basic types should be noted as representative of their development.[1]

The first type, as we have seen, was a single-dome structure set on a longitudinal base, as at St. Irene, borrowing elements of its design and elevation from the model of Haghia Sophia but developing different interior arrangements. This form evolved into the single-domed cross church in which a large central dome rests on a drum supported by squinches or pendentives at the intersection of transeptal volumes. The cruciform shape, however, is contained within the ground plan; the transepts become evi-

dent only in the external elevation above the roof of the aisles or galleries. Many Byzantine churches use this form, for instance, the **Katholicon at Hosios Lukas** (consecrated 1011 or 1022), where a single dome on a drum dominates a cruciform plan contained within the outlines of the building (figs. 4.1–4.3). The drum rises from a central octagon formed by corner squinches. Aisles, and galleries above, penetrate the massive crossing piers. On the exterior, the transeptal volume with a gable rises above the gallery roof, but does not project beyond the rectangular plan of the building. The exterior masonry also uses decorative brickwork, a feature that became common in Byzantine buildings of the twelfth century.

The interior of Hosios Lukas contains representations of every conceivable saint in the Byzantine pantheon, arranged in hierarchical order according to their importance.[2] The dome mosaic representing Christ as Pantocrator surrounded by four archangels was replaced by a fresco. Every surface, like S. Marco, was covered either with marble veneer or with narrative or portrait icons, invoking the incidents of the twelve liturgical feasts and the presence of all the saints in heaven. Thus, all of these Byzantine buildings function as icon-filled spaces, reminding the congregation of the events of Christ's life and evoking the hope of entry into the celestial kingdom. Regardless of their form, the uplifting

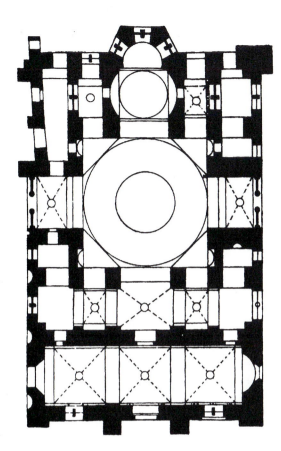

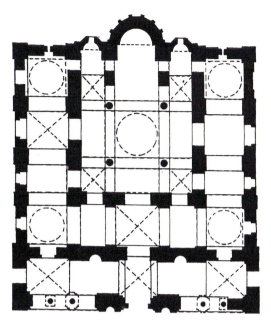

4.1 *Left:* Hosios Lukas, Katholicon, 1011 or 1022: plan. *Right:* Salonica, Holy Apostles, 1312–15: plan. (After Diehl, Le Tourneau, and Saladin.)

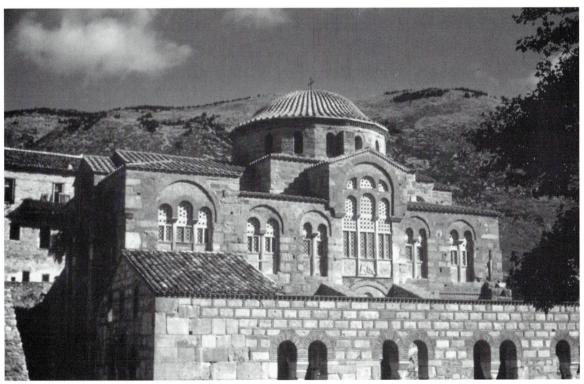

4.2 Hosios Lukas, Katholicon, 1011 or 1022: exterior. (R. G. Calkins.)

4.3 Hosios Lukas, Katholicon, 1011 or 1022: interior. (Courtesy of Cecil L. Striker.)

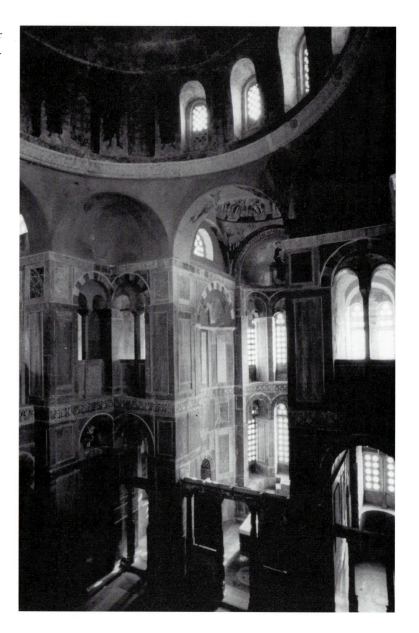

quality and vertical emphasis of the central dome in these buildings works with the glittering surfaces and spiritualized abstractions to create an other-worldly ambience.

Armenian churches built between the seventh and tenth centuries also used distinctive variations of these domed Byzantine cruciform plans.[3] Built with fine ashlar masonry facing a rubble core, they were usually single-domed structures, compact and vertical in their exterior mass. **S. Hrip'simé at Vagharshapat** (618) (figs. 4.4–4.5), built within a rectangular plan penetrated by two deep V-shaped

niches on each exterior side, contains four axial apses and four tall, almost circular, corner niches emanating off the central core. This "cross octagon" plan was repeated at the church of the **Holy Cross at Aght'amar** (915–21) (figs. 4.4, 4.6), which retains the tall corner niches of the interior space, but now its vertical exterior masses clearly reflect the Greek cross of its plan. Decorative friezes of figurative and animal reliefs break up the severe exterior. These vigorous variations of the Byzantine formula, particularly in the precision of their masonry construction and bold silhouettes were precocious forerunners of

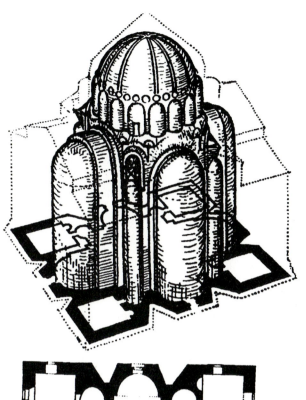

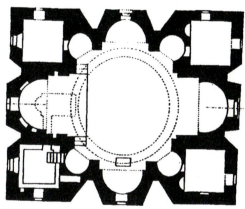

4.4 *Top:* Vagharshapat, S. Hrip'simé, 618: interior volumes. (After S. Der Neressian.) *Middle:* Vagharshapat, S. Hrip'simé, 618: plan. (After J. Strzygowski.) *Bottom:* Aght'amar, Holy Cross, 915–21: plan. (After J. Strzygowski.)

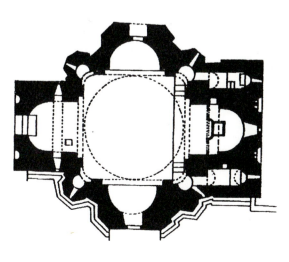

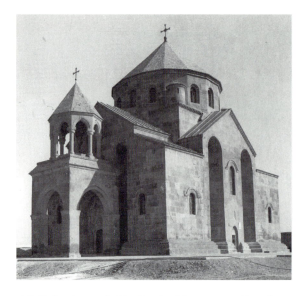

4.5 Vagharshapat, S. Hrip'simé, 618: exterior. (Josephine Powell.)

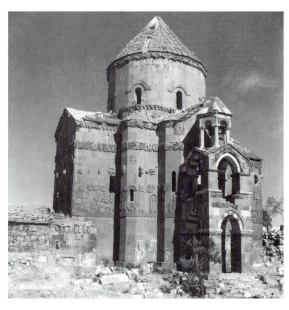

4.6 Aght'amar, Holy Cross, 915–21: exterior. (Josephine Powell.)

European Romanesque churches, although any direct link to the West remains difficult to prove.

The second major type of Byzantine church consisted of variations of the axial five-domed cross, as we have seen at St. John at Ephesus, the Holy Apostles in Constantinople, and its surviving copy of San Marco in Venice (see chapter 3). The plan was also reflected at Saint-Front at Périgueux, beginning about 1100 (figs. 10.28–10.29) and the domed bay proliferated in Romanesque churches of southwestern France.

A third type of Byzantine church, a variant of the five-domed configuration, known as the quincunx plan, placed four of the domes over corner bays and accentuated the central dome over the intersection of the longitudinal nave and a transverse space. As in

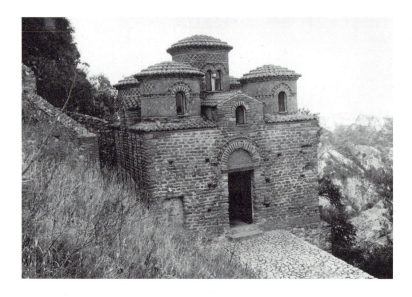

4.7 Stilo, Katholicon, after 982: exterior. (R. G. Calkins.)

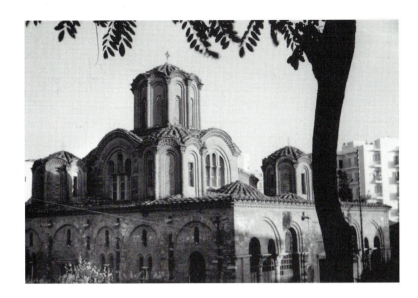

4.8 Salonica, Holy Apostles, 1312–15: exterior from northwest. (R. G. Calkins.)

the domed cross type, the transepts were usually contained within the outlines of the building. A diminutive version of this arrangement exists in the **Katholicon at Stilo** in Calabria, built after 982 during a time when Byzantium occupied southern Italy and Sicily (fig. 4.7). The domes are set on tall drums, and decorative brickwork that became one of the characteristics of Byzantine architecture adorns the exterior. This form also occurs at the **Church of the Holy Apostles at Salonica** (1312–15) (figs. 4.1, 4.8). Here the center dome rests on an octagonal drum above an elevated crossing square. Tall, octagonal and widely spaced drums support the corner domes. Bands of decorative brickwork in various patterns enliven the exterior surfaces. Many variations of this form, with picturesque silhouettes of multiple turretlike drums with cupolas and decorative masonry or exterior arcading, occur throughout the Byzantine world, particularly in Russia.

5

EARLY MONASTICISM AND NORTHERN TRADITIONS

The development of medieval monasticism and the architecture to which it gave rise took place against a background of the disintegration of the Roman Empire. The empire collapsed under the pressure of repeated invasions by Barbarian tribes, resulting in the sacking of Rome by the Visigoths under Alaric I in 410 and the destruction of Milan in 450 by Attila the Hun. The disintegration of Roman military power was accompanied by political instability and the isolation of pockets of Christianity as it spread throughout the farthest reaches of a largely pagan Europe. As a result, some buildings emulated early Christian models, while others assimilated indigenous characteristics dictated by local materials, building techniques, and the nature of their sites.

THE GROWTH OF MONASTICISM

During the fourth century, as the church became increasingly bureaucratic and hierarchical, monks seeking a purer and more spiritual form of Christianity turned to a hermitlike existence of solitude and meditation in the deserts of Egypt and the Mount Sinai peninsula. As the ascetic existence of this eremitic monasticism frequently proved to be impracticable, Pachomius (290–346), a monk in Upper Egypt, formulated a rule for monastic communities (cenobia) in 318, that became the basis for "cenobitic monasticism." This rule allowed the her-

mits a fair amount of autonomy in their daily lives, but also provided for common worship and a rule (regula) requiring them to take vows of poverty, chastity, and obedience. St. Patrick (385–461) was trained in this tradition of monasticism, which he reputedly established in Ireland in 432. However, it may have been Palladius, a Gaul sent by Rome, who began the conversion of the Irish in 431.[1] Nevertheless, various forms of eremitic and Pachomian monasteries were established in Ireland in the fifth century ranging from simple hermitages to monastic communities for both men and women.

The simplest hermitage usually consisted of a small cell, oratorio, and shrine. Originally these were built of timber and sod; only stone replacements for these structures, some dating from the seventh century, survive. Some idea of the nature of these early cenobitic monasteries can be gleaned from the surviving remains at **Skellig Michael**, a monastic community situated on a barren rock off the western coast of Ireland (fig. 5.1). Although rebuilt in 823 or 860 after a series of Viking raids, the surviving buildings probably closely reflect those that existed earlier. The buildings consisted of rough field stones, corbelled inward to form beehive-shaped huts. Several small cells for the monks and a larger oratory for worship all probably reflected this same rudimentary form, their arrangement determined by the irregularities of the site.

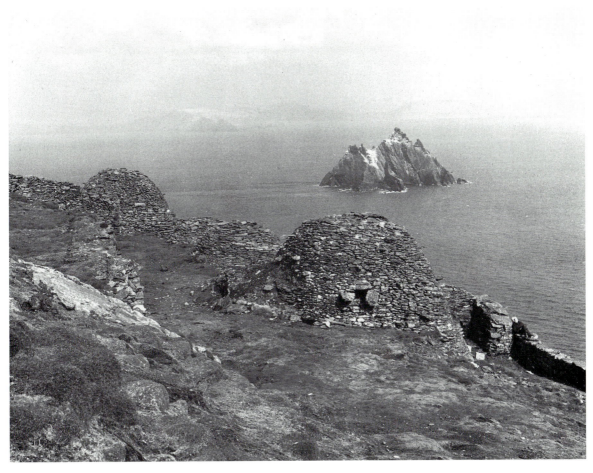

5.1 Skellig Michael, rebuilt circa 823 or 860: view. (Heritage Services, Department of Arts, Culture and the Gaeltacht.)

On the mainland, with a better supply of building materials, such buildings might have had a more finished look, such as the oratorio at Dingle, thought to date from about 700, where the stones of the bee-hive-shaped structure have been hammer-dressed and fitted together more carefully. Sometimes, as at Glendalough, these complexes had tall freestanding, cylindrical towers that may have served as watch-towers and as defensive refuges. Such towers became a feature in a variety of later buildings on the Continent, a device that may have been brought there by the Irish missionary monks.

Irish monasticism in turn spread over northern Europe through the activities of subsequent missionaries. St. Columban founded Iona off the coast of Scotland in 563, Aidan founded Lindisfarne in Northumbria in 633, and Columbanus founded Luxeuil in France in 610, St. Gall in Switzerland and Bobbio in northern Italy in 612. These small monastic communities survived as Christian enclaves in an otherwise largely barbarian, pagan Europe.

St. Benedict of Nursia (ca. 480–547) formulated another form of monasticism that also contrasted markedly with the relatively loosely administered hermit communities. His rule governed every aspect of the monks' daily behavior and stipulated the strict organization of the community. It may in part have been inspired by the example of the rule drawn up in the east by Basil the Great (ca. 330–79) that became the basis of Greek Orthodox monasticism. Basil's insistence on a balance of prayer and work, meditation, and social works prefigured St. Benedict's specification of a practical balance between the *vita activa* necessary to make the com-

munity self sufficient in every way and the *vita contemplativa,* the life of meditation and prayer. The Benedictine rule was first applied at the monastery Benedict founded at **Montecassino**, Italy, in 520. Its plan made possible the precept that "Whenever possible, the monastery should be so laid out that everything essential, that is to say, water, mills, garden, and workshops for the plying of the various crafts is found within the monastery walls." Monks there were required to take vows of poverty, chastity, obedience, and *stabilitas loci;* namely, they were to stay put. Benedict added that the monastery should be self sufficient " . . . so that there be no occasion for monks to wander about, since this is in no wise expedient for their souls." As a constant reminder the rule, which was second only to the scriptures, was read on a daily basis, giving rise to the chapter house where it was read, and where other affairs of the monastic community were administered.

The architectural consequence of the rule manifested itself in a complex of buildings appropriate for all of the activities of the monastery, but the layout evolved slowly. A reconstruction drawing of Montecassino, as it was believed to exist in the year 1075 (fig. 5.2), reveals a monumental staircase leading to a propylaeum and a forecourt, or atrium, before a large timber-roofed basilica with a transept at its eastern end. While this arrangement resembles that of many early Christian basilicas, the addition of numerous structures around the church differentiates it. A covered, arcaded cloister for walking and meditation was situated on the south side, with many buildings surrounding it: a large chapter house on the east side, a long dormitory on the south, and the refectory (eating hall) and novices dormitory on the west. Sometimes there were special structures that were adapted to the particular self-sustaining activities provided by the site. (Such is the case with the presence of the forge at the monastery of Fontenay in Burgundy.)

Irish monasticism collided with Benedictine monasticism in England. St. Augustine founded

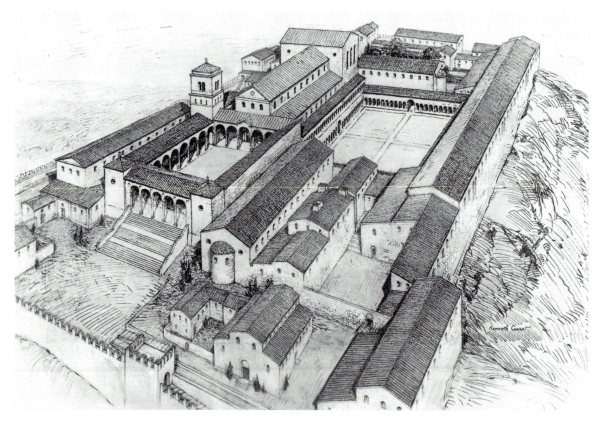

5.2 Montecassino, as of circa 1075: reconstruction. (Kenneth J. Conant.)

Canterbury in 595 as a center of Benedictine monasticism. A synod held at Whitby in 664 sought to resolve some of the differences with the result that Benedictine monasticism gained the upper hand in the British Isles. In Northumbria, Benedict Biscop established Benedictine foundations at Monkwearmouth in 665 and at Jarrow in 671. British missionary activities continued on the continent with the foundation of new Benedictine monasteries by St Willibrod at Echternach in 698 and St. Bonifatius at Fulda.

The consolidation of the Benedictine order on the Continent manifested itself in the Carolingian period in an unusual document, a carefully drawn plan laying out the specifications for an ideal monastic community according to the Benedictine rule (see also chapter 6). Abbot Haito, abbot of Reichenau, copied the plan from a now lost original as an aid for Abbot Gozbert of St. Gall in Switzerland, who contemplated rebuilding his monastery around 830. The monastery was to consist of forty buildings to accommodate more than 110 monks and support staff. The **plan of St. Gall** (figs. 5.3–5.4), drawn on several sheets of parchment stitched together, presents the earliest surviving medieval blueprint of the ideal layout for a monastery.

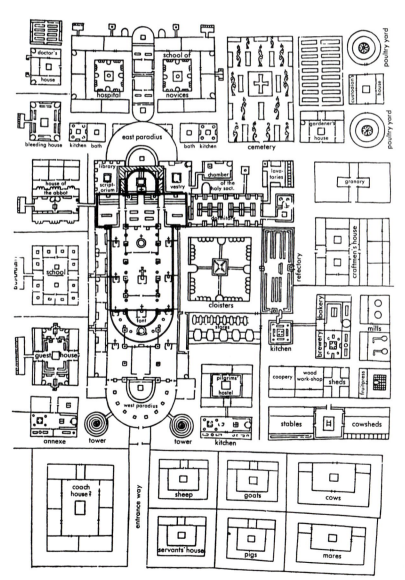

5.3 St. Gall, plan of Abbey, 820–30: redrawn plan. (Kenneth J. Conant.)

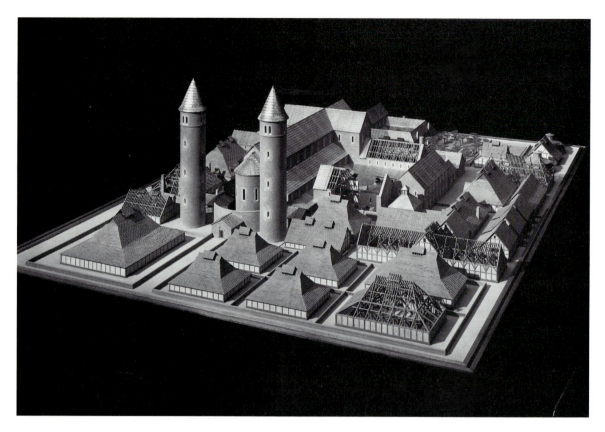

5.4 St. Gall Abbey, 820–30: hypothetical model. (Wim Cox.)

The complex was to be dominated by a vast double-apse basilica, 360 feet long, preceded by two freestanding cylindrical towers. The walls of the church and its towers were to be built of stone and roofed with timber. Housing multiple altars dedicated to many saints, the aisles and nave compartmentalized by screens, the interior left visitors only narrow passageways for circulation.

A variety of buildings would have surrounded the church; on the plan, each was labeled according to its use. Here the dormitory connects with the south transept for convenient access to celebrate the early morning offices of Matins and Prime—a location that was to become standard in later monasteries. Adjacent baths and latrine in the southeast corner, a refectory and kitchen on the south, and the cellar on the west enclosed the cloister. Hostels, housing for important visitors, an external school, and the abbot's quarters occupied the north flank of the church. An infirmary and novitiate, with separate chapels, were to be situated to the east of the church.

A brewery, bakery, numerous barns for livestock, and buildings for various crafts were to be situated to the south and southwest of the complex. These latter structures, comparatively less important, would have used the cheaper indigenous half-timber construction of northern Europe with steeply pitched roofs (see next section). No evidence exists, however, that any of these buildings were ever built, but since the diagrams of the structures reflected the types of buildings prevalent in the Carolingian period, Walter Horn and his colleagues have published evocative conjectural drawings of the monastery ensemble and constructed a model of its intended configuration (fig. 5.4).[2] The plan nevertheless represents a final synthesis of the monastic layout that was repeated over and over in later medieval monasteries. A more compact and austere version of the standard monastic plan, built by the Cistercians at Fontenay in Burgundy survives (see chapter 10).

The Benedictine monastery at Cluny developed into the largest manifestation of this monastic plan.

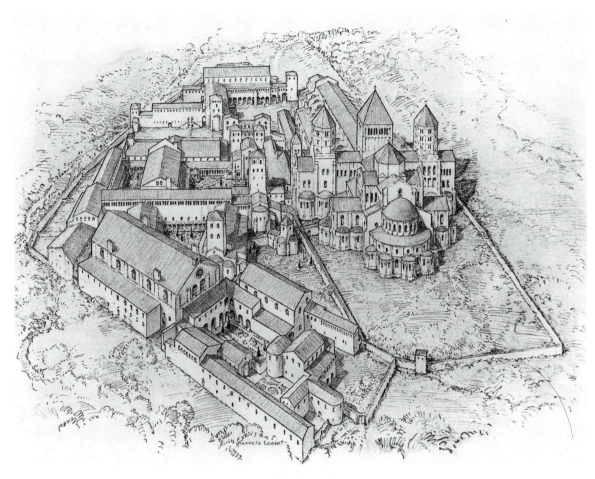

5.5 Cluny III, as of circa 1150: reconstruction. (Kenneth J. Conant.)

Duke William of Aquitaine gave the lands for the first humble monastery at Cluny in 909 and the first church, Cluny I, was built under Abbot Berno in 910. Favorable connections with the Ottonian court and a growth of the monastic population prompted the building of a new church, Cluny II, between 950 and its dedication under Abbot Majoulus in 981 (see also chapter 10). The number of monks increased dramatically, from 73 in 1063 to more than 300 by 1122. To accommodate them, and the brethren of more than 1,500 monasteries Cluny controlled all over Europe, a huge new church was begun under Abbot Hugh in 1088 and completed under Abbot Peter the Venerable in 1120. In the middle of the twelfth century, Cluny was the largest monastic complex in western Europe containing the largest church, Cluny III, until the construction of the new

basilica of St. Peter's in Rome during the late Renaissance (fig. 5.5). A vast array of ancillary buildings was added during and after the three major campaigns of construction of the Abbey church, adapted to existing buildings and resulting in an irregular layout. Revisions in the eighteenth century, and almost total destruction after the French Revolution have left us with only a fragment of this extensive complex.

Monasteries like Montecassino and Cluny in the Middle Ages became a locus of economic, spiritual, and educational activity in the surrounding landscape—little pockets of stability in the flux of the virtual anarchy in Europe during the period of the Barbarian invasions. Monasteries were usually peopled by the lesser sons of nobility, and nunneries by their daughters who were not successfully married

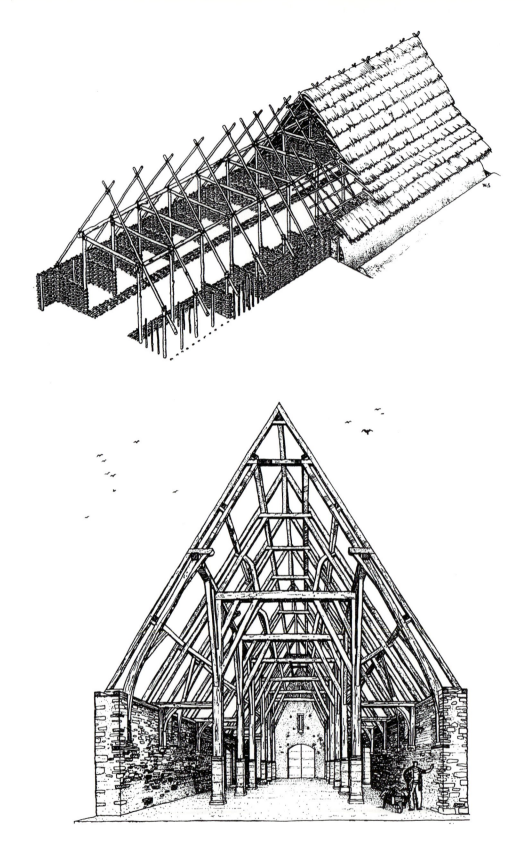

5.6 *Top:* Ezinge (Groningen), The Netherlands, second century B.C.: reconstruction. (Walter Schwarz.)
Bottom: Great Coxwell, Berkshire, Barn of the Abbey Grange, mid-thirteenth century. (Ernest Born.)

off for political reasons. Perhaps most important, men and women received an education in these establishments, for they learned to read and write in order to conduct their devotions: St. Benedict had specified that reading the Bible was one of the daily duties. In order to service this requirement, each monastery or nunnery usually had a scriptorium where the scriptures were dutifully copied, as well as other texts, often literary or scientific. In fact, if it were not for the assiduous activities of these monastic scriptoria, much of classical learning would be lost to us today.

NORTHERN TIMBER CONSTRUCTION

With the exception of the remains of massive Roman buildings of brick, concrete, or masonry, timber construction dominated throughout northern Europe as the indigenous form of architecture. Only scant archaeological evidence of such domestic buildings still survives. A cattle barn at **Ezinge (Groningen)** in Holland, dating from the second century B.C. (fig. 5.6, *top*) exemplifies their structure. These buildings were post-hole constructions consisting of a series of upright poles placed in holes in the ground lashed together with longitudinal and transverse beams to form bays and support both sides of a lean-to roof. The bottom edge of the roof was sometimes embedded in a raised earthen-work mound defining the contour of the building and directing the melting snow outside its perimeter. The interior thus consisted of a series of additive, transparent compartments that Josef Strzygowski and Walter Horn have proposed as the origin of the bay system found in masonry buildings throughout the Middle Ages in northern Europe.[3] This articulation of units did not occur in early Christian basilicas, where the repetitive colonnades of the ground story terminate with either an arcade or an entablature and the blank wall with clerestory above interrupts any visual linkage of supports with the timber roof system above. The nave of the basilica formed one unified rectangular block of space in contrast to the repetition of stated units at Ezinge. Such structures on the Continent often had two aisles, as at Ezinge, while Anglo-Saxon buildings apparently contained a single interior space. Whether used for livestock, human habitation, or both, these posthole structures were undoubtedly similar to the long houses described in *Beowulf*, a variation of which

has been excavated at the royal palace complex at Yeavering in Northumbria.[4]

Later post-built houses, medieval barns, and market halls simply elaborated the timber truss work of such structures. The mid-thirteenth-century barn of the Abbey grange at Great Coxwell, Berkshire, England (fig. 5.6, *bottom*) are three-aisled structures with stone walls and timber truss roofs with more complex bracing (see also chapter 18). Some monastic tithe barns used rows of stone columns or piers and arcades to define the aisles and support the trusses above.[5] Even the great monastic church of St. Gall would have been such a structure. The universality of these buildings throughout many regions of Europe, subject to local variations and techniques of carpentry, and their continuity over the centuries indicate that they represent the prevailing indigenous building tradition, the backdrop against which innovations in stone construction were developed.

Timber construction was combined with masonry to create a more durable variation. Walls built of rubble or clay mixed with straw replaced wattle siding in more elaborate buildings. Timber beams placed at corners and at regular intervals along the sides, often reinforced with diagonal braces, stabilized these walls and resulted in more permanent half-timber construction. Such structures became ubiquitous throughout northern Europe and Walter Horn proposed that half-timbered buildings would have constituted the ancillary structures of the planned ninth-century monastery at St. Gall in Switzerland (fig. 5.4).

An elaborate manifestation of timber construction, though admittedly later than the rudimentary forms just considered, exists in timber stave churches and related buildings of Norway and Sweden that date from the twelfth and thirteenth centuries just after the Christianization of Scandinavia. An example at **Borgund,** Norway, constructed entirely of timber, dates from about 1125 (figs. 5.7–5.8). Huge, tall masts form a vertical central core that rises several stories to a steeply pitched roof, surrounded, pagoda-like, by several lower concentric skirts of roof. Although really a longitudinal building composed of several additive interior compartments and external masses, the interior has a centralized effect by virtue of its strong vertical emphasis. Similar buildings may have existed earlier, and may have had an impact of the design of early Carolingian buildings.

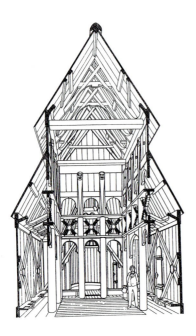

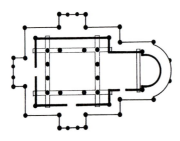

5.7 Borgund, Stave church, circa 1125: section and plan. (After L. Dietrichson and G. Bull.)

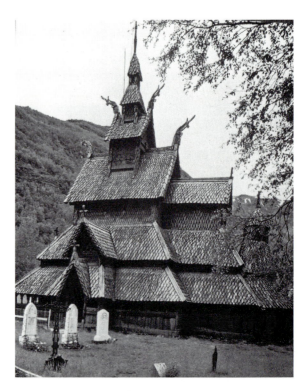

5.8 Borgund, Stave church, circa 1125: exterior. (R. G. Calkins.)

GALLO-ROMAN AND MEROVINGIAN BUILDINGS

While timber construction was the prevalent mode of vernacular building throughout northern Europe, the remains of Roman buildings served as continuing sources for the forms of monumental ecclesiastical structures. Reflections of Roman and early Christian buildings and their decorations were translated into a native architectural vernacular during the Merovingian dynasty (so named for its first king, Merowech). The most famous rulers of this dynasty who began to consolidate power over the Frankish tribes included Clovis (481–511), baptized a Christian by St. Remi in 496, and Dagobert (628–38), the last strong ruler of the dynasty. After his conversion, Clovis made Paris his capital. During this time the huge five-aisled cathedral of Saint-Étienne was built (on the site of Notre-Dame) and thirty-seven other Merovingian churches arose in the city. Many of these buildings, as well as Saint-Pierre at Vienne, Selles-sur-Cher, and Saint-Martin at Tours had marble columns and capitals, *spolia* from antique monuments, or replicas made in imitation of them. Of the many large basilicas and domed centralized structures, we have only scant remains: the nave elevation of Saint-Pierre at Vienne with two levels of wall arcades flanked by engaged marble columns, and the baptisteries of Fréjus and Albenga of the fifth to sixth centuries.

The largest surviving Merovingian building, the monumental **Baptistery of Saint-Jean in Poitiers** (figs. 5.9–5.10) of the seventh century, consists of the additive accumulation of rectangular chambers in a cruciform plan. Its compartmentalized interior results in an exterior of juxtaposed volumes. Merovingian interpretations of Roman decorative motifs adorn the exterior. Pedimented and arcaded forms sit above flat pilaster strips, awkwardly covering the exterior brick-

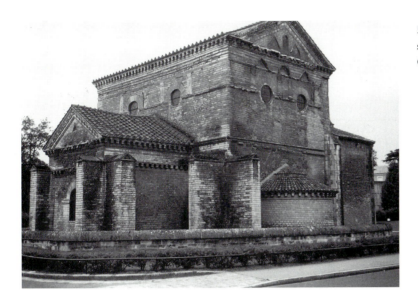

5.9 Poitiers, Baptistery of Saint-Jean, seventh century: exterior. (R. G. Calkins.)

5.10 Poitiers, Baptistery of Saint-Jean, seventh century: exterior detail. (R. G. Calkins.)

work in a seeming debasement of classical motifs. Multicolored stones and terra-cottas form patterns in emulation of decorative Roman masonry. Similar translations of antique sculptural decoration occur in the seventh-century Hypogeum des Dunes, also at Poitiers, a funerary vault resembling Gallo Roman tomb chambers. Thus the Merovingians sought to maintain visual associations and a sense of continuity with their Roman heritage through the reuse of spolia and the imitation of classical motifs, even when the copies and their placement lacked accuracy and sophistication.

With the exception of Saint-Jean at Poitiers, none of the large-scale Merovingian buildings have survived. For the most part, only vestiges, as in the crypts at Saint-Denis and Jouarre, have been preserved, incorporated into the later structures. Nevertheless, Merovingian buildings showed continuing attention to classical models, however misunderstood, and this attitude, combined with the assimilation of indigenous building techniques and the requirements of burgeoning monastic communities provided the basis for the variations and innovations of the Carolingian period.

6

CAROLINGIAN ASSIMILATIONS AND INNOVATIONS

As king of the Franks from 754 to 771, Pepin began a program of religious reforms that called for a close adherence to the Roman liturgy and an emulation of Roman church buildings. This process received considerable impetus under his son, Charlemagne, who became king of the Franks in 771. Charlemagne consolidated his political and military power by pushing the Moslems back over the Pyrenees, removed the Lombard threat to the papacy, and stabilized the boundaries of the Frankish kingdom. Consequently, the pope crowned him "emperor of the Romans" in Rome on Christmas Day in the year 800. As a result of Charlemagne's successes and his focus on religious reform, considerable imperial resources financed new forms of sophisticated and monumental structures built throughout the kingdom. Many of these buildings made visual symbolic and political statements consistent with Charlemagne's program for reviving the less-tangible institutions of the Christian Roman Empire of the late antique period. In the process, the Carolingians accurately copied classical forms and contributed new variations of them that would in turn be the inspiration for copies in later periods. Although very little intact Carolingian architecture has survived, either totally destroyed or vastly restored, surviving vestiges show that the Carolingians were accomplished builders whose innovations led to the development of subsequent styles.

Architectural reflections of the monuments of late antiquity were used in the post-Merovingian kingdom of the Franks even before it became the Carolingian Empire. For instance, a freestanding, two-story building with an apse at each end in the form of a Roman triumphal arch, a **Torhalle,** was erected after 774 in the atrium of the monastery at Lorsch (fig. 6.1). Its upper chamber, perhaps originally intended as a reception hall for distinguished visitors,[1] was later converted into a chapel dedicated to the archangels. Its distinctive exterior consists of three large arches flanked by engaged columns with copies of composite capitals supporting a decorative entablature on the ground story. It repeats the format of the Arch of Constantine in Rome, and perhaps more explicitly the entrance gate of Old St. Peter's that had a chapel above its triple opening. However, multicolored hexagonal stones form decorative patterns across the fabric of the facade emulating the *opus reticulatum* of Roman masonry. On the exterior of the second story, decorative pilaster strips support thinly defined pediments like mitered picture frames, combining half-timber motifs translated into stone with classical details of channeling and Ionic capitals. Thus, long before Charlemagne became emperor of the Romans in 800, structures in the Frankish kingdom deliberately imitated visual forms from the Roman antiquity to evoke purposefully the parallels between the

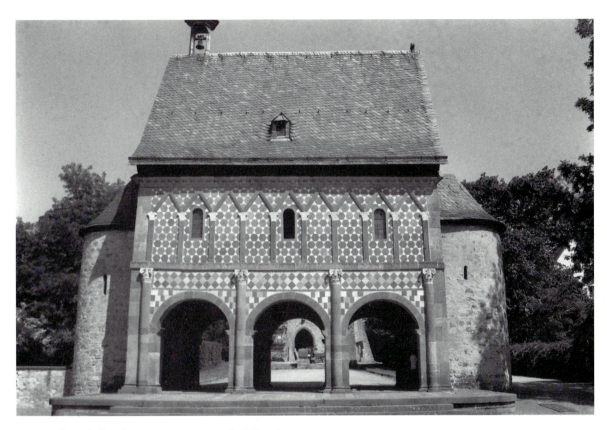

6.1 Lorsch, Torhalle, after 774: exterior. (R. G. Calkins.)

authority of the Frankish kingdom with that of imperial Rome.

These connections to imperial Rome became particularly evident at the royal palace complex built for Charlemagne at **Aachen** (fig. 6.2) between 789 and 808. It consisted of a palace, a palace chapel, and a tribunal building linked to the each other by a long, two-story, covered corridor. This corridor connecting the disparate buildings in the Aachen complex recalls the peristyle linking the triumphal arch and mausoleum of Galerius at Salonica (fig. 2.9). Charlemagne also had an equestrian statue of Theodoric brought from Ravenna and placed outside the palace in the same way the life-sized statue of Marcus Aurelius—believed throughout the middle Ages to represent Constantine—had been placed outside the Lateran Palace in Rome. Charlemagne named the palace at Aachen "The Lateran" to reaffirm this symbolic connection.

The royal hall combined features of Constantine's Basilica in Rome and his great Aula Palatina at Trier of the fourth century (compare fig. 1.14): with a huge semicircular apse at one end, and apses on each side, as in Rome, and on the exterior, large, two-story wall arches along the sides as at Trier. The palace now serves as the Rathaus of Aachen, and although a neo-Gothic veneer covers its north facade, and a square stairwell replaces the apse facing the palace chapel, much of the original masonry still remains visible on the south side and eastern apse.

Odo of Metz built the **Palatine Chapel** (figs. 6.3–6.5), dedicated to the Virgin Mary, between circa 792 and 800, basing his design on the double-shell church of S. Vitale (compare fig. 3.5). Evoking the splendor of Byzantium in its welling interior spaces, glittering imperial mosaics of Justinian and Theodora, and its association as the episcopal palace of Archbishop Maximinian, S. Vitale was the most sumptuous chapel in the West, itself an emulation of the Palace chapel of SS. Sergius and Bacchus in Constantinople. Odo even placed longitudinal chapels to the north and south of his centralized church, repeating the arrangement of the palace chapel of S. Lorenzo in Milan that was surrounded

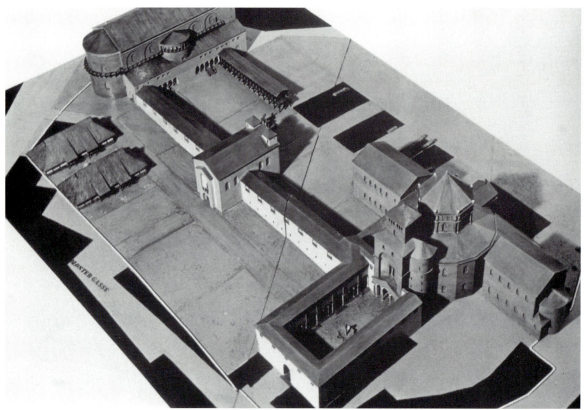

6.2 Aachen, palace and chapel, 789–808: model of complex. (R. G. Calkins.)

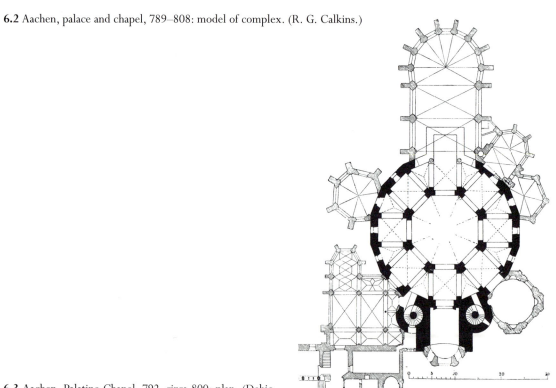

6.3 Aachen, Palatine Chapel, 792–circa 800: plan. (Dehio and Bezold.)

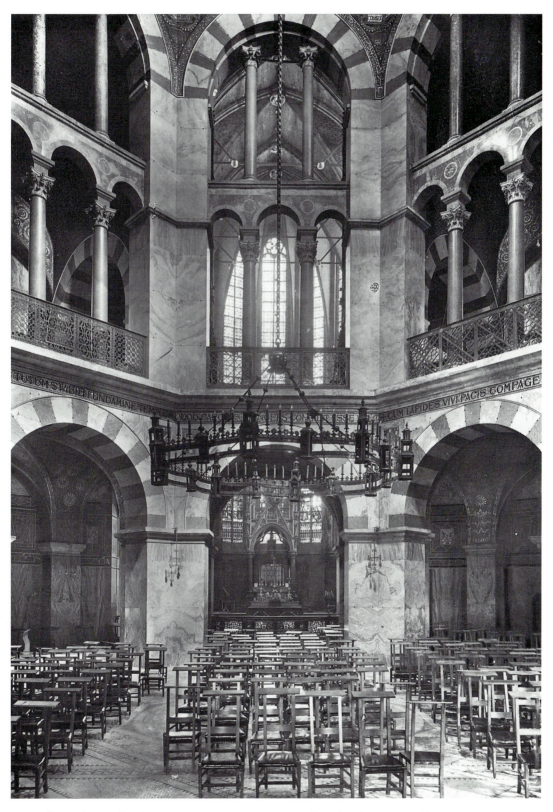

6.4 Aachen, Palatine Chapel, 792–circa 800: interior. (Foto Marburg/Art Resource, N.Y.)

6.5 Aachen, Palatine Chapel, 792–circa 800: facade. (R. G. Calkins.)

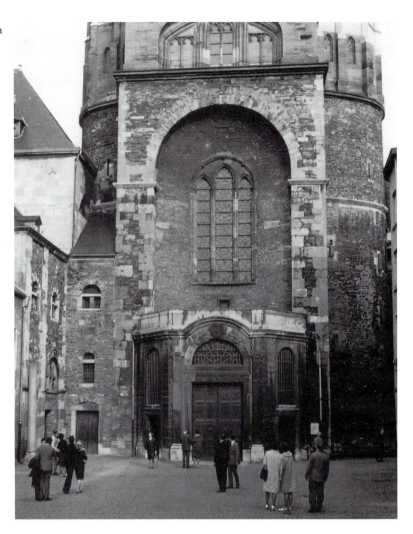

by ancillary chapels on its cardinal sides. To further emphasize classical connections, he imported used columns and marbles, *spolia,* from Rome and Ravenna, and copied classical ornament in the wrought-iron balustrade of the gallery.

Nevertheless, Odo greatly changed the effect of S. Vitale in his translation of the octagonal interior core of the chapel (fig. 6.4) at Aachen. The sides of his octagon are flat and support an eight-sided segmental dome. Massive arches on the ground story replace the curved arcaded exedrae of S. Vitale. The exterior shell has sixteen sides, resulting in a succession of square and triangular groin vaults in the ambulatory. The original square sanctuary, which interrupted the ambulatory as at S. Vitale, was later replaced by a Gothic choir. Above the ambulatory, a gallery with raking transverse barrel vaults set on diaphragm arches opens onto the central space through colonnades on two levels. The lower colonnade of the gallery supports arches and a flat sill, on top of which a pair of columns unceremoniously collides with the curve of the arch above. The alternating red and white bands on the arches, a feature that persisted into the Romanesque period, recalls a similar polychrome device found in the Mosque at Córdoba (fig. 8.4) where, in the earliest portion of the building, courses of red brick alternate with light stone voussoirs, perhaps in an Islamic translation of decorative Roman masonry.

In 936 Otto I placed a marble throne in the gallery opposite the sanctuary, a point from which the entire building is revealed, as in the western loggia at Haghia Sophia and the imperial gallery of SS. Sergius and Bacchus. But the interior effect was dif-

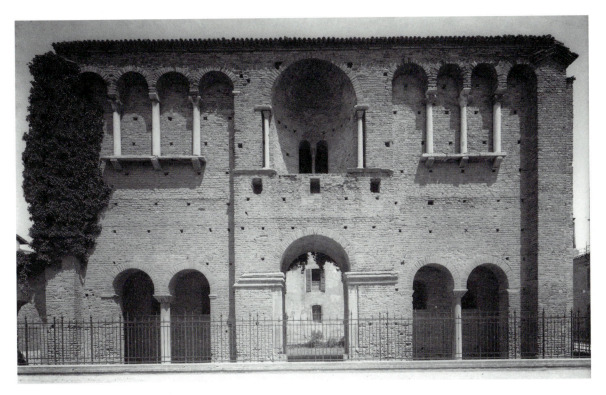

6.6 Ravenna, Palace of Exarchs, eighth century: facade. (Foto Marburg/Art Resource, N.Y.)

ferent. The huge angled piers and flat banded arches create a massive and solid-appearing interior, in contrast with the more ephemeral welling exedrae and rising arches of S. Vitale, achieving an effect of strength and permanence appropriate for the political iconography of the Carolingian regime.

The facade (fig. 6.5), facing a narrow atrium, introduced several new symbolic features. It consists of a tall vertical block flanked by semicircular stair turrets and punctuated by a monumental arched niche. This niche reiterated a comparable tall arch on the west front of Centula and on the facade of the **Palace of the Exarchs** in Ravenna (fig. 6.6), dating from the eighth century. Different in form but similar in symbolic intent, these niches, like the pedimented arch on the facade of Diocletian's palace at Spalato and on the peristyle before S. Lorenzo at Milan, became another imperial framing device. In addition, the vertical western block, known as a "westwork," may have served some special imperial or liturgical purpose. In any event, it was a significant Carolingian innovation that also appeared at Centula, on a variety of Carolingian longitudinal buildings, and had a long afterlife as a symbolic imperial form and liturgical space.

Charlemagne's Palatine Chapel at Aachen in turn served as an inspiration for later buildings. Theodulf, a Visigoth and bishop of Orléans, who had served at the court of Charlemagne, had a variation of a centralized plan built as a small Oratorio at **Germigny-des-Prés** near Orléans in the Loire valley. Built as a chapel next to Theodulf's summer palace between 801 and 806, it consists of a Greek cross within a square, a nine-bay plan featuring a horseshoe-shaped apsidal projection on each side, two chapels flanking the eastern apse, and a tall lantern tower with a domical vault over the crossing (fig. 6.7). The resulting exterior (fig. 6.8), dominated by a pyramidal piling up of equal masses to the crossing tower, reveals the developing Carolingian predilection for boldly articulated exteriors. The present exterior, however, was altered by the addition of a nave in the eleventh century. Other reconstructions occurred in the fifteenth and sixteenth centuries, and drastic restorations to the interior took place in the nineteenth century.

The building incorporates elements derived from a variety of sources. The horseshoe plan of the apses perhaps originates in Visigothic architecture in Theodulf's native Spain. They repeat in the arches

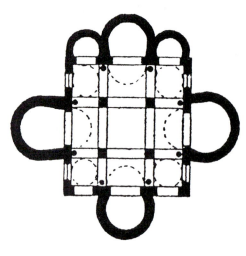

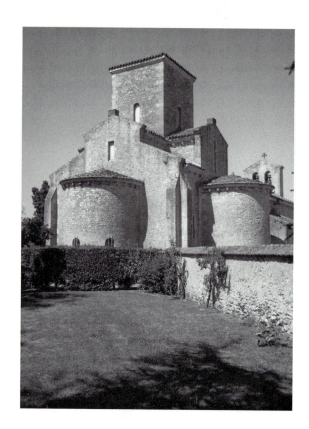

6.7 Germigny-des-Prés, 801–06: plan. (After Kenneth J. Conant.)

6.8 Germigny-des-Prés, 801–06: exterior. (R. G. Calkins.)

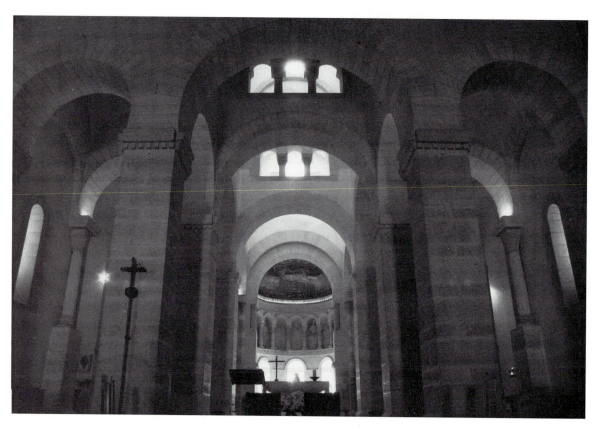

6.9 Germigny-des-Prés, 801–06: interior. (R. G. Calkins.)

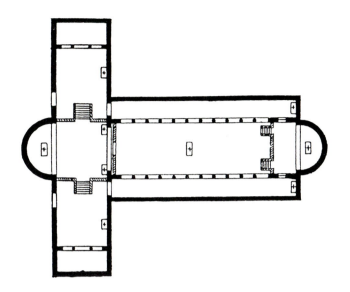

6.10 *Top:* Fulda, 802–19: plan. (After Lehmann.) *Bottom:* Cologne Cathedral, ninth century: plan. (After Doppelfeld.)

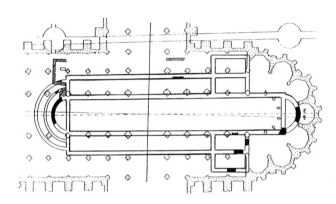

defining each of the interior compartments (fig. 6.9). The interior cruciform plan with four square piers supporting the central tower and dominating the compartmentalized interior reflects earlier Near Eastern cross-within-a-square plans. Barrel vaults cover each of the short arms, while small domical vaults cover each corner bay. Curtain walls pierced by a triple arcade screen the vertical crossing area from the arms and allow light to filter into the farther reaches of the interior. This decorative device perhaps refers to the diaphragm walls found in the galleries of the Palatine chapel at Aachen, reinforcing a perceived connection with that structure, asserted by a tenth-century commentary.[2]

Basilican structures built in the Carolingian period turned to Rome for inspiration, but added dis-tinctive innovations that would affect the form of northern Romanesque architecture. These basilicas, usually large-scale timber-roofed buildings, reflected their Roman prototypes. A timber-roofed basilica with three aisles and a large eastern transept was erected at Saint-Denis north of Paris by Pepin in 754. Pepin was buried before its facade, which may have consisted of a tower porch like that at Tours. A western apse may have been intended, an innovation that was carried through at **Fulda,** Germany. There, a basilican structure begun in 794 housed the relics of St. Boniface, its founder, under its principal altar. It received, between 802 and 819, a huge western transept and western apse reflecting the "occident-ed" plan of Old St. Peter's in Rome (fig. 6.10, *top*).[3] But since Fulda already had an eastern apse, the

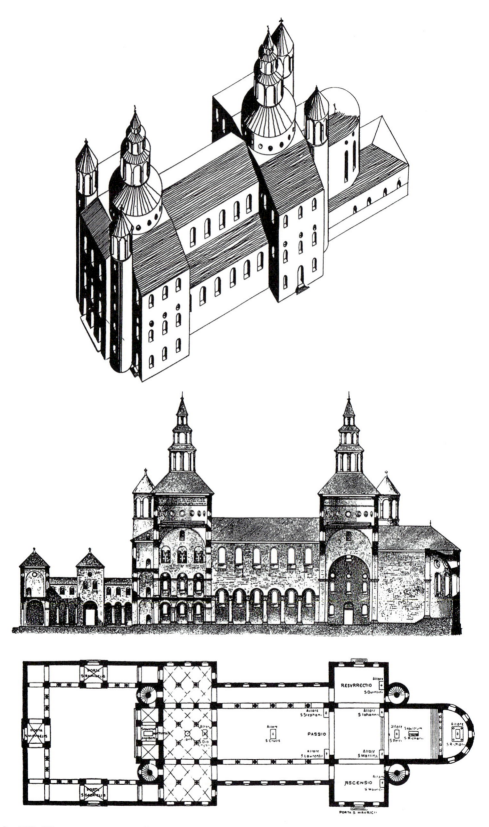

6.11 Centula, 790–99: reconstruction (After Pevsner: *Yale University Press Pelican History of Art*); section and plan. (After Effmann.)

addition resulted in a double-ended plan with east and west apses. This double-apse plan also appears in the Carolingian cathedral at Cologne (fig. 6.10, *bottom*) and at Saint-Maurice- d'Agaune in Switzerland, and would remain prevalent in Ottonian and German Romanesque churches.

The great **Abbey of Saint-Riquier at Centula** (fig. 6.11) in northern France, begun in 790 and dedicated in 799 by Abbot Angilbert was largely financed by Charlemagne himself (he attended Easter Mass there in 800). It introduced significant innovations in plan and exterior form that were to prevail into the twelfth century. Before its destruction by the Vikings in 881, it housed more than three hundred monks, one hundred novices, and a large support staff within an area believed to be equal to that of the twelfth-century monastery of Cluny III. Although now totally destroyed, we know approximately what it looked like from medieval descriptions and from two seventeenth-century engravings based on a late eleventh-century miniature: they show a large complex with a triangular cloister measuring almost one thousand feet on a side with chapels at the corners dedicated to St. Benedict and the Virgin (a rotunda with an added longitudinal nave), and the dominating bulk of a huge two-transept church, 250 feet long, with tall crossing towers 180 feet high.[4] Because the walls are believed to have been built of masonry and the roof, drums, and spires of timber, Saint-Riquier superimposed traditional timber forms on the basilican form of Mediterranean origin. The result manifested several important Carolingian innovations: the balanced silhouette of two transepts and clusters of towers, the westwork, and an interior, like that of St. Gall, divided for multiple altars and different liturgical functions.

On the exterior, the bold vertical mass of the eastern transept, the crossing topped by a cylindrical drum, the sanctuary flanked by two cylindrical stair turrets, and all topped by timber spires, dominated the east end. Perhaps this clustering of towers derived from the effect of five-tower group that dominated the east end of Trier Cathedral (fig. 2.26) and the group of four towers around the dome of S. Lorenzo in Milan (fig. 2.19). The vertical mass of the east transept of Saint-Riquier was repeated at the western end of the nave, where a western transept with crossing tower doubled as a westwork. A balanced silhouette with six towers resulted. The build up of exterior volumes and balance of vertical masses of western and eastern transepts with crossing

towers reveal, as at Germigny-des-Prés, a developing aesthetic of the building's exterior massing that was no longer simply the residual consequence of the desired interior spaces.

The westwork, perhaps the first, may have been the immediate source for that at Aachen. Like Aachen, it had a projecting porch penetrated by a tall monumental entrance arch and was flanked by two stair turrets. This arrangement may be an elaboration of the tower porch on the west end of Saint-Martin of Tours (ca. 470; fig. 2.7) and of Saint-Denis of about 775, before which Charlemagne's father, Pepin, had himself buried face down in expiation of his sins.

The interior of the westwork at Saint-Riquier established many of the elements found in later repetitions of this structure. The entry led from an atrium into a low groin-vaulted entrance hall occupying the width of the westwork.[5] Above this entrance was a tall upper chapel with the main altar dedicated to the Holy Savior. The chapel may have been open the entire height of the crossing tower. A western gallery looked down into it, repeating the arrangement at Aachen. Galleries for choirs flanked each side of this vertical upper chapel.

The purpose of the upper sanctuary in the westwork has been variously interpreted.[6] At Aachen, in 936 it served as an imperial loggia, but its use before then is unknown. At Saint-Riquier it was virtually a tall centralized space dedicated to the Holy Savior. Although the placement of its altar is in dispute, Carol Heitz believes this chapel recalled the rotunda of the Holy Sepulchre and therefore served important liturgical functions in the celebration of the Easter rites. This space could therefore be interpreted as a fusion of a martyria and basilica, especially in the context of the cult of the Savior in such a setting, and in the light of the funerary implications of the tower porch at Saint-Denis. Documents also reveal that the upper chapel was used for parish services, thereby providing access for the general populace to this monastic church during feast days, and also segregating them from the monks during the celebration of services. Although the basic form of the westwork was often repeated, it varied in exterior format and interior configuration in later buildings, and its function changed according to each context.

The interior of Saint-Riquier consisted of varied spatial units. It was divided into three choirs with altars dedicated to the Holy Savior in the tribune of

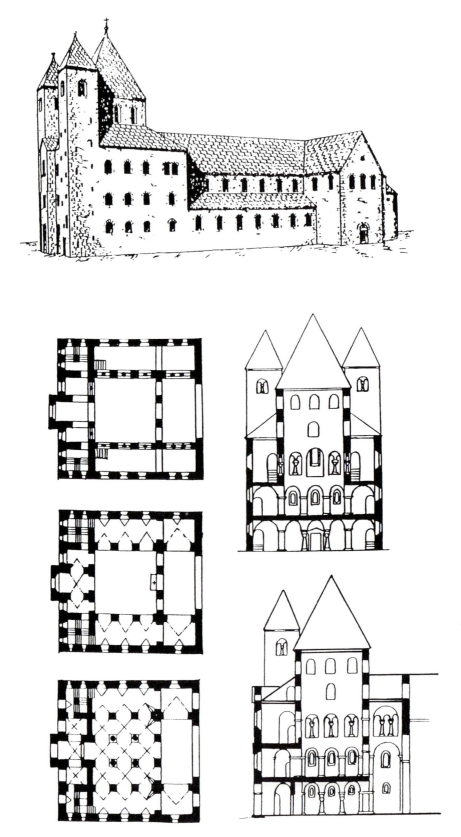

6.12 Corvey an der Weser, 873–85: exterior reconstruction; plans of each level of westwork; transverse and longitudinal sections of westwork. (After Effmann.)

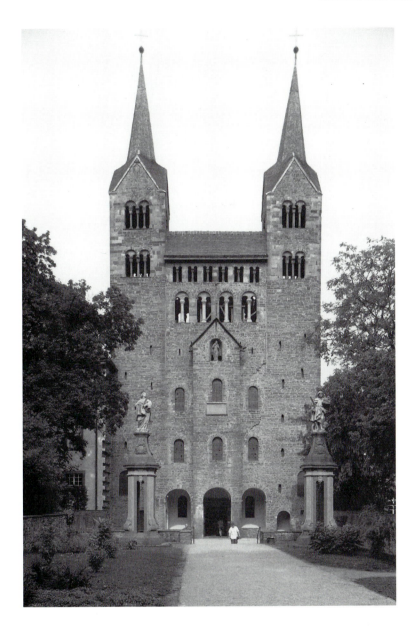

6.13 Corvey an der Weser, 873–85: facade. (R. G. Calkins.)

the westwork, the Virgin Mary, and Saint Ricarius, the patron saint, in the eastern apse. The three-aisled nave, containing twelve altars dedicated to various saints, led to the vertical space of the eastern crossing. The two vertical crossing spaces, like those of the later Scandinavian stave churches, may reflect a previous northern European tradition of vertical timber constructions. These tall crossing spaces also prefigure the well-lit crossing lanterns of Anglo-Norman churches. Combined with the longitudinal nave, they produced an innovative juxtaposition of vertical and horizontal interior spaces. Saint-Riquier

influenced subsequent buildings, for the Carolingian church at Reims used a similar configuration, and the balanced massing and multi-towered silhouette, with variations, became prevalent throughout northern Europe.

As Saint-Riquier no longer exists in its Carolingian form, the arrangement of its westwork can be surmised from an examination of the Carolingian monastery of St. Stephen at **Corvey an der Weser** in Germany (figs. 6.12–6.15). This Benedictine monastery was founded in 815 by two cousins of Charlemagne, dedicated in 844, and

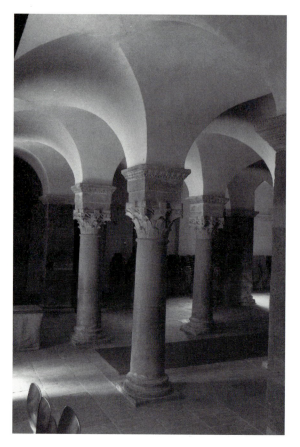

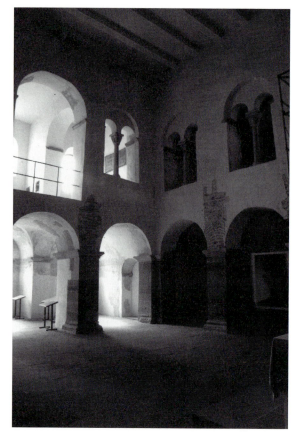

6.14 Corvey an der Weser, 873–85: entrance level of west-work. (R. G. Calkins.)

6.15 Corvey an der Weser, 873–85: upper level of west-work. (R. G. Calkins.)

reworked between 873 and 885 with an addition of a westwork, massive square crossing tower, and two flanking square stair turrets to the original three-aisled timber-roofed basilica. The present upper portion of the facade had Romanesque alterations giving it a more imposing vertical emphasis, and baroque additions were made to the nave in the 1660s.

In spite of these revisions, the interior of the westwork stands largely intact. The entrance is through a low groin-vaulted entrance hall with stout columns forming fifteen bays, into a tall, vertical space framed by a large arch. A tribune on three sides looks down into a two-story upper chapel above the entrance hall in the same manner as at Centula. From the elevated position, perhaps reserved for high-ranking persons, appears a vista through a series of arcades into the high chapel dedicated to John the Baptist and finally through a monumental arch into the nave. As at Centula, the side

galleries around this upper sanctuary perhaps served as choirs, and the upper chapel itself for parish services.

With its triple entryway reminiscent of a triumphal arch, and its imposing three-towered mass, the westwork block suggested imperial connotations, whether it was reserved for court personages or not. Moreover, presenting a fortresslike aspect on the exterior, the facade contains a stone inscribed with the invocation to the angels to "protect this, his city." This inscription is a clear reference to the idea that imposing edifices such as Corvey and Centula with their volumetric masses and clusters of vertical towers formed the terrestrial embodiments of the heavenly city of Jerusalem.

As discussed earlier, the ideal plan for the monastic community at St. Gall formulated by Abbot Haito, bishop of Basle, is one of the most significant and lasting contributions of the Carolingian period (see chapter 5). Abbot Haito's plan reflected the

6.16 Crypt plans, *Left to Right:* Ravenna, S. Apollinare Nuovo, mid-ninth century; Saint-Philibert-de-Grandlieu, first crypt, 814–19; revised plan and choir above, 836–47. (After Green.)

Carolingian desire to make the Benedictine Rule universal throughout the kingdom and to codify the layout of the Benedictine monastic communities. Such organization had been the subject of synods held at Aachen in 816 and 817 under Louis the Pious, Charlemagne's successor. These efforts resulted in the supremacy of the Benedictine order throughout Europe for the next three hundred years.

The monks who built the monastic church at **Saint-Philibert-de-Grandlieu** in the western Loire valley at Déas near Noirmoutier created another important Carolingian innovation. They first built a cruciform three-aisled church, dating from 814 to 819, of hammer-dressed masonry with a timber roof. Its original crypt (fig. 6.16) consisted of a narrow angular passageway flanking the square sanctuary that led to a small rectangular oratory beneath the elevated semicircular apse. This "occidented" chamber contained the relics of Saint Philibert, an arrangement that derived from westward oriented *confessio* with a surrounding passageway in seventh century Roman churches, and repeated at S. Apollinare Nuovo in Ravenna in the mid-ninth century (fig. 6.16, *left*).

Responding to increasing numbers of pilgrims venerating the relics, the monks of Saint-Philibert developed between 840 and 847 an innovative arrangement of the choir and crypt resulting in a new apsidal plan (fig. 6.16). This revision created five narrow, parallel chapels to the east, two extending from the transepts and two flanking and one behind the sanctuary. A passageway between them and a small cruciform oratory under the apse allowed access. In the eleventh century a small three-bay groin-vaulted *confessio* further to the west expanded the original space under the elevated sanctuary to house the sarcophagus of St. Philibert. It could be viewed through small windows in the steps leading up to the main apse above. Devotees could worship in each of the crypt chapels without being disturbed by pilgrims circulating behind them and without disturbing services in the main sanctuary. This parallel or échelon plan, a staggered variation of which was used in the crypt of Saint-Germain at Auxerre in the 850s, became the standard solution for the multiplication of chapels to house altars displaying relics until the development of the radial plan in the middle of the next century.

Carolingian architecture represents the beginning of a specifically medieval architecture. Although Carolingian builders borrowed heavily from earlier traditions, their assimilation of early Christian forms, combined with indigenous northern structural traditions and their own innovations in plan and exterior articulation, became the basis from which Romanesque architecture emerged.

7

OTTONIAN CONTINUATIONS

After 875 the political power of the Carolingian Empire declined and the center of power shifted eastward the to area of present-day Germany. Henry the Fowler of the House of Saxony was crowned Holy Roman Emperor in 919. Called Ottonian after three of the major emperors—Otto I (962–73), Otto II (973–83), and Otto III (991–1002)—this dynasty not only reconsolidated power into a new political entity but also revived the practice of borrowing the trappings of previous regimes. As the Carolingians had done, the Ottonians sought to make visual the political and symbolic manifestations of authority of the revived Holy Roman Empire, though they, too, added new elements. Particularly after the marriage of Otto II to the Byzantine princess Theophano, the daughter of the Byzantine emperor Romanus II, the desire to emulate the imperial iconography and splendor of Byzantium resulted in a fusion of elements of Early Christian, Carolingian, and Byzantine art into a new eclectic style that became Ottonian art. Ottonian buildings copied and varied the centralized plan as exemplified by Aachen, borrowed rhythmic nave arcades from Byzantium, developed the balanced massing of exterior volumes derived from Centula, and reintroduced the monumental groin vault over large spaces.

The small octagonal convent chapel of **St. Mary at Ottmarsheim** in Alsace, erected about 1019 and consecrated in 1049 by Pope Leo IX, exemplifies one Ottonian borrowing from Carolingian sources (figs. 7.1–7.2). This double-shell building, repeating the centralized form for buildings with the same dedication at Centula and Aachen, has a pronounced westwork block like that at the Palatine Chapel at Aachen. The interior elevation, although without the resplendent marble veneer, directly copies Aachen, with broad ambulatory arches and a triple arcade with two columns abutting the gallery arches above. The gallery extends into the westwork in the same manner as in the imperial gallery at Aachen.

An even more innovative borrowing from Aachen occurs at the **Münster at Essen** (figs. 7.3–7.4). The westwork and crypt were built under Abbess Theophano (1039–58) and dedicated in 1051. A Gothic hall church replaced the nave after a fire in 1275. The westwork on the outside consists of an octagonal tower rising above a facade flanked by two octagonal stair turrets and faces a narrow, cloistered atrium similar to that at Aachen. The westwork contains within it an emulation of the Aachen elevation: a segment of the interior octagon, surmounted by a half-dome facing the length of the nave. A gallery like that at Aachen lies above a low, irregularly shaped entrance hall between the atrium and the nave. Thus, this structure fuses three segments of the octagonal plan and elevation of Aachen with a three-aisled basilican plan.

The Ottonian basilica derived its principal inspiration from Carolingian variations of the early Christian

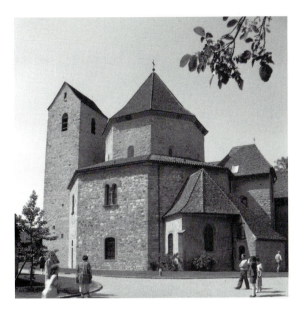

7.1 Ottmarsheim, St. Mary, 1019–49: exterior. (R. G. Calkins.)

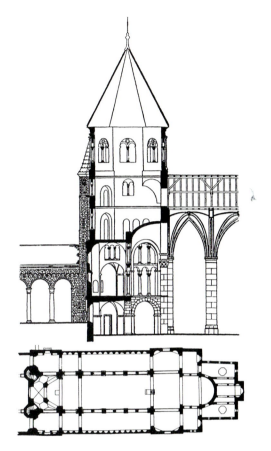

7.3 Essen, Münster, 1039–51: westwork section (After Jantzen); plan. (After Zimmermann.)

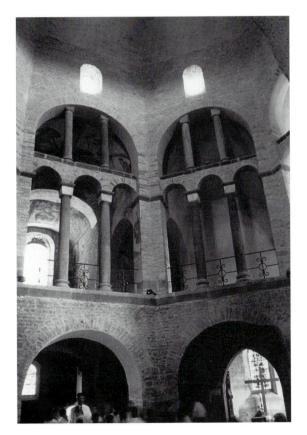

7.2 Ottmarsheim, St. Mary, 1019–49: interior. (R. G. Calkins.)

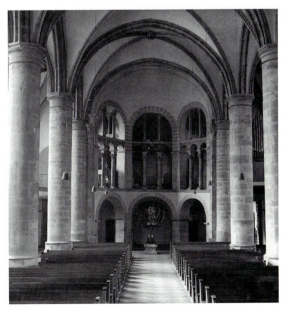

7.4 Essen, Münster, 1039–51: westwork interior. (Foto Marburg/Art Resource, N.Y.)

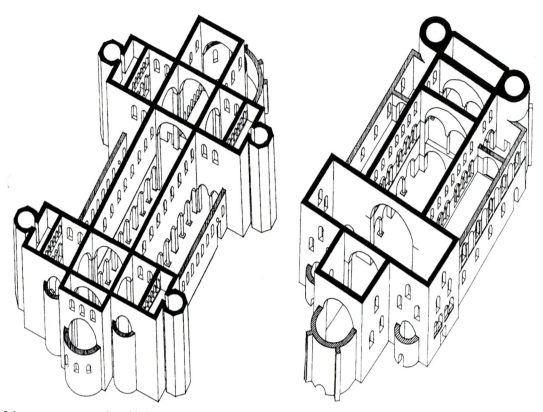

7.5 Isometric views: *Left:* Hildesheim, St. Michael's, 1001–33; *Right:* Gernrode, St. Cyrakus, 961–83. (After P. Capron.)

type, but it also occasionally added an element from Byzantium. Margrave Gero, one of the Ottonian noblemen, had the convent church of **St. Cyrakus at Gernrode** constructed between 961 and 983 (figs. 7.5–7.7). By 1150, with the addition of a westwork between two stair turrets, and a western apse, it assumed its present double-apse form (fig. 7.5, *right;* fig. 7.6) which may have been inspired by this Carolingian innovation at Fulda. The west choir rises over a low groin-vaulted crypt and the eastern apse contains a sanctuary raised over a hall crypt beneath the choir and transepts. The two transepts and clustering of towers present a variation of the additive accumulation of exterior volumes found in the Carolingian church at Centula, although without the same balance.

The interior of St. Cyrakus consists of a sequence of compartmentalized spaces: a vestibule, rectangular nave, crossing areas, transept ends, and sanctuary with apsidal spaces—all clearly delineated by large arches supporting curtain walls (figs. 7.5, 7.6). The three-aisled timber roofed building with a gallery follows the tradition of earlier Constantinian basilicas.

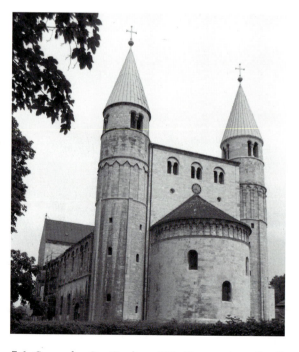

7.6 Gernrode, St. Cyrakus, 961–83: exterior. (R. G. Calkins.)

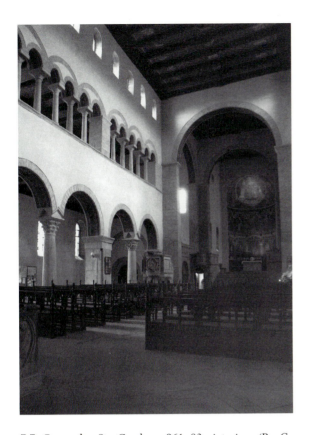

7.7 Gernrode, St. Cyrakus, 961–83: interior. (R. G. Calkins.)

Square piers after every other column in the nave arcade and after every five columns in the smaller gallery arcade above introduce a rhythmic variation. As the square piers are vertically aligned, they divide the nave into three successive subunits. This rhythmic articulation of the nave elevation, although independent of the plain wall and clerestory level above, reflects a similar device in the Byzantine basilica of H. Demetrios of the fifth century at Salonica in Greece (fig. 3.17). This example demonstrates but one borrowing of Byzantine design preferences that permeated Ottonian art and architecture in the late tenth and early eleventh centuries. In this case these Byzantine elements may have resulted from the reputed funding by the Empress Theophano. Similarly, elements of Byzantine style and iconography found their way into Ottonian manuscript illumination and ivory carving.

Ottonian basilicas continued to add the Carolingian westwork to the early Christian basilican form. Such is the case at **St. Pantaleon in Cologne,** built between 966 and 980 by Bishop Bruno, a son of Otto I (figs. 7.8–7.9; fig. 7.13, *top*).

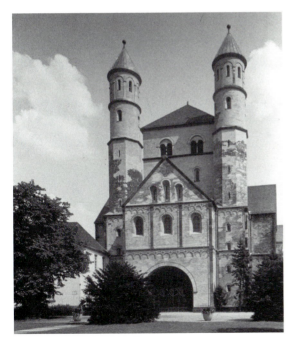

7.8 Cologne, St. Pantaleon, 966–80: exterior of westwork. (R. G. Calkins.)

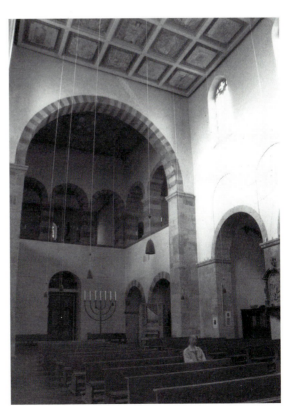

7.9 Cologne, St. Pantaleon, 966–80: interior of westwork. (R. G. Calkins.)

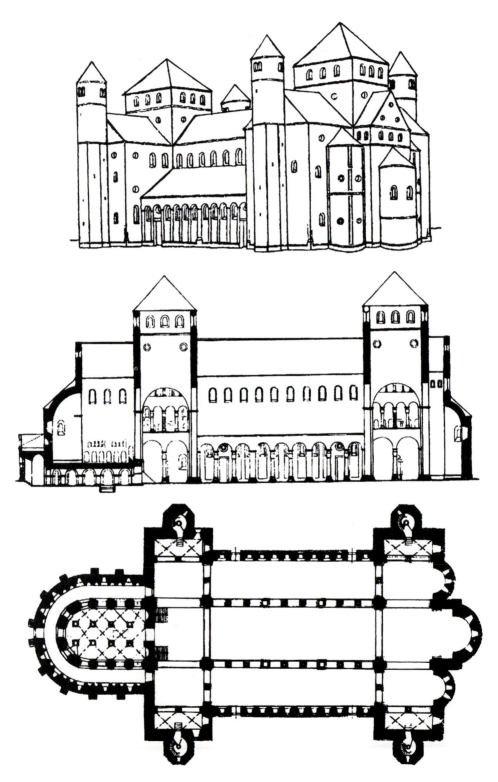

7.10 Hildesheim, St. Michael's, 1001–33: exterior reconstruction, section, plan. (After Beseler.)

The impressive westwork consists of a projecting porch flanked by octagonal stair turrets before a west transept surmounted by a massive square tower. This ensemble precedes a three-aisled, timber-roofed basilica of the late twelfth century. Like the original squat but powerful westwork of Corvey, the westwork of St. Pantaleon ultimately derives from the tower clusters at Centula but dramatically changes it into a dominating cruciform block.

The entrance to the westwork of St. Pantaleon leads to a low groin-vaulted entrance hall. Above, an upper chapel surrounded by aisles, galleries, and a western tribune faces a wide diaphragm arch opening into the nave, reflecting the Carolingian arrangement at Corvey.

St. Michael's at Hildesheim, built by Bishop Bernward between 1001 and 1033, exemplifies the maturation of the Ottonian basilica as interpreted from Carolingian models (fig. 7.5, *left*; figs. 7.10–7.12). Bishop Bernward was intimately connected with the Ottonian Court and traveled with it to Rome in 1001. The great bronze doors he commissioned for St. Michael's may have been inspired by doors with narrative reliefs he saw in Milan and Rome, and the monumental Paschal candlestick for his church undoubtedly derived from the Columns of Marcus Aurelius and Trajan.

Bernward was also sensitive to the Carolingian heritage of the empire, for the chronicles of his abbey state that St. Michael's was patterned after the cathedral at Reims, a ninth-century building that in turn copied Centula. The exterior masses of east and west transepts with crossing towers present a similar balance of additive volumes, but at St. Michael's, the stair turrets occupy the ends of the transepts. A large west apse, with raised sanctuary above a hall crypt containing the tomb of Bernward, balances a triple apse at the east end.

Like Gernrode and Centula before it, St. Michael's follows the basilican formula with three

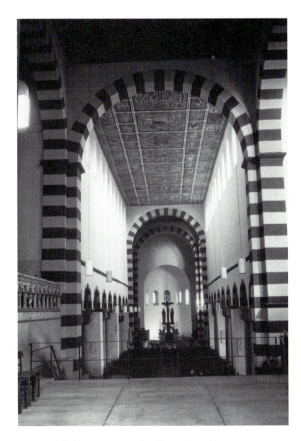

7.11 Hildesheim, St. Michael's, 1001–33: nave interior looking east. (R. G. Calkins.)

7.12 Hildesheim, St. Michael's, 1001–33: cushion capital. (Foto Marburg/Art Resource, N.Y.)

aisles, timber roof, clearly defined interior spaces consisting of the sanctuary, transept ends, crossing areas, and the rectangular volume of the nave. The transept ends, with two stories of galleries, contain altars dedicated to the archangels. The nave arcade varies the rhythmic arrangement of St. Cyrakus at Gernrode: intrusions of square piers occur after every two columns and subtly restate the module of the crossing square; three of these squares equal the length of the nave. Cushion capitals, a pristine geometric fusion of a cube and a half sphere, not only make a forthright transition from the cylinder of the columns to the square of the impost blocks (fig. 7.12), they also embody the same clarity of forms found in the interior spaces and the juxtaposition of exterior volumes.

Bold and impressive, even fortresslike in its apparent solidity, the exterior of St. Michael's embodies the idea stated in the annals of Hildesheim that the church was consecrated as "a bulwark of the peace of the Church and dedicated to the salvation and defense of Christendom." The balanced, picturesque silhouette develops this architectural form and its attendant symbolic meaning expressed on the westwork of Corvey: a terrestrial evocation of the *Civitas Dei,* the City of God.

The balanced two-transept form of Hildesheim was enlarged and elaborated at the great **Kaiserdom at Speyer** (Speyer I) begun by Conrad II in 1030 and dedicated by Henry III in 1061 (figs. 7.13–7.17). Intended as the Imperial Pantheon of the Ottonian Emperors, it stood at the head of an avenue that invited a processional approach in the same manner as the peristyle before the imperial palace at Spalato. Essentially a massive three-aisled basilica, 435 feet long, with western transept dou-

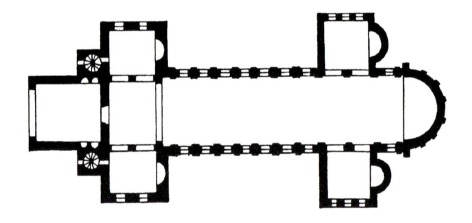

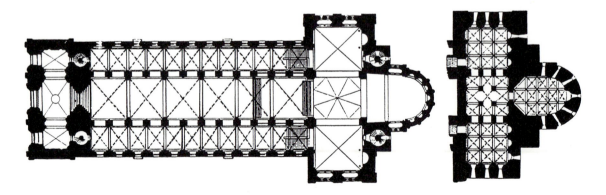

7.13 *Top:* Cologne, St. Pantaleon, 966–80: plan. (After Tholen.) *Bottom:* Speyer, Kaiserdom, 1030–61: plan and crypt plan.

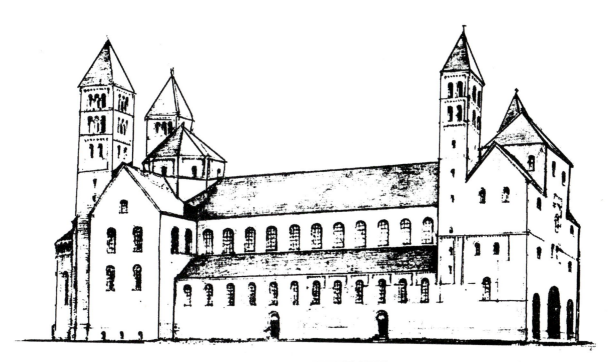

7.14 Speyer, Kaiserdom, 1030–61: exterior reconstruction. (After Kenneth J. Conant.)

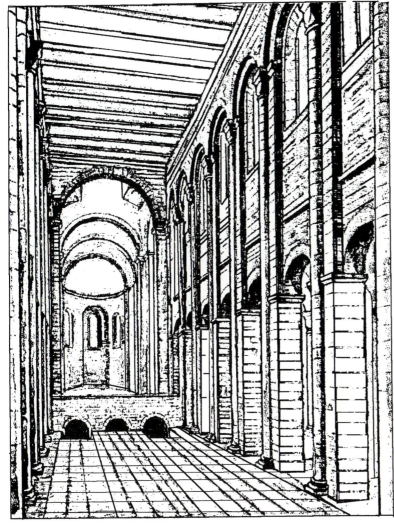

7.15 Speyer, Kaiserdom, 1030–61: interior reconstruction. (After Kenneth J. Conant.)

7.16 Speyer, Kaiserdom, 1030–61: hall crypt. (R. G. Calkins.)

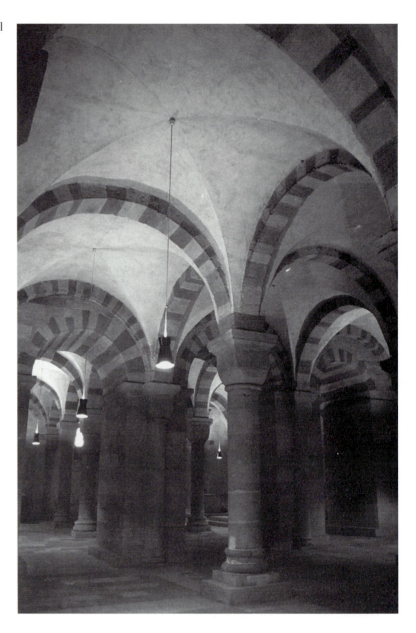

bling as a westwork, it originally bore a timber roof. Restorations of the towers have changed the exterior silhouette, but it still resembles the basic formulas of Hildesheim and, ultimately, Centula, with a pair of stair turrets flanking each crossing tower.

The original timber-roofed interior of Speyer evoked the monumental scale and splendor of Imperial Rome. The visitor enters through the lower story of the west transept, a three-bay narthex that opens into the nave through a massive doorway with splayed jambs and archivolts on each side. The nave

measures 45 feet wide, 90 feet tall, and 235 feet long. At the east end a huge groin-vaulted hall crypt exists beneath the entire elevated pavement of the large transepts and sanctuary (fig. 7.16). A forest of sturdy columns with cushion capitals supports its vaults.

In the nave, massive square piers with engaged semicylindrical shafts on the nave side support the arcade leading to the aisles. Before alterations (fig. 7.15), this shaft rose to the abacus, and responded to a pilaster strip and another half cylindrical shaft that

7.17 Speyer, Kaiserdom, after 1087: groin-vaulted nave. (R. G. Calkins.)

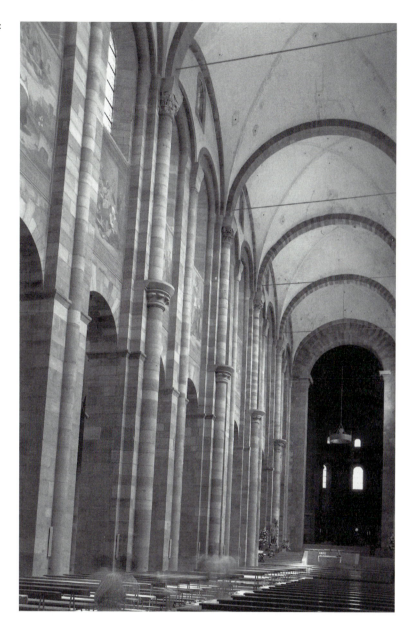

soared to a double-layered enclosing wall arch over the clerestory window. Thus the nave elevation, in contrast to the smooth mural surfaces of Gernrode and Hildesheim, was strongly articulated with a series of monumental two-story arches creating the effect of a Roman aqueduct, an interior reflection of the similar massive arcade on the exterior of the Imperial Aula Palatina at Trier. This arcade motif, derived from an earlier imperial building, represented an appropriately monumental motif for the imperial pantheon. It also effectively divided the nave into bays, an articulation that Jean Bony suggested began in the last decade of the tenth century in the old cathedral at Orléans and was then repeated in the parish church at Jumièges in the late eleventh century.[1]

No sooner was the Kaiserdom completed than Henry IV, after 1087, replaced its timber roof with a succession of large domical groin vaults built over the nave (designated **Speyer II;** fig. 7.17). These groin vaults were among the first covering a large span since late antiquity and they extend the height

of the nave to 107 feet.[2] At the same time, the octagonal lantern of the crossing tower, supported on squinches, was extended to a height of about 160 feet, a monumental reflection of the vertical crossing spaces at Saint-Riquier.

Because the original nave elevation with the monumental wall arcade effectively corbelled the upper portion of the nave wall inward, some scholars believe that a vault was intended from the beginning. In any event, when the groin vaults of Speyer II were added, they spanned two of the original bays; every other pier—corresponding to the junction of transverse arches between the bays and the convergence of two adjacent groins—was thickened with an additional pilaster strip and a colossal nave shaft. The emphatic presence of these new massive shafts juxtaposed to the original lighter, and now intermediate, ones divided the nave into a series of six pronounced and identifiable bays, each with its own canopy. This solution may mark the beginning of the articulated bay system, and although groin-vaulted naves remained rare (one was built at Vézelay between 1120 and 1132, a smaller one at Anzy-le-Duc at the same time; and one was added to monastic church at Maria Laach in the twelfth century), it provided the starting point for the development of rib vaults in bays of mature Romanesque buildings. Speyer's impressive size, sophisticated vaulting, and bold, balanced massing of exterior volumes exemplifies the mature Ottonian style that was repeated many times in subsequent Romanesque German churches.

8

VISIGOTHIC, ASTURIAN, MUSLIM, AND MOZARABIC BEGINNINGS IN SPAIN

While the Merovingian dynasties ruled Gaul, the Visigoths occupied the Iberian Peninsula. This branch of the Goths, like the Ostrogoths, had been forced westward from the region north of the Caspian Sea by the invasion of the Huns in the fifth century. During their retreat, the Visigoths, as well as the Huns after them, largely contributed to the collapse of the Roman Empire. Eventually the Visigoths established a kingdom in present-day Spain that lasted from about 469 until its conquest by the Muslims in 711. The Visigothic Christian Kingdom was succeeded by the Kingdom of Asturias, a Christian enclave sandwiched between the mountains north of León and the Bay of Biscay, that flourished contemporaneous with the Carolingian Empire. The fusion of Visigothic, Asturian, and Islamic artistic characteristics produced a Mauro-Hispanic art called Mozarabic. Elements of all of these styles eventually found their way into the rich architectural vocabulary of Romanesque Spain.

Small, compact, but well-built churches of the seventh century reveal the sophistication of Visigothic building techniques. The tiny chapel of **S. Juan de los Baños** (figs. 8.1–8.2), built under King Recceswinth and dedicated in 661 to St. John the Baptist, originally had three projecting square chapels on the east (now filled in with a continuous wall). Pier, or spur, buttresses reinforce the hammer-dressed masonry of the exterior. The compartmen-

talized interior contains a short nave, two aisles, a small entrance porch, and three chapels. Horseshoe-shaped barrel vaults of carefully shaped ashlar blocks cover the three sanctuary chapels, while horseshoe-shaped arches grace the nave arcades—all this a good century before the Muslims used them in the mosque at Córdoba (fig. 8.4).[1] The capitals below the arches are Visigothic translations of Roman Corinthian capitals, an abundance of which would have been found in Visigothic Spain to serve as models. The horseshoe arches and compartmentalized interior were to be reflected at Germigny-des-Prés built by the Visigoth Theodulf about 800.

Another diminutive, compartmentalized church, **Sta Combe de Bande** (figs. 8.1, 8.3), probably built at the end of King Recceswinth's reign about 672 and restored under the Asturian King Alfonso II (866-910), made use of the Greek-cross plan. It consists of an additive accumulation of five square chambers with three along the main axis, and two flanking ones serving as lower diminutive transepts. Two small chambers flanking the sanctuary were added later. The herringbone brickwork of the groin-vaulted crossing underwent restorations in 872, but solid ashlar masonry barrel vaults remained in the rest of the building. A small horseshoe arch supported on a pair of columns led to the sanctuary chamber at the east end. These typical Visigothic characteristics of well-worked masonry, small barrel vaults, horseshoe

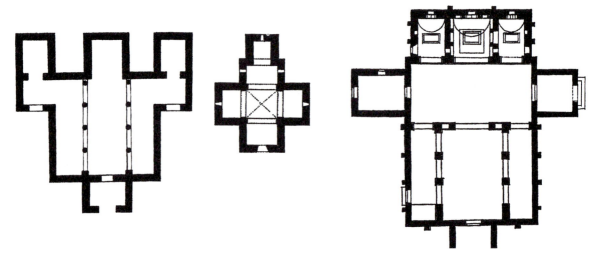

8.1 Plans, *Left to Right:* S. Juan des los Baños, 661 (After Alvarez); Sta Combe de Bande, circa 672 (After Lampérez); S. Julián de los Prados, circa 830 (After Manzanares).

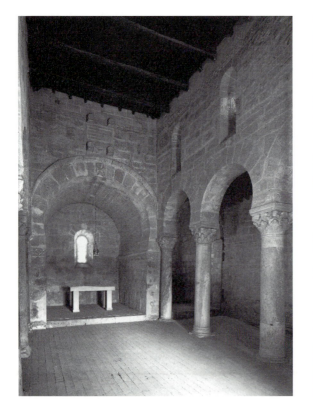

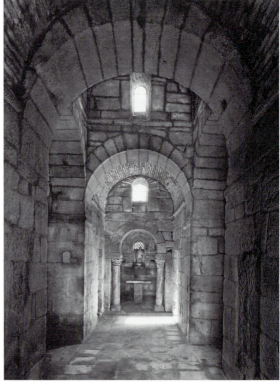

8.2 S. Juan des los Baños, 661: interior. (Hirmer Fotoarchiv.)

8.3 Sta Combe de Bande, circa 672: interior. (Hirmer Fotoarchiv.)

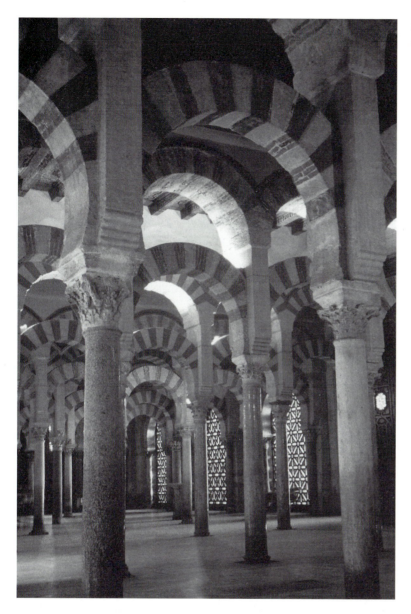

8.4 Córdoba, Mosque, eighth to tenth centuries: interior. (R. G. Calkins.)

arches, and compartmentalized interiors provided the basis for further developments in the Christian kingdom of Asturias in the ninth century.

The establishment of a Muslim caliphate at Córdoba confirmed the strong Islamic presence in the Iberian peninsula that lasted from 711 until the expulsion of the Muslims in 1492. Caliph Abd ar-Rahman (756–88) began a great **mosque at Córdoba** intended to become the principal Muslim mosque of Spain (figs. 8.4–8.5). Patterned after the multi-aisled form established in Cairo in the seventh century, the mosque originally had 110 columns, but with additions between the years 912 and 1002,

the number grew to 850. A forest of marble columns supports double arches and bays of groin vaults. The alternating red brick and white stone voussoirs of the eighth century arcades were copied in later arches with painted alternate bands of red on the white stone. Although the interior of the Córdoba mosque was later disrupted in the midst of these arcades by the insertion of a Baroque Catholic cathedral for Charles V of Spain in the sixteenth century, the multiple screened vistas through the remaining columns and arches remain magical.

Increased decorative elaboration, painted and in stucco relief, accent the approach to the vestibule,

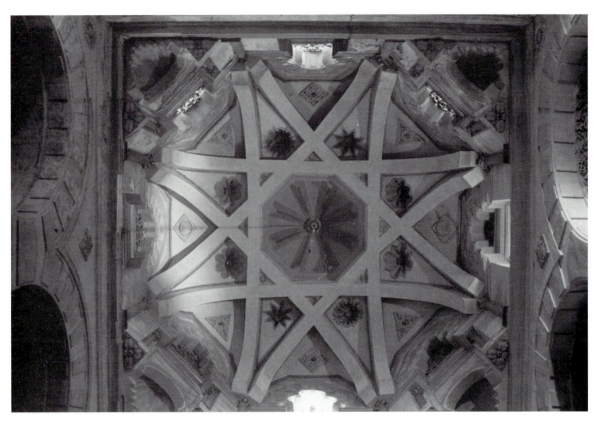

8.5 Córdoba, Mosque, eighth to tenth centuries: mihrab vestibule vault. (R. G. Calkins.)

or *maksurah,* for the caliph, and the *mihrab,* the sanctuary on the eastern side of the building facing Mecca toward which prayers were directed. Polylobed intersecting arches, still maintaining the alternate banding but now adorned with elaborate foliate designs in gilded stucco, become more intricate in the vestibule area. Small melon domes supported on intersecting square ribs cover three bays of the vestibule (fig. 8.5). The ribs spring from the intersections of squinches with each wall and span the corner to an opposite point on adjacent walls forming a square that echoes the shape of the bay. Small scalloped domes and other decorative embellishments cover residual corners. Some bays multiply the number of ribs supporting the tiny octagonal dome above and create an intricate spiderweb effect.

These exotic configurations exemplify an early use of the decorative rib that was adapted and used as a structural device in later Romanesque architecture. They were copied in a twelfth-century church at Torres del Rio in Spain (fig. 13.1). Other decorative features found at Córdoba, such as trilobed

arches and rich decorative panels, also found their way into Romanesque art. These devices, combined with a developing penchant for exterior decoration of ornamental patterns of multicolored bricks in the Byzantine world, results in the "orientalized" exteriors of some Romanesque churches, such as Saint-Michel at Le Puy in France.

Meanwhile, in the Christian Kingdom of Asturias, a sophisticated and well-built group of buildings was erected under royal patronage during the ninth century. Tioda built a royal chapel adjacent to the royal palace at **Oviedo, S. Julián de los Prados,** known as " El Santullano," for Alfonso the Chaste about 830 (figs. 8.1, 8.6). The timber-roofed, three-aisled basilica has a monumental transept higher than the rest of the church containing a royal gallery in one end. The pronounced arch leading into the transept, the low arches leading into the aisles, and three parallel barrel-vaulted chapels on the east end divide the interior into discrete rectangular spaces. Massive square piers, channeled like classical pilasters, support the three nave arcades, and elaborate architectural frescoes in the Pompeian

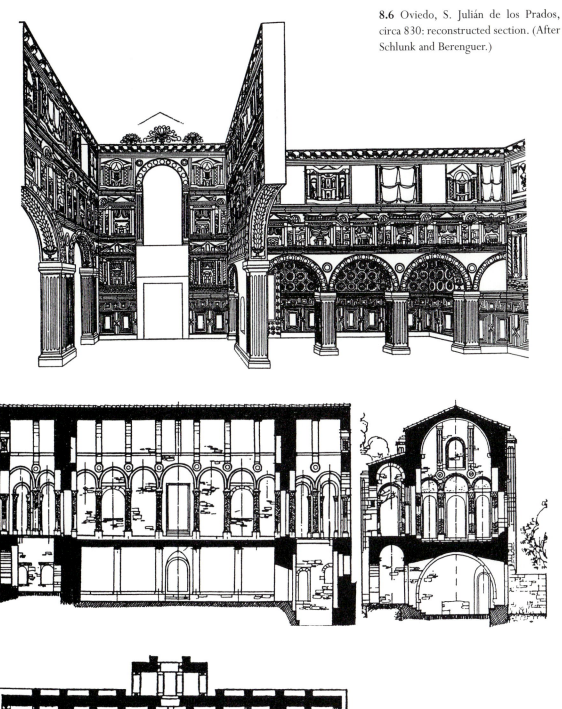

8.6 Oviedo, S. Julián de los Prados, circa 830: reconstructed section. (After Schlunk and Berenguer.)

8.7 Oviedo, Sta María de Naranco, circa 842: longitudinal and transverse sections; plan. (After Gómez Moreno and Menéndez Pidal.)

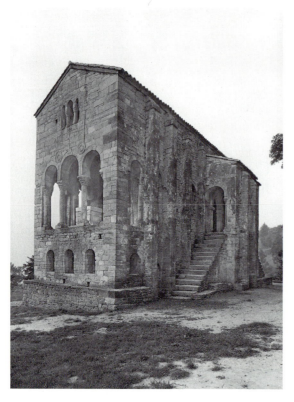

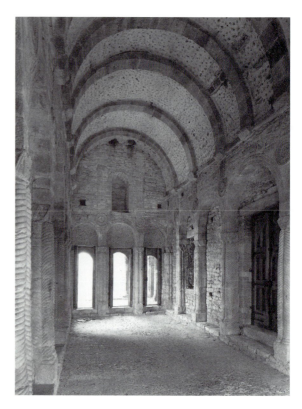

8.8 Oviedo, Sta María de Naranco, circa 842: exterior. (Hirmer Fotoarchiv.)

8.9 Oviedo, Sta María de Naranco, circa 842: interior. (Hirmer Fotoarchiv.)

manner once decorated the wall surfaces throughout. Reflecting the decoration of now lost Roman structures in Spain, and similar to the Theodosian architectural mosaics in the dome of H. Georgios in Salonica, these lavish frescoes evoked imperial architectural symbols appropriate for a royal chapel. On the exterior, projecting pier or spur buttresses reinforce the wall and punctuate the surface of the rough, hammer-dressed masonry.

The Asturians constructed many small vaulted and compartmentalized buildings in the tradition of their Visigothic predecessors and developed a variety of vaulting solutions that point to the Romanesque. On a hillside above Oviedo stands a longitudinal stone structure built for King Ramiro I of Asturias about 842 as a royal hall adjoining a royal palace and baths at Naranco. However, an altar to Santa María was dedicated in it in 848. **Sta María de Naranco** (figs. 8.7–8.9) has two-stories built of hammer-dressed masonry reinforced by bold pier buttresses on the exterior. Twin staircases on each side once led up to entrance vestibules; only the

stairs on the uphill side now survive. The lower level, serving as a crypt, is covered by a barrel vault supported on large transverse arches. The upper chamber, also barrel vaulted with transverse arches, opens onto two arcaded loggias that overlook the surrounding countryside. These may be the among the earliest substantial barrel vaults in western Europe since the collapse of the Roman Empire. Paired columns incised with spirals support a blind arcade along both interior walls that corbels the wall inward under the springing of the vault, an effective structural device that helps keep the thrusts of the vault within the wall. Incised lines along the arches with medallions in relief set into the spandrels introduce ornament reflecting earlier Visigothic traditions of metalwork.

The nearby church of **Sta Cristina de Lena** (fig. 8.10, *top*; fig. 8.11) of about 905 also exemplifies an entirely barrel-vaulted structure built of solid hammer-dressed masonry. Its exterior presents a compact accumulation of additive masses around a tall central block, emphasized by reinforcing pier but-

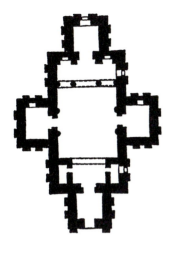

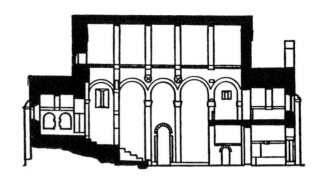

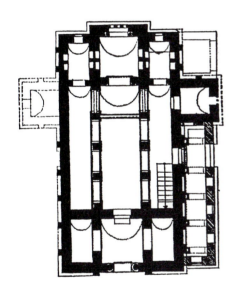

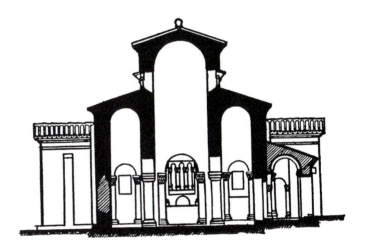

8.10 *Top:* Sta Cristina de Lena, circa 900: plan and longitudinal section. (After Lundberg and Saalman.) *Bottom:* S. Salvador de Valdedíos, 866–910: plan and transverse section. (After Hanson; Schlunk and Manzanares.)

tresses, with low arms defining a Greek cross plan in the manner of Sta Combe de Bande. Barrel-vaulted compartments comprise the interior, which includes an enclosed porch, a transverse vestibule, a short nave with compartmentalized transeptal chapels, and finally a raised sanctuary beyond a triple arcade and an altar chamber beyond. Blind arcades above columns corbel the wall inward beneath the tunnel vault, and decorative medallions in the spandrels repeat these features found at Sta María de Naranco. Carefully cut ashlar masonry in the barrel vault and the voussoirs of the arches gives the interior a solid, muscular appearance in spite of its diminutive scale.

This accomplishment in Asturian vaulting developed further in the longitudinal church of **S. Salvador de Valdedíos,** built 856–910 (fig. 8.10, *bottom*). Although a porch runs along the south side,

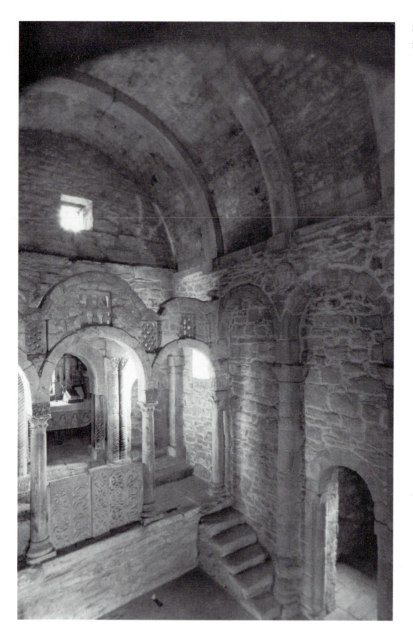

8.11 Sta Cristina de Lena, circa 900: interior. (Hirmer Fotoarchiv.)

pier buttresses strengthening the walls articulate the exterior, continuing this traditional device and prefiguring the bold Romanesque exteriors of the next century. Inside, two aisles and the nave terminate in square chapels on the eastern end. The three-aisled building has massive rectangular piers along the nave supporting a barrel vault that is in turn buttressed by two lower, narrow barrel vaults along the aisles: similar triple parallel barrel vaults will be used in early Romanesque buildings around the millennium.

The timber-roofed church of **S. Miguel de Escalada** (figs. 8.12–8.13) of 913 represents another phase of early medieval Spanish architecture. Its combination of Visigothic, Muslim, and Christian motifs exemplifies the "Mozarabic" style. S. Miguel has three groin-vaulted eastern chapels with horseshoe-shaped plans. The nave arcades, compartmentalizing transverse screens, and on the exterior, the arcade of a lean-to porch, repeat these Visigothic and Muslim motifs in an elegant and spacious ensemble. Although refugé monks from the region of Córdoba

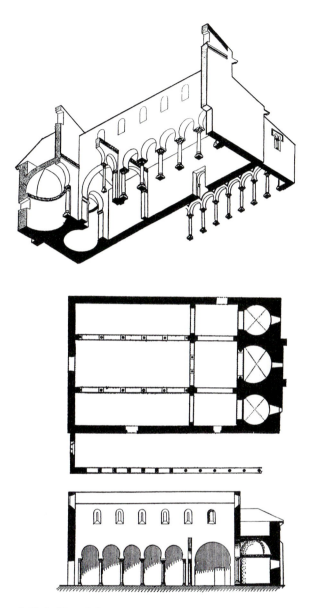

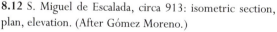

8.12 S. Miguel de Escalada, circa 913: isometric section, plan, elevation. (After Gómez Moreno.)

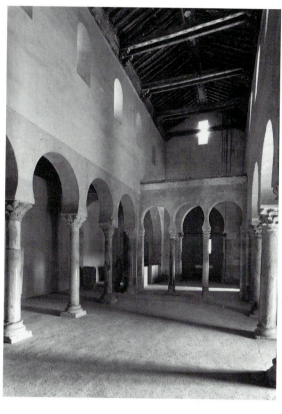

8.13 S. Miguel de Escalada, circa 913: interior. (Hirmer Fotoarchiv.)

built this monastic church, they did not hesitate to use such Muslim devices. Similar Mozarabic elements even provided the basis for some synagogues in the large Jewish communities in Spain, as at Sta Maria del Blanca in Toledo that has a similar interior.

The mixture of Visigothic, Muslim, Asturian, and Mozarabic elements found in Spanish buildings may have provided the source of some of the "oriental" motifs found in Romanesque buildings such as band-

ed voussoirs and horseshoe arches, particularly as knowledge of these churches spread along the pilgrimage routes beginning in the ninth century. Indeed, the completely vaulted buildings of the Visigoths and Asturians, with compartmentalized interiors, pier buttresses articulating the exterior, and compact massing of exterior volumes set the stage for more monumental manifestations of these characteristics in Romanesque architecture.

9

EARLY ROMANESQUE SOLUTIONS

In the tenth and eleventh centuries many factors enabled the building of large and sometimes innovative structures in France, northern Spain, and northern Italy. Often sharing similar characteristics, these buildings were the consequence of a virtual building boom that occurred throughout western Europe around the year 1000. Raoul Glaber (ca. 986–1046), a Cluniac monk and chronicler, wrote of this development:

> Therefore, after the above-mentioned year of the millennium, which is now about three years past, there occurred throughout the world, especially in Italy and in Gaul, a rebuilding of church basilicas. Notwithstanding the greater number which were already well established and not in the least need, nevertheless, each Christian people strove against the others to erect nobler ones. It was as if the whole world, having cast off the old by shaking itself, were clothing itself everywhere in the white robe of the church. Then at last, all the faithful altered completely most of the espicopal seats for the better, and likewise the monasteries of the various saints, as well as the lesser places of prayer in the towns.[1]

Raoul Glaber implied, and Henri Focillon in his *L'An Mil* suggested, that this activity may have been partly occasioned by a sense of relief and thanksgiving at having been spared the anticipated Second Coming during the year of the millennium.[2]

Nevertheless, the church could not have undertaken so many widespread projects without a resurgence of the economic means to finance them. Moreover, the increasing sophistication of cutting and shaping stone required improved metallurgy to produce better tools, particularly the stone saw. Innovative vaulting arrangements became possible only with a growing understanding of the partially forgotten principles of statics. Some scholars have called the vaulting schemes of early Romanesque buildings "experimental" or "tentative.[3] Although the builders of the early Middle Ages may have made mistakes, they were not just experimenting, for nothing is tentative about their buildings: the masons built—maybe even overbuilt—them with assurance, and they intended them to last. With increased confidence, the buildings became increasingly higher and larger, and their size, detailing, and vaulting solutions set the stage for later Romanesque structures.

Although dating from the twelfth century, such churches as **Sta María** and S. Clemente at Tahull in Catalonia, both consecrated in 1123, represent a continuation of the timber-roofed basilican form combined with vaulted sanctuaries and refined exterior decoration common to the developing early

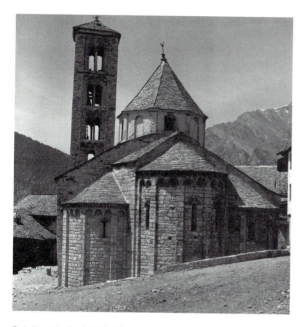

9.1 Sta María de Tahull, consecrated 1123: apse. (Hirmer Fotoarchiv.)

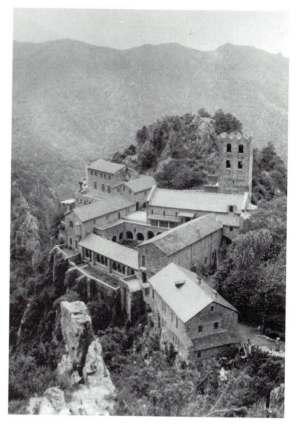

9.2 Saint-Martin-du-Canigou, 1001–09: view. (R. G. Calkins.)

Romanesque Style (fig. 9.1). They consist of carefully shaped hammer dressed stone that creates an effect of rugged strength and solidity. Both churches have three aisles defined by robust cylindrical columns supporting arcades and timber roofs. However, stone barrel vaults cover the sanctuaries leading into the chapels, and half-domes extend over the apses.

On the exterior, distinctive recessed panels between pilaster strips supporting an arched corbel table decorate their apses. Tall belfries placed at the corner of each building contain recessed panels with arched corbel tables similar to those on the apse. These decorative panels first appeared in earlier buildings farther afield: Sta Cecelia at Montserrat (ca. 957) and S. Vincenzo in Prato at Milan (ca. 814–33). In fact, the arched corbel table above recessed panels, sometimes referred to as "Lombard decoration," may have originated in northern Italy. Its use exemplifies an increased interest in the orna-

mental articulation of building exteriors that coincides with the use of decorative masonry on the exteriors of Byzantine churches. Such exterior decoration and the rhythmic use of pier buttresses on Asturian churches also compliments the developing aesthetic of the harmonious massing of exterior volumes begun in Carolingian buildings.

Just after the year 1000 a variety of vaulting systems began to appear in monastic churches. One of the first Romanesque monasteries begun after the millennium is **Saint-Martin-du-Canigou,** built from 1001 to 1009, but heavily restored in the twentieth century (figs. 9.2–9.5). This diminutive monastery on the north side of the Pyrenees exhibits a solution to the problem of vaulting an entire three-aisled space, one that had been used in the Asturian church of S. Salvador de Valdedíos a century before (fig. 8.10, *bottom*). Two small, low barrel vaults over the narrow aisles flank the higher barrel-vaulted nave and absorb much of the outward thrust of the

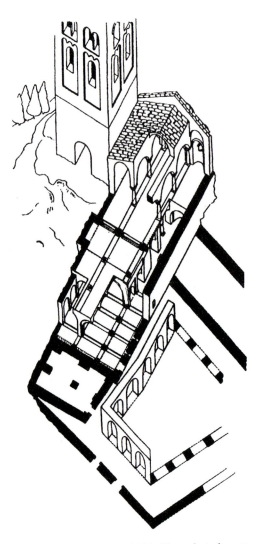

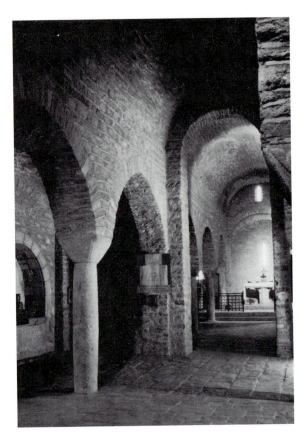

9.4 Saint-Martin-du-Canigou, 1001–09: nave interior. (R. G. Calkins.)

9.3 Saint-Martin-du-Canigou, 1001–09: analytical section. (After Puig i Cadafalch.)

central vault. Massive walls of hammer-dressed stone in turn buttress the aisle vaults. This system repeats on a lower level, where cruciform piers support transverse arches under the vaults. In the upper level, surprisingly slender columns, single shafts of stone, support the massive walls of the nave arcade, interspersed by a single pair of compound piers supporting a heavy transverse arch that divides the sanctuary from the nave. The square belfry and exterior of the apsidal chapels, decorated with pilaster strips and arched corbel tables, repeat these features of Lombard decoration.

In Catalonia to the south of the Pyrenees, the church of **S. Pedro de Roda** consecrated in 1022,

exhibits another vaulting system that was to be repeated frequently in other Romanesque churches. Over the aisles, half barrel vaults, quadrant vaults, buttress the barrel-vaulted nave (fig. 9.6, *top*). This is a system that had been used in previous buildings on both sides of the Pyrenees, as at the large monastic church of Saint-Michel-de-Cuxa, begun in the Mozarabic style between 955 and 974, and at Sta Maria de Vilabertrán in Catalonia, where low half-barrel vaults abut the nave wall.[4] Such quadrant vaults became a prevalent buttressing device in the gallery level of mature Romanesque churches as a continuous buttress for barrel vaulted naves.

Another Catalan building, **S. Vicente da Cardona,** represents a third solution to the vaulting problem (fig. 9.6). Originally dating from 981 to 985, the church was revised between 1029 and 1040.[5] The imposing result consists of a three-aisled basilica with a staggered triple apse built of hammer-dressed stone. Beneath the main sanctuary is a

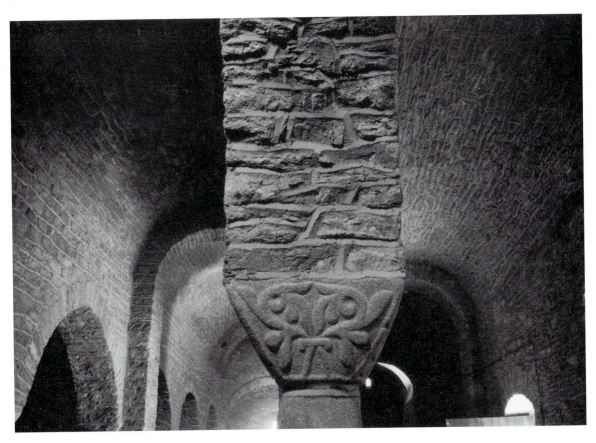

9.5 Saint-Martin-du-Canigou, 1001–09: nave and aisle vaults. (R. G. Calkins.)

three-aisled, groin-vaulted hall crypt. Instead of barrel vaults, three small groin vaults in each bay of the tall aisles buttress the barrel-vaulted nave. Square compound piers with flat, pilaster-like nave shafts respond to transverse arches beneath the main vault. Shafts and arches divide the wall and vault into a regular series of units, or bays, down the length of the nave, contributing to the vigor and monumentality of the interior. A dome set on squinches covers the crossing, another feature that became common in Romanesque churches. The robustness of this structure, the vigor of its exterior and interior articulation, and the use of the dome over the crossing may derive from Byzantine sources current in the Mediterranean region.[6]

With growing confidence in their vaulting techniques, Romanesque builders designed increasingly large scale churches. The immense structure of **Saint-Bénigne at Dijon,** built under William of Volpiano between 1001 and 1018 formed one of the largest early Romanesque buildings (fig. 9.7). This five-aisled basilica, 301 feet long, had a huge rotunda behind the apse. This combination of longitudinal basilica and centralized martyrium returned to the authoritative model of the Church of the Nativity in Bethlehem. The function of its parts differed, however: the basilica housed the relics of St. Bénigne, the patron saint of Burgundy, and the rotunda, dedicated to the Virgin, was used for the celebration of Christmas mass.

In the basilica, twenty-six huge square piers, six feet on a side, flanked the nave of the otherwise vast interior, occupying one-eighth of its floor area. Groin vaults covered the aisles, and are believed to have supported a gallery over the inner aisle that buttressed a barrel-vaulted nave. The transept area, barely projecting beyond the outlines of the ground plan, was mostly evident in the projection of its gabled mass above the sloping roofs of the adjacent aisles, while a squat tower surmounted the crossing.

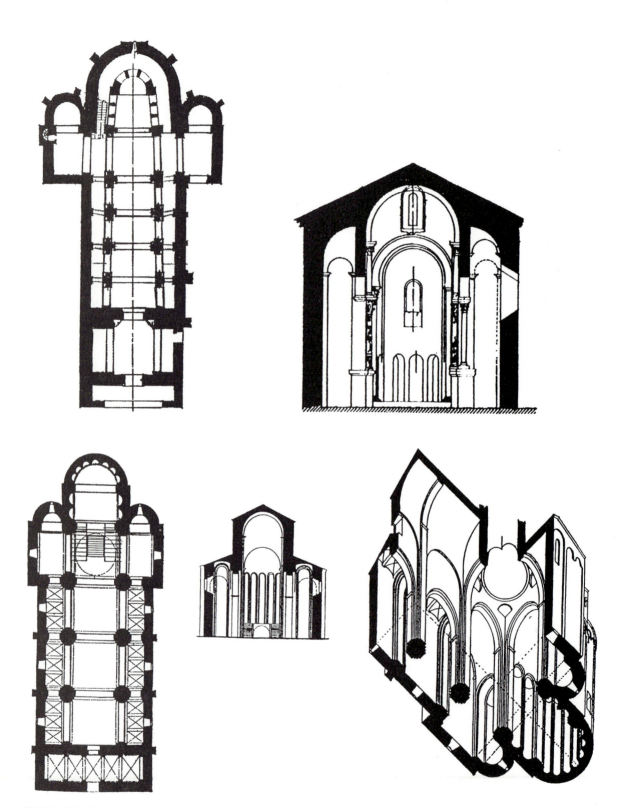

9.6 *Top:* S. Pedro de Roda, by 1022: plan and transverse section. (After Iñiguez.)
Bottom: S. Vicente da Cardona, 1029–40: plan, transverse and isometric sections. (After Puig i Cadafalch.)

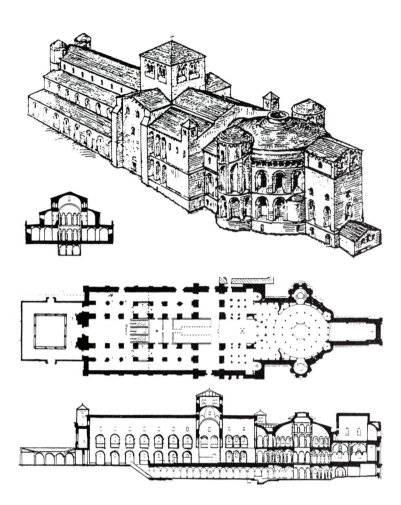

9.7 Dijon, Saint-Bénigne, 1001–18: reconstruction, sections, and plan. (After A. S. Wethy and Kenneth J. Conant.)

The staggered echelon plan fused with the ambulatories of the rotunda.

The rotunda had three stories. It consisted of a crypt with double ambulatory, a main level with double ambulatory, and a gallery. The central core rose through the three stories to an oculus in the center of the dome. Two cylindrical stair turrets flanked this structure, while a three-story rectangular sanctuary extended beyond it on the east. Of this vast complex, only the crypt of the rotunda with its heavy squat columns remains. St. Bénigne would would remain the largest structure in Burgundy until the construction of Cluny III at the end of the eleventh century.

The church of **Saint-Philibert at Tournus,** founded by monks who were forced to flee from their original monastery at Saint-Philibert-de-

Grandlieu after its destruction by invading Hungarians in the early tenth century, used one of the most innovative vaulting systems of the early Romanesque (fig. 9.8, *right*; figs. 9.9–9.14). This complex building combines three innovations resulting from different building campaigns. Its three-aisled plan with projecting transepts has an apse with radiating square chapels around the crypt and ambulatory, a massive two-tower facade that forms a three-aisled, two-story westwork, or "église porche," and a later innovative vaulting system for the nave.

The crypt, built between 950 and 979, introduced an early version of the radial plan to Burgundy. The chapels and ambulatory surrounding the sanctuary above, erected between 1008 and 1019 (fig. 9.10) result from carrying this same plan

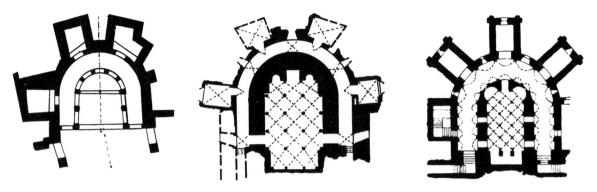

9.8 Crypt plans, *Left to Right:* Saint-Maurice-d'Agaune, mid-ninth century; Clermont-Ferrand, Cathedral, 946; Tournus, Saint-Philibert, 950–79.

9.9 Tournus, Saint-Philibert, 950–circa 1120: longitudinal section, plan. (After Aubert.)

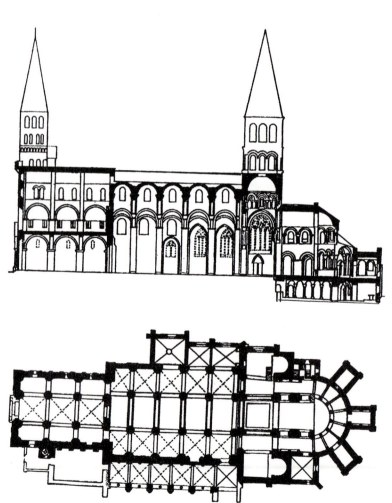

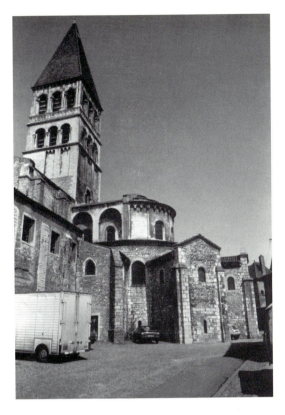

9.10 Tournus, Saint-Philibert, apse exterior, 950–1019. (R. G. Calkins.)

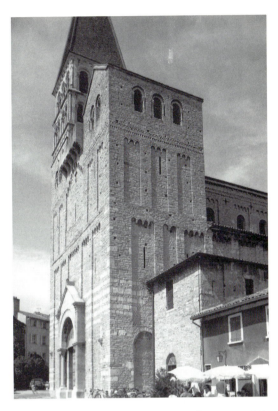

9.11 Tournus, Saint-Philibert, westwork exterior, 990–1019. (R. G. Calkins.)

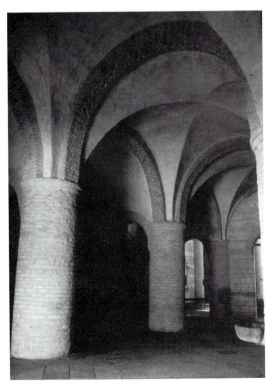

9.12 Tournus, Saint-Philibert, lower narthex interior, 990–1019. (R. G. Calkins.)

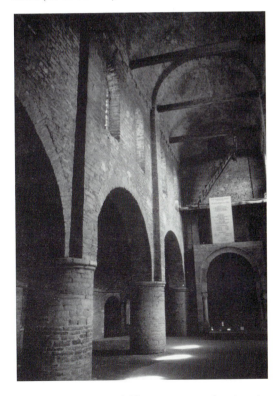

9.13 Tournus, Saint-Philibert, upper narthex interior, 990–1019. (R. G. Calkins.)

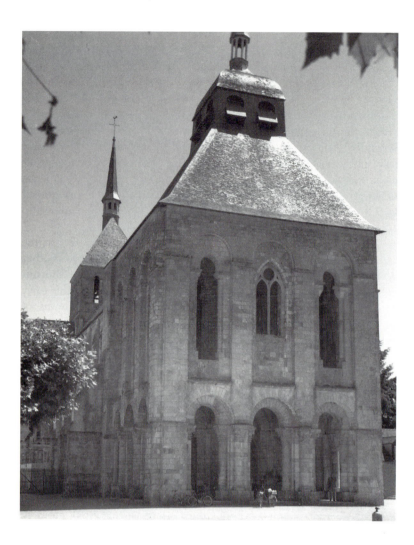

9.15 Saint-Benoît-sur-Loire, west tower, early eleventh century. (R. G. Calkins.)

a major pilgrimage site, for the reputed relics of St. Benedict of Nursia were brought there between 690 and 707 after Montecassino had been left in ruins by the Lombards in 585.

These buildings of the early Romanesque period thus developed a variety of effective structural systems: three parallel barrel vaults, barrel vaults abutted by quadrant vaults, barrel vaults reinforced by flanking groin vaults, and a succession of transverse barrel vaults. These eleventh- and early twelfth-century solutions to the problem of buttressing high nave vaults were combined to form a structural ensemble that became the standard for many mature Romanesque churches.

10

ROMANESQUE STYLES IN FRANCE

Although the mature Romanesque style flourished in the first half of the twelfth century, it was perfected during the last half of the previous century. Mature Romanesque evolved out of the solutions of early Romanesque buildings, combining a synthesis of vaulting techniques with the radial plan, attention to exterior silhouette, and a magnification of scale. These developments occurred in the churches of the large and prosperous monasteries such as Cluny and particularly those along the pilgrimage route to Santiago de Compostela in Spain. In these cases, the need to house many people and provide easy access to multiple altars determined the scale and the plan.

DEVELOPING ROMANESQUE IN BURGUNDY

Elements of this development can be traced in the evolution of the great monastic complex at Cluny that bridges tentative beginnings of ecclesiastical architecture in Burgundy (Cluny I) with a major example of the early Burgundian Romanesque style (Cluny II), and finally with the most developed example of the mature Romanesque, Cluny III, the largest building in western Europe until the construction of the new St. Peter's in Rome during the Renaissance. Duke William of Aquitaine founded the first church, Cluny I, in 910. Only fragmentary archaeological remains indicate what this building, built under Abbot Berno, was like, because it was demolished to make way for the later mammoth Cluny III. It may have been a small, three-aisled, timber-roofed building with a single apse. Because the structure soon became too small to house the expanding number of monks at the monastery, a larger building, Cluny II, was built to the south and Cluny I became its sacristy.

Cluny II had three aisles with a pronounced transept and two chapels in echelon flanking each side of the main apse (fig. 10.1). At the time of its dedication in 981, it had a timber roof, but after 1000 this was replaced with a stone barrel vault, and a three-bay narthex was added to the west front. A huge square tower with Lombard decoration dominated the crossing. The nearby small church of **Saint-Martin at Chapaize,** of about 1050, gives a fairly accurate impression of the exterior of Cluny II, where a similar massive square tower looms over the eastern end (figs. 10.2–10.3). Like Cluny II, stocky cylindrical piers with triangular capitals support the nave arcade: Cluny II used similar supports reminiscent of the tall piers at nearby Tournus. Chapaize also has a slightly pointed barrel vault of the twelfth century, flanked by aisles with a succession of groin vaults, perhaps reflecting the vaulting of Cluny III after 1090.

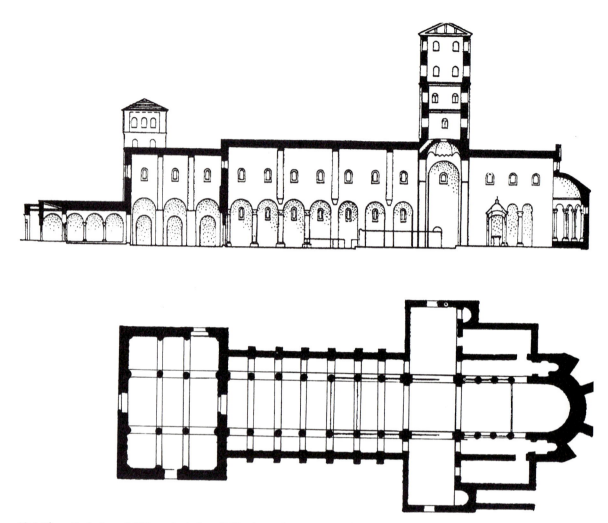

10.1 Cluny II, dedicated 981, vaulted after 1000: plan and reconstructed section. (After Kenneth J. Conant.)

As Gregorian chant had become a major element of the liturgy at Cluny, the barrel-vaulted nave of Cluny II may have been built partly to enhance the flowing and swelling effects of this monophonic music. So important did this chant become that symbolic representations of the various modes of plainchant adorned some of the carved capitals around the choir in the new church of Cluny III begun in 1088.

Saint-Étienne at Nevers manifests one of the earliest surviving examples of the fully developed structural system of the Romanesque style to be used at Cluny III and in the great pilgrimage churches (figs. 10.4–10.6). However, it was constructed between 1063 and 1097, begun well before Cluny III in 1088. Nevers abandoned the echelon arrangement of apsidal chapels. Instead it placed a semicircular chapel on the east flank of each transept and a radial plan with three semicircular chapels emanating off the ambulatory as at Saint-Martin at Tours by 997 (fig. 10.18; fig. 10.19, *left*). This radial plan became a major feature of most Romanesque churches, particularly those of the pilgrimage routes that needed many altars to display a variety of relics of saints. This arrangement provided for the easy flow of pilgrims around the ambulatory and ready

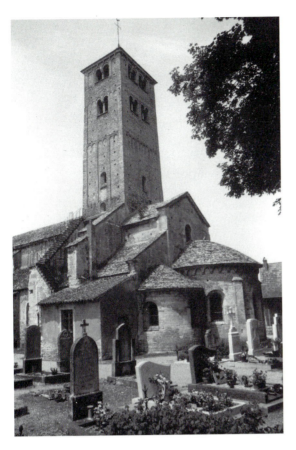

10.2 Chapaize, Saint-Martin, circa 1050 and twelfth century: apse exterior. (R. G. Calkins.)

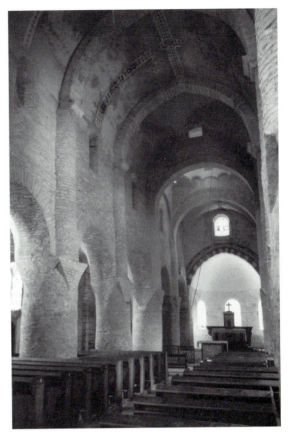

10.3 Chapaize, Saint-Martin, circa 1050 and twelfth century: nave interior. (R. G. Calkins.)

access to the chapels without disturbing the devotions of those attending services in the central apse, or praying in the other chapels.

The resulting exterior of cylindrical volumes grouped around the larger curved mass of the ambulatory became the prevalent Romanesque chevet throughout France and Spain. At Nevers (fig. 10.5), the cluster of cylindrical volumes build up to the gable of the sanctuary and, originally, to a huge octagonal crossing tower with four stories of open arcades. Nevers makes ample use of decorative motifs superimposed on the exterior mass of the building: richly carved moldings surround the windows, figurative corbels support the eaves, engaged columns articulate the exterior surfaces of the chapels, and arched and peaked blind arcades adorn the transept ends. A monumental two-story

blind arcade, like that at the Aula Palatina at Trier, runs along the exterior walls of the aisles and galleries. These decorative devices impart a richness of detail and a sense of solidity and strength to the exterior.

The interior of Nevers displays the fully evolved Romanesque structure (fig. 10.6). Thin elegant columns bound the curve of the sanctuary and support tall stilted arches dividing the groin-vaulted ambulatory from the main sanctuary, a pattern used later at Cluny III and other of its affiliated monastic churches. The nave is barrel vaulted, the aisles groin vaulted, and above them, a gallery with a quadrant vault abuts the upper nave wall. This structural system, a combination of vaulting techniques evolved in early Romanesque buildings, became widespread in many Romanesque pilgrimage churches. The three-

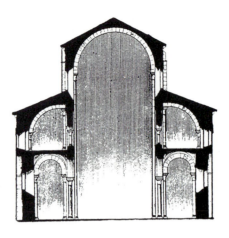

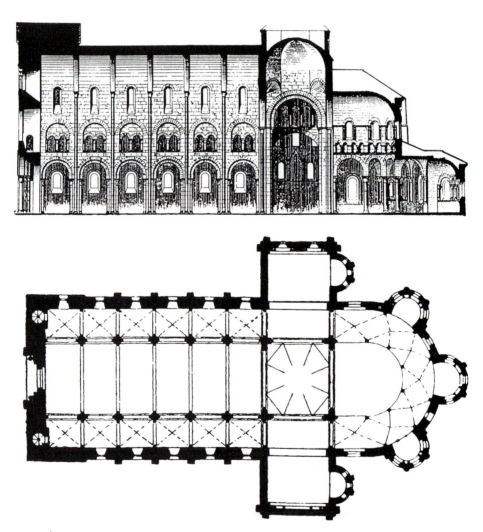

10.4 Nevers, Saint-Étienne, 1063–97: transverse and longitudinal sections, plan. (After Dehio and Bezold.)

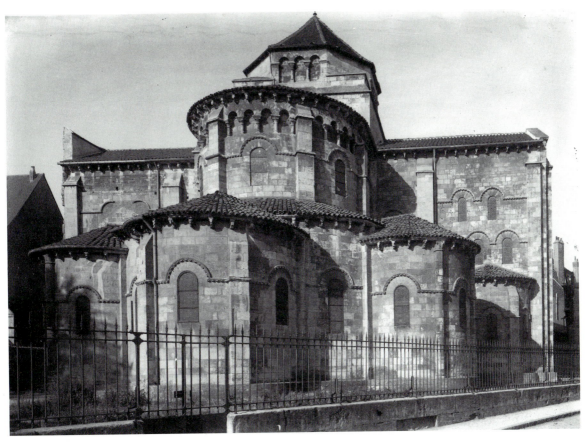

10.5 Nevers, Saint-Étienne, 1063–97: apse exterior. (Foto Marburg/Art Resource, N.Y.)

story elevation of Nevers is unusual, however, for like the upper westwork chapel of Tournus, narrow arched clerestory windows penetrate the thick nave wall just below the springing of the vault. Many other barrel-vaulted structures omit these windows, resulting in a two-story, dark interior. At the crossing, a domical vault rises above squinches. Curtain walls pierced with a triple arcade separate the crossing from the arms of the transepts, a feature that may originate from Saint-Germigny-des-Prés, but was also frequently used in Romanesque churches in the nearby Auvergne. Transverse arches under the barrel and quadrant vaults and between the groin vaults of the aisles divide the interior spaces into a succession of bays. Square compound piers with engaged half-cylindrical shafts support these arches. The square core of the pier relates to the wall surface, while the nave shafts rise uninterrupted to a capital at the springing of the transverse arch. Stepped-in archivolts of the nave arcade and an enclosing arch over

the gallery openings, layer the wall, and with the high quality ashlar masonry throughout, emphasize its thickness and solidity. Although not necessary for the structure of the building, these elements result in an effective tectonic statement of support and create a succession of spatial units in spite of the continuity of the barrel vault. This repetitive articulated bay system, evolving from tentative beginnings in the early eleventh century at Orléans and S. Vincente da Cardona (fig. 9.6) and refined in the Kaiserdom of Speyer II (fig. 7.17), reoccur in most mature Romanesque churches.

The grandest manifestation of the mature Romanesque style was the great abbey church of **Cluny III** (figs. 10.7–10.10). Its construction spanned forty-two years, not including later additions and renovations. Abbot Hugh (1049–1109) commenced building Cluny III on the site of the first church in 1088. The choir had probably been completed by the time of its dedication in 1095 by Pope

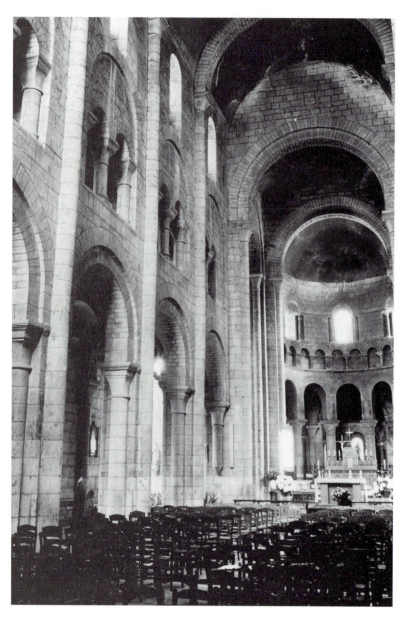

10.6 Nevers, Saint-Étienne, 1063–97: nave interior. (R. G. Calkins.)

Urban II, a former Cluniac prior on his way to preach the First Crusade at Clermont Ferrand. The great transept may have been completed by 1100 and the five-aisled nave vaulted by 1121 under Abbot Pons (1109–22). A collapse of the nave vaults in 1125 necessitated repairs, and the completion of the entire building did not occur until its dedication in 1130 by Pope Innocent II. To this huge complex was added a galilee, a virtual entrance church where the eastern bays were completed between 1135 and 1145 under Abbot Peter the Venerable (1122–56)

and the western bays completed between 1179 and 1190. The west towers completed the complex in the thirteenth and fifteenth centuries.

Unfortunately, Cluny III was secularized during the French Revolution and was dismantled for building materials during the early nineteenth century. Only the south arm of the major transept with its stair turret and tower, and a few fragments of transept chapels remain of the church. Of the other buildings, only the grange, now a lapidary museum containing sculptural fragments, remains. However,

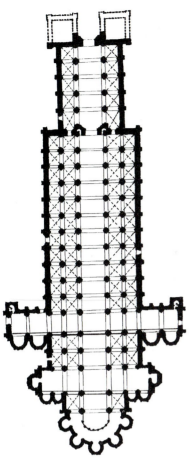

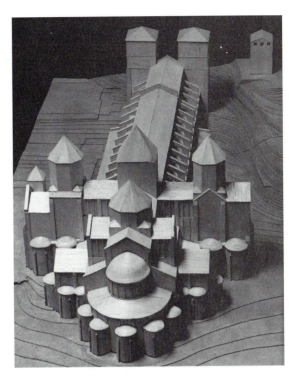

10.8 Cluny III, 1088–1190: model by H. Hilberry. (J. Combier.)

10.7 Cluny III, 1088–1190: plan. (After Kenneth J. Conant.)

the surviving remnants reveal that Cluny III exhibited major developments in the mature Romanesque style.

Cluny III possessed one of the most elaborate examples of the radial plan (figs. 10.7–10.8). The eastern end of the main church consisted of two transepts, each with chapels on their east flanks, two crossing towers, and an apse providing five radiating chapels around the ambulatory: the whole ensemble resulted in a total of fifteen chapels clustered around the east end. Although Cluny III was not a pilgrimage church, these chapels provided ample and necessary worshiping space at secondary altars for the private devotions of the large monastic community of monks that had grown from seventy in 1042, to two hundred in 1083, and to three hundred in 1109. The volumetric buildup of the exterior would have been overwhelming, leading up to the crossing tower over the east transept and then the higher crossing tower flanked by two others over the major transept, an elaborate variation of the massing of crossing towers ultimately derived from Carolingian and Ottonian sources.

Cluny III adopted an innovative vaulting system: a slightly pointed barrel vault covered the nave and transepts, reducing the effect of the lateral thrust. High inner aisles and lower outer ones with groin vaults buttressed the nave. The stepped-up aisles and barrel-vaulted nave repeated the formula used at Saint-Bénigne at Dijon. The nave vault may have been inspired by the small pointed barrel vault found in the central bay of the porch of Sant' Angelo in Formis near Capua, a building erected in the fourth quarter of the eleventh century by Desiderius, Abbot of Montecassino, whom Abbot Hugh visited in the 1180s (fig. 11.6). However, Muslim buildings had used pointed arches and pointed barrel vaults in the eighth and ninth centuries, and these devices at Cluny could have been derived ultimately from Islamic sources.[1] In addition to using the pointed barrel vault, the builders of

10.9 Cluny III, 1088–1190: reconstruction of nave interior. (Kenneth J. Conant: The Cluny Collection, Frances Loeb Library, Graduate School of Design, Harvard University.)

10.10 Cluny III, 1100–20: South transept interior. (R. G. Calkins.)

Cluny III corbelled the nave wall inward: the span of the nave at the base of its columns measured thirty-six feet, five inches, and at the springing of the vault, thirty-four feet, seven inches, a decrease of twenty-two inches resulting in a thickening of the nave wall at the springing on each side of almost a foot. After its collapse and reconstruction, this vault was further buttressed by raking buttresses above the inner aisle roof.

The nave interior had an elegant three-story elevation (figs. 10.9–10.10), consisting of decorative archivolts in the nave arcade, a blind arcade with openings leading into an attic gallery under the lean-to roof over the inner aisle, and then a clerestory under the springing of the vault. Channeled pilasters, decorated colonettes, and cusped archivolts added to the richness of the nave elevation. As at Nevers, compound piers, nave shafts, and transverse arches articulated a series of bays.

Vestiges of these elements survive in the remaining portion of the south transept. The ambulatory arcade, with tall stilted arches and decorative archivolts supported by eight exceedingly thin and elegant columns, resembled that at Nevers. These columns supported richly carved capitals depicting, among other subjects, the fall of man, the sacrifice of Abraham, and the eight modes of Gregorian plainchant. An apsidal fresco showing Christ in majesty surrounded by the four signs of the evangelists was probably similar to one still surviving in the tiny, nearby chapel built by Abbot Hugh at Berzé-la-Ville.

A miniature in the Chronicles of Cluny shows the monk Gunzo dreaming that Saints Stephen, Peter, and Paul appear before him and show him how to generate a proportional system to lay out the plan of the abbey (fig. 19.1). Perhaps the saints are demonstrating how to generate a rectangle based on the mathematical proportions of the golden mean

achieved by rotating the diagonal of a square. This system followed the precepts described in Vitruvius's *Ten Books of Architecture,* a copy of which was in the Cluny library. The dimensions of the building, in fact, approximate those proportions, achieved by whatever means, and reflect, therefore, the divine order and appropriately, the similar proportional musical harmonies of the universe. Transmitted by a vision, they provided the basis for the layout of a structure, that, with its multiple apses and towers, evoked the heavenly city of Jerusalem on earth. The monk Gunzo, assisted by Hézelon of Liège, translated this visionary schema and system of geometric proportions into practice. This system had been used elsewhere; for instance, the square as the basic module, and the proportional dimensions generated from it, provided the basis for the plan of St. Michael's at Hildesheim, and earlier, a grid system underlying the layout of the palace complex at Aachen and the monastic plan of St. Gall.

Since only a fragment of Cluny III remains, one must look elsewhere to find buildings that reflect

10.11 La Charité-sur-Loire, 1059–circa 1140: choir interior. (R. G. Calkins.)

10.12 Plans: *Left to Right,* La Charité-sur-Loire, 1059–circa 1140 (After Aubert); Paray-le-Monial, circa 1080–1130 (After Aubert); Vézelay, La Madeleine, 1120–36 (After Salet).

the interior of that structure. The priory church of **Sainte-Croix at La Charité-sur-Loire** (fig. 10.11; fig. 10.12, *left*) contains a similar decorative interior elevation. Originally built between 1059 and 1107 as the oldest affiliate of Cluny, Sainte-Croix was added onto and transformed after 1125 and dedicated in 1140. The eleventh-century building emulated the echelon plan of Cluny II: three increasingly long chapels projecting to the east of the transept flanked each side of the main sanctuary and apse. In the twelfth century, when La Charité-sur-Loire accommodated two hundred monks, an ambulatory and radial chapels were wrapped around the east end. An elegant ambulatory arcade, compound piers with nave shafts, pointed barrel vaults with transverse arches, channeled pilaster strips, and cusped arches around the openings of the attic gallery, all reflect Cluny III. Vestiges of this rich decoration also exist in the remnants of the destroyed nave, now integrated into domestic structures that occupy the area of the north aisle.

The small priory church of **Paray-le-Monial** in the Brionnais, built between about 1080 and 1130, also reveals the effect of Cluny III (fig. 10.12, *middle*; figs. 10.13–10.14). It is often called a "pocket Cluny III" because it repeats elements of the great monas-

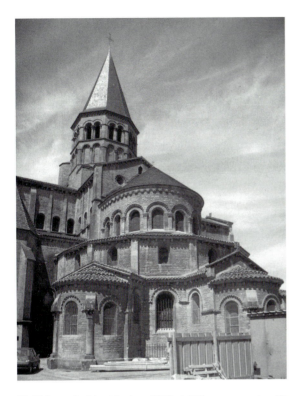

10.13 Paray-le-Monial, circa 1080–1130: apse exterior. (R. G. Calkins.)

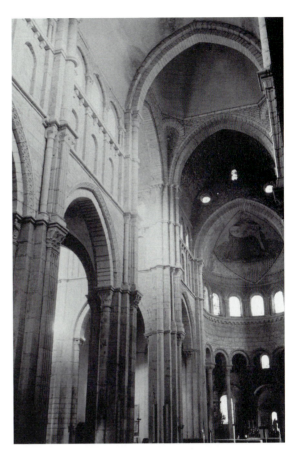

10.14 Paray-le-Monial, circa 1080–1130: nave interior. (R. G. Calkins.)

tic building on a diminutive scale. A small "église porche," with twin towered facade and upper chapel, of the late 1080s or early 1090s precedes the nave. The nave, dating from the 1120s or 1130s, is only three bays long and consists of a pointed barrel vault with transverse arches, and is flanked by groin-vaulted aisles. A triple blind arcade extends above the nave arcade, the middle arch of which opens into the lean-to roof over the aisles. Three clerestory windows in each bay penetrate the thick wall at the springing of the barrel vault. The elevation closely reflects that of Cluny III, particularly in the use of channeled pilaster strips and decorative moldings that provide a muted reflection of the richness of the larger church.

Saint-Lazare at Autun, built between about 1120 and 1146, exhibits a severe version of the Cluniac decoration (fig. 10.15). Originally Saint-Lazare had a triple apse that was changed in the

Gothic period. An open west porch contains an imposing tympanum over the portal of the last judgment signed by Gislebertus. The interior, with pointed barrel vault, transverse arches, and groin-vaulted aisles, replicates the basic structural system of Cluny III and Paray-le-Monial. The elevation also emulates that of Cluny, with a blind arcade and a single clerestory window in each bay beneath the vault. Like Paray-le-Monial, Saint-Lazare uses channeled pilaster strips for the nave shafts. These not only emphasize their verticality, but also intensify the severity of the interior. Similar elements on the upper story of the Roman Porte d'Arroux (fig. 10.16) of the third century still surviving at Autun, and on other nearby Roman remains, may have inspired these channeled pilasters at Autun and Paray-le-Monial, as well as along the gallery level of Cluny III.

In contrast with these barrel-vaulted buildings, the pilgrimage basilica of **La Madeleine at**

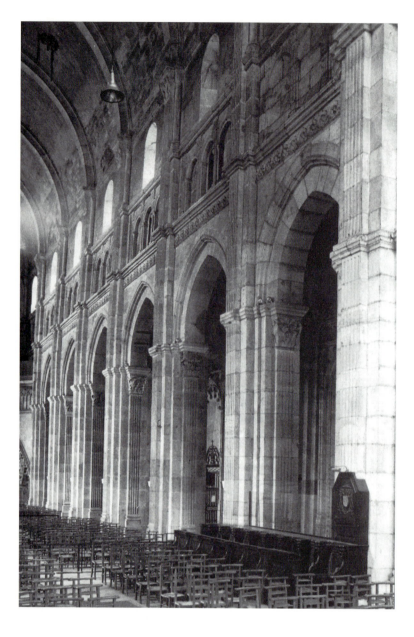

10.15 Autun, Saint-Lazare, circa 1120–46: nave elevation. (R. G. Calkins.)

Vézelay adopted a different structural system (fig. 10.12, *right*; fig. 10.17). Believed to contain a relic of Mary Magdalene, it became one of the major pilgrimage sites of Burgundy. Pope Urban II consecrated the present building, erected between 1120 and 1132. The long nave consists of a series of flattened, groin-vaulted bays separated by transverse arches, the next major space vaulted in such a manner after the Ottonian church of Speyer II (fig. 7.17). Originally, transverse wood tie beams tied the walls together; however, when they were removed, flying buttresses had to be added to bolster the inadequate external pier buttresses. The lower aisles also have groin vaults and wide arches, creating ample circulating room for pilgrims. The nave elevation consists of only two stories, the nave arcade and the clerestory with a window in each bay just beneath the longitudinal arches where the nave wall abuts the vault.

The addition of the three-bay narthex took place by 1150, enclosing the triple portal that over the center door contains a large tympanum depicting the Pentecost and the miracles and preaching of the

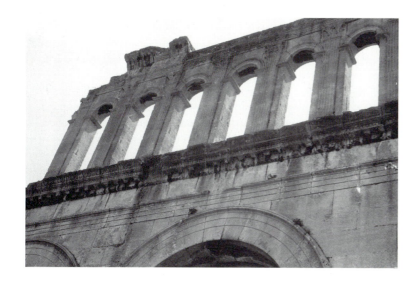

10.16 Autun, Porte d'Arroux, third century A.D. (R. G. Calkins.)

10.17 Vézelay, La Madeleine, 1120–40: nave interior. (R. G. Calkins.)

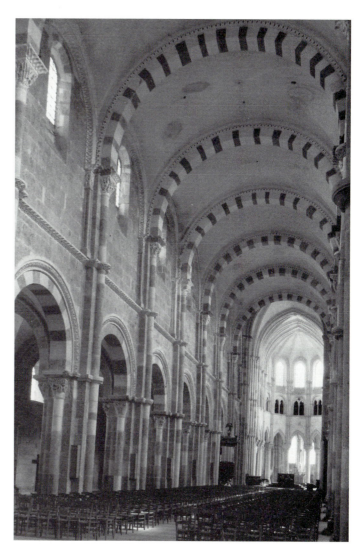

apostles, a missionary theme appropriate to the event in 1146 when St. Bernard of Clairvaux preached the Second Crusade at Vézelay. An early Gothic choir replaced the Romanesque one over a hall crypt that dates from 1096 to 1104. Although not intended from the beginning, the building now presents a remarkable sequence of illuminated spaces, from a relatively dark, low narthex area to a higher, lighter nave, to a soaring, shimmering Gothic choir in white limestone.

ROMANESQUE PILGRIMAGE CHURCHES

The veneration of the relics of saints became a major impetus for pilgrimages to such distant shrines as St. Michael at Monte Gargano in Italy, St. Peter's in Rome, Santiago de Compostela in Galicia in northwest Spain (the site of the tomb of St. James the Major), and, after the Crusades had made access to the Holy Land easier, the holy sites of Jerusalem and Bethlehem.

In western Europe, with the discovery of the relics of St. James the Major at Santiago de Compostella in 813, increasing numbers of pilgrims began to make their way across Europe to Spain. In France, several major routes developed: one led from Saint-Denis and Paris via Chartres; another from Vézelay in Burgundy, or from Le Puy in the Auvergne, via Conques, Cahors, and Moissac; another from Arles in Provence. These trails led to two passes over the Pyrenees, either the high Col de Somport or the low crossing further west at Roncevalles. All routes converged at Puenta la Reina in Spain where a single route went westward to Santiago via Burgos and León (an earlier route traversed the Christian Kingdom of Asturias to the north). Hostelries and small pilgrimage churches with their own relics sprang up along these routes, often about a day's walk or ride apart. A twelfth-century manuscript of the *Liber Sancti Jacobi,* a book of the life of St. James, included a guide to this route, a twelfth-century *Guide Michelin* describing churches, their relics, and conditions of the route.[2] Churches like La Madeleine at Vézelay and Saint-Nectaire in the Auvergne were situated on hilltops and visible for miles around—beacons in a landscape that attracted pilgrims to their own highly venerated relics. Moreover, the process of the pilgrimage—the arduous journey that could take a month or more to trav-el through France and across Spain to Santiago de Compostela on foot or horseback and the seeking out of relics on the way—became a significant act of contrition and devotion for pilgrims.

This heightened devotion to relics and their subsequent proliferation had a direct impact on the layout of the apses of Romanesque pilgrimage churches and a dramatic effect on their exterior volumes. The echelon plan of the crypt at Saint-Philibert-de-Grandlieu (fig. 6.16) provided several accessible chapels with altars in addition to the *confessio* with the relics of St. Philibert in the western niche. The final improvement of this plan produced the radial arrangement of chapels, not only in the crypt as at Clermont-Ferrand and Tournus, but also on the sanctuary and ambulatory level, of the Romanesque church of **Saint-Martin at Tours,** probably built about 997 and dedicated in 1014 (fig. 10.18; fig. 10.19, *left*). By the twelfth century Saint-Martin had an imposing effect with a volumetric buildup of radial chapels around the apse leading to a crossing tower and two flanking towers, balanced at the west end by two facade towers. Other, increasingly larger pilgrimage churches adopted and elaborated this plan (fig. 10.19).

Saint-Sernin of Toulouse best exemplifies the Romanesque Pilgrimage church (figs. 10.19–10.21): a huge five-aisled building, now crowned by a massive crossing tower, the upper stories of which were added in the Gothic period. Construction on Saint-Sernin began about 1060 and vaulting of the nave occurred about 1119. The building consists largely of brick with stone around apertures and reinforcing quoins at corners. It used the mature Romanesque structural system: a tall barrel-vaulted nave, quadrant-vaulted galleries, and groin-vaulted aisles similar to that of Saint-Étienne at Nevers (fig. 10.4). The lack of a clerestory level darkens the upper reach of the vault. Semicylindrical nave shafts rise uninterrupted to the springing of transverse arches dividing the vault into bays. A single arch encloses twin openings into the gallery. The diminutive **Sainte-Foy at Conques,** largely dating from about 1100 to 1130, follows the same system (fig. 10.22). Narrow, elegant proportions give this building a feeling of verticality that belie its small size. Curtain walls with semicircular arches, rather than the mere arc of a transverse arch under the vault surface, divide the quadrant vaults in the gallery into bays.

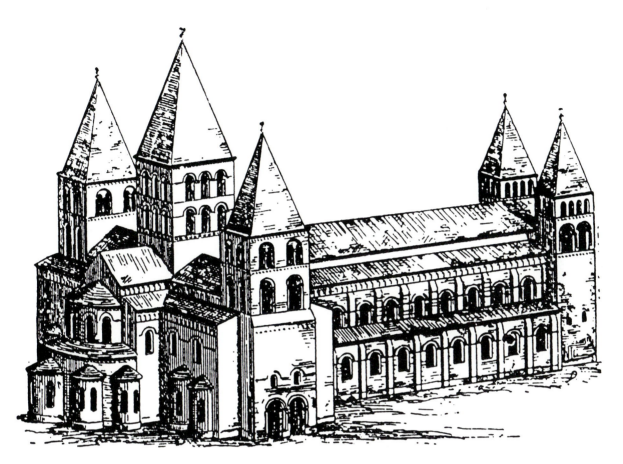

10.18 Tours, Saint-Martin, 997–1014: reconstruction of Romanesque church. (After Pevsner: *Yale University Press Pelican History of Art.*)

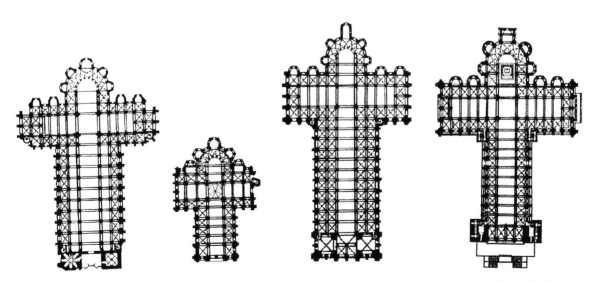

10.19 Pilgrimage route plans: *Left to right:* Saint-Martin, Tours, 997–1014; Sainte-Foy, Conques, circa 1050–1120; Saint-Sernin, Toulouse, 1060–1119; Santiago de Compostella, circa 1075–1115. (After Kenneth J. Conant.)

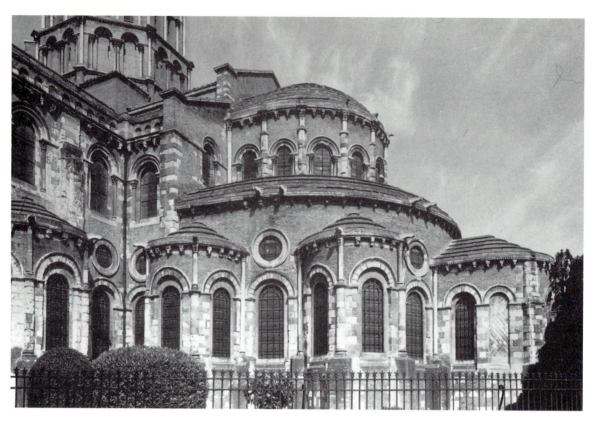

10.20 Saint-Sernin, Toulouse, 1060–1119: apse exterior. (R. G. Calkins.)

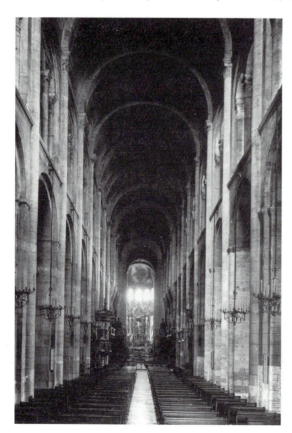

10.21 Saint-Sernin, Toulouse, 1060–1119: nave interior. (R. G. Calkins.)

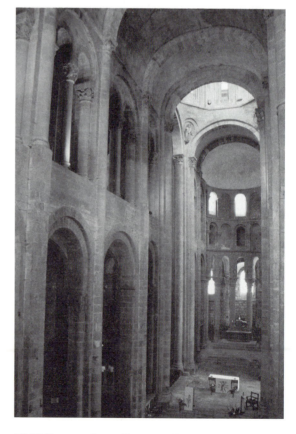

10.22 Conques, Sainte-Foy, circa 1050–1120: nave interior. (R. G. Calkins.)

The goal of the pilgrimage to Spain was **Santiago de Compostela** and its relics of St. James the Major. The large pilgrimage church of Santiago today has its Romanesque core obscured by later buildings and an elaborate Baroque frontispiece, the "Obradorio." Dating from 1666 and 1738, this facade is filled with multiple statues of St. James wearing the pilgrim's hat with upturned brim and cockleshell of Galicia and carrying a pilgrim's staff. The main body of the church dates from between 1075 and 1115 (figs. 10.19, 10.23), with a portal sculpture of 1168 to 1211 in the west porch. A three-aisled basilica, with the aisles continuing around the transepts, radial chapels, and standard structural system, it closely reflects the form of its French cousins.

Nevers, Cluny III, and the pilgrimage churches manifest relative uniformity of design and structure and they exemplified the mature Romanesque style in its most grandiose form. Nevertheless, many variations of the basic arrangement and structural system in smaller buildings abounded throughout western Europe, even within France and Italy. In France, different "pockets" of building styles exist in the Auvergne, Périgord, Provence, and Normandy (Normandy will be discussed in conjunction with Anglo-Norman developments in chapter 12). Even within Burgundy the newly founded Cistercian order developed a new austere style that soon transcended regional boundaries, but was itself subject to local variations. Some of the variations in Romanesque

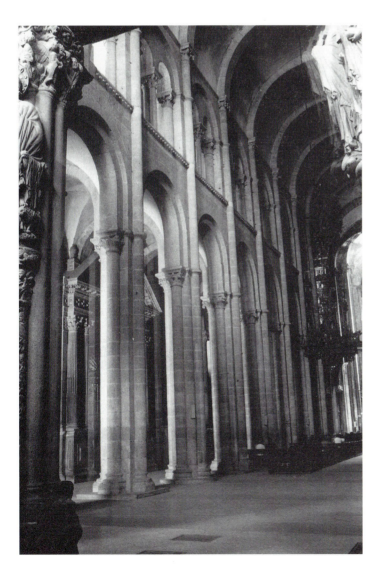

10.23 Santiago de Compostella, circa 1075–1115: nave elevation. (R. G. Calkins.)

were responses to the nature of the site, the quality of the available stone, the training of the masons, as well as factors of individual taste, local traditions, and external influences. Some of these distinctive regional schools of church architecture laid the foundations for the development of the Gothic.

THE AUVERGNE

In the Auvergne, a mountainous region in central France, a homogenous group of buildings introduced a distinctive variation of the mature Romanesque style. **Saint-Nectaire** (fig. 10.24; fig. 10.25, *top*), Notre-Dame-du-Port at Clermont-Ferrand (fig. 10.25, *bottom*; fig. 10.27), Sainte-Marie at Orcival, Saint-Austremoine at Issoire, and many others all exhibit several of these regional traits. The usual Auvergnat characteristics include the use of four radial chapels, without an axial chapel, as at Notre-Dame-du-Port (Saint-Nectaire, however, only has three), and a tall octagonal crossing tower

above an upraised shoulder transept. These shoulder transepts, as at Saint-Nectaire, may reflect the slanted roof form of the transepts at the Carolingian Saint-Riquier at Centula. Inside, the raised transept volume corresponds to the continuation of the aisles across the transept to the ambulatory, and encloses two raised barrel vaults abutting the dome set on squinches over the crossing and providing additional support for the tower. Orcival (about 1100, with further construction between 1150 and 1175), also uses barrel vaults, but at Notre-Dame-du-Port, quadrant vaults abut the domical vault over the crossing (fig. 10.26).

Auvergnat churches contain other references to Carolingian motifs, such as the curtain walls surrounding their crossings. Curtain walls penetrated by a triple arcade separate these spaces from the ends of the transepts and a similar curtain wall divides the nave from the crossing. These arcaded

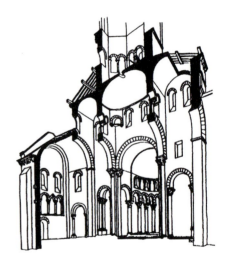

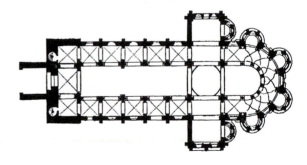

10.24 Saint-Nectaire, twelfth century: apse exterior. (© CNMHS.)

10.25 *Top:* Saint-Nectaire, twelfth century: crossing section. *Bottom:* Clermont-Ferrand, Notre-Dame-du-Port, twelfth century: plan. (After Aubert.)

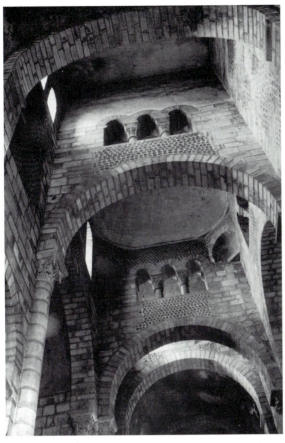

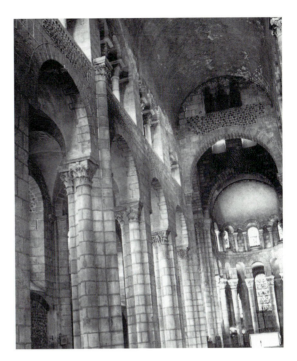

10.27 Clermont-Ferrand, Notre-Dame-du-Port, twelfth century: nave interior. (R. G. Calkins.)

10.26 Clermont-Ferrand, Notre-Dame-du-Port, twelfth century: crossing vaults. (R. G. Calkins.)

walls may refer to similar arcaded walls surrounding the crossing at Germigny-des-Prés (fig. 6.9), in turn possibly a garbled evocation of the gallery arcades at Aachen. Similar curtain walls also occur in the transepts of Saint-Étienne at Nevers, and in the crossing of Sainte-Marie at Orcival.

Another reference to a Carolingian motif occurs at the west end of the nave of Notre-Dame-du-Port, where a large arch opens onto an upper chapel: this may reflect the westwork gallery found in a more elaborate form at Centula, Corvey, and Aachen. A similar westwork with an open arched gallery exists at Conques, and a gallery with an Aachen-like arcade occurs at Saint-Nectaire and at Manglieu. Occasionally, as at Conques, such devices may refer to a moment of Carolingian patronage (purportedly Charlemagne bestowed a bejeweled metalwork reliquary upon Conques and twenty-three other abbeys as tokens of his favor). Whether true or not (the reli-

quary in the shape of the letter **A** is now considered to date from the end of the eleventh century),[3] the legend parallels the reuse of a variety of Carolingian architectural forms, which although they may have lost their original symbolic or referential context, nevertheless became standard features among this group of buildings.

The naves of Auvergnat churches have barrel vaults, as at Notre-Dame-du-Port, but without transverse arches or clerestory windows (fig. 10.27). Quadrant vaults of the gallery buttress these barrel vaults. At Notre-Dame-du-Port semicylindrical nave shafts appear only intermittently on the compound piers, and rise only to the gallery level. These shafts have an unclear purpose. One hypothesis states they were intended to support other curtain walls, further dividing the nave into pronounced compartments. At Orcival, nave shafts occur on alternate piers, but end at different heights, one pair ending at the sill of the gallery as at Clermont Ferrand, but another extending to the springing of the barrel vault, both without transverse arches, further confusing the issue.

Monumental blind arcades usually articulate the exteriors of these Auvergnat buildings, as at Nevers

and Saint-Nectaire. These arcades recall the aque-
duct-like treatment of the exterior of the Aula
Palatina at Trier, and the interior elevation of Speyer.
While their supporting piers thicken the wall at the
conjunction of interior bays, their effect is primari-
ly aesthetic: a Romanizing device emphasizing the
mass and solidity of the exterior of these
Romanesque buildings.

PÉRIGORD AND AQUITAINE

Southwest of the Auvergne, in Périgord and
Aquitaine, another group of buildings used a differ-
ent structural system: a series of domes on penden-
tives. An early example of this type, the former
cathedral of **Saint-Étienne-de-la-Cité** in
Périgueux (fig. 10.28, *middle*) originally consisted

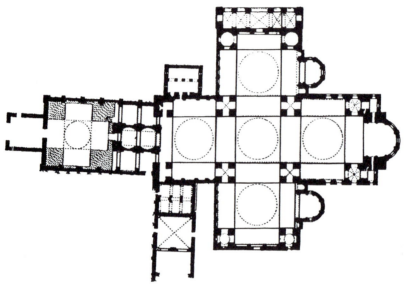

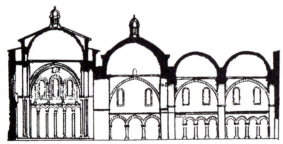

10.28 *Top to Bottom:* Périgueux, Saint-Front,
1047–circa 1130: plan; Périgueux, Saint-
Étienne-de-la-Cité, 1100–after 1150: sec-
tion; Angoulême, Saint-Pierre, 1105–28:
plan.

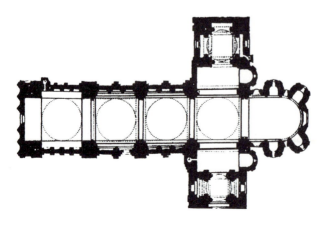

of two hemispherical domes on pendentives over square bays dating from about 1100, to which were added two successively higher domes after 1150. Only one eleventh-century dome on the west and a twelfth-century dome on the east have survived. Thus, four sequential domes arranged along the axis, without aisles or transepts, recalled the axial arrangement of such Byzantine domed basilicas as St. John at Ephesus and St. Irene in Constantinople, but without references to the elevation of Haghia Sophia. Blind arcades articulated the interior nave walls and massive Romanizing arcades punctuated the exterior.

Construction of another domed church at **Périgueux, Saint-Front** (fig. 10.28, *top*; fig. 10.29) began with a basilican plan about 1047. However, a Greek cross with five domes—a replica of the plan of San Marco—was added to the original

structure either at the end of the eleventh century or after a fire of 1120. The original west bays of the building, oriented with an apse to the west, contained the tomb of Saint-Front. They consisted of a single dome supported by four massive piers, preceded on the east by a curious set of two tall bays capped by small twin domes, now under a tall tower embellished in the nineteenth century by Paul Abadie (1812–84). When the equal armed domed cross structure was added, the previous church, now roofless, served as an entrance atrium and porch. The plan and structural principles are the similar to the Holy Apostles in Constantinople and the almost contemporary S. Marco in Venice (1063–94): five domes on pendentives separated by broad arches (or short barrel vaults), and supported by massive piers penetrated with cruciform passages on the ground level to provide aisles flanking the nave.

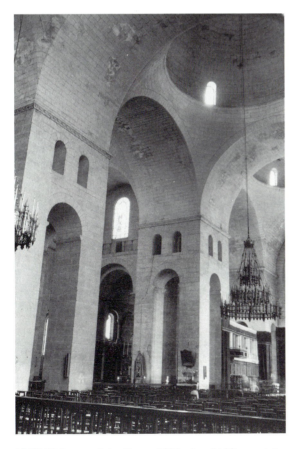

10.29 Périgueux, Saint-Front, 1047–circa 1130: nave interior. (R. G. Calkins.)

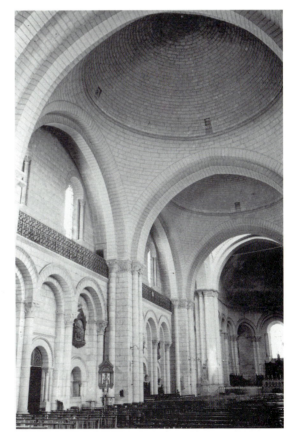

10.30 Angoulême, Saint-Pierre, 1105–28: nave interior. (R. G. Calkins.)

The severe interior, virtually rebuilt and harshly restored between 1852 and 1884, obliterated the irregularities of the original masonry and changed the original pointed transverse arches to round. This present interior may reflect S. Marco before it received most of its interior mosaic decoration. In any event, Saint-Front translates the Byzantine five-domed cruciform interior into the raw masonry aesthetic prevalent in much of the French Romanesque architecture. If the interior had once been polychromed, as is evident in some French Romanesque churches, no vestige remains. Thus, the five-domed cross of Byzantine churches had a pronounced effect on the builders in Périgord, although the reason for this influence beyond an increased awareness of this type occasioned by the Crusades has not been established. The elaborate exterior owes much of its effect to the addition of multiple cupolas and scalelike shingles on the domes added by Abadie during his restorations.[4]

The **Cathedral of Saint-Pierre at Angoulême** (figs. 10.28, 10.30), also in western France, but north of Périgueux, built between 1105 and 1128 (also restored by Abadie), placed four hemispherical domes on pendentives in a row above an aisleless nave. Each bay is defined by massive wall piers supporting the pendentives. This plan recalls that of Saint-Étienne-de-la-Cité. In addition, barrel vaults cover projecting arms of the transepts. Four chapels radiate directly off the curve of the apse, without an intermediate ambulatory around the semicircular choir. Other domed buildings in this region that repeat this model exist at Ste. Marie at Souillac, and the cathedral of Cahors, both of the early twelfth century.

Another feature of the Romanesque churches of the southwest was the development of the screen facade in which arcaded niches, often filled with sculpture, decorate the entire breadth of the building. As at **Notre-Dame-la-Grande at Poitiers** of

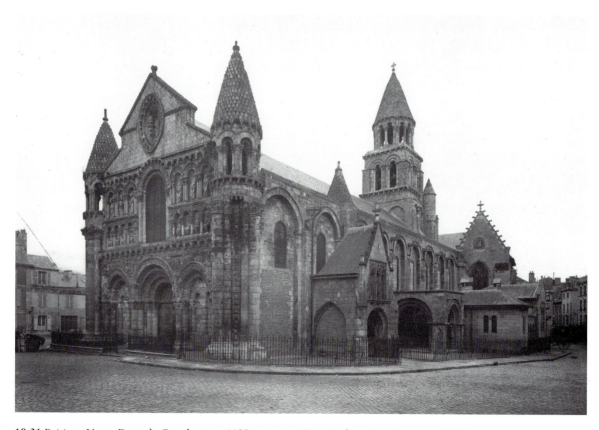

10.31 Poitiers, Notre-Dame-la-Grande, circa 1130: exterior. (Foto Marburg/Art Resource, N.Y.)

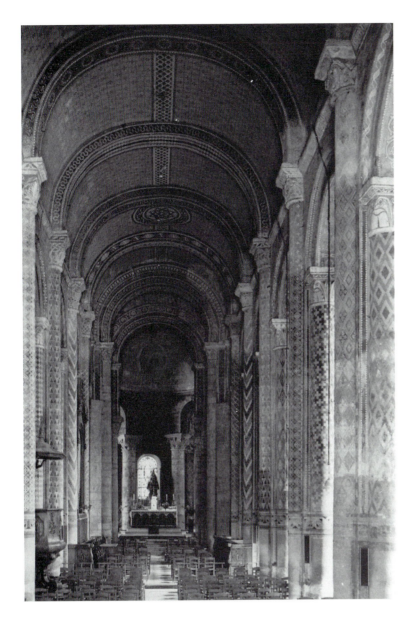

10.32 Poitiers, Notre-Dame-la-Grande, circa 1130: nave interior. (R. G. Calkins.)

about 1130 (fig. 10.31), these facades were often flanked at the corners by cylindrical turrets with open arcades and conical roofs. Angoulême has such a facade, now much restored. Because of the English connection with western France through the marriage of Henry II Plantagenet with Eleanor of Acquitaine, such screen facades may have inspired a similar development in English architecture.[5] The interior, barrel vaulted and dark (fig. 10.32), is heavily polychromed with decorative patterns. Although

heavily restored, such painted decoration occurred in many Romanesque churches.

The interior also manifests another predilection of southwestern builders: the use of tall cylindrical columns separating groin-vaulted aisles that are almost as high as the barrel-vaulted nave. A higher, lighter variant occurs at nearby Saint-Savin-sur-Gartempe.[6] The resulting effect approaches the interior spaciousness that reaches its ultimate resolution in the hall churches with three naves of equal height

found in the Gothic churches of Périgord (see chapter 13) and in Germany (see chapter 17).

CISTERCIAN REACTIONS

In Burgundy, a severe reaction against the wealth and ostentatious decoration and furnishing of the churches of the Cluniac order, led by the Cistercian reform, resulted in the perfection of a simple and austere building style. This new Cistercian order was named after a monastery at Cîteaux founded by Robert of Molesmes in 1098. St. Bernard of Clairvaux soon joined the Cistercians and founded Clairvaux in 1119. He proved a vociferous critic of Cluniac Romanesque, castigating the churches of that Order for "the vast height of [the] churches, their immoderate length, their superfluous breadth, the costly polishings, [and] the curious carvings which attract the worshiper's gaze and hinder his attention."

Consistent with the return to austerity advocated by this reform, many of the Cistercian monasteries of the twelfth century were founded in secluded valleys, usually with ample access to water, building materials, and resources that would make their inhabitants self sufficient. The structures had no crypts or tall towers (towers were formally forbidden in 1157), minimal sculptural decoration (elaborate sculpture was outlawed in 1124), and only glass in *grisaille* (white and various shades of gray) was permitted (a statute of 1182 decreed the removal of colored stained glass from previous structures).

Fontenay, founded in 1118 by St. Bernard, begun in 1130 by Bishop Everhard of Norwich, and consecrated in 1147 by Pope Eugene III, provides one of the best examples of a surviving Cistercian monastery (figs. 10.33–10.35). Fontenay occupies an idyllic vale, and has a well-built stone building that served as a forge, as iron ore existed on the land. A closely knit group of structures around the cloister to the south of the church consists of a chapter house, a rib-vaulted chamber said to be a scriptorium, and a dormitory above these rooms with access by a night stair to the south transept. The nave has a pointed barrel vault with transverse arches; the aisles consist of transverse pointed barrel vaults set on pointed arches between their bays. The Cistercians abandoned radial chapels—only a simple

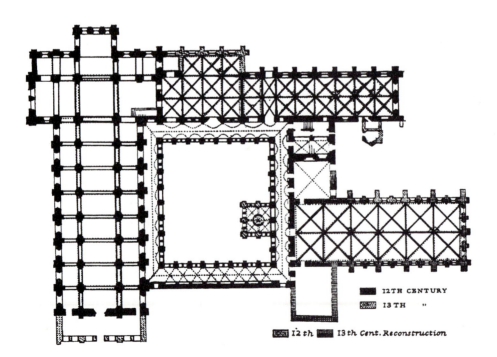

■ 12TH CENTURY
▨ 13TH "

▨ 12th ▨ 13th Cent. Reconstruction

10.33 Fontenay, circa 1130–47: monastery plan.

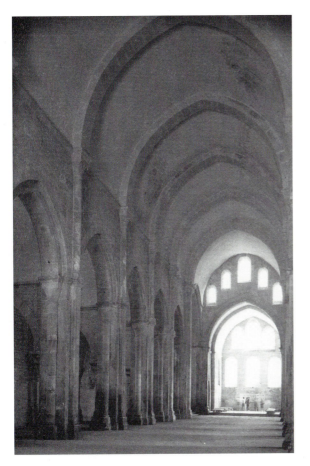

square chancel terminates the eastern end. As the nave has no clerestory, the only light enters from seven windows in the facade, six in the chancel, and some in the north transept. Very simple, geometric capitals adorn the shafts of the nave and the columns supporting the groin-vaulted passage of the cloister. The simplicity and austerity of this building style may have influenced the formulation of the Gothic style already evolving by the time of Fontenay's completion.

10.34 Fontenay, circa 1130–47: nave interior. (R. G. Calkins.)

10.35 Fontenay, circa 1130–47: church and cloister from dormitory. (R. G. Calkins.)

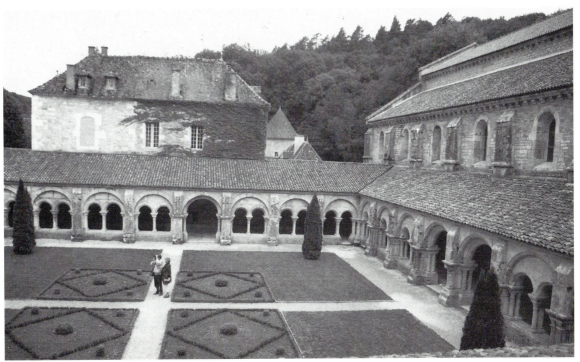

11

OTHER ROMANESQUE VARIATIONS: GERMANY AND ITALY

Regional manifestations of the Romanesque style were even more varied in Germany and Italy than in France, where local traditions usually prevailed. While German churches remained largely faithful to Ottonian prototypes, an extraordinary group of trefoil plan churches evolved in Cologne, and in Italy, pronounced regional differences resulted from varied foreign influences interacting with the traditional basilican tradition.

GERMANY

Buildings erected in the area of present-day Germany during the eleventh and twelfth centuries usually carried on the traditions established by the Ottonian buildings examined above (see chapter 7). In fact, they all can be called Ottonian, although they coincide with the development of the mature Romanesque structures of France and Spain. Such an example, the typical multitowered Benedictine Abbey church at **Maria Laach** (fig. 11.1), begun in 1093 and dedicated in 1153, demonstrates the continuity of the Ottonian form. Its exterior reflects the formula found at Hildesheim, with western apse, west and east transepts, and a cluster of three towers on each. As at Speyer, the west transept does not project beyond the confines of the ground plan; rather it asserts itself with its westworklike mass ris-

ing above the sloping roof over the aisles. As at Hildeshiem, the octagonal and round stair turrets occupy the ends of the west transept. A triple apse sanctuary rises above a groin-vaulted hall crypt supported on columns with cushion capitals. Its three-aisled plan was originally timber roofed; however, like Speyer II, Maria Laach later received groin vaults separated by transverse arches supported by nave shafts and pilaster strips in the twelfth century.

While Maria Laach represents the continuation of the Ottonian basilican tradition repeated in many German Romanesque structures, an innovative group of buildings in Cologne developed another configuration combining a bold massing of eastern towers with a trefoil plan. **St. Maria in Capitol** (figs. 11.2–11.3), built circa 1040 to 1069, uses on the east end a trefoil plan consisting of three ample semicircular apsidal spaces emanating off a crossing area—a re-evocation of the welling exedrae of San Lorenzo in Milan or the Treconch of Hadrian's Villa (figs. 2.17, 1.9). Groin-vaulted ambulatories continue around each curved lobe, separated from the main space by screening, space holding arcades that further dematerialize the structure. The crossing echoes this outward welling effect with a domical vault continuing the curve of the pendentives—a much larger version of the dome in the crossing tower of the mausoleum of Galla Placidia in Ravenna. Tacked onto

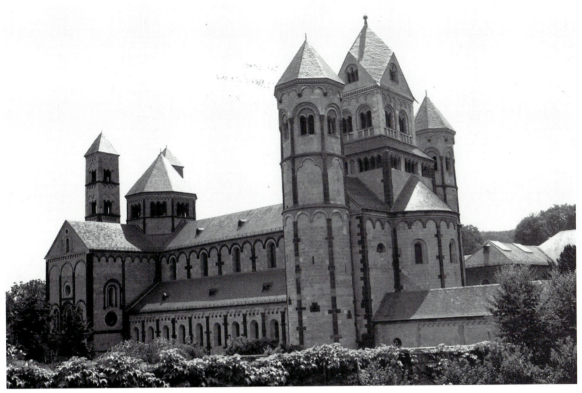

11.1 Maria Laach, begun 1093, dedicated 1156: exterior from the northwest. (R. G. Calkins.)

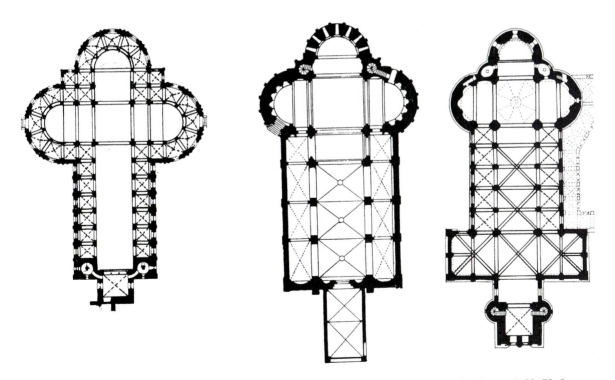

11.2 Cologne plans: *Left to Right,* St. Maria in Capitol, circa 1040–69 (After Rahtgens); Gross St. Martin, 1150–72; St. Aposteln, 1190–1219.

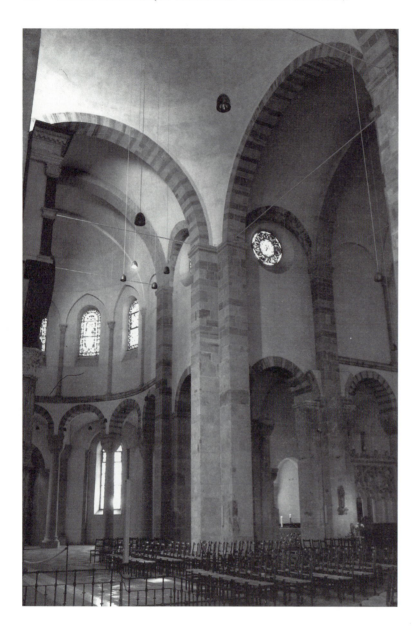

11.3 Cologne, St. Maria in Capitol, 1040–65: transept and choir interior. (R. G. Calkins.)

an originally timber-roofed nave flanked by groin-vaulted aisles (rebuilt with a sexpartite rib vault in 1219), this plan demonstrates yet another variation of the combined longitudinal and centralized config-urations used in the fifth and sixth centuries. It may reflect Justinian's revision of the Church of the Nativity as it was in the eleventh century. In keeping with its dedication to Mary as Mother of God, Christmas Eve Mass was performed in this space. Although the side apses replace transepts, a gabled transeptal block rises above them on the exterior.

Gross St. Martin in Cologne (1150–72; figs. 11.2, 11.4), with Gothic additions of 1230 to 1250, also uses the trefoil plan dating from about 1185. Originally intended to have a dome in the center of the treconch, the crossing now supports a tall square crossing tower with corner turrets. The resulting massive vertical volumes assert a powerful German equivalent of the magnificent buildup of volumes on the east end of Cluny III. Here again, the trefoil apse, an essentially centralized plan, combines with a short timber-roofed nave. Instead of the ambulato-

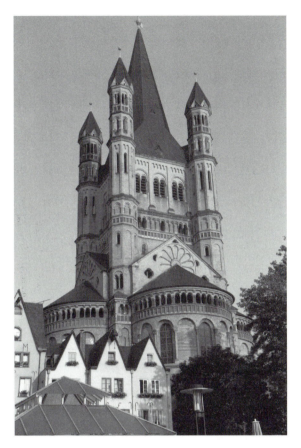

11.4 Cologne, Gross St. Martin, 1150–72: apse and crossing tower. (R. G. Calkins.)

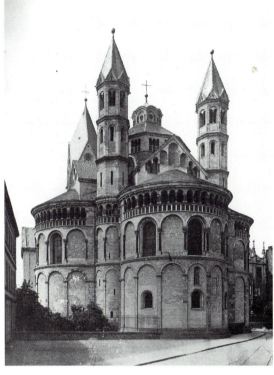

11.5 Cologne, St. Aposteln, 1190–1219: apse exterior. (Foto Marburg/Art Resource, N.Y.)

ry at St. Maria in Capitol, a distinctive narrow wall passage at the level of the clerestory windows follows around all three lobes and penetrates the crossing piers. Thin colonnettes supporting arcades define its interior surface and create a space-holding screen. This device elaborates the similar wall passages used in contemporary Norman churches: around the apse of La Trinité and in the clerestory level of Saint-Étienne at Caen, both by 1066. This wall passage, rebuilt in the thirteenth century, continues in the nave as a triforium.

St. Aposteln (fig. 11.5), also in Cologne, dating from 1190 and later, employs the same combination of elements: a basilica with a trefoil apse and interior dome over the crossing. A tall square entrance tower precedes the west transept and balances the east-end accumulation of curved volumes, octagonal turrets, and crossing tower. Tall stair turrets clustered next to the wide octagonal crossing tower, the undulating volumes of the trefoil, and the rich exterior arcading result in an exterior silhouette reflecting the tall drums and domes of Byzantine quincunx churches and create the effect of an exotic domed reliquary.

The continued use of the balanced clusters of multiple towers in German Romanesque architecture became a distinctive feature of later buildings built in this region, and led to the development of the multitowered transeptal blocks in such Romanesque churches in the lowlands as St. Trond and Tournai Cathedral (fig. 13.20). This tradition ultimately produced the remarkable clustered towers, often intended, sometimes built, of major French and German early Gothic cathedrals.

ITALY

Meanwhile in Italy, local and foreign traditions modified the persistent influence of the early Christian basilica, resulting in regional styles in the south, in

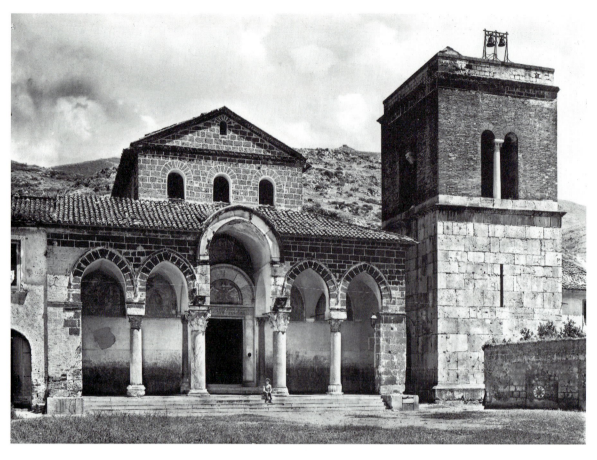

11.6 Capua, S. Angelo in Formis, 1058–75: porch. (Alinari/Art Resource, N.Y.)

Apulia and Sicily, and in the north, in Tuscany and Lombardy. For instance, the small church of S. Angelo in Formis (figs. 11.6–11.7) near Capua in the Benevento that Abbot Desiderius of Montecassino founded in 1058 and finished about 1075, is a simple three-aisle timber roofed basilica, with a half-dome over the apse. Frescoes cover the wall surface between the nave arcade and the clerestory windows, emulating the rich mosaics of the early Christian basilicas. This mural tradition persists in Italian architecture into the Gothic and Renaissance periods, and enables the vast fresco cycles by Trecento and Quattrocento artists.

The porch with pointed arches that precedes **S. Angelo in Formis** (fig. 11.6) introduced the pointed arch, perhaps for the first time in Western architecture. Groin vaults occur in its side bays but a slightly pointed barrel vault covers the higher central bay. Perhaps inspired by the pointed arch

appearing in Muslim architecture since the beginning of the eighth century, this device may have influenced the pointed arches and barrel vaults at Cluny III, as Abbot Hugh visited Montecassino in the 1080s.[1]

In southern Italy and Sicily, vestiges of the basilican tradition combined with other influences to result in a new architectural synthesis. The Byzantines had occupied most of southern Italy and Sicily since the invasion of Ravenna by Belisarius in 540. The small five-domed Katholicon at Stilo testifies to the Byzantine presence (fig. 4.7). However, with the backing of the pope, the Normans began a conquest of Apulia, a province of southern Italy, in 1017, and by 1071 they had expelled the Byzantines from the Italian peninsula.

The Normans imposed their vigorous architectural style on the buildings they constructed in this region. **S. Nicola at Bari** (fig. 11.8, *left*; figs.

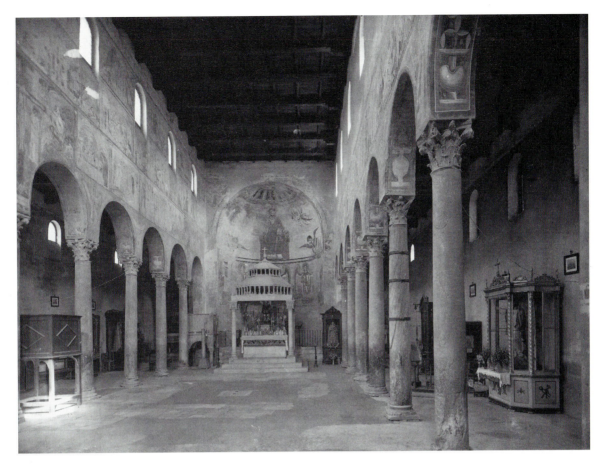

11.7 Capua, S. Angelo in Formis, 1058–75: nave interior. (Alinari/Art Resource, N.Y.)

11.9–11.10) begun in 1089, is the first major Norman-style building in Southern Italy—it was partially complete when Pope Urban II held the Council of Bari in 1098. S. Nicola was originally planned to have massive towers at each corner of its rectangular plan, but they never rose above the height of the nave. The result on the exterior is a massive volumetric block, enlivened by Lombard decoration and a pronounced division of the facade by pilaster strips into three sections corresponding to the aisles and the higher nave.

Inside, groin-vaulted aisles, with timber-roofed galleries above, flank a timber-roofed nave. The western part of the nave is divided into compartments by three diaphragm walls on arches supported by double columns. A triple arcade supports a similar curtain wall screening the entrance to the monk's choir in the sanctuary. These transverse walls extend only to just above the nave arcade; they have

no relevance to the elevation or the flat ceiling above. Although structural difficulties may have required these walls as braces, they may also be a variation of similar transverse curtain walls found at Jumièges in Normandy, begun in 1037. The sanctuary, really a projecting transept beneath the eastern towers, consists of three tall bays with three semicircular apses on the east side. Elements of the design of S. Nicola, particularly the decorative use of exterior dwarf galleries, blind arcading, and the tripartite division of the facade by pilaster strips, were also used at the Cathedrals at Bari (under construction in 1179), and of S. Valentino at Bitonto (begun about 1175).

Beginning in 1060 and continuing until 1090, the Normans invaded and conquered Sicily. The Norman presence resulted in a remarkable fusion of northern European, Byzantine, and Muslim characteristics in Sicilian architecture of the early twelfth century. The

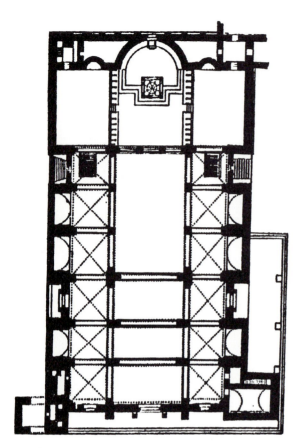
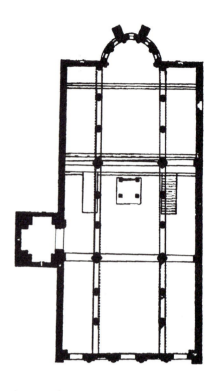

11.8 Plans: *Left*, Bari, S. Nicola, begun 1089 (After Clapham); *Right*, Florence, S. Miniato, 1013–70.

Capella Palatina in Palermo (fig. 11.11), completed about 1140 under Roger II (1129–43), constitutes a cross-cultural encyclopedia. It uses a three-aisled Latin cross plan, reused classical columns supporting the nave arcade, Byzantine mosaics on all available wall and vault surfaces, a Byzantine crossing dome set on three-layered squinches, and an Islamic honeycomb ceiling. The Byzantine influence was stronger in some buildings, supplanting the Islamic elements, as in La Martorana (S. Maria del Ammiraglio) in Palermo, built and decorated between 1143 and 1151 for Admiral George of Antioch, the chief naval officer under Roger II.[2] It was used for the Greek Orthodox rite, and therefore replicates a Byzantine single-domed plan complete with mosaics on the walls and in the cupola before its sanctuary. S. Cataldo, also in Palermo, presents a series of cupolas set on layered squinches in the

Byzantine manner. But since it never received mosaic decoration its interior remains a vigorous Norman variant by the assertion of raw masonry piers, walls, and pointed arches. It was originally built as a synagogue, but was transformed into a church in 1161. A similar building, S. Giovanni degli Eremiti, built in 1148 as a mosque, combined a succession of two Byzantine domes on layered squinches with Muslim pointed arches.[3]

The basilican plan served as the basis for the vast cathedral of **S. Maria Nuova at Monreale** (fig. 11.12–11.13), built between 1174 and 1182 under William II on a hill over looking Palermo. Massive twin towers flank the facade decorated with interlocking arches of ornamented terra-cotta derived from Islamic sources.[4] This decoration is used to create an even more elaborate design on the apse, reminiscent of Byzantine decorative masonry. Interlocking

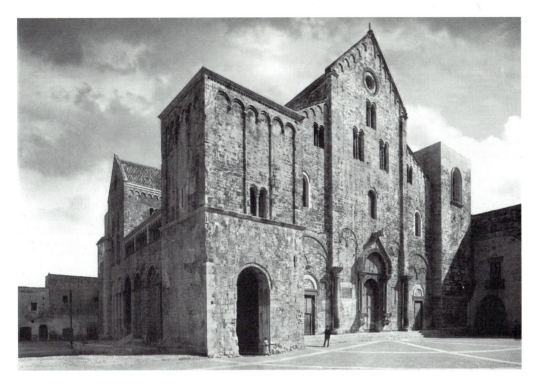

11.9 Bari, S. Nicola, begun 1089: exterior. (Alinari/Art Resource, N.Y.)

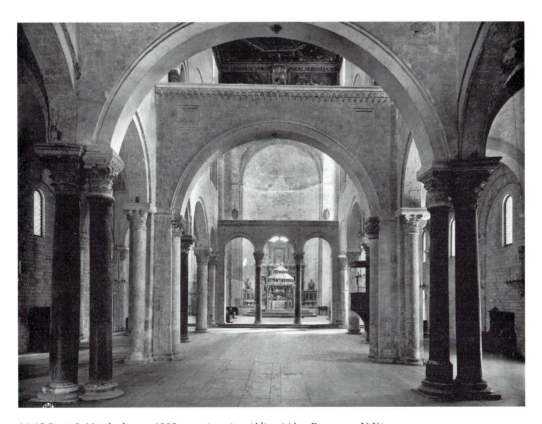

11.10 Bari, S. Nicola, begun 1089: nave interior. (Alinari/Art Resource, N.Y.)

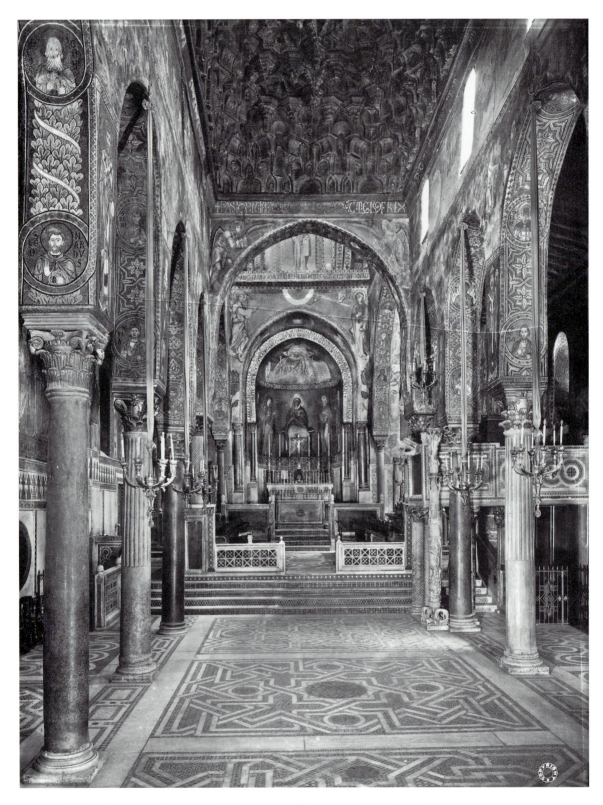

11.11 Palermo, Capella Palatina, 1129–40: nave interior. (Alinari/Art Resource, N.Y.)

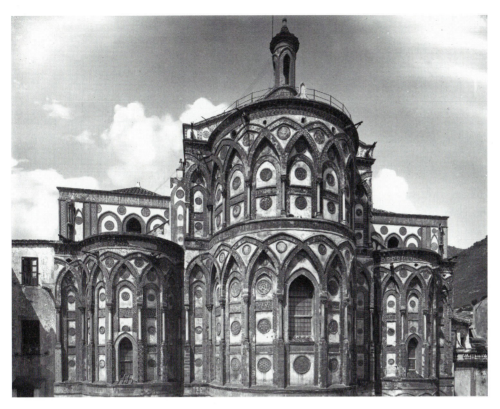

11.12 Monreale, S. Maria Nuova, 1174–82: apse exterior. (Alinari/Art Resource, N.Y.)

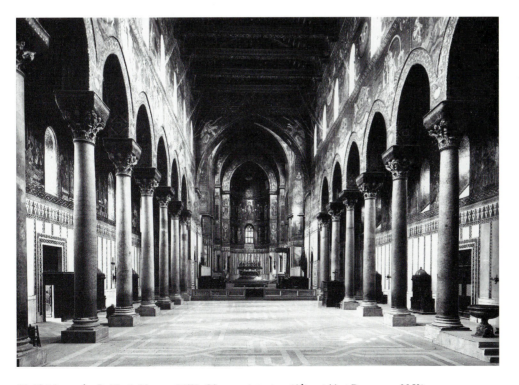

11.13 Monreale, S. Maria Nuova, 1174–82: nave interior. (Alinari/Art Resource, N.Y.)

blind arcades of this sort became a major decorative feature on the facades of Anglo-Norman buildings throughout the twelfth century. The wide three-aisled interior has a timber roof, the walls are decorated with extensive cycles of Byzantine mosaics, and in the ceiling of the sanctuary Islamic honeycomb motifs combine with elaborately carved and decorated timber beams. This fusion of Norman, Byzantine, and Islamic elements is a reflection of the enlightened tolerance and cultural assimilation that prevailed during the Norman rule of Sicily.

In Tuscany in northern Italy, the small monastic church of **S. Miniato al Monte** (figs. 11.8, 11.14–11.15) on a hill overlooking Florence, presents a variation of the three-aisled basilican format. The groin-vaulted crypt was begun in 1013, forcing a raised sanctuary area, while much of the nave was completed about 1070. The façade, constructed of brick, like the rest of the building, has marble veneer facing with greenish strips articulating decorative squares, rectangles, lozenges, and outlining arches and architraves. This decorative paneling emphasizes the planarity of the facade and sets up a subliminal

resonance of geometric proportions that is abstract and divorced from the muscular empathy and tectonic statement found in Romanesque architecture of northern Europe. The later decoration of the gable continues the same aesthetic principles, though with smaller decorative units. Such a geometric marble veneer became the basis of similar façades in the Renaissance, as at S. Maria Novella in Florence, designed by Alberti.

The three-aisled interior is timber-roofed and curtain walls, set on arches and responded to by compound piers, divide the nave into compartments. The compound piers alternate with marble columns taken from Roman monuments. The decoration of the interior surfaces resembles that of the facade, with white and dark green geometric forms painted in the nave, and marble veneer in the choir, denying any visual structural statement. Similar ornamentation covers the beams and trusses.

At Pisa construction of a cathedral in a vast ecclesiastical complex began in 1063 (fig. 11.16), the same year as S. Marco in the rival maritime city of Venice. The construction continued with a baptis-

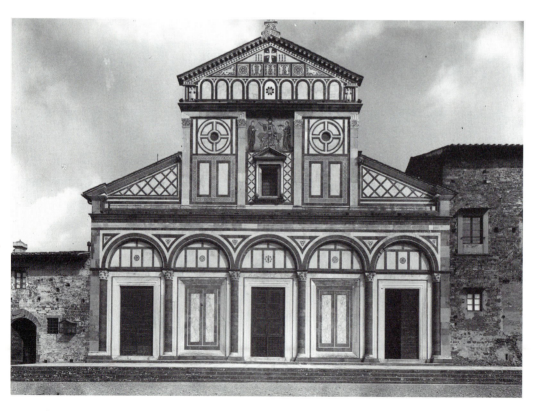

11.14 Florence, S. Miniato, circa 1070: facade. (Foto Marburg/Art Resource, N.Y.)

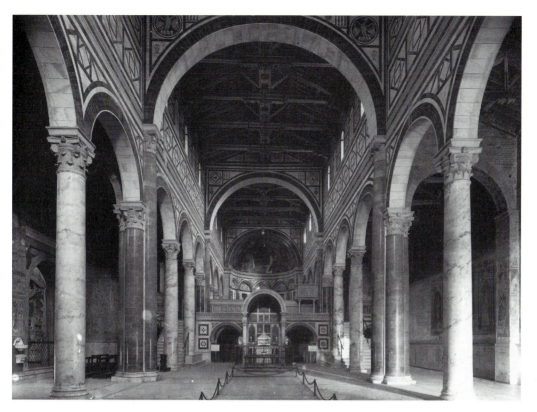

11.15 Florence, S. Miniato, 1013–circa 1070: nave interior. (Foto Marburg/Art Resource, N.Y.)

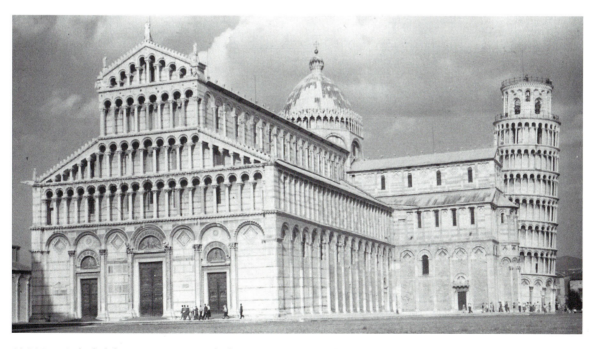

11.16 Pisa Cathedral, begun 1063; campanile, begun 1174. (R. G. Calkins.)

tery in 1153; a campanile, the "leaning tower," in 1174; and then in the Gothic period, an enclosed cemetery, the Campo Santo in 1278. The cathedral, designed by Busketos, is a huge five-aisled basilica intersected by two smaller basilican transepts surmounted by a cupola over the crossing—a Latin cross variant of the arrangement built at Qalat Siman at the end of the fifth century. Marble veneer covers the exterior in the Tuscan manner, with dark horizontal stripes and the facade, finished by Rainaldus in the twelfth century, uses geometric patterns and raking galleries of stepped-up space-

holding arcades that became characteristic of Pisan and nearby Luccan architecture. This patterned treatment of the exterior almost obscures the relief of the blind arcades and multilayered recessed lozenges under the arches that articulate the lower surfaces of the nave exterior. Although of later dates, the other buildings of the complex continue and vary this decorative system.

Inside the cathedral, groin vaults cover the aisles of staggered heights, but a timber roof spans the nave (fig. 11.17). Nave and aisle walls and piers all have horizontal stripes that emphasize the horizon-

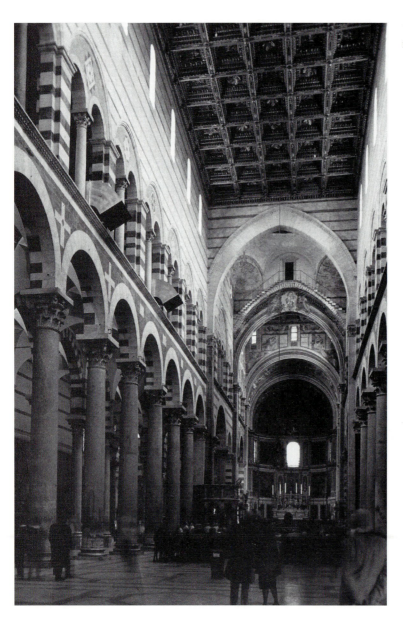

11.17 Pisa Cathedral, begun 1063: nave interior. (R. G. Calkins.)

tality of the interior spaces. A lean-to timber roof covers the gallery.

The campanile, begun in 1174 on weak foundations, soon began leaning. Although construction halted for a while, Geraldo continued in 1271 and it was completed in 1350, its 179-foot height thirteen feet out of plumb. Its exterior latticework of arcaded galleries reflect the openwork design of the facade of the cathedral. As a detached belfry it follows the well-established Italian tradition of such towers, found at S. Apollinare Nuovo and S. Apollinare in Classis at Ravenna, and at Pomposa.

The baptistery, designed by Diotisalvi in 1153 (figs. 11.18–11.19), and eventually finished with Gothic arcades in the upper portion in 1265, exemplifies another Italian tradition of placing centralized baptisteries in front of cathedrals—an arrangement also found in Florence and Parma. The Pisan example has a double-shell structure, perhaps evocative of the Anastasius dome at the church of the Holy

Sepulcher in Jerusalem. Originally a truncated cone with an oculus topped the central core, around which a domical shell was wrapped in the Gothic period. The exterior, with its blind arcading and marble veneer, harmonizes with the other buildings in the complex. In the interior, alternating columns and piers define the ambulatory and massive, horizontally striped piers support the gallery arcade.

In contrast to the prevalence of timber roofing over the naves found in many Italian Romanesque churches, **S. Ambrogio in Milan** (fig. 11.20) introduced a new vaulting system. This building now consists of a composite of variously dated parts: an apse with deeply recessed arches as at S. Pietro at Agliate, perhaps dating from about 859; a south facade tower of the tenth century; a barrel-vaulted sanctuary of the eleventh century; and a vaulted nave of perhaps about 1128 to 1140. A long narrow atrium precedes a facade with three deep arched recesses and square towers of uneven height, the left one

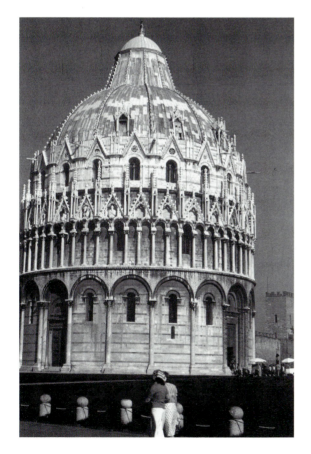

11.18 Pisa, Baptistery, 1153–1265: exterior. (R. G. Calkins.)

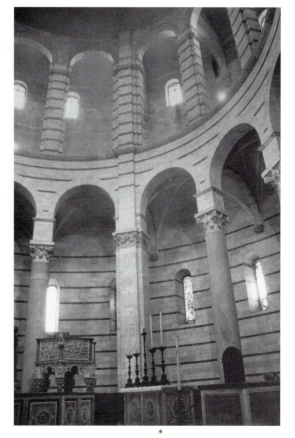

11.19 Pisa, Baptistery, 1153–1265: interior. (R. G. Calkins.)

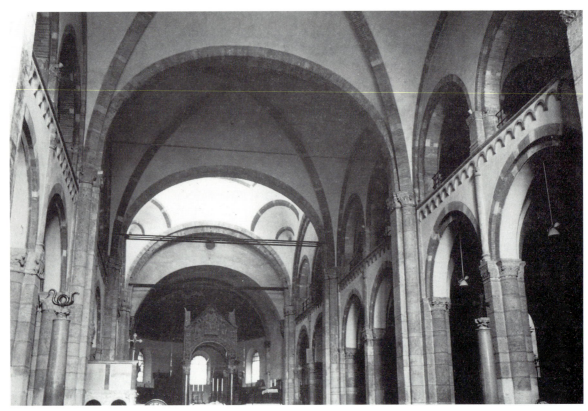

11.20 Milan, S. Ambrogio, circa 1128–40: nave interior. (R. G. Calkins.)

with decorative Lombard arcading, flank the build-ing. An octagonal tower dominates the apse; within it rests a cupola set on squinches over the bay of the nave that precedes the barrel-vaulted sanctuary.

The nave uses domical groin vaults reinforced with ribs over square bays (fig. 11.20). Thick ribs, square in section and forming a semicircle, arch diagonally from one corner of the square bay to the other. To accommodate this system, alternating supports, sim-ple columns between the two nave arcades in each bay, and compound piers supporting the low trans-verse arch between bays, provide a rhythmic articula-tion the length of the nave. Groin-vaulted aisles cor-respond to the nave arcade, and groin-vaulted gal-leries with two arcades opening into each bay buttress the lateral forces generated by the domical nave vaults. Transverse arches between the gallery vaults receive the aggregate of the diagonal forces generated by the groins and diagonal ribs—an early interior buttressing system. For all of the innovative effect of the diagonal ribs that visually tie together and unify each bay, these are probably not the first large-scale rib vaults, as they seem to have been used first over

the choir of Durham Cathedral just before 1100.[5] Similar domical rib vaults may have appeared at S. Sigismondo at Rivolta d'Adda about 1120. Never-theless, the appearance of rib vaults in both England and Italy herald the beginning of a new structural sys-tem that was to become prevalent in the early twelfth century. Other northern Italian churches had their timber roofs replaced later by similar vaulting, as at the cathedrals of Parma in the twelfth century and of Modena, in the fifteenth. Usually, however, the basil-ican tradition remained dominant throughout the Italian peninsula, well into the Renaissance period.

Elements of these various Romanesque building styles influenced further developments in the Gothic. The domed churches of southwest France provided the basis for the domical vaults of Angevin early Gothic, and the decorative polychromy of Florentine and Pisan buildings persisted in Italian early Gothic buildings. Perhaps most influential, the Cistercians' proclivity for paring down the building to its structural essentials and the resultant austerity and clarity of design carried over into the aesthetics of the developing Gothic style in the Île-de-France.

12

ANGLO-SAXON, NORMAN, AND ANGLO-NORMAN ROMANESQUE

The architecture of the British Isles during the Romanesque period encompasses developments in three styles that combine to form a mature but distinctive variation of the Romanesque style. Anglo-Saxon architecture before the Norman conquest of England in 1066 drew heavily on indigenous northern European traditions. Norman Romanesque in France, considered here for its relevance to Anglo-Norman developments, had produced a vigorous style before the conquest, and was imported to England. Thus, after the invasion, monumental buildings incorporating features of the mature Norman Romanesque and some from the tradition of Cluny II rose throughout England and developed distinctive Anglo-Norman features: large longitudinal buildings, frequently with double transepts; rich decorative arcading; and sometimes intense vertical linearity. These developments culminated in the first large-span rib vaults, erected at Durham Cathedral around 1100.

ANGLO-SAXON ENGLAND

Very little architecture from Anglo-Saxon England between the decline of the Roman presence there at the end of the fifth century and the Norman invasion of 1066 remains. The building materials and construction techniques used in this period for domestic buildings—timber, post and lintel structures with lean-to pole roofs often covered with thatch—made them subject to easy destruction. Archaeological vestiges indicate that the palace complex at Yeavering consisted of such buildings (see chapter 5). Undoubtedly, some early churches were built in this timber post and lintel method.

The desire to build more permanent ecclesiastical structures resulted in a few small stone churches built of fieldstone and reused Roman materials. Surviving examples consist of small buildings with stone walls, timber roofs, and compartmentalized interiors dating from the seventh and eight centuries. For example, the church at **Escomb** in Northumbria (fig. 12.1), dating from the late seventh or early eighth century, consists of rough courses of field stone covered with a timber roof. The tall, narrow, single-aisled nave has a small chancel arch giving access to small chancel on the east end. The entire structure measures only 43½ feet long by 14½ feet wide. Similar structures were erected at Bradwell in the mid-seventh century, and at Jarrow, about 700.

In comparison, **All Souls at Brixworth** (fig. 12.2, *left*; fig. 12.3) in Mercia of the mid- to late eighth century, is considerably larger and more monumental: the entire length measures 160 feet; the nave measures sixty by 30 feet. All Souls is the earliest surviving large-scale building in England. Originally it consisted either of a single nave with compartmentalized side chapels or of a three-aisled

12.1 Escomb, late seventh or early eighth century: exterior. (R. G. Calkins.)

12.2 Plans: *Left,* Brixworth, All Souls, mid- to late eighth century; *Right,* Bradford-on-Avon, St. Lawrence, circa 975.

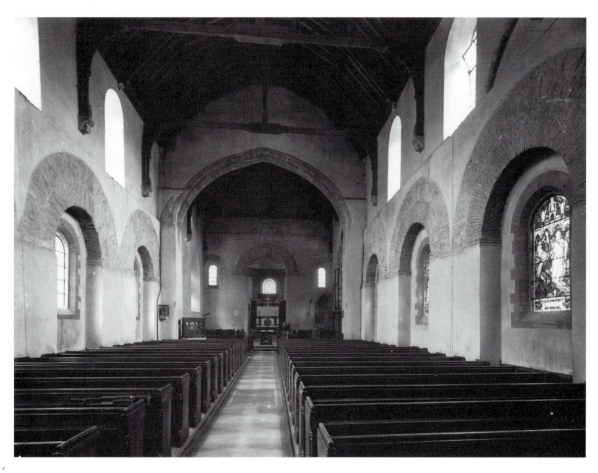

12.3 Brixworth, All Souls, mid- to late eighth century: nave interior. (RCHME © Crown copyright.)

basilican space. (The archaeological evidence, however, is unclear: massive rectangular piers supporting arches of reused Roman bricks set in radial courses virtually turned the aisles into lateral compartments. But the side compartments have been destroyed and the arches filled with walls and windows.) A triple arcade separated the presbytery from the nave, and a chancel arch leads to a small semicircular apse beyond. A subterranean ambulatory once wrapped around the apse. An entry porch may have had an upper story used as a "state pew" in the tenth or eleventh century; a tower over the west porch and flanking cylindrical stair turrets were added later.

One of the best preserved of the early Anglo-Saxon structures is the church of **St. Lawrence at Bradford-on-Avon** (fig. 12.2, *right*; fig. 12.4),

one of the few surviving Anglo-Saxon buildings of this era built of ashlar masonry. Dating from about 975 but laid out on an eighth-century cruciform plan, it consists of a group of high compartments tacked onto a taller nave, one serving as a sanctuary beyond a chancel arch, and two lateral compartments forming an entry porch and transept. The tall proportions of the nave continue the same vertical effect found at Escomb. Decorative blind arcades adorn the exterior, perhaps a reference to similar motifs on surviving Roman buildings in the area.

The west tower of the church at **Earl's Barton** (fig. 12.5) reveals a variety of late Anglo-Saxon masonry techniques. Dating from about 1000, the tower, adorned by thin vertical shafts, is divided into four stories by horizontal string courses. Odd arched and gabled motifs, even gables on gables

12.4 Bradford-on-Avon, St. Lawrence, circa 975: exterior. (RCHME © Crown copyright.)

12.5 Earl's Barton, circa 1000: tower. (RCHME © Crown copyright.)

occur, and some gables support colonnettes without reason; these elements rarely correspond to the shafts above the horizontal sills. Barrel-shaped columns support arcades on the first and fourth stories. These details might translate into stone motifs found in half-timber constructions and recall the surface details of the Carolingian Torhalle at Lorsch in the Rhine Valley. Another curious device is the use of carefully cut vertical and horizontal stones, or quoins, at the corners of the tower, commonly referred to as "long and short work," which stabilizes the rough rubble masonry of the wall surfaces at the corners.

NORMAN ROMANESQUE

In Normandy before the Norman conquest of England, a regional school developed that profoundly affected not only subsequent English architecture but also the development of the Gothic style. The abbey church of **Notre-Dame at Jumièges** (fig. 12.6, *left*; fig. 12.8), built between 1150 and 1067,

combines a vertical twin-towered westwork like that of Ottonian churches with a distinctive nave, originally with alternating supports, arched curtain walls, and a timber truss roof.[1] Of the ruined church, only the westwork, walls of the nave, and west walls of the transept survive; the roof, high crossing tower, and single apse with ambulatory have all been destroyed.

The projecting porch and flanking twin facade towers, a westwork configuration borrowed from earlier Carolingian and Ottonian sources, in Norman architecture developed into a characteristic two-tower facade with a strong vertical emphasis. Within the westwork, an upper chapel surmounted a groin-vaulted entrance bay similar to the arrangement in Auvernant churches of west galleries overlooking the nave.

Although timber-roofed, Jumièges contained various devices that articulated its wall surfaces. The timber roof, perhaps with open truss work, required no such articulation; nevertheless, nave shafts and pilaster strips rose from compound piers, alternating with cylindrical columns as intermediate sup-

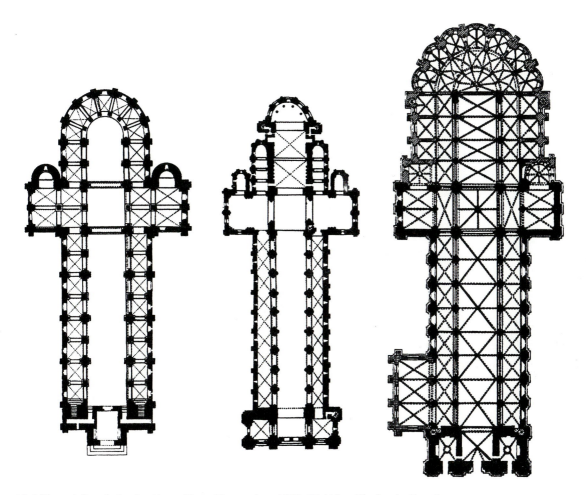

12.6 Plans, *Left to Right:* Jumièges, Notre-Dame, circa 1050–67 (After Clapham); Caen La Trinité, 1063–66; Caen, St. Étienne, 1064–77 (After Lambert).

ports. These shafts supported a series of curtain walls that sprang from the sill of the clerestory level and divided the nave into double-bay compartments in the same manner as at S. Miniato al Monte in Florence and S. Nicola at Bari. At Jumièges, vestiges of these curtain walls still appear above the shafts on the nave walls. In addition, triple arches under a recessed tympanum, embraced by an enclosing arch in each bay, penetrated the wall and opened into groin-vaulted galleries above groin-vaulted aisles. The engaged shafts and pilaster strips dividing the wall into bays further enhanced the verticality of the narrowly proportioned nave. A tall crossing space that rose uninterrupted into the lantern tower intensified this verticality, creating a perpendicular space analogous to the crossings at Centula.

Caen, the capital of eleventh-century Normandy, possesses two of the most important Norman churches. The first of these, **La Trinité,** or Abbaye aux Dames, was founded in 1063 by Queen Mathilda, wife of William the Conqueror and received a preliminary dedication in 1066 (fig. 12.6, *center;* figs. 12.9, 12.11–12.12). A six-part rib vault replaced the original timber roof, perhaps between about 1130 and 1135, which in turn was supplanted by a replica in a complete renovation of the church after the vaults collapsed in the nineteenth century.

The west front (fig. 12.9), with the addition of seventeenth-century arcading and nineteenth-century restorations on the twin towers, may still manifest characteristic elements of the developing

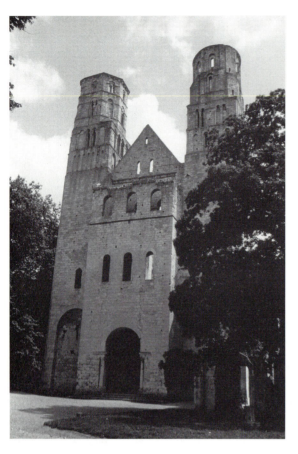

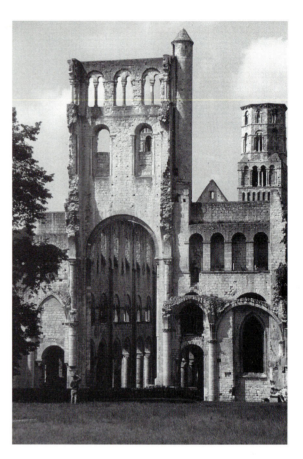

12.7 Jumièges, Notre-Dame, circa 1050–67: facade. (R. G. Calkins.)

12.8 Jumièges, Notre-Dame, circa 1050–67: nave and crossing. (R. G. Calkins.)

Norman facade. In contrast to the projecting porch and westwork formulation at Jumièges, La Trinité shows strongly articulated pier buttresses that emphatically provide visual supports for the tall towers above and demarcate a three-part division corresponding to aisles and nave with a triple portal leading into each interior space. The stepped-in layering of the surfaces from the projecting pier buttresses to the recesses of the splayed portals result in a vigorous facade in considerable sculptural relief. Perhaps the towers were originally even taller, repeating the Norman preference for verticality found at Jumièges, but now alleviated by rows of arched windows, blind arcading, and subtle horizontal string courses. Behind this facade, a raised open gallery level above the entrance bay, a remnant of the westwork gallery as at Jumièges, originally opened through a large arch into the nave.

The chevet consists of staggered chapels in echelon off the east side of the transepts flanking the choir and main apse, a plan consistent with the Benedictine abbey of Cluny II before the radial plan of Cluny III in 1089. Beneath the apse lies a small but elegant groin-vaulted hall crypt on slender columns surrounded by an ambulatory. However, the choir introduces two innovations. The first of these are the two groin vaults from 1063 to 1066 covering the sanctuary (fig. 12.11), separated by a transverse arch, perhaps just predating the larger groin vaults built in the nave of Speyer II after 1087. The second innovation is the use of wall passages along two stories of windows that punctuate the curved wall of the apse. In front of the windows run narrow colonnaded passages that effectively dematerialize the wall. These passageways continue as wall passages along the length of the choir, penetrating the wall between the clerestory windows. Conant suggested that the double colonnades around the central core of the rotunda at Saint-Bénigne de Dijon may have inspired this space-holding screen. This device was

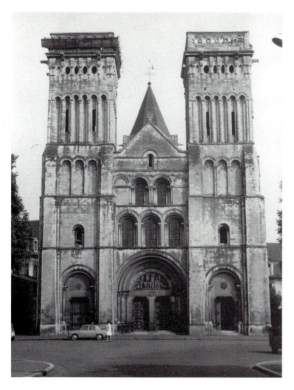

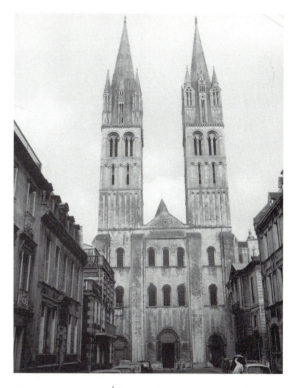

12.9 Caen, La Trinité, 1063–66: facade. (R. G. Calkins.)

12.10 Caen, Saint-Étienne, 1064–77: facade. (R. G.

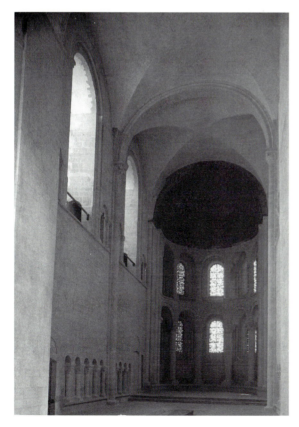

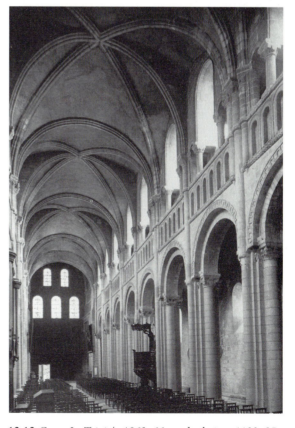

12.11 Caen, La Trinité, 1063–66: choir interior. (R. G. Calkins.)

12.12 Caen, La Trinité, 1063–66; vaulted circa 1130–35: nave interior looking west. (R. G. Calkins.)

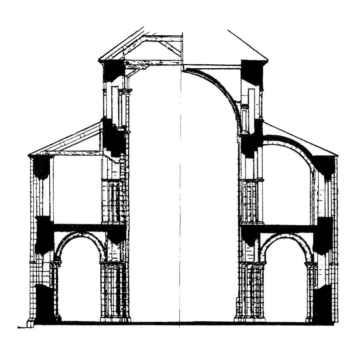

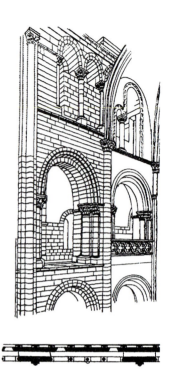

12.13 Caen, Saint-Étienne, 1064–77: *Left:* section before and after vaulting of circa 1130–35 (after Dehio and Bezold); *Right:* reconstuction of nave wall elevation before and after vaulting (after Lambert); *Below,* thick wall diagram.

also used in the twelfth-century trefoil churches of Cologne, particularly at St. Maria in Capitol and St. Aposteln. Similar screening arcades before wall passages also exist in the two upper stories of the apse at Cerisy-la-Forêt of about 1090, effectively dissolving the curved wall surface.

The nave of La Trinité (fig. 12.12), originally timber-roofed, has a well-defined three-story elevation: broad nave arcades, a band of blind arcades above, and then a clerestory with a wall passage as in the choir. The blind arcade enlivens what otherwise would have been a blank wall in front of the timber-roofed attic above the aisles. The aisles, groin vaulted without transverse arches defining individual bays, appear as tunnel vaults with side penetrations. Shafts rising from the compound piers divide the nave into vertical bays, but this vigorous wall articulation simply supported a timber roof.

At **Saint-Étienne** (fig. 12.6, *right*; figs. 12.10, 12.13–12.15), or the Abbaye aux Hommes, founded by William the Conqueror in 1064 and dedicated in 1077, the Normans amplified the design of La Trinité. This church also had an apse with an echelon plan, but the present Norman Gothic choir replaced

it after 1202. Pier buttresses boldly divide the dramatic, towering west facade into three parts, as at La Trinité (fig. 12.9). The facade appears more planar than its counterpart at La Trinité, an effect further emphasized by the seeming breadth and flatness of the pier buttresses. Nevertheless, their double-layered relief, particularly when seen obliquely, form convincing supports for the tall towers, now capped by Norman Gothic aedicules. Multiple colonnettes and blind arcades in the upper stories of the towers continue the developing Norman tradition of vertical linear accents. Slight horizontal string courses and two rows of windows—six over the central portal and two over each side doorway—alleviate the otherwise overwhelming verticality.

Continuing previous traditions, the original timber-roofed nave was flanked by aisles with groin vaults surmounted by a gallery with a lean-to roof (figs. 12.13–12.14). Nevertheless, the nave elevation developed a remarkable openness for a Romanesque church. A spacious nave arcade, equally wide gallery arches, and above, a quartet of clerestory arches before a wall passage in each bay, effectively eroded the interior wall surface. The

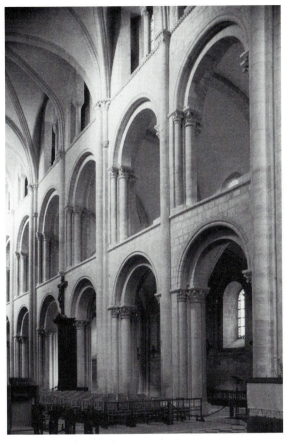

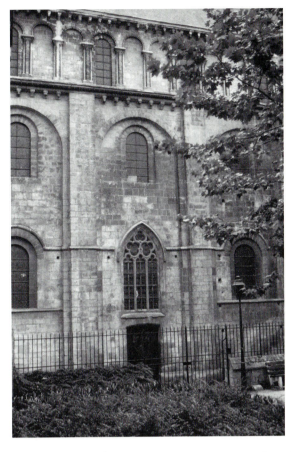

12.14 Caen, Saint-Étienne, 1064–77, vaulted circa 1130–35: interior nave elevation. (R. G. Calkins.)

12.15 Caen, Saint-Étienne, 1064–77: exterior nave elevation. (R. G. Calkins.)

exterior of the clerestory level beneath the eaves corbel table still reveals the original sequence of arcading with a clerestory window in each bay (fig. 12.15). Below, monumental, aqueduct-like blind arcades on the exterior enclose aisle and gallery windows, repeating this device found on many Romanesque buildings.

The clerestory wall passage originally formed a space holding screen under the timber roof, resulting in a device that Jean Bony called the "thick wall."[2] Four arches voided the inner wall surface of each bay while the outer surface remained intact except for windows situated behind the end arches. Where the clerestory passage tunneled through to the next bay, the wall effectively thickened to form a virtual pier buttress within its fabric, invisible from either side. This arrangement has led to the speculation that these internal piers were intended to receive the thrusts of groin vaults even though the building orig-

inally bore a timber roof: the nave of Cerisy-la-Forêt of about 1090, which still has its timber roofing, probably gives a good indication of the original nave at Saint-Étienne, complete with nave shafts and clerestory wall passages. In both cases, the articulation of a bay system and the "thick wall" are irrelevant to support the timber roof above, but at Saint-Étienne these elements precociously anticipate the future vaulting system. In any event, when groin vaults replaced the timber roof between about 1130 and 1135, the interior arcading of the clerestory had to be altered to adapt to the descending ribs. The gallery was quadrant vaulted with transverse arches, and the thickening of the clerestory wall only partly corresponded to the springing of the ribs of the new sexpartite vaults. When the rib vaults were installed, they required an alternation of supports to correspond to the convergence of two diagonal ribs and a transverse arch on major supports, and only a trans-

verse rib on intermediate ones. An extra pilaster shaft was therefore placed behind the major nave shafts that in turn supported small colonettes responding to the diagonal ribs.

ANGLO-NORMAN ROMANESQUE

When William the Conqueror invaded England in 1066 he brought with him numerous Norman prelates whom he appointed to the important espicopal sees, such as Abbot Lanfranc of Saint-Étienne at Caen who became archbishop of Canterbury in 1070. Many of these imported bishops immediately set about replacing Saxon churches with monumental edifices. One of the earliest constructions was the massive rebuilding of Canterbury Cathedral by Lanfranc between 1067 and 1093 (fig. 15.1, *left*). The three-aisled plan with massive square piers along the nave had a transept with four staggered chapels in echelon flanking the apse—a reflection of the plans of Cluny II and La Trinité at Caen. When Anselm added to it after 1093, he created a second transept and three rectangular chapels arranged around the ambulatory of the extended choir in a

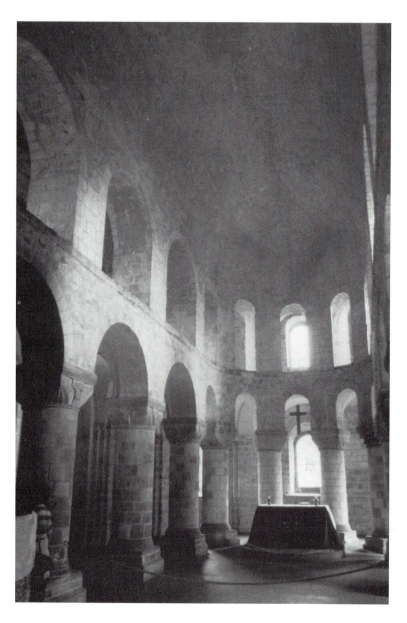

12.16 London, Tower of London, Chapel of St. John, 1070s: interior. (R. G. Calkins.)

vague reference to the new system of radial chapels of Cluny III.

Nevertheless, the first of these buildings after the conquest showed few Norman characteristics. Another early structure, the White Tower in London, begun in the 1070s, was a square keep now forming the central core of the Tower of London. The **Chapel of St. John** (fig. 12.16) within this complex has thick cylindrical piers that separate a heavy barrel-vaulted nave from groin-vaulted aisles. Above, a quadrant-vaulted gallery, demarcated by a heavy horizontal sill, has arches separated by massive square piers and continues around the hemicycle of the apse. These piers blend uninterrupted into the curve of the vault: the interior is devoid of the vertical linearity of Norman buildings.

With the imposition of Norman bishops and the reformulation of the episcopal sees, a veritable building boom began in England. At **St. Alban's,** Abbot Paul of Caen began a new cathedral in 1077

(fig. 12.17, *left*; fig. 12.19). Construction of the nave and crossing lantern occurred between 1080 and 1090, and the structure was consecrated in 1115. It employed the echelon plan popular among the Normans, with six staggered and separated chapels emanating from the transept flanking the main apse. St. Alban's was distinctive for its great length: the nave extended ten bays with a choir of four bays. To this were added additional nave bays and an early Gothic facade in the thirteenth century. The original structure consists of field stone, flint, and reused Roman brick. The handsome square crossing tower in this material of about 1150 is articulated on the outside with blind arcades and on the interior with arcades, wall passages, and windows. The nave elevation consists of massive square compound piers supporting a multilayered nave arcade with flat pilaster strips that rise to the timber roof. Heavy gallery arches open into the attic under the lean-to roof over the aisles. In the transepts vestiges of

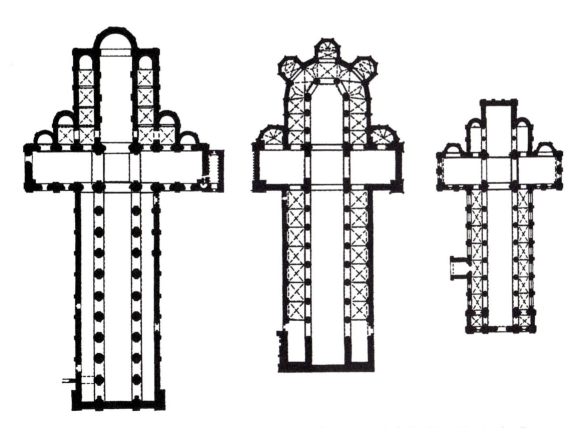

12.17 Plans, *Left to Right:* St. Alban's Cathedral, 1077–1115; Gloucester Cathedral, 1089–1121; Southwell Minster, circa 1150.

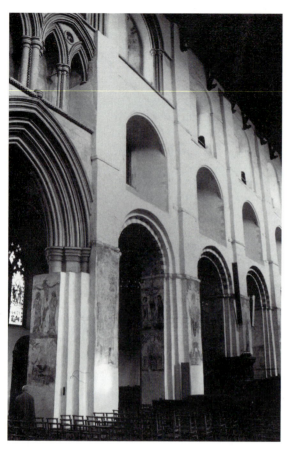

12.18 St. Alban's Cathedral, 1077–1115: nave. (R. G. Calkins.)

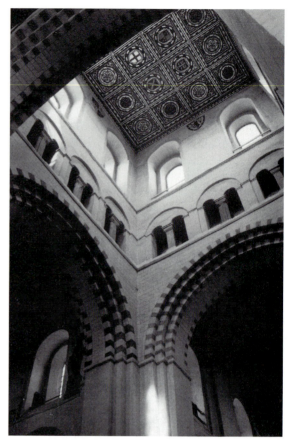

12.19 St. Alban's Cathedral, circa 1150: crossing. (R. G. Calkins.)

Saxon work remain: barrel-shaped columns support arcades with helter-skelter brickwork in a tympanum under an enclosing arch. The massive, mural quality of the nave had little in common with churches in Normandy, but its inordinate length became a dominant feature of future Anglo-Norman buildings.

Winchester Cathedral, begun under Bishop Walkelin in 1079, however, introduced typical Norman characteristics. The building is now a conglomerate of later English styles: the only surviving Norman Romanesque portions are the north and south transepts, which probably date from 1080 to 1090 (fig. 12.20). The elevation consisted of an arcade before groin-vaulted aisles, a gallery level of about the same height, and a clerestory with a "thick wall" passage below a timber roof. An open gallery across the ends of the transepts connects the east and

west timber-roofed galleries. Nave shafts divide the wall surface into bays, introducing vertical accents as in Normandy. The layered archivolts of the bottom arcade and pronounced enclosing arches over twin arcades on the gallery level emphasize the thickness of the wall, giving it the effect of strength and solidity characteristic of the Norman Romanesque.

The original Anglo-Norman cathedral at Gloucester incorporated different architectural characteristics from the Continent. Begun under Abbot Serlo in 1089, it may have been largely completed by the time of the consecration of the nave in 1121. The cathedral consisted of a long three-aisled nave, projecting eastern transepts, and introduced an atypical choir with three radiating chapels off an ambulatory above a hall crypt (fig. 12.17, *center;* fig. 12.22). This shift to a radial plan for the apse may be an intentionel reflection of the choir of Cluny III,

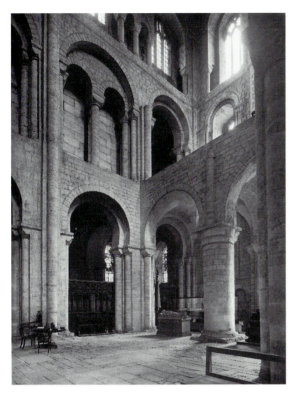

12.20 Winchester Cathedral, 1079–1090: interior of North transept. (RCHME © Crown copyright.)

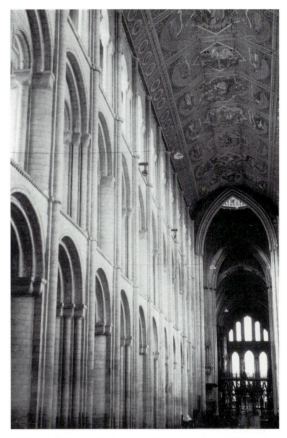

12.21 Ely Cathedral, begun 1081: nave. (R. G. Calkins.)

begun at about the same time. In the nave, Norman decoration enlivens the heavily articulated arches. A gallery with two pairs of small double arcades under enclosing arches opens into the lean-to roof over the aisles, and a clerestory with a wall passage occurs above. The present rib vault, replacing the original timber roof, dates from 1242. Elaborate perpendicular Gothic tracery now obscures the choir, but in the nave massive cylindrical columns reminiscent of those at Tournus and Cluny II are evident. These cylindrical piers remained a major feature in many Anglo-Norman Romanesque buildings, at Southwell Minster (fig. 12.23), Tewkesbury Abbey (fig. 17.8), Hereford Cathedral, and Fountains Abbey.

Ely Cathedral (fig. 12.21) in East Anglia, begun in 1081 by Abbot Simon, brother of Bishop Walkelin of Winchester, continued the Anglo-Norman propensity for length, with thirteen bays in the nave

and four in the choir. The three-aisled structure bears a timber roof, while triple archivolts of the wide nave and gallery arcades dramatically layer the wall. The openness of the nave and gallery openings, as at Saint-Étienne at Caen, creates a remarkable effect of lateral spaciousness.

Clusters of colonnettes, pilaster strips, and nave shafts virtually obscure the subtly alternating compound cylindrical and square piers of the nave and gallery arcades. These vertical linear accents dissolve the wall, molding it into bundles of multiple sculptural elements that rise throughout the elevation, past the clerestory with a wall passage, to the timber ceiling. Delicate horizontal stringcourses that demarcate the divisions between the stories visually tie the shafts to the wall and only slightly counterbalance the vertical accents. Very similar in its inordinate length and three-story elevation, the nave of

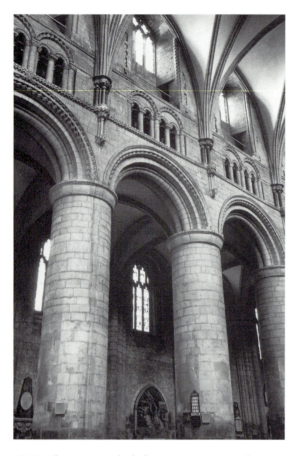

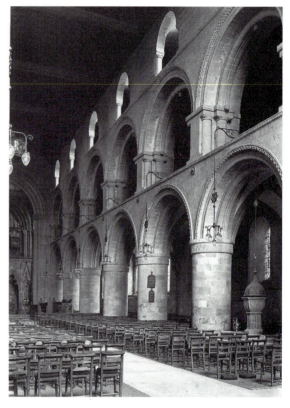

12.23 Southwell Minster, circa 1150: nave. (RCHME © Crown copyright.)

12.22 Gloucester Cathedral, 1089–1121: nave elevation. (R. G. Calkins.)

Peterborough Cathedral (1118–75) multiplies even further the number of bundled columns and shafts. The vertical linearity of the interior is here taken to the extreme.

The extreme length of English buildings often resulted in a strong horizontal emphasis contrasting with the verticality of Norman buildings on the Continent. In the nave of **Southwell Minster** of about 1150 (fig. 12.23) three stories of massive aqueduct-like arcades are stacked with no linkage between the stories, further accentuating the length and horizontality of the building. Similar massive horizontal nave elevations, supported on huge cylindrical piers, exist at Malmesbury Abbey (ca. 1160); Worksop Priory (ca. 1180); and Dunfermline Abbey (ca. 1150).

Durham Cathedral breaks with the developing Anglo-Norman tradition and evolves a new structural system: it introduces rib vaults throughout, result-

ing in a new interior spatial aesthetic (fig. 12.24–12.26). Considerable controversy surrounds the dates of the construction of the building, particularly of its early phases. Bishop William of Saint-Calais founded Durham in 1093. John James suggested that the choir aisles were rib vaulted in 1101 to 1103; the semidome of the apse constructed in 1103 to 1104; the high rib vaults of the choir built between 1108 and 1113; the north transept between 1113 and 1118; the south transept between 1115 and 1120; the nave aisles from 1115 to 1118; and the nave rib vaults from 1128 1133.[3] An aisled entrance porch, or galilee, was added to the west end between 1170 and 1175. Although these dates may be overly precise, the sequence is more or less correct. Originally, Durham was a three-aisled building with pronounced transept and crossing tower, a choir of four bays, and an echelon plan of two small chapels terminating the aisles and flanking the central apse.

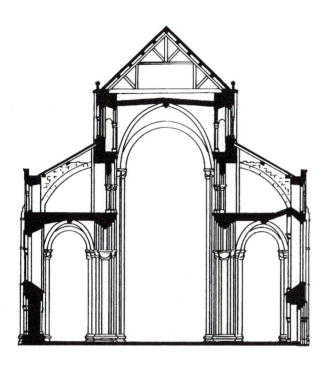

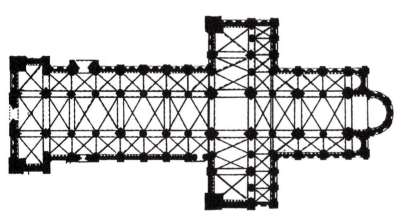

12.24 Durham Cathedral, 1093–1133: section (After Leland Roth); plan (After J. Bilson).

Early Gothic construction replaced the echelon apse with a second eastern transept.

Although the plan for the transepts called for timber roofing, the choir apparently had two six-part rib vaults, perhaps the earliest high rib vaults in Medieval Europe. Essentially, rib vaults are groin vaults to which arches have been added along the diagonal creases from one corner to the other, intersecting in the middle. However, it is unclear whether the early ribs at Durham developed for aesthetic reasons—to obscure the ugly and sometimes uneven groin—or for constructional reasons. John

James showed that in the early vaults at Durham the courses of the vault and of the rib in the choir aisles are continuous, indicating that they were built simultaneously. Thus, at first apparently, the builders did not consider them as devices upon which the cells of the vault could be laid. Later, however, in the construction of the nave, two-inch ridges along the upper edge of the ribs show that they were built first and then supported planks between them as centering for the construction of cells with coursed rubble. The cells of the eastern choir vault measured twenty inches thick, those of the western nave vaults

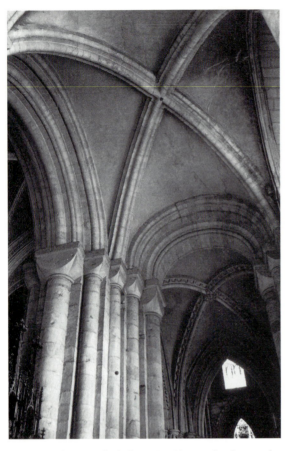

12.25 Durham Cathedral, 1101–03: south choir aisle vaults. (R. G. Calkins.)

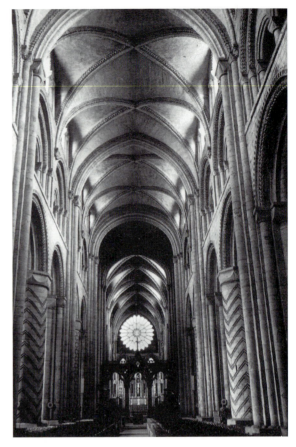

12.26 Durham Cathedral, 1115–33: nave. (R. G. Calkins.)

only fourteen inches thick, indicating the builders' greater confidence and understanding of the vaulting system as the building progressed.

The rib vaults of the choir aisle bays may have been altered. Those at the east end have been replaced by Gothic vaults, but the western rib vaults reflect the early use of semicircular diagonal ribs. The high rib vaults substituted for the timber roof of the transepts are the earliest surviving high rib vaults (ca. 1113–20). They consist of thick rubble masonry and have a curious arrangement of two sets of intersecting ribs—essentially two unseparated four-part vaults over a double bay—between transverse arches. This arrangement repeats in the nave. The diagonal ribs of the transepts follow a semicircular arc, and shafts rising from the sill of the gallery on the east wall and from corbels on the west wall support the intermediate converging ribs. The east wall of the

transepts with its layered aisle arcade, layered enclosing arch over twin arches in the gallery, and clerestory with wall passage became the model for the nave elevation; the west wall, however, has two stories of wall passages, the top one in the clerestory and the bottom one corresponding to the gallery of the nave.

Huge cylindrical columns decorated with zigzag and chevron motifs dominate the nave of Durham, alternating with compound piers and shafts that support pointed transverse arches between three sets of "double X" rib vaults. Only corbels support the intermediate converging ribs between the enclosing arches of the gallery openings. Here, carved Norman geometric ornament decorates semicircular ribs, transverse arches, and the archivolts of the nave and gallery arcades.

The gallery of the choir, beneath the lean-to roof, still has heavy transverse arches supporting a sloping

wall at points corresponding to the supports of the choir wall; in the nave galleries, similar sloping walls rest on quadrant arches abutting the nave wall. These walls were not really intended to be undercover raking buttresses responding to the converging forces generated by the diagonal ribs of the vaulting system, though they may in fact have worked that way; rather they have been shown to have supported timber trusses for a series of gables punctuating the length of the roof of the nave and choir galleries.[4]

As Durham Cathedral neared completion and understanding of the structural possibilities created by the rib vault increased, this device was rapidly adapted elsewhere: the six-part rib vaults of La Trinité and Saint-Étienne at Caen of perhaps 1130 show increased sophistication and lightness of form. The rib vaulting system constitutes the next step in the evolution from the groin-vaulted canopies at Speyer II. A fully articulated skeleton accompanies this system not only defining the bay as a unit of space, but emphasizing the vault by links to corresponding members diagonally across the nave. When the ribs changed from being aesthetic devices to constructional armatures, they began the development that led to the Gothic.

13

EARLY GOTHIC IN FRANCE

Many of the components that together make up the Gothic style when it appeared about 1140 in northern Europe had, in fact, been present for a long time. Groin vaults on a large scale were used in Romanesque buildings such as Speyer and Vézelay. The wall had already been eroded, ribs had been added to groin vaults above a repetitive bay system, and these devices were combined with the structural advantages of the pointed arch. Perhaps the only Gothic innovation was the flying buttress that appeared in the late twelfth century. The result of combining these elements, however, equalled more than the sum of their parts, for it produced a new skeletal interior, space-holding and expansive, delicate and soaring, and an exterior both projecting and penetrated, that evoked a terrestrial manifestation of the vision of the heavenly city of Jerusalem.

The groin vault, which Romans had used on a monumental scale in their baths and huge imperial basilicas, provided the basis for this development. In the middle ages, it was used consistently on a small scale over ambulatories and aisles. In the late eleventh century, groin vaults spanned large spaces, at La Trinité by 1066, at Speyer II after 1087, and at Vézelay between 1120 and 1136.

Another device, often considered a major feature of the Gothic style, is the pointed arch. It had also been used with increasing frequency in Romanesque architecture since the eleventh century. Pointed arches and their prolongation into pointed barrel vaults had been used in Muslim architecture since the eighth century, and were incorporated into the porch at S. Angelo in Formis at Capua about 1080.[1] Slightly pointed barrel vaults were perhaps used at Cluny II, then at Chapaize, at Cluny III after 1089, at Paray-le-Monial and Autun, and then in Cistercian abbeys such as Fontenay.

A third device, the rib, also had existed in Europe for a considerable time before its use at Durham about 1100. Decorative, interwoven ribs support the *mirhab* vaults of the mosque at Córdoba in the tenth century (fig. 8.5). They were copied as supports for the dome over the rotunda of San Sepolcro at Torres del Rio in Spain in the twelfth century (fig. 13.1). After their structural use at Durham over large spaces, ribs began appearing at numerous sites. About the same time, Italian builders introduced heavy square ribs under the domical groin vaults at S. Sigismondo at Rivolta d'Adda, maybe by 1120, and at S. Ambrogio in Milan of about 1120 (fig. 11.20). The low entrance porch at Saint-Pierre at Moissac of about 1125 to 1130 also used massive heavy square ribs, forming slightly pointed arches (fig. 13.2), and precociously multiplied them into a radiating scheme in the chamber above, rising from the walls of the square space to a center oculus and supporting small pinched triangular barrel vaults between them (fig. 13.3). In the Abbey church at

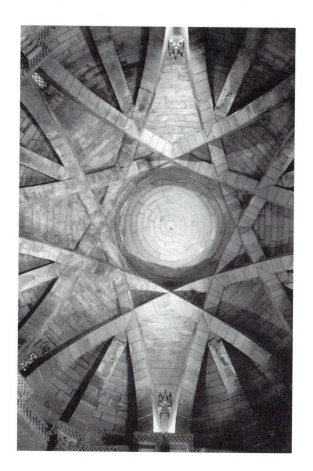

13.1 Torres del Rio, San Sepolcro, twelfth century: ribs. (R. G. Calkins.)

13.2 Moissac, Saint-Pierre, circa 1125–30: entrance porch ribs. (R. G. Calkins.)

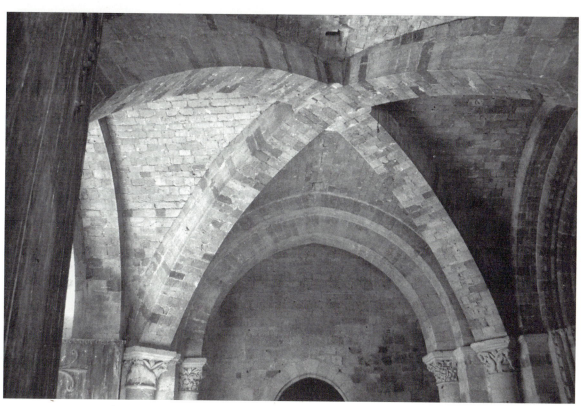

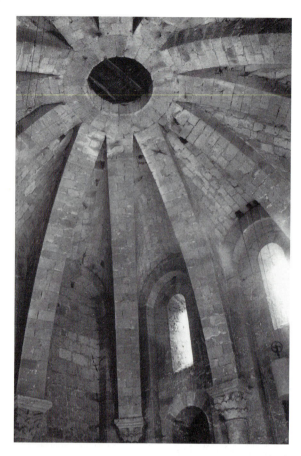

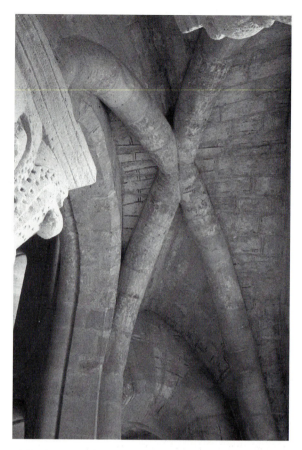

13.3 Moissac, Saint-Pierre, circa 1125–30: upper chamber ribs. (R. G. Calkins.)

13.4 Morienval, Abbey, circa 1130–35: ambulatory ribs. (R. G. Calkins.)

Morienval, in a tight little ambulatory wrapped around the apse of about 1130 to 1135, heavy sausage-shaped ribs—with a round rather than a square profile—awkwardly traverse the curved trapezoidal bays, intersecting incongruously close to the inner edge and result in a considerable disparity in the size of the cells (fig. 13.4). And at **Saint-Étienne at Beauvais** in the aisle of the Romanesque nave of about 1130 to 1140, one bay has square ribs; the rest, round diagonal ones forming semicircular arcs (fig. 13.5). Small, highly stilted transverse arches divide the bays, their elevated springing necessitated by their short radii in contrast to the longer arches of the diagonal ribs.

The repetitive bay system with domical groin vaults and appropriate clusters of shafts and pilaster strips made a major appearance at Speyer II, but it existed even before the vaulted canopy with the use of nave shafts and monumental arcades under the

timber roof of Speyer I of about 1030 to 1060 (fig. 7.15). The bay system required a variety of articulated supports: square piers with pilaster strips at Saint-Philibert-de-Grandlieu in the tenth century; cylindrical columns with transverse arches rising from above their capitals at Chapaize; or the most effective system, the compound pier. In the latter, any combination of pilaster strips and half-cylindrical nave shafts could be engaged against a square core, as at Nevers (fig. 10.6) and Speyer, to respond to the system of arches above. The resulting pier makes logical responses to elements it supported: side shafts support the nave arcades, an aisle shaft rises to the transverse arches that separate bays of the aisle, and tall nave shafts rise to support transverse arches across the high barrel vault as at Nevers. The subdivision of wall surfaces into repeated units under the barrel vault at Nevers, Saint-Sernin at Toulouse, and other major Romanesque

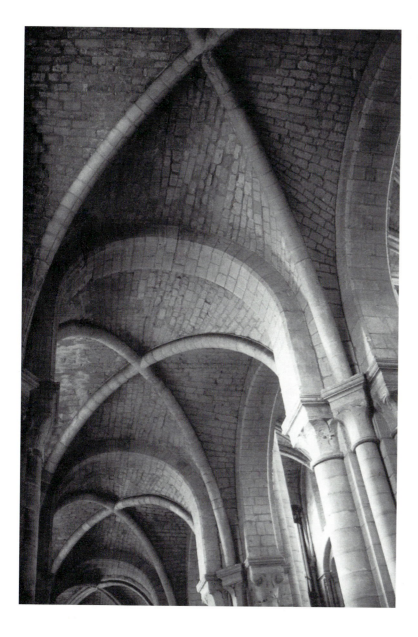

churches became a widespread device throughout Romanesque architecture.

The proclivity for having an alternation of supports—evident at Gernrode and Hildesheim, though without any correspondence to the nave elevation—yields at Jumièges, Durham, and elsewhere a rhythmic articulation of the bays. Usually stated as major compound piers and minor cylindrical ones, these supports ultimately respond to the requirements of the six-part rib vault used in such twelfth-century Romanesque vaults as those added to Saint-Étienne at Caen about 1130 (fig. 12.14).

Even the skeletal treatment of the wall developed in the Romanesque period. The space-holding effect of the thick wall screened by an arcade in the clerestory of Saint-Étienne at Caen or in two stories of the apse at La Trinité resulted in a remarkably dematerialized apse at Cerisy-la-Forêt of about 1090. The sculptural molding of supports with the openness of ample arcades of the nave and galleries at Caen led to the bundling of multiple shafts that totally obscure the wall at Ely and Peterborough, and set the stage for lighter and more delicate variants that evolved in the Gothic period. These are not

the solid, heavy interiors of the Romanesque pilgrimage churches, but rather, expansive spaces delineated by clustered supports, not walls.

A variant of this developing skeletal system occurred in the churches of the Paris region. Multiple shafts of compound piers projected into the space of the nave to support the vaulting, and were combined with an apparent "thin wall" penetrated with clerestory openings. Vestiges of this system exist at Saint-Pierre-de-Montmartre, built about 1134 to 1147, where a thin exterior shell sheaths a strongly articulated interior skeleton. However, here the appellation "thin wall" deceives, for the gallery wall is thicker than that of the nave arcade and must be therefore partially supported by the aisle vaults. In effect the gallery wall corbels outward to withstand better the thrusts of the main vaults. Since this wall is misaligned over the pier beneath, it is called a "false bearing" wall.

Flying buttresses, considered to be a major hallmark of the Gothic style, may not, however, have appeared until about 1175 at Notre-Dame de Paris and Saint Germigny-des-Prés. Some scholars argue for their presence on the choir of Saint-Denis or even earlier in the Paris region, but the evidence continues to be debated.[2] Rudimentary forms of a buttressing wall, set perpendicular to the nave wall, whether a raking wall, or spur buttress, or full or segmental arches under a roof, as at Durham, were still "under cover," hidden by the structure of the building. In any event, flying buttresses developed as a major structural device with the growing sophistication of early Gothic vaulting systems during the twelfth century. In effect, they created an exterior skeleton reflecting the interior bay system and resulted in a picturesque silhouette of space embracing arches and soaring pinnacles. The builders of the abbey church of Saint-Denis brought many of these elements together in a new synthesis that marked the beginning of the Gothic style.

The **Abbey of Saint-Denis** had long had significant associations. It was the burial site of Saint Denis, the patron saint of France, and since the sixth century served as the royal pantheon for the Merovingian kings. An eighth-century basilica was built by Abbot Fulrad under Pepin, the father of Charlemagne, and became his burial place. Because of these royal connections (the *oriflamme,* the crimson forked banner, reputedly of Charlemagne, was deposited there; Louis VI (reigned 1108–37) adopted it as his military standard), the abbey church became a symbolic center of the Capetian Kingdom of France and its burgeoning power in the Ile-de-France. It also became an increasingly important pilgrimage site, for in addition to the relics of St. Denis, the abbey possessed relics of the Passion, namely a nail from the Crucifixion and the crown of thorns. On feast and fair days throngs of people overcrowded the cramped, three-aisled, timber-roofed Carolingian basilica.

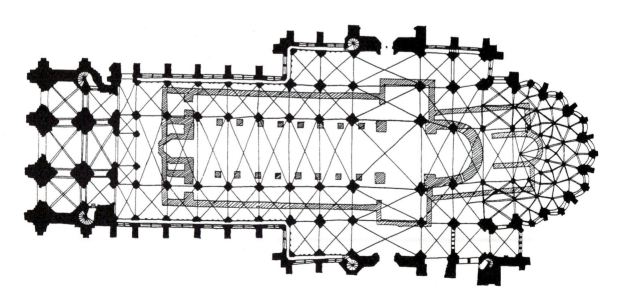

13.6 Saint-Denis, 1135–44, 1225–40: plan. (After Sumner Crosby.)

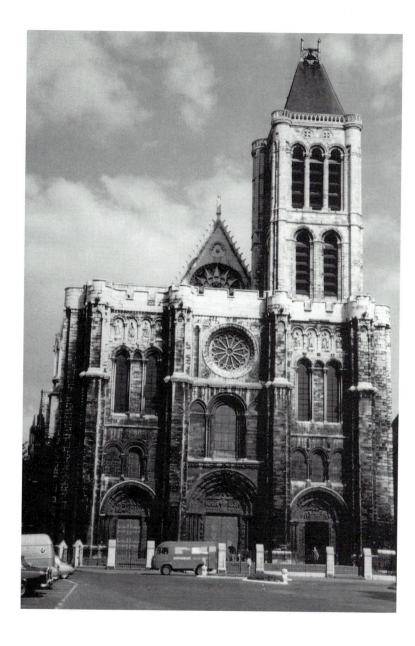

13.7 Saint-Denis, 1135–40: west facade.
(R. G. Calkins.)

Under Suger (1081–1155; abbot 1122–51), work began on rebuilding the Abbey of Saint-Denis (figs. 13.6–13.10) to improve the circulation of worshipers, taking care to integrate the new construction with the revered Merovingian and Carolingian structures. Work commenced on a monumental two-tower westwork in 1135, which was consecrated in 1140. Its three large portals helped to solve the problem of congestion created by the single Carolingian entrance in its tower porch. At the opposite end of the building, the construction of the foundations of a crypt wrapped around the hallowed ninth-century crypt of Hilduin began in 1140; above, an innovative chevet was completed in 1144. The spacious plan of the chevet provided good visibility of the relics and easy circulation. The plan also allowed the mass to be celebrated at the high altar, as Abbot Suger wished, "in secret without disturbance by the crowds."[3] Innovations in structure also allowed the builder to maximize the size of numerous large stained-glass windows.

Two masters, both unknown, built the westwork and facade (figs. 13.6–13.7). The first designed the west bays of the ground story. The second master

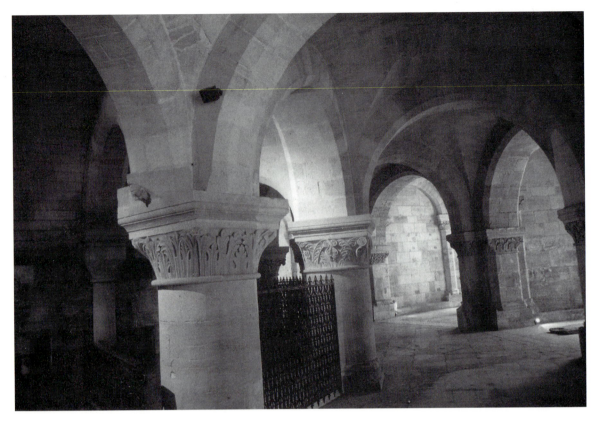

13.8 Saint-Denis, 1140–44: ambulatory of crypt. (R. G. Calkins.)

built the east bays of the westwork and the upper stories.[4] Corresponding to the nave and the two aisles, three ample splayed portals dominate the facade, opening into three entrance bays behind them. Boldly projecting pier buttresses emphatically punctuate the tripartite division of the facade and define the supports of the towers, which, with the splayed jambs and archivolts of the portals, create an increased effect of relief compared to the facades of Saint-Étienne and La Trinité with which Saint-Denis has the most in common. Staggered stringcourses indicate the different levels of the interior stories. Blind arcades and round and pointed arches over windows alleviate the severity of the frontispiece and obscure the many inconsistencies in level, dimensions, and detailing. The crenelation along the top, thought to reflect the original, gives the facade a fortresslike aspect, consistent not only with the idea of the church militant and the crusading aspirations of Louis VII but also with an evocation of the heavenly city of Jerusalem.

In the lower west bays, the first master emphasized linearity, bundling multiple shafts, archivolts, and rib moldings. Massive compound piers at each corner of his bays to support the towers consisted of huge sculptural clusters of shafts accentuating their verticality. The tall narrow proportions of the interconnecting arches between the westwork bays of the ground story would originally have been even steeper, for the floor of this area was raised six feet in the nineteenth century. Springing from the clusters of shafts, multiple archivolts form round and pointed arches over the openings to adjacent bays. Massive diagonal ribs, round in profile but flanked by a narrow fillet on each side, extend across the vaults. In the center west bay, the first master reduced the profile of his diagonal ribs: still forming a semicircular arc, they consist of three thin round elements forming a trefoil profile that from below looks like a triplet of fine linear accents. When the second master vaulted the center east bay, he further diminished the rib profiles and continued the process in his rib

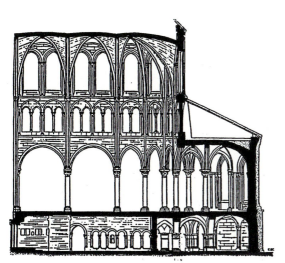

13.9 Saint-Denis, 1140–44: restored chevet section; chevet and crypt plans. (William Clark after Sumner Crosby.)

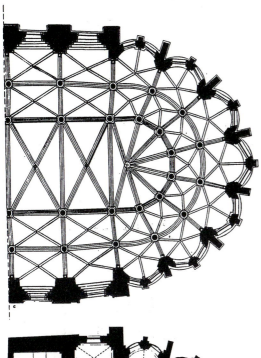

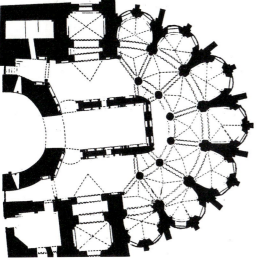

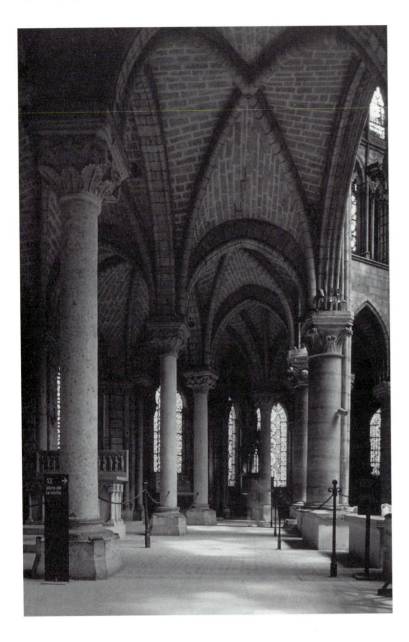

13.10 Saint-Denis, 1140–44: ambulatory of choir. (R. G. Calkins.)

vaults of the upper story. Thus the ribs became increasingly lighter and more delicate as each master worked on the westwork vaults.

When the second master laid out the crypt around Hilduin's pre-existing crypt in 1140, he built thick cylindrical columns and massive wedge-shaped piers to support heavy round arches and groin vaults over the enveloping ambulatory (figs. 13.8–13.9), beveling the edges of piers and arches to ease the visual flow. Between the piers that serve as walls, he built deep groin-vaulted radiating chapels. The groins of the ambulatory bays and chapels meet at the midpoint of their trapezoidal spaces: four in the ambulatory, five in the chapels. In spite of the heaviness of the structure, two large windows dominate most of the interior surface of the chapel walls, separated by piers with engaged columns. One is more conscious of sculptural elements and large expanses of glass than of mass.

On the exterior, however, only segments of the outside curves of the apsidal chapels appear between projecting pier buttresses, yielding a unified undu-

lating surface rather than the bold, additive volumes of Romanesque chapels. This effect derives from concurrent Parisian plans; a similar undulation occurs on the exterior of the Romanesque apse and even the trilobed projecting axial chapel of the contemporaneous church of Saint-Martin-des-Champs of about 1130 to 1142.[5]

In building the chevet above, the second master achieved a truly skeletal armature embracing a unifying space. He achieved this largely by omitting the walls between the chapels, and in their place substituted slender cylindrical columns—perhaps a deliberate emulation of the "classical" columns of Pepin's basilica—that supported a network of converging arches and ribs over what effectively became a double ambulatory. He employed skeletal rib vaults in the ambulatory and chapels rather than the massive groin vaults of the crypt below. Although the ribs follow a semicircular arc, they intersect in the middle of the trapezoidal bays and therefore angle their direction, giving them the effect of pointed arches like those that define the boundaries of each bay, enhancing the vertical effect of each canopy. As a result, the spaces of the chapels now flow uninterrupted, from one bay to the next, resolving an awkward and rudimentary linkage of chapels and ambulatory that had occurred in the ambulatory at Saint-Martin-des-Champs. The openness of this area at Saint-Denis, emphasized by the slender screening columns, created an entirely innovative and remarkable lateral spaciousness. The double ambulatory provided easy traffic flow around the sanctuary and good visibility of the relics that Abbot Suger had sought in his revisions to the abbey.

In the process, his builder may have responded to a third motivating factor in developing a skeletal structural system: it permitted a maximum use of stained glass. The outer walls had even larger windows than in the crypt, occupying all available interior wall surfaces, enveloping the unified space with an undulating envelope of richly colored glass. Its nature and visual effects totally enthralled Abbot Suger, and he was involved in planning the pictorial program of the windows. He was attuned to the effects of puddled colored light dematerializing the masonry. The theme of the St. Paul window, according to Suger, urged "us onward from the material to the immaterial,"[6] but so did the interaction of colored light and structure.

The original nature of the elevation of the chevet is uncertain, for the upper stories were replaced in the Rayonnant style in 1231. It may have consisted of two small paired gallery openings into the attic roof over the aisles and ambulatory, and a clerestory with double lancet windows, perhaps about the same size as those in the chapels. Christopher Wilson argued that the wedge-shaped piers between the chapels supported simple, massive flying buttresses that arched to the choir vault between the clerestory windows and that they derived from earlier Parisian variants, but this hypothesis is the subject of continuing controversy.[7] If this were not the case, then raking spur walls under the roof of the aisles and ambulatory may have buttressed the upper vaults.

During the time of the first construction, Abbot Suger associated closely with Louis VI, who died in 1137. After the completion of the chevet, Suger served as regent of France from 1147 to 1149 while Louis VII participated in the Second Crusade. Perhaps as a result of Suger's preoccupation with affairs of the kingdom and also a falling out with Louis VII after his return, the reconstruction of Saint-Denis during the abbacy of Suger virtually halted after 1145. The bottom story of the north transept arm with a sculpted portal, known as the Valois Portal, may have been built about 1164 to 1168 under Suger's successors, Abbots Eudes de Deuil and Eudes de Taverny, but the Carolingian nave was not replaced until after 1231 with the building of the present Rayonnant structure.

Abbot Suger succeeded in improving traffic flow, increasing visibility for the display of the relics, and maximizing the use of stained glass, all of which he mentioned in his two accounts of his accomplishments, *De Administratione* and *De Consecratione*.[8] Although he frequently mentioned the "new" structure and how he sought to tie it in with the "old," nowhere did he indicate that it is innovative in structure or spatial effects. The coming together of rib vaults, pointed arches, clustered linear accents, increased spatial flow, quality of the light from large stained-glass windows, and undulating chevet may have seemed to him to have been only small incremental improvements from other contemporary buildings in the Paris region and not necessarily a noteworthy radical departure from tradition. Saint-Martin-des-Champs of about 1130 to 1140 had achieved a remarkable spaciousness in its groin-vaulted ambulatories without the visual linkage of rib vaults.[9] Nevertheless, others quickly recognized the potential of the new synthesis at Saint-Denis, and construction began on a series of buildings that improved upon this new system.

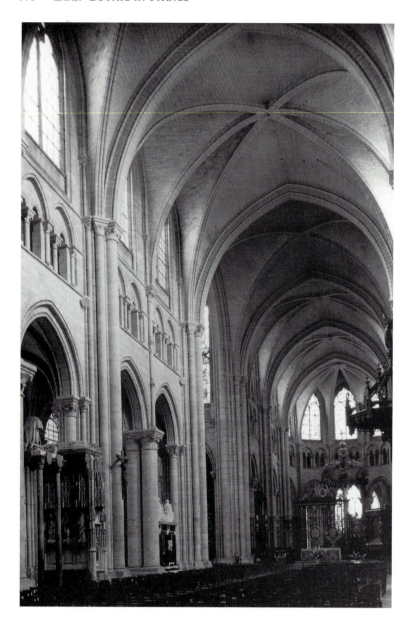

13.11 Sens Cathedral, 1130s–80: nave and choir. (R. G. Calkins.)

The Cathedral of **Saint-Étienne at Sens** (fig. 13.11, 13.25, *left*) constitutes the earliest complete surviving example of the new Gothic system. (Saint-Denis fails to receive this distinction as it remained incomplete until the 1230s when a more advanced style replaced the upper stories of the choir and was introduced in its Rayonnant nave.) The Archbishop of Sens, Hugues de Toucy (1142–68), had attended the consecration of Saint-Denis. He began the construction of Sens, perhaps revising in the 1140s an earlier Romanesque plan of the 1130s: the choir was completed by 1163 and the nave by 1180. Sens neared completion just about the time that William of Sens, who apparently copied some details from the cathedral, was rebuilding the burned out choir of Canterbury Cathedral in England between 1174 and 1179. The plan of Sens originally consisted of a single ambulatory around the choir with an axial rectangular chapel. Three radiating semicircular ones were added later. Slightly projecting transepts had chapels on their eastern flanks; they were replaced by widened transepts with elaborate flamboyant facades, begun in 1490 by Martin Chambiges and completed in 1517.

The choir and nave of Sens may best exemplify the original three-story elevation and structure of the chevet at Saint-Denis. Above the choir and nave arcades at Sens, gallery openings, with two enclosing arches, each embracing a pair of openings in each section of the bay, originally opened into the timber attic roof over the aisles but were later walled in to form a proper triforium wall passage. Small double-lancet windows appeared in the clerestory (they were replaced with larger ones in the thirteenth century).[10]

A six-part vaulting system, like that at Saint-Étienne at Caen, covers the interior. Two sexpartite vaults cover the bays in the choir before the turn of the apse and three sexpartite vaults appear in the nave. A system of alternating supports responds to their ribs and arches. Paired cylindrical columns support a single slender shaft rising from the abacus to the transverse rib. This rib, in turn supports a steep curtain-wall-like cell that meets the clerestory wall. From the alternate compound piers clusters of five shafts rise uninterrupted through the sill of the gallery. Three center shafts respond to the converging diagonal ribs and transverse arch, while two slender flanking shafts respond to the formerets (arch

moldings that frame the top of the windows) over the clerestory windows. The semicircular diagonal ribs have profiles similar to the triple forms found in the upper central bay of the westwork at Saint-Denis. The clustered shafts and diagonal placement of the abaci at the springing of the ribs create a sculptural molding of the wall as in some Anglo-Norman churches, but with an increased lightness and linear delicacy that now define the Gothic.

As at Saint-Denis, the four-part vaulted bays in the aisles are separated by heavy, slightly pointed transverse arches. Smaller bays of the aisles and ambulatory use four part vaults, but the ribs of some of the trapezoidal ambulatory vaults converge near the inner edge with a break in their direction.

Sturdy, heavy flying buttresses survived at Sens into the nineteenth century, but it is unclear whether they were part of the twelfth-century construction or the result of thirteenth-century revisions that changed the clerestory windows. Nevertheless, the three-story elevation of Sens gained limited popularity during the early Gothic period of the twelfth century and remained an alternative to the four-story elevation that prevailed in the region north of Paris.

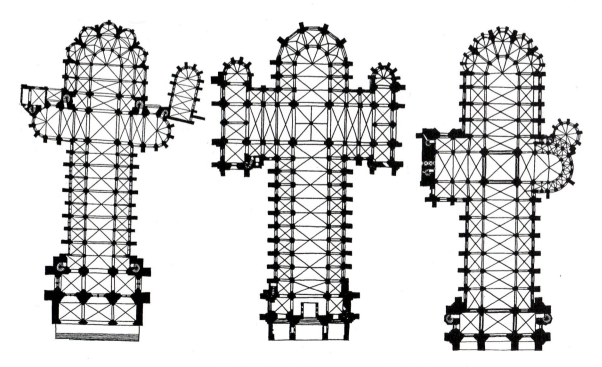

13.12 Plans, *Left to Right:* Noyon, circa 1150–1215; Laon before extension of choir, circa 1155–1205; Soissons, 1177–1225.

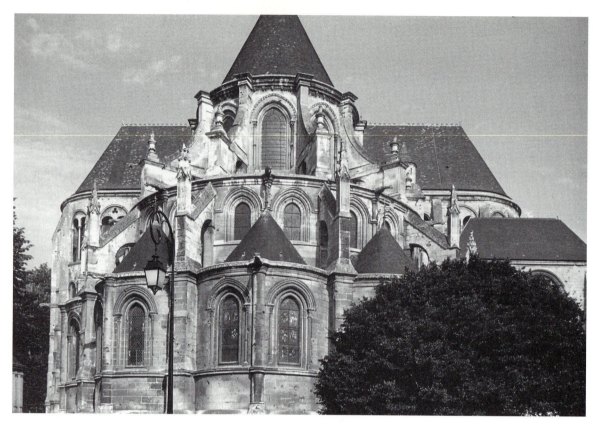

13.13 Noyon Cathedral, circa 1150–85: chevet exterior. (R. G. Calkins.)

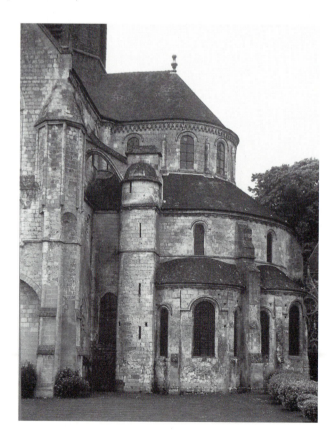

13.14 Saint-Germer-de-Fly, 1160s: chevet exterior. (R. G. Calkins.)

The Cathedral of **Notre-Dame at Noyon** north of Paris reveals the development of the other major elevational system during this period: the four-story elevation. Noyon had a significant heritage, for Charlemagne was crowned king of the Franks there and the city retained royal connections. Moreover, Noyon was the center of an economically prosperous region. After a fire destroyed a previous church, construction of the present Gothic cathedral began about 1150. The choir and transepts of Noyon were completed by 1185, the nave by 1205, and the two-tower facade by 1235. The plan varies the trefoil arrangement found in Cologne (fig. 13.12, *left*): a large semicircular apse with unified undulating chapels around an ambulatory is echoed in the round-ended, but narrower and aisleless, north and south transepts.

The exterior of the chevet (fig. 13.13) shows a unified layering of horizontal masses without the boldly projecting additive volumes of the Romanesque. An undulating lower volume wraps around the concentric semicircular walls of the

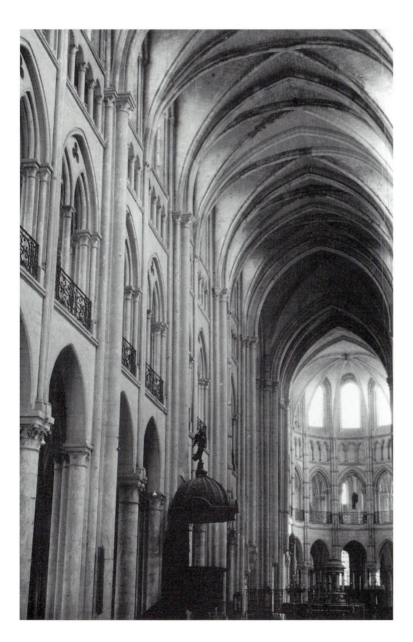

13.15 Noyon Cathedral, circa 1150–1205: nave and choir. (R. G. Calkins.)

gallery and then the apse. Originally without any articulation by later flying buttresses the chevet may have exhibited a similar compactness and layering of volumes found at Saint-Germer-de-Fly of about the same date (fig. 13.14).

Noyon developed the four-story elevation in series of permutations as the building progressed westward. The first version occurs in the choir, where, above the ambulatory and aisles extends an ample vaulted gallery with wide openings (fig. 13.15). Above that, a band of blind arcading corresponds to the area of the roof over the gallery. There is no need for this decoration, but it gives vitality to an otherwise blank wall hiding the attic under the roof and the raking buttress walls within it. The top story consists of the clerestory with single lancet windows.

This four-story system varies in the north and south transepts. The transepts have neither aisles nor ambulatories (figs. 13.16–13.17). Thus, in the rounded ends a decorative blind arcade articulates the bottom level with lancet windows immediately above. Above the windows run two stories of wall passages: the lower one links the galleries of the choir and nave; the upper, with tall arcades supported on remarkably thin colonnettes that emphasize the space-holding, diaphanous quality of the wall, preface the wall penetrated with windows. The windows in this level are set into the outer surface of the wall; in the clerestory above, they are brought into the inner surface, while on the exterior a wall passage penetrates the pier buttresses and envelopes this level with a space-holding screen. The Norman thick wall here achieves its ultimate expression, corbelling the upper wall

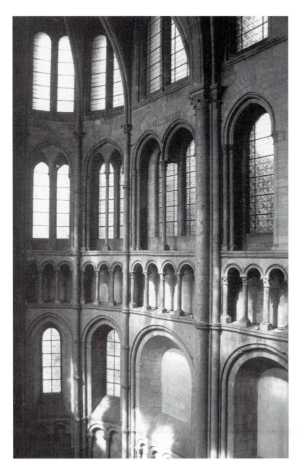

13.16 Noyon Cathedral, circa 1170–85: south transept, interior elevation. (R. G. Calkins.)

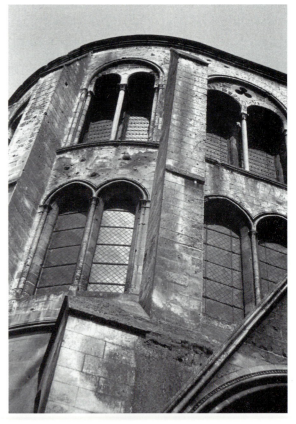

13.17 Noyon Cathedral, circa 1170–85: south transept, exterior elevation. (R. G. Calkins.)

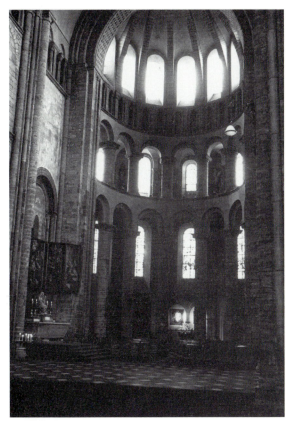

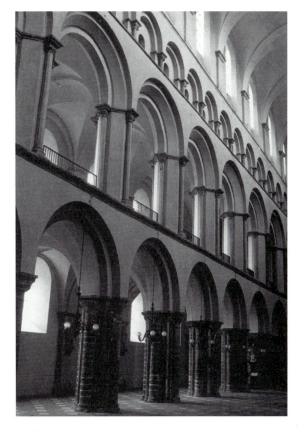

13.18 Tournai Cathedral, circa 1160: south transept interior. (R. G. Calkins.)

13.19 Tournai Cathedral, circa 1135–40: nave interior. (R. G. Calkins.)

inward for the springing of the ribs, and voiding the exterior and interior walls. In the interior, the whole ensemble is united by thin shafts that rise from the pavement to the springing of the radial ribs above, further emphasizing its skeletal structure.

These round-ended transepts closely relate to the Romanesque transepts of **Tournai Cathedral** (ca. 1135–60) not only in their apsidal form but also in the use of the four-story elevation (figs. 13.18–13.19). At Tournai the massive wall system consists of a curved ambulatory passage, a gallery level, an arcaded triforium opening into the lean-to roof, and then the clerestory level beneath heavy square radiating ribs. Tournai also has an exterior wall passage at the clerestory level of the transept and nave, a motif that may ultimately derive from the dwarf galleries under the eaves in German and Lombard Romanesque buildings.[11]

The final resolution of the four-story elevation occurs in the nave of Noyon (fig. 13.15), with nave arcades, gallery openings, a proper triforium (a wall passage articulating the wall surface at the level of the lean-to roof over a gallery), and then the clerestory. This elevation also relates to that in the Romanesque nave of Tournai (fig. 13.19) where heavy aqueduct-like arches of the nave arcade and gallery support an increased rhythm of layered triforium and clerestory openings. As a result Tournai exhibits a massive and horizontal emphasis. But at Noyon, where alternating compound piers and single cylindrical columns support clusters of five and three nave shafts respectively, the effect is vertical and sculptural. The outer shafts of both groups respond to the colonettes and formerets of the clerestory level. This logical alternating sequence of responding elements, however, no longer relates to the vaulting system, for four-part vaults, with their uniform convergence of three elements, replaced the six-part ones in the thirteenth century.

The Cathedral of **Notre-Dame at Laon,** begun under Bishop Gautier de Montagne about 1155,

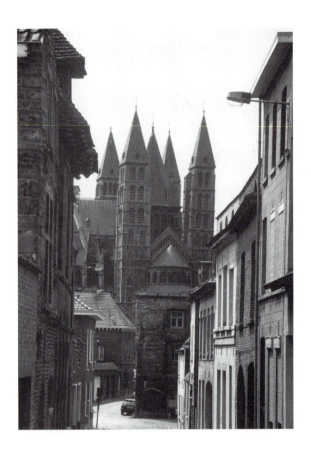

13.20 Tournai Cathedral, circa 1160–1200: north transept and crossing towers. (R. G. Calkins.)

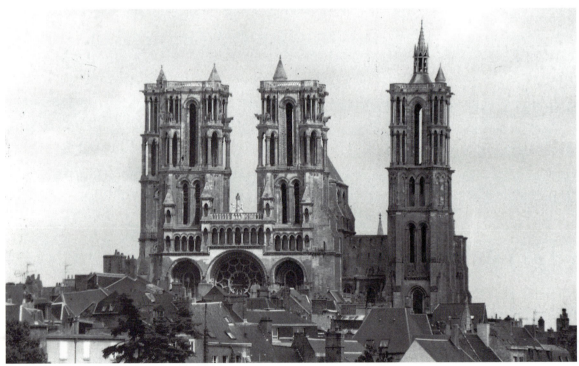

13.21 Laon Cathedral, circa 1155–1205: exterior view with towers. (R. G. Calkins.)

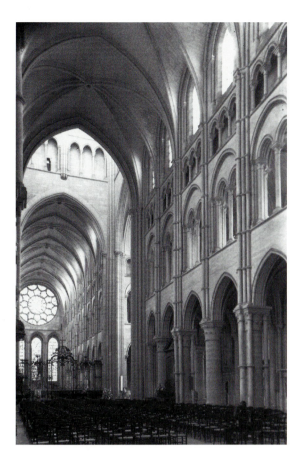

borrowed another striking feature from the tradition manifested at Tournai: the use of two tower facades on each transept, clustered around the crossing tower (compare figs. 13.20–13.21). This group of five towers derives from St. Trond in Belgium (1055–82), perhaps ultimately inspired by the cluster of towers at Trier (fig. 2.26), and the balanced grouping of towers at Centula and varied in German Romanesque buildings. At Laon the crossing tower, four transept towers, and another two on the west front, created a silhouette of seven towers topped by spires (only five survive, without spires). Originally this assemblage at the east end was even more imposing, for it dominated a short choir with a rounded apse, flanked by chapels on the east side of the transept. A long choir with a flat chancel replaced this chevet after 1205.

The interior of Laon manifests the classic early Gothic four-story elevation formulated at Noyon: nave arcade, vaulted gallery, triforium, and clerestory with single lancets (fig. 13.22). In addition, it

13.22 Laon Cathedral, circa 1155–75: nave elevation looking east. (R. G. Calkins.)

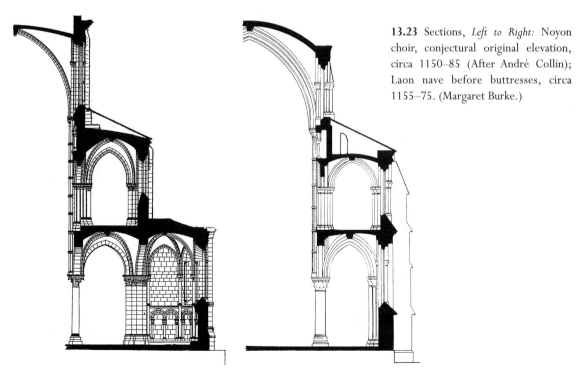

13.23 Sections, *Left to Right:* Noyon choir, conjectural original elevation, circa 1150–85 (After André Collin); Laon nave before buttresses, circa 1155–75. (Margaret Burke.)

retains the six-part vaulting system, responded to by a logical arrangement of alternating clusters of five and three shafts rising from the abaci of the cylindrical nave columns. These cylindrical columns may deliberately copy the supports used in the choir of Saint-Denis. In the first two bays of the nave next to the crossing, a second master continued the elevation of the choir but introduced freestanding colonettes around the alternate cylindrical columns with five shafts. Perhaps he intended to demarcate the liturgical choir that extended two bays into the nave to accommodate Laon's many canons, for when work continued westward in the nave, this articulation ceased.

When the choir was extended eastward about 1205 it varied only slightly the details of the existing design. Its three additional bays closely repeat the system of the original choir, transepts, and beginning of the nave completed about 1175, differing only in such details as a looser clustering of nave shafts and more pointed arches of the triforium. The original six-part vaults of the choir were more domical; they were revised in the thirteenth century to become consistent with the continuous longitudinal crown achieved in the later nave vaults.

The extension provided ample room for all the canons. It also resulted in a remarkably long interior in which the flood of light from the tall lantern tower over the crossing now occurred more nearly in the center (fig. 13.22). The length, horizontal bands of stringcourses, and the four stories they delineate balance the multiple vertical accents of wall shafts to achieve the most harmonious and spectacular Gothic interior of the twelfth century.

Controversy prevails, as at Saint-Denis and Noyon, whether Laon originally had flying buttresses. According to Christopher Wilson, Laon did have them, while other scholars believe that they were added in the thirteenth century.[12] In any event, the present flying buttresses function as wind bracers abutting the nave wall well above the springing of the vaults (fig. 13.23). Raking walls still under the lean-to gallery roof and behind the triforium actually buttress the thrusts of the converging ribs and arches. As a result, the exterior of the choir and nave presents, even with the addition of thirteenth- and fourteenth-century chapels between the pier buttresses of the nave, a massing of staggered layers similar to that of the exterior of Noyon.

The chapels on the eastern flank of the transepts reflect the wall voiding techniques found in Normandy and at Noyon. They extend two stories, the upper level opening into the ample vaulted gallery that continues across the ends of the transepts.[13] As at La Trinité, Cerisy-la-Forêt, and Noyon, space-holding screens articulate the interiors of these chapels: freestanding columns support boldly projecting arches at the gallery level and continue past a layer of clerestory windows surrounded on the exterior by a wall passage cutting through the pier buttresses.

Embedded in the pavement of the nave lies a *pierre carré*, a paving stone with incised rectangles that generate the dimensions and proportions of the entire building. The width of the nave equals eight of these squares (thirty-two feet). The distance between the columns of the nave arcade and the width of the aisle equals two of them (eight feet). Subdivisions of the square define rectangles whose diagonals generate successively the linear equivalents of the square roots of two, three, four, and five. They also produce the proportions of the golden section where the smaller part is to the larger as the larger part is to the whole. Repetitions of modular units of one, two, three, and five are articulated on the nave elevation of Laon by the string courses that tie the nave shafts to the wall: they state the triforium as two units, the gallery as three, the nave arcade story to the sill of the gallery as five. Proportional relationships of two, three, and five reflect the musical harmonies and therefore were considered to be divinely inspired. The two corners of the square, set diagonally on the axis of the building, reflect its orientation to the point on the horizon where the sun rises on September 8—the feast of the Nativity of the Virgin to whom the church is dedicated. It thus provides a key to the understanding of the building as a symbolic entity, as the sum of its proportions, orientation, processional and uplifting space, and heaven-reaching exterior form.

The facade of Laon (fig. 13.24), built between 1190 and 1205, makes a dramatic departure from earlier designs. It accentuates staggered horizontal lines even more dramatically than had occurred at La Trinité and Saint-Denis. Three deep semicircular niches above the projecting porch, two narrow ones with lancets flanking a wider and therefore also higher central one enclosing a rose window, punctuate the second story. These openings echo the width of the portals below that in turn correspond to the three-aisled interior. A higher gable over the center portal and a jogged up stringcourse and arcade

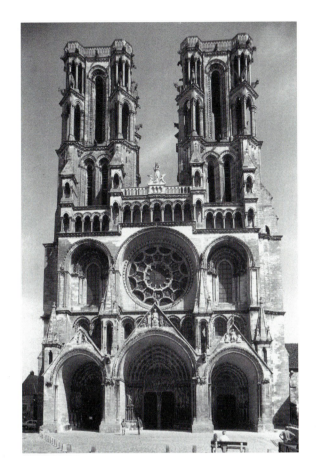

above the wide central niche emphasize the height of the nave. The addition of the projecting three-gabled porch dramatically deepens this facade, already penetrated by three huge niches above. Originally the front piers of the porch were freestanding, creating an open space behind them. This arrangement inspired similar porches on the transepts of Chartres Cathedral. Eaten into by space, projecting out into it, openwork towers and tabernacles thrusting upward, the Laon facade retains the strength and vigor of the early Gothic but anticipates the increasing sculptural quality of later facades.

When the Capetian king Louis VI made Paris his place of residence about 1130, the city flourished. Increased wealth of the diocese led the canons of the **Cathedral of Notre-Dame,** about 1150, to begin a huge new building on the site of a previous large five-aisled Merovingian basilica dating from the fourth to the sixth centuries (fig. 13.25, *middle*; figs.

13.24 Laon Cathedral, 1190–1205: facade. (R. G. Calkins.)

13.25 Plans, *Left to Right:* Sens before addition of transepts, 1130–80 (Margaret Burke); Paris, Notre-Dame before addition of thirteenth-century exterior chapels, circa 1150 –1220s; Bourges Cathedral, 1195–1250.

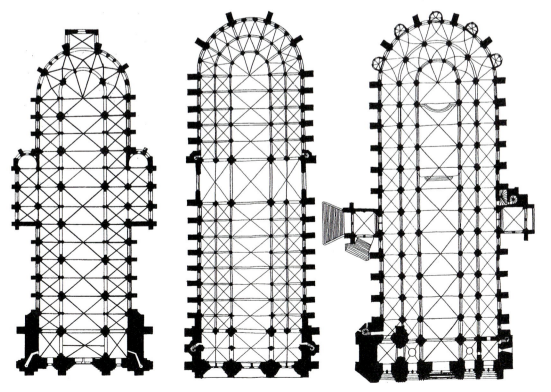

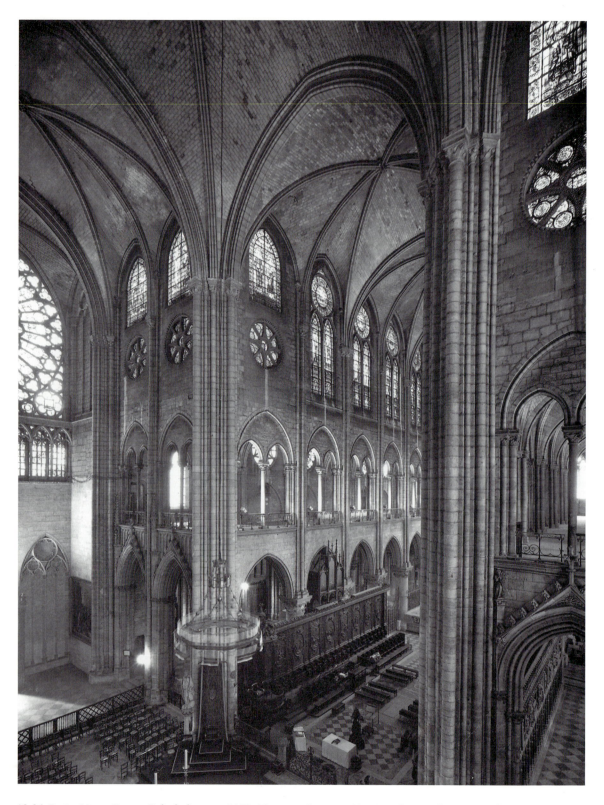

13.26 Paris, Notre-Dame Cathedral, circa 1150–80, revised circa 1225–30: choir and transept elevation. (Hirmer Fotoarchiv.)

13.26–13.27). Construction may have begun at both ends simultaneously, linking the old basilica to the new building.

Notre-Dame has undergone numerous vicissitudes, reconstructions, and restorations over the centuries so that the present building differs significntly from its original form. Its original plan (fig. 13.25, *middle*) formed a five-aisled basilica with a transept contained within its outline, projecting its volume only above the roof of the aisles and galleries. The two aisles of the nave continued into a double ambulatory around the choir without any chapels. Unlike the ambulatories of Saint-Denis, those of Notre-Dame had extra columns inserted in the curving row of supports between them. These resulted in a system of three-part vaults with two ribs radiating out from each column of the inner bays, and a five-part vault with ribs forming a W in the outer ones. Rather than the radiating plan of the Saint-Denis chevet, Notre-Dame emphasizes diagonal linkages that unified both ambulatories even more effectively.

Completion of the choir may have occurred by 1182 when the patriarch of Jerusalem celebrated mass there, but construction of the nave lasted until the 1220s. The choir and nave have six-part vaults (two meters lower and more domical in the choir), but a uniform system of massive cylindrical columns, continuing the twelfth-century tradition established at Saint-Denis, supports the nave arcade. Uniform bundles of three shafts rise from the abaci of their capitals to the ribs and arches despite the number of converging elements above. The only reference to the alternating elements of the high vault occurs in the intermediate row of columns separating the two aisles, where single cylindrical columns alternate with similar supports surrounded by bundles of shafts with no visible relationship to the nave elevation and the logical consequences of its six-part vault.

Although Notre-Dame originally had a four-part elevation it was one that differed considerably from those developed at Noyon and Laon. Above the nave and choir arcades were vaulted galleries, then a

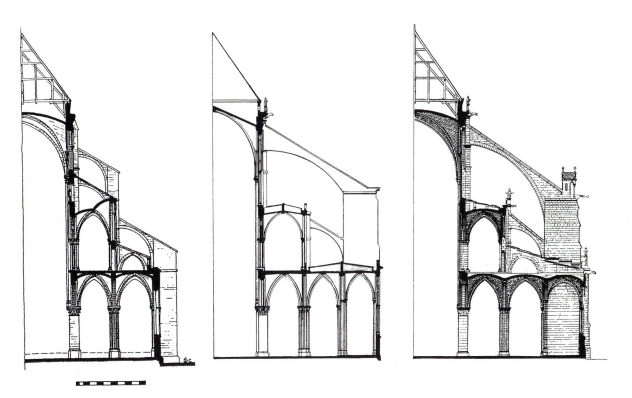

13.27 Notre-Dame, sections of nave, *Left to Right:* as originally built, circa 1150–82 (William Clark, drawing by D. Sanders, modified by W. Clark); as revised in thirteenth century (prerestoration state in 1842, William Clark after Leconte); at present with Viollet-le-Duc's restorations (William Clark after A. Chancel, 1887).

small oculus that opened into the lean-to roof over the gallery, and finally a wide but short single lancet window in the clerestory. The galleries had windows placed high in their exterior walls under awkward, upturned outer cells of the vault to allow light to come into the central space. The curious use of the oculus before a dark space and above a gallery reflects a four-story tradition that also appears in the small church at Chars of 1190 to 1200.[14] The colonettes flanking the clerestory windows on the exterior reveal the original placement and height of these windows. The relative thinness and planarity of the walls, thinly layered at the nave arcade and gallery levels dominated the original elevation of Notre-Dame.

The twelfth-century plan and elevation were changed beginning about 1225 to 1230, with the outward extension of the pier buttresses and the construction of chapels between them. A band of double-bay chapels was wrapped around the ambulatories, the gallery vaults lowered, the oculi removed, and taller clerestory windows inserted. If these changes were intended to allow more light into the nave, they did not succeed, for lowering the windows in the gallery wall reduced their effectiveness, as did moving the windows on the outer aisle walls a bay farther out to the walls of the new chapels. In his restorations of the cathedral of 1843 to 1865, Viollet le Duc restored several bays of the choir, transepts, and nave around the crossing to an approximation of their original elevation. About 1246, Jean de Chelles began the extension of the ends of the transepts and their magnificent Rayonnant facades; they were completed by Pierre de Montreuil, who inserted their rose windows in the 1250s.

Most scholars believe that Notre-Dame, like Sens, Noyon, and Laon, originally had no flying buttresses; nevertheless, the controversy surrounding whether Notre-Dame received its first flying buttresses before 1175 continues. Without them, the exterior of the chevet, with its smoothly curving double ambulatory, gallery layer above that, and the core of the apse on top, consisted of a similar piling up of unified, concentric volumetric layers, as at Noyon and at Saint-Germer-de-Fly of the 1160s (fig. 13.14). The most frequently accepted hypothesis is that triangular spur walls or raking buttresses extended under the gallery roof and under the roof of the attic over the outer aisles, like those found behind the triforium at Laon (fig. 13.24) and above the galleries at the contemporary Saint-Germer-de-

Fly. These walls buttressed the forces generated by the rib vaults.

As the vaults of Notre-Dame rose to new heights, the builders encountered new problems. The choir vaults rise 108 feet high, those of the nave 115 feet, seven feet higher. They measure, therefore, 36 percent to 45 percent higher than the vaults of Laon at seventy-nine feet. The slope of the roof added approximately another thirty-three vertical feet, or more than 39½ feet along the slope that caught the wind like a sail. As Robert Mark has shown in his studies of Gothic structures,[15] the force of wind on the exterior of these buildings increases geometrically with their height. Therefore, because of the increased wind load, the builders of Notre-Dame may have encountered difficulties with cracking vaults under the roof when they began the choir vaults perhaps about 1175. They may have responded to the problem by constructing the first proper flying buttresses as wind bracers. William Clark discovered a vestige of one of the early buttresses on the south transept, which confirms that they were heavy, simple quadrant arches rising from thick pier buttresses to abut the wall at the springing of the arch of the clerestory window.[16] However, Christopher Wilson contends that buttresses had been used in most of the major early Gothic buildings beginning with Saint-Denis. Whatever the case, at Notre-Dame, the piers and new arching buttresses braced the gallery walls and the choir walls at the clerestory level (fig. 13.27). Similar heavy buttresses still survive at Saint-Martin-de-Champeaux (ca. 1190–1205) and were added to the exterior of the chevet of Saint-Germain-des-Prés about 1180 to 1185 (fig. 13.28).[17]

The buttressing system of Notre-Dame changed along with the nave elevation in the 1230s (fig. 13.27, middle). Long, thin, steeply curving buttresses were placed around the choir and nave, arching over the double aisles and galleries, abutting the upper reaches of the nave wall. Viollet-le-Duc in his nineteenth-century restorations made these flyers excruciatingly thinner (figs. 13.27, right, 13.29).

The facade of Notre-Dame (fig. 13.30) presents a more planar and subtle design than previous examples. Its construction began one bay farther west than originally intended; it was completed through the bottom story by 1200, and extended to the window level and gallery by 1220. The rose window was inserted in 1236, and the towers built between 1225 and 1250. Seen frontally, it appears deceptively pla-

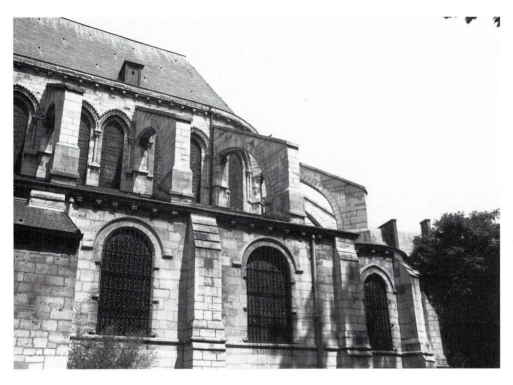

13.28 Paris, Saint-Germain-des-Prés, circa 1180–85: choir buttresses. (R. G. Calkins.)

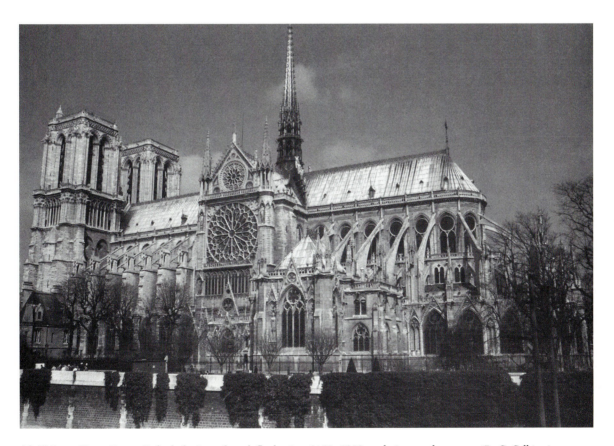

13.29 Paris, Notre-Dame Cathedral, view of south flank, circa 1150–1250s and nineteenth century. (R. G. Calkins.)

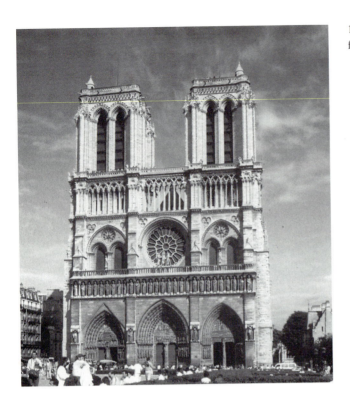

13.30 Paris, Notre-Dame Cathedral, 1200–50: facade. (R. G. Calkins.)

13.31 Reims, Saint-Remi, begun 1170: choir exterior. (R. G. Calkins.)

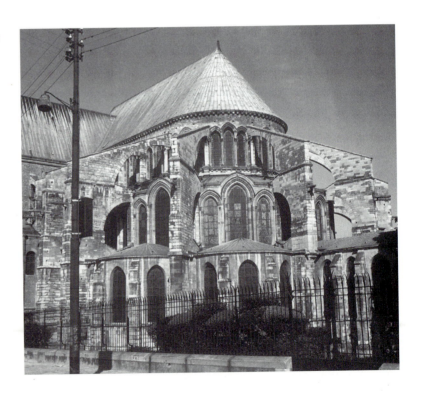

nar, but an oblique vantage point reveals the considerable projection of the pier buttresses and increased depth of the multiple jambs and archivolts of the portals in comparison with the mid-twelfth-century facade of Chartres. At Notre-Dame, three portals mask the five-aisled structure behind it. Nevertheless, the side doors under the towers, the central door opening into the nave, the rose window providing a tracery halo for the statue of the Virgin before it, and the horizontal unification of the towers by the open arcade screening the gable of the nave between them result in one of the most harmoniously proportioned facades of the Gothic period.

Variations in the early Gothic style continued to be made during the last decades of the twelfth century. **Saint-Remi at Reims** combined the four-story elevation of Noyon and Laon with the heavy twelfth-century buttressing system of Notre-Dame de Paris (figs. 13.31–13.32). Abbot Pierre de Celle began the choir in 1170, adding it to a Romanesque

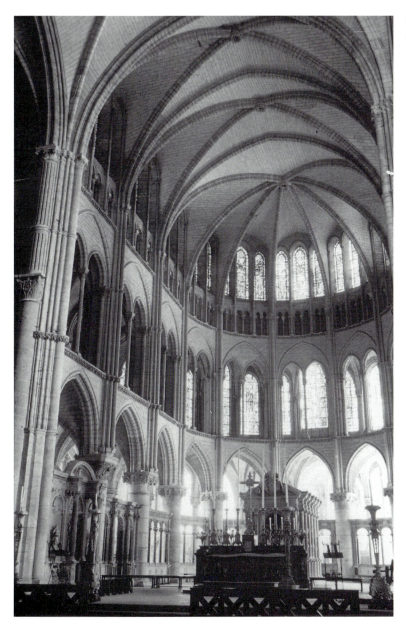

13.32 Reims, Saint-Remi, begun 1170: choir interior. (R. G. Calkins.)

nave (it and its later Gothic vault were destroyed in the German bombardments of World War I and were subsequently restored). In the choir, the massive pier buttresses between the radial chapels and heavy flyers, similar to those at Notre-Dame and Saint-Germain-des-Prés, distinguish the exterior of the chevet (fig. 13.31). The choir interior uses the four-story elevation with spacious gallery openings above the ambulatory, triforium, and clerestory with a triplet of narrow lancet windows. Shafts between these windows continue uninterrupted into the triforium level, linking the two stories. Columns placed before the openings to the radial chapels and delicate colonnades in the gallery level create a breathtakingly diaphanous space, dematerializing the fabric further than any previous examples.

When the Romanesque apse of **La Madeleine at Vézelay** (figs. 13.33–13.34) underwent renovations from about 1185 to 1190, an early Gothic structure

with a three-story elevation of main arcade, attic gallery, and clerestory, perhaps inspired by those of Saint-Denis and Sens, was combined on the exterior with heavy twelfth-century buttresses. The undulating effect of the radiating chapels restate the unified plans of Saint-Denis, Noyon, and Saint-Germer-de-Fly. Inside, the walls between the chapels are partially voided, increasing the expansiveness of the space. The choir has a six-part vault preceding a four-part one before the radial ribs of the apse. Built of white limestone, the choir presents a shimmering, skeletonized space filled with light, a dramatic culmination of the darker Romanesque nave.

As demonstrated by the parallel use of three- and four-story elevations, the development of the early Gothic style did not evolve in a strictly progressive manner. Other alternatives developed, some of them awkward and some of them dead ends. In the early Gothic church of Saint-Quirace at Provins, of about

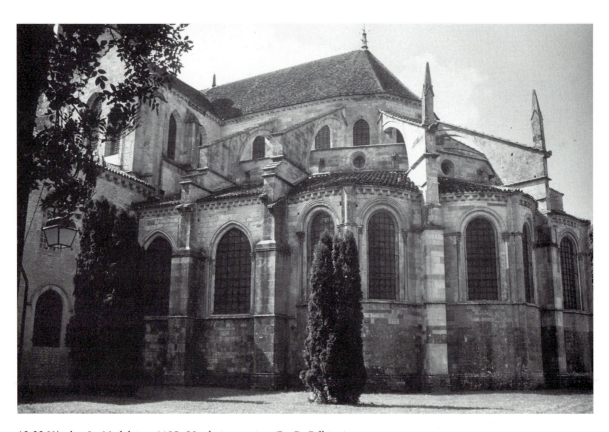

13.33 Vézelay, La Madeleine, 1185–90: choir exterior. (R. G. Calkins.)

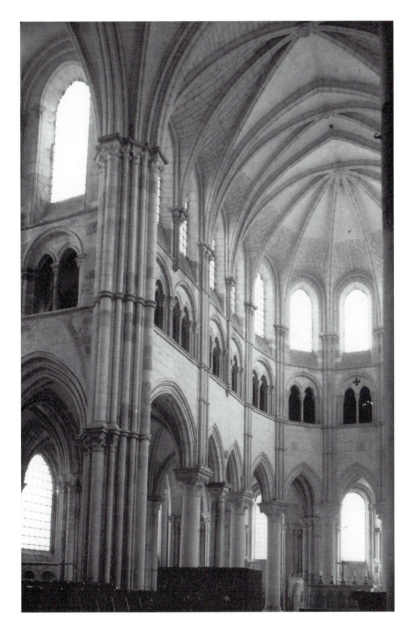

13.34 Vézelay, La Madeleine, 1185–90: choir interior. (R. G. Calkins.)

1160 and contemporary with Notre-Dame, a curious eight-part vault extended over the choir.[18] Two intermediate diagonal ribs descend to single shafts supported by cylindrical columns. A heavy transverse arch, with Norman chevron decoration, rises from a compound pier and separates the radiating vault of the apse. The choir has a three-story elevation with a triforium beneath single lancet clerestory windows. In the ambulatory, the builder was obviously uncertain how to proceed. Repeatedly, ribs spring from different heights, even when they converge at a single point. An awkward vault in the curve of the ambulatory has two ribs forming a T intersection, separated by a lozenge-shaped cell from four other ribs intersecting in a more normal manner. The result is a highly irregular six-part vault.

In western France the development of the Gothic style took a different direction, perhaps inspired by

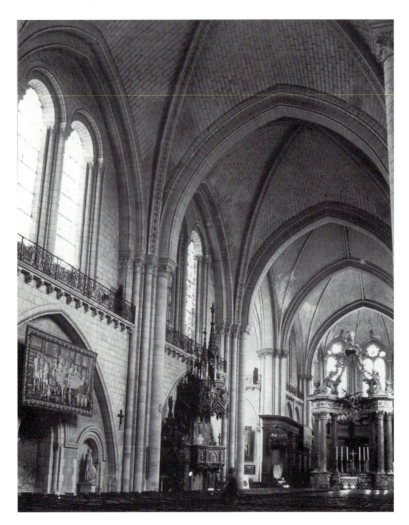

13.35 Angers Cathedral, 1149–52: nave interior. (R. G. Calkins.)

local traditions coming out of the Romanesque style. The **Cathedral at Angers** (fig. 13.35), a revision of an eleventh-century building in 1149 to 1452, appears as a Gothicized version of the succession of domes of Saint-Pierre at Angoulême: it consists of an aisleless church of five bays with deep, domical four-part rib vaults. Later, the vaults of the transepts and choir received thin ridge ribs, called tiercerons, that follow the curve of the crown of the vault down to the apex of the pointed arches below.

The pronounced compartmentalization of such bays persisted in another variation evolving from the use of high aisles flanking a central vessel. In the **Cathedral at Poitiers** (fig. 13.36), built between about 1162 and 1180, the domical Angevin vaults combined with a developing hall church formula originating in the Romanesque (see chapter 10), with aisles almost the same height of the nave, resulting in a remarkable unity of the interior space. The small monastic church of **Saint-Serge in Angers** (fig. 13.37) combines an actual hall church with aisles the same height as the choir with the Angevin domical vaults. In the choir of about 1215 to 1220, added onto a late-twelfth-century nave, linear accents of the tiercerons emphasize the curve of the domical vaults above. The remarkably slender supports, billowing vaults, and spatial continuity result in a totally different interior effect than the soaring height of the cathedrals of central and northern France, creating a delicate and viable Gothic alternative that prefigures the exuberant vaulting patterns and open spaces of the German hall churches.

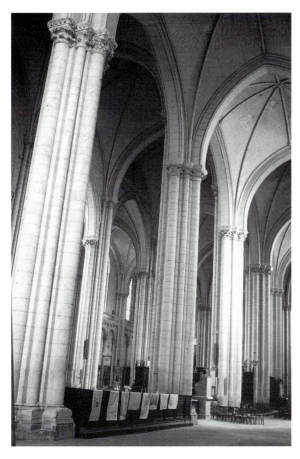

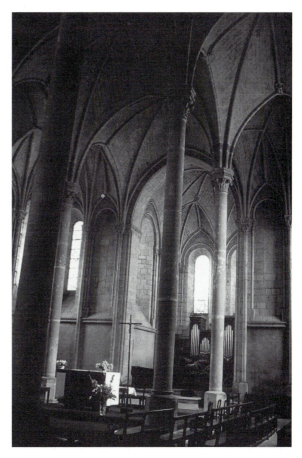

13.36 Poitiers Cathedral, begun circa 1162–80: aisle and nave. (R. G. Calkins.)

13.37 Poitiers, Saint-Serge, circa 1215–20: choir interior. (R. G. Calkins.)

Thus, various parallel solutions evolved in France during the first sixty years of the Gothic style as builders increased the height and complexity of their structures and fine-tuned their designs. The details of these solutions are so varied—as between Sens, Laon, and Notre-Dame de Paris—that they do not constitute a unified early Gothic style. Rather, early Gothic consists in the totality of its effects: an increased lateral and vertical spaciousness, a more delicate and logical articulation of the skeletal bay system, and a greater unity and compactness of plan and exterior volumes.

14

THIRTEENTH-CENTURY GOTHIC IN FRANCE

The great cathedrals under construction in the Île-de-France during the first three decades of the thirteenth century—Chartres, Soissons, Amiens, and Reims—are often called "high Gothic" to distinguish their "classic" form evolved from the early Gothic buildings of the twelfth century. William Clark questioned this distinction, for as twelfth-century buildings evolved through several parallel solutions and various incremental adjustments to previous "experiments," so mature Gothic buildings manifest but additional and varied steps in this process.[1] However, like the early Romanesque buildings, early Gothic structures were not intended as experiments, but as lasting solutions. Refinements of design occurring in early Gothic reveal the master mason's developing aesthetic sense, a desire to "tweak" previous solutions to arrive at arrangements more consistent with the logic and artistic vision of the builder.[2] In the thirteenth century this continuing development also results in a variety of solutions, albeit many of them more homogenous than in the previous century, and coincides with the emergence of the names of renowned architects in charge of major projects. Whether thirteenth-century buildings constitute a new style or just an evolution of twelfth-century forms, they do manifest a definable synthesis and regularization of structural and design elements that lead naturally to the next developments in the Rayonnant phase, itself simply an evolution from previous forms. These labels should not, therefore, be construed as absolute categories of definable styles, but as useful indications of stages in the development of the Gothic style as a whole.

In the Cathedral of Notre-Dame at Chartres many devices of the early Gothic buildings came together to create a major synthesis of the mature Gothic style. The nave and choir of Chartres exhibit remarkable overall consistency in their design, a result of the unusually short time it took for their construction—approximately thirty years between 1194 and 1225. Chartres defined many of the characteristics of the mature Gothic phase and heavily influenced later developments at Soissons, Reims, Amiens, and other structures throughout France.

Chartres (figs. 14.1–14.6) dominates the surrounding plains of the Beauce, a wheat-growing region serving as the breadbasket of medieval France. The cathedral looms over the town, prosperous from commerce as depicted in the stained glass windows believed to have been commissioned by the trade and craft guilds.[3] The site of Chartres had been sacred since the first century B.C. when a Druidic cult worshiped a statue of a pre-Christian virgin mother there. St. Avetin, bishop of Chartres in the fourth century, constructed the first Christian church on the spot. In 876 Charles the Bald donated the *Sancta Camisia,* a veil reputed to have been worn by the Virgin at the birth of Christ, to a Carolingian church occupying the site.

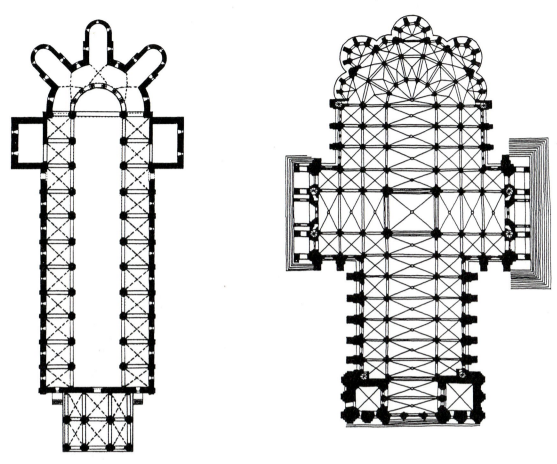

14.1 Plans of Chartres Cathedral, *Left to Right:* Fulbert's church, 1020–37 (after Branner); Gothic cathedral, 1194–circa 1220 (After Dehio and Bezold).

A huge Romanesque structure begun under Bishop Fulbert (1006–28) and dedicated by his successor, Bishop Thierry, in 1037, replaced a tenth-century building that burned down in 1020. A surviving manuscript miniature shows that Fulbert's church had aisles, a clerestory, a crossing tower, radiating chapels, and a massive entrance tower similar to the bell tower and entrance porch at Saint-Benoît-sur-Loire (fig. 9.15). Fulbert constructed his three-aisled basilican structure over a large crypt—the largest in France—with two long groin-vaulted aisles under the length of the nave aisles and an ambulatory with three boldly projecting, barrel-vaulted radiating chapels ending with half-domes (fig. 14.1, *left*). This crypt survives, and serves as the foundation for the Gothic cathedral.

In 1134, a fire in the town of Chartres destroyed the west tower, at which point the present two-tower façade was planned (fig. 14.2). Construction began on the north tower in that year; the south tower in 1142. Shortly afterwards the three unified entrances of the Portail Royale were placed in the central panel, all opening directly into the nave. The south tower, completed in 1170 appears essentially Romanesque in its massiveness and decorative richness but tends toward Gothic verticality in its linear accents. Probably about 1150, the three large lancet windows were installed above the triple portal. The north tower apparently never rose much higher than the present balustrade and gallery of sculpture. During much of the Middle Ages a wooden spire topped it: when that burned in 1507, Jean de Texier, known as Jean de Beauce, replaced it with an elaborate flamboyant Gothic stone spire. This façade joined Fulbert's eleventh-century church until a great fire in 1194 destroyed everything behind it.

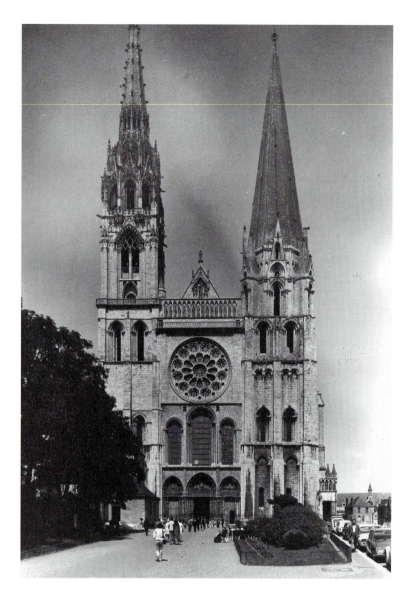

14.2 Chartres Cathedral: 1134–1500: facade. (Foto Marburg/Art Resource, N.Y.)

During the ensuing construction of the higher Gothic nave, in about 1215, the great twenty-three-foot rose window was placed above the lancets.

The massive walls of the Romanesque crypt served as the foundations for the reconstruction, and the resultant new Gothic building, its nave and aisles, choir, inner aisle, and ambulatory, for the most part conforms to the outlines of the old (fig. 14.1, *right*). Four additional, shallow rib-vaulted chapels were placed between the boldly projecting Romanesque ones of the crypt, creating an alternating rhythm of major and minor projections in plan and exterior elevation. The Romanesque windows of the original

crypt chapels and aisles still appear under the later chevet and nave. The two aisles of the nave become double aisles each side of the choir east of the transepts and continue in a double ambulatory reminiscent of Saint-Denis. The north and south transepts, under construction into the 1220s, projected beyond the original Romanesque plan. The placement of the transepts, between four bays of the choir and seven of the nave, increases the balance of the plan in comparison with earlier buildings. Stumps of towers begun but abandoned by 1260 flank the facades of the transepts and the beginning of the curve of the apse: these, along with the two west

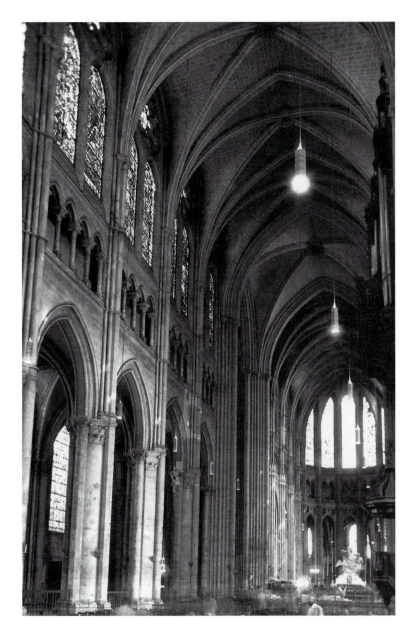

14.3 Chartres Cathedral: nave, 1194–1220. (R. G. Calkins.)

towers and an intended tall crossing tower (indicated only by massive crossing piers in the interior), reveal a projected plan for a nine-towered cathedral, developing even further the tradition of clustered towers around the crossing at Laon (fig. 13.21). Its intended multi-spire silhouette, more sharply pointed and elaborate than its Romanesque predecessors, would have evoked the most etherial image of the heavenly kingdom of any European cathedral at that time.

The new Gothic nave manifests the earliest full synthesis of elements that constitute the mature Gothic phase (fig. 14.3), consisting of four-part rib vaults over repeated rectangular bays resulting in a unified flow of interior space. As a result, equal triangular cells of vault alternate with evenly spaced clerestory openings, as opposed to alternating vault cells and curtain walls on transverse ribs found in sexpartite vaults at Notre-Dame de Paris. Moreover, the relatively uniform thickness and profiles of the diagonal ribs and transverse arches separating the bays give them an equal emphasis that lessens the distinctiveness of each individual bay. In addition,

14.4 Diagram of *tas-de-charge*. (After Viollet-le-Duc.)

the convergence of the springing ribs and the transverse arches that tie them into the wall. This is the point where the forces of the vaults are transmitted and met by the arch of the exterior flying buttress (fig. 14.5, *left*). Flying buttresses do not exert an inward force on the wall; they redirect the forces from the wall, merely transmitting them out and down the pier buttresses. In ruined churches where walls with remnants of the *tas-de-charge* of destroyed vaults still stand, they support the inner end of surviving external flying buttresses without being pushed inward.

Along the nave at Chartres we find the first aesthetically articulated flying buttresses: they consist of a lower quadrant arch and an upper diagonal strut linked by tumbling arcades (figs. 14.5, *left*; 14.6). These buttresses rise from massive pier buttresses as opposed to the earlier rudimentary arches presumed at Saint-Denis and Laon, and still visible at Notre-Dame de Paris and Saint-Germain-des-Prés (fig. 13.28). At Chartres, at the point of the *tas-de-charge,* the lower arch abuts the clerestory wall where it receives maximum thrust from the nave vaults, while the upper strut braces the wall at the springing of the arch above the plate tracery rose of the clerestory. The later addition of wind braces stabilized the top of the nave wall where it meets the slightly curved transverse vaults. The perception that the structure needed wind braces may result from the experience at Notre-Dame de Paris where the wind load may have caused the vaults to crack. Since Chartres measured 116 feet high—a foot taller than Notre-Dame—similar wind braces may have seemed prudent.

The nave buttresses of Chartres were massively overbuilt, but as construction proceeded eastward around the transepts and to the choir on the upper level, their design changed. On the east side of the transepts, lighter, narrower buttresses with thinner columns, pointed arches, and holes punched through the strut above abut the building. Around the choir the buttresses thin even more: the columns become diamond-shaped struts blending into the arch above (fig. 14.7). In addition, Chartres retained triangular spur walls behind the triforium and under the aisle roof, a holdover from the system used at Laon. After Chartres, the flying buttress became, with increasing refinements, a standard structural and articulating device on the outside of many Gothic cathedrals.

Chartres also introduced an innovative support system consisting of a massive cylindrical pier with

adjacent cells in contiguous bays, creating a series of diamond shapes, link one bay visually with the next. The even height of the crown of the vault reinforces this unifying effect along the axis of the nave and choir. Because a rectangular bay requires three different lengths of radii for its sides and diagonals, the builders used pointed arches throughout, adjusting their pitch to achieve this uniformity of height.

Increased understanding of the structural possibilities of the rib vault led to the accomplished use of the *tas-de-charge* (fig. 14.4), the courses of stone at

14.5 Sections, *Left to Right:* Chartres, 1194–1220; Bourges, 1195–1214; Reims, 1211–1287; Amiens, 1220–69. (After Christopher Wilson.)

14.6 Chartres Cathedral: nave buttresses, 1194–1200. (© CNMHS.)

14.7 Chartres Cathedral: choir buttresses, circa 1200–1225. (R. G. Calkins.)

four round shafts at its cardinal points—a *pilier can-tonné*—responding to the nave arcades, the arch between aisle bays, and the major nave shaft. The capitals of the nave piers measure twice the height of the three capitals of the engaged shafts, a reference to their relative visual weight; the nave shaft, however, rises unadorned to the abacus. At this point, corresponding to the springing of the nave arcade, the clustered responds rise from their own bases to the transverse arch between the bays. However, these supports retain a subtle reference to a vaulting system no longer used at Chartres: cylindrical piers with octagonal shafts alternate with octagonal piers with round shafts, faintly referring to earlier systems of alternating supports appropriate for six-part vaults.

The four-part vaults at Chartres result in the even convergence of ribs and arches at the divisions between each bay. Consequently the uniform bundles of five nave shafts rise from the abacus of the capitals on the massive nave arcade supports. The thickness of these shafts is graduated: the widest center shaft responds to the transverse arch, two thinner flanking ones to the diagonal ribs, and the two narrowest outside shafts continue up above the springing of the vault to the formeret, a molding over the top of the clerestory windows. The diagonal abaci below the ribs and the clustering of the shafts throughout the nave elevation give the wall, particularly at the triforium and clerestory levels, a sculptural modeling that reinforces the diagonal linkage. These bundles of shafts also state a skeletal system supporting the canopies above. Evidence exists that the interior was originally polychromed, the effect of which would have further emphasized a skeleton in which white shafts and ribs contrasted against ocher walls. Thus, the logic of the four-part vaulting system descends from the ribs and arches at the top of the nave to the nave piers, much as the alternating system does at Laon.

The use of a three-story elevation further characterized the mature Gothic phase, following the tradition that Saint-Denis possibly established and Sens and the choir at Vézelay continued. Chartres omits the gallery level, and the nave arcade and the clerestory level measure the same height, forty-five feet, while the triforium equals one-third of that height (fifteen feet). These proportional relationships continue, for the height of the clerestory below the springing of the vault matches the height of the triforium. This proportioning of the elevation, demarcated by horizontal accents, reads as fol-

lows: nave arcade = three; triforium = one; clerestory = three, compared with that of Laon (four units in the nave arcade; three in the gallery, one in the triforium, and two in the clerestory level, marked out by horizontal stringcourses). The Chartres system balances the proportions and subtly interweaves their horizontal accents with the strong vertical supports; contrasting with Laon which emphasizes stacked horizontal layers.

The vaults spring from a point one third up the height of the clerestory windows creating an opportunity for a wall of glass equaling the height of the nave arcade. In contrast to the small single lancet clerestory windows tucked up under the canopy of the descending vaults of Laon and Notre-Dame de Paris, Chartres displays paired lancets approximately twenty feet tall that descend almost half of their height below the springing of the vaults. Large circular rose windows of plate tracery, approximately fifteen feet in diameter, surmount the lancets. The plate tracery consists of eight flat pieces of stone carved from templates that, when put together, form an eight-petal flower (fig. 14.8, *left*) surrounded by alternating large and small quatrefoils. The last and most elaborate version of a plate tracery window at Chartres is the twenty-three-foot diameter rose above the triple lancets of the west facade, installed about 1215, where profuse sculptural relief decorates the contours of the openings. In both cases, thick heavy stones form and define the window pattern, particularly evident in an oblique view of the west rose.

Of the surviving Gothic cathedrals, Notre-Dame at Chartres is special, not only because of its synthesis of Gothic structural systems and its resulting height and vertical proportioning (1:2.17),[4] but also because it contains most of its original twelfth- and thirteenth-century stained glass. Resplendent blue and red glass fills most of the expanse of the walls and diffuses the light, producing in the relatively dark interior a warm purplish glow in which puddles of colored light further dematerialize supports and walls. The windows even dematerialize the exterior, for the edges of the heavy pier buttresses, seen obliquely (fig. 14.5), present a deeply corrugated surface that, when seen head on, leads to walls that are not of stone but of glass. Thus the exterior mass appears penetrated and space-holding, an effect accentuated by the triple flying buttresses. With the presence of the nine originally planned towers, Chartres would have become an ethereal Gothic

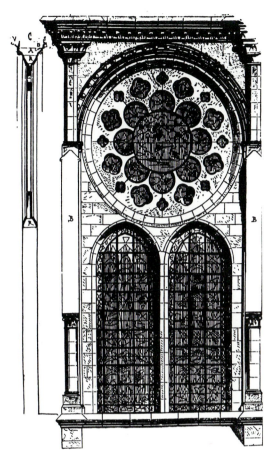
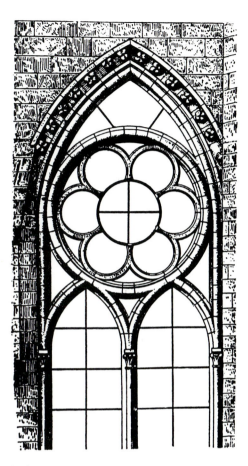

14.8 *Left to Right:* Plate tracery (After Viollet-le-Duc); bar tracery (After Charles H. Moore).

crown, rising above the town and the surrounding wheat fields, a monument to civic and ecclesiastical pride.

A reexamination of the documents concerning **Cathedral of Notre-Dame at Soissons** indicates that Soissons may compete with Chartres as the building that first developed the mature Gothic synthesis.[5] The choir and crossing were possibly constructed between 1192 and 1212—begun two years before Chartres. The nave may date from between 1200 and 1225 (not 1225 and 1250 as previously supposed). These were added onto an earlier south transept dating from 1177 to 1185, a round-ended, four-story structure similar to that at Noyon.

The south transept represents the final erosion of the four-story elevation as it developed in the nave at Noyon, placing a vaulted gallery, triforium, and clerestory above the aisle and ambulatory that curve around its semicircular end. The exterior shows the simple vertical stacking of volumes of Saint-Germer-de-Fly (fig. 13.14), Notre-Dame de Paris, and of Noyon (fig. 13.13) without having the space-articulating clerestory passage found in the transept at Noyon (fig. 13.17). The interior, however, has a delicate and diaphanous quality, the screening effect of slender columns emphasizing the slightness of its skeleton (fig. 14.11).

The chevet contains five gently undulating radiating chapels reflecting the unified plan that had gained popularity since construction of the choir of Saint-Denis, but with only a single ambulatory. In the manner of Saint-Denis, the vaults of these chapels extend over those of the contiguous ambulatory, resulting in an eight-part pattern.

The choir and the nave incorporate the heavy twelfth-century flying buttresses evident at Saint-Remi at Reims (fig. 14.10). Massively deep pier buttresses and two sturdy arches abut the wall. The

14.9 Soissons Cathedral: south transept exterior, 1177–85. (R. G. Calkins.)

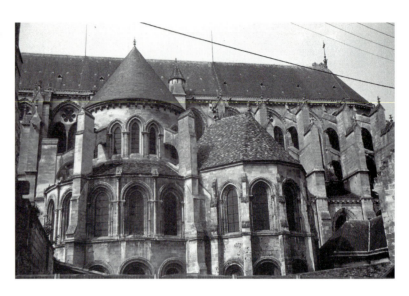

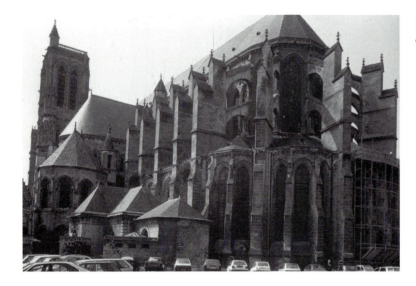

14.10 Soissons Cathedral: choir exterior, 1192–1212. (R. G. Calkins.)

lower arch responds to the forces generated by the rib vaults, while the upper serves as a wind brace.

Soissons also has a tall clerestory, equal to the height of the nave arcade, with a plate tracery rose above twin lancets—features found at Chartres. The clerestory at Soissons, however, is smaller, and the plate tracery rose has a simple six-petal form, perhaps reflecting those of the earlier choir aisle windows rather than those of the later clerestory level at Chartres.

At Soissons, the interior of the nave and choir abandons the four-story elevation of the transept

and instead uses the three-story system of nave arcade, triforium, and clerestory (fig. 14.12). Although Soissons is not as high as Chartres (97.5 feet), it is narrower (39.7 feet), and thus is more steeply proportioned (1:2.46), in contrast to the broader proportions of Chartres (1:2.17). In addition, the linear shafts and steeply pointed arches enhance the effect of verticality at Soissons. Colossal cylindrical columns still form the nave supports, now with only a single shaft applied to the nave side that rises past a two-tiered capital to the abacus. Uniform clusters of five shafts then rise from the

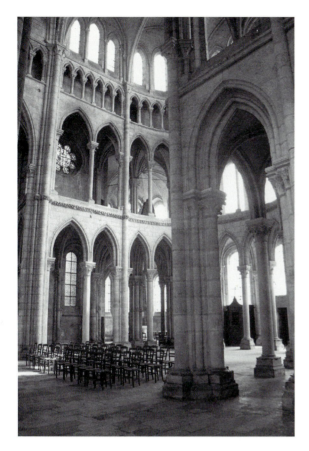

14.11 Soissons Cathedral: south transept interior, 1175–90. (R. G. Calkins.)

bays emulated the radiating **W** rib vaults of Notre-Dame, vestiges of which still appear in the outer passage of the crypt. By 1210, however, tiny octagonal chapels were added, precariously perched on alternate pier buttresses around the exterior of the chevet.

The choir and nave use an unusual three-story system that reads as a five-story elevation (figs. 14.14–14.16). The very tall nave arcade rises to a broad five-opening triforium below a triplet of lancets and an oculus in the clerestory level. In the choir, simple plate tracery forms a rose window more similar to that at Soissons than that at Chartres (in the nave, these roses change to bar tracery). The inner aisles and therefore the nave arcades are exceedingly tall (sixty-nine feet, over half the height

abacus to the four part vaults and the formerets over the clerestory windows. As at Chartres, delicate horizontal accents of stringcourses above the nave arcade and the clerestory level balance the vertical linearity of the elevation.

While this synthesis evolved at Soissons and Chartres, the cathedral of **Saint-Étienne at Bourges** developed an alternative design (fig. 13.25, *right*; figs. 14.8, 14.13–14.17). Construction of its choir took place between 1195 and 1214, contemporary with Soissons and Chartres. Construction of the nave progressed until about 1255, incorporating two small side entrance porches with sculpture dating from about 1150, and finished with the construction of a huge five-portal facade. The plan (fig. 13.25) resembles that of Notre-Dame de Paris: five-aisled, without transepts, and a double ambulatory that curves around a simple rounded apse. Even the plans for vaults of the ambulatory

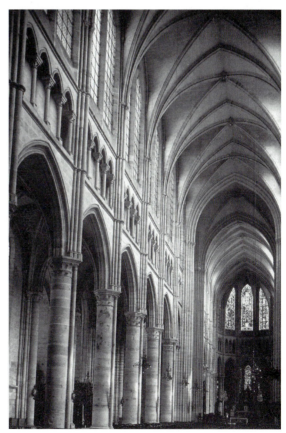

14.12 Soissons Cathedral: nave and choir interior, 1192–1225. (R. G. Calkins.)

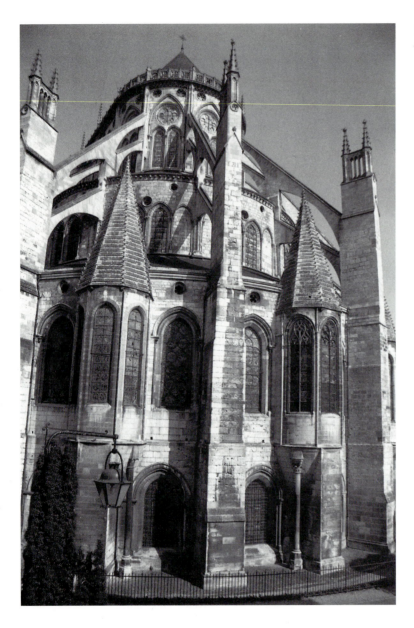

14.13 Bourges Cathedral: apse exterior, 1195–1214. (R. G. Calkins.)

of the nave at 123 feet), separated by incredibly slender cylindrical columns with thin shafts that rise to the triforium level, analogous to the *piliers cantonnés* of Chartres (fig. 14.3). Since the outer aisles measure much lower (29.5 feet), the outside wall of the inner aisle receives the same three-story elevation above its arcade as that of the nave: a broad triforium and a wide and short clerestory window. From a vantage point from across the nave, one sees, in effect, five levels of elevation—three of the inner aisle wall and an additional two above the nave

arcade. The remarkable height of the inner aisle and ambulatory and the thinness of the nave supports create a constantly shifting vista of screened spaces and a lateral expansiveness analogous to that in the choir of Saint-Denis. This visible width and openness counterbalances the soaring height of the nave and inner aisles.

Despite its innovative form, Bourges retains the archaic six-part vault system throughout, requiring alternating clusters of responds in the nave. Groups of three and five thin, widely spaced shafts rise from

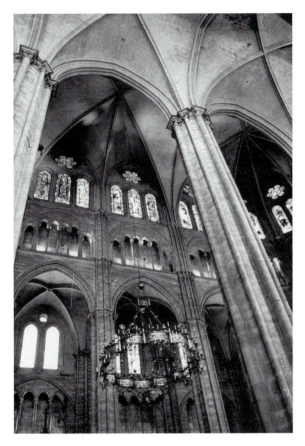

14.14 Bourges Cathedral: choir elevation, 1195–1214. (R. G. Calkins.)

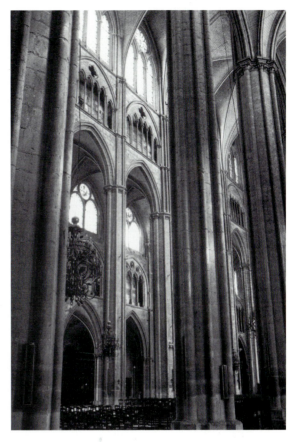

14.15 Bourges Cathedral: nave elevation through aisles, 1195–1255. (R. G. Calkins.)

the abaci of the nave columns to appropriate members above; below, three delicate shafts engaged against the nave pier do not correspond to the responds above and are too thin to convey any convincing tectonic statement. However, the diameter of the piers responding to the five shafts measure subtly greater than the intermediate piers supporting three.

Nevertheless, Bourges develops the most advanced and efficient external buttressing system of the first mature Gothic cathedrals (fig. 14.8). Deep pier buttresses rise above the outer aisle from which spring two tiers of steep, thin flying buttresses, arching to the upper inner aisle wall and to an inner intermediate pier buttress (atop the piers separating the inner and outer aisles) from which two further arches rise to the clerestory wall. Because of the staggered height of the aisles, the flying buttresses maintain a very steep angle forming a triangular

configuration that closely approximates the angle of the forces. Robert Mark determined that this system is more efficient than the more horizontal and over-built one at Chartres.[6] The arching struts of Soissons and Saint-Remi are here considerably thinned out, so much so that the second master thickened them when he completed the nave. Although the choirs of Le Mans, Toledo in Spain, and Milan in Italy copied the broad, triangular section of Bourges, its elevation, vaulting and buttressing systems were not repeated again. The proportioning and verticality established by Chartres became the basis for later variations at Reims and Amiens.

The facade at Bourges, completed by 1285 and flanked by two massive towers, covers the vast width of the building with five gabled portals that reflect its five-aisled interior (fig. 14.17). Deep pier buttresses emphatically divide the design into vertical panels penetrated with arcades and windows, but

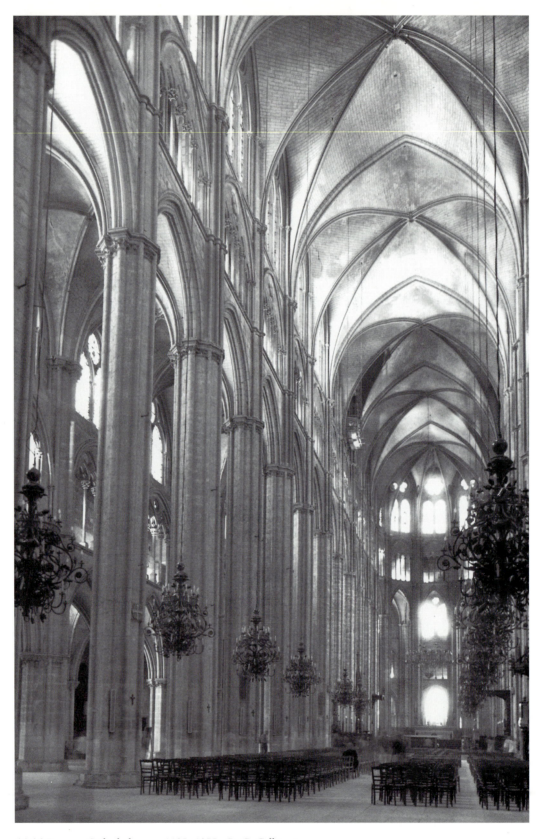

14.16 Bourges Cathedral: nave, 1195–1255. (R. G. Calkins.)

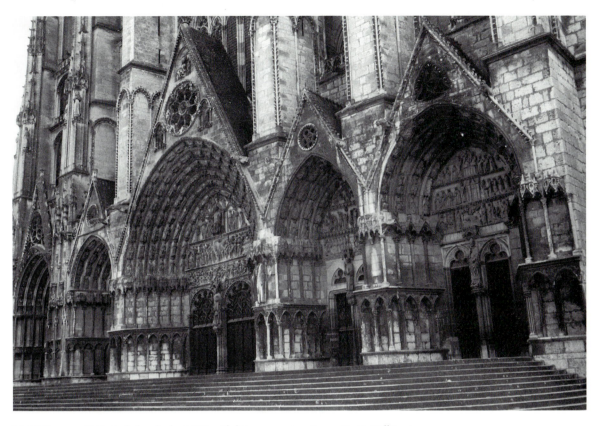

14.17 Bourges Cathedral: facade, by 1285 with later reconstructions. (R. G. Calkins.)

subsequent architects considerably transformed the effect: a huge Rayonnant tracery window by Guy de Dammartin, architect of Jean de Berry, replaced the earlier rose at the west end of the nave. The north tower, which collapsed in 1506, was rebuilt in the flamboyant style between 1508 and 1540.

The **Cathedral at Reims** (fig. 14.8, *left*; figs. 14.18–14.23) developed the Chartrain solutions further and introduced a new window tracery system that immediately became the basis for subsequent developments. St. Niçaise, the first bishop of Reims, built an early Christian style basilica on the site. Because Clovis, the first Christian king of the Franks, had been baptized here by St. Remigius, Louis the Pious asked to be crowned Emperor at Reims in 816. Subsequently twenty-five royal coronations of French kings took place at Reims until 1825. A Carolingian building emulating the plan of the Carolingian Abbey Church of Centula in northern France occupied the site in the ninth century; it may have inspired the balanced form of St. Michael's

at Hildesheim. In 1210 the town of Reims burned, destroying a late Romanesque church, necessitating replacement by the present Gothic cathedral. During its construction, considerable financial and political problems caused numerous delays.[7]

A now-destroyed labyrinth on the nave floor of the Gothic building contained the names of four architects who worked on the new cathedral. Considerable controversy surrounds the sequence and dates of these architects.[8] According to the most widely accepted chronology, Jean d' Orbais worked on the choir between 1211 and 1220 as Reims's first recorded Gothic architect. Jean de Loup continued construction between 1220 and 1236, starting the nave in 1230, and beginning work on the west portals. Gaucher de Reims took over from him in 1236, completing the chevet, the transepts, and three east bays of the nave. He may deserve credit for having the west facade sculptures in place by 1254. Although retaining the use of monumental sculpted figures placed against the splayed door jambs as at

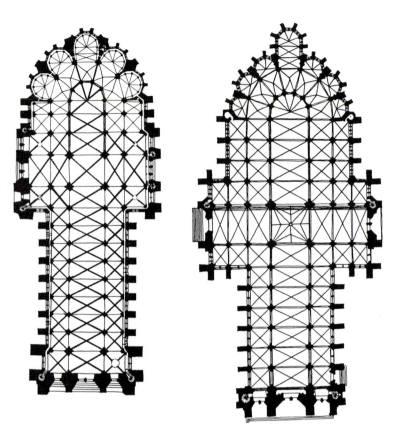

14.18 Plans, *Left to Right:* Reims, 1211–87 (after Reinhardt); Amiens, 1211–69 (After Durand).

Saint-Denis and Chartres, Gaucher, or his successor, substituted stained glass for the traditional sculpted tympana over the doors, and placed additional sculpture in the gables above the portals and on the great pier buttresses that support the towers. Bernard de Soissons continued work on the facade from 1254 to 1289, completing the four west bays of the nave and installing the great west rose above the main gable by 1287.[9] A fifth architect, Robert de Coucy, who is known from documentary sources, worked on the west facade between 1290 and 1311. Completion of the upper stories of the towers did not occur until between 1406 and 1428.

The plan of Reims (fig. 14.18, *left*) shows a greater elongation of the nave than Chartres, but more compactness of the chevet. Nine bays of the three-aisled nave precede the projecting transept, which then continues as double aisles into the choir. A single ambulatory with horseshoe-shaped radial chapels continues the undulating, unified exterior contour of the chevet (figs. 14.18–14.19). As at Laon and Chartres, the planners intended Reims to be a multitowered cathedral: stumps for the four projected transept towers are still evident. This intention formed the basis for Viollet-le-Duc's reconstruction drawing of the ideal seven-towered Gothic cathedral in the nineteenth century (fig. 14.20).

Jean d' Orbais built the choir with a three-story elevation that approximated the design of Chartres with tall aisle arcades (fifty-three feet high) supported by huge cylindrical *piliers cantonnés,* a triforium, and tall clerestory windows (figs. 14.21–14.22). He also introduced four important innovations: bar tracery windows; uniform four shafted cylindrical piers; subtle linkage of the triforium and clerestory windows; and two-tiered flying buttresses with intermediate pier buttresses around the choir.

His bar tracery windows void the walls of the aisles, chapels, and clerestory. These consist of twin lancets surmounted by a rose formed by curved bars of stone fitted together to form a skeletal armature, leaving residual areas between them open for addi-

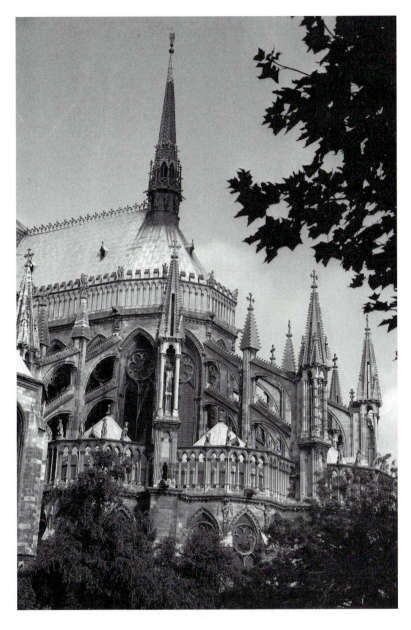

14.19 Reims Cathedral: chevet exterior, 1211–41. (R. G. Calkins.)

tional stained glass (fig. 14.7, *right*). This device erodes the heavy stone-filled mural effect of the plate tracery at Chartres and Soissons. Often the barlike stones had to be carved in exotic curved V, T, or bent X shapes linking the curve of the lancets to each other or to the circumference of the rose above.

The huge cylindrical piers with four engaged shafts designed by Jean d'Orbais for the choir and continued in the nave constituted his second innovation (figs. 14.21–14.22). These piers eliminated the

decorative alternation found at Chartres and reflect the uniformity of the four-part vaulting system above. At Reims, a broad capital of realistically carved foliage wraps around all of the shafts, effectively terminating them below the abacus; then, above, on bases of their own, regular clusters of five shafts rise to the springing of the vault, lightly tied in to the wall surface by stringcourses at the triforium and clerestory levels. The horizontal accents provided by the richly carved capitals and the increasingly lighter stringcourses above interweave

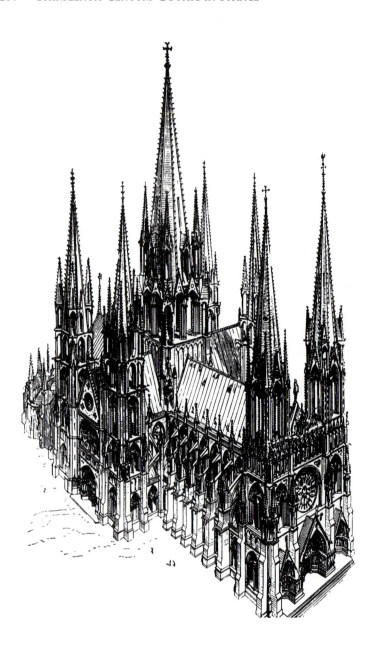

14.20 Ideal seven-towered cathedral. (After Viollet-le-Duc.)

and counterbalance the inexorable verticality of multiple lines of shafts and the steep proportioning (123/41.76 ft = 1:2.94) of the nave.

In his third innovative feature, Jean d'Orbais subtly linked the clerestory and triforium areas and began a process of fusion and overlapping that became a major characteristic of the Rayonnant style, the next major phase in the development of the Gothic. Responding to the mullion between the two lancets of the clerestory, Jean d'Orbais slightly thickened the middle column of each bay of the triforium, a device Villard de Honnecourt noticed and exaggerated in his portfolio of drawings when he visited Reims sometime in the 1230s (compare figs. 14.21, 19.3).[10] Jean d'Orbais strengthened this linkage at the sides of the bay where additional thin colonettes start at the abacus level and rise to respond to the formerets over the clerestory window. These relationships, along with Villard de Honnecourt's drawings, confirm that the builders,

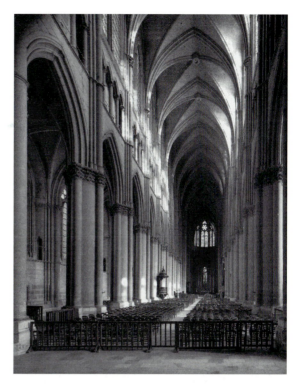

14.22 Reims Cathedral: nave, 1211–circa 1250. (Hirmer Fotoarchiv.)

14.21 Reims Cathedral: choir elevation, 1211–41. (R. G. Calkins.)

increasingly well known masters, now concerned themselves with the aesthetic details of architectural correspondences, and analyzed earlier designs to "improve" them by incremental adjustments.

Finally, Jean d'Orbais developed an innovative treatment of the flying buttresses at Reims. He created a two-tiered system around the exterior of the choir in which two arches rise from deep pier buttresses between the chapels to an intermediate pier supported on the inner edge of the dividing wall between the chapels. This system is contemporary with that used at Bourges (compare figs. 14.5, 14.19). From the intermediate piers, two separate arches rise to the clerestory wall. Because the nave only had a single aisle on each side, the two flying buttresses spring from single-pier buttresses over the aisles to the nave wall without any intermediate support.

The facade of Reims Cathedral (fig. 14.23), begun in the 1230s by Jean de Loup and completed above the west rose by Bernard de Soissons in 1287,

represents an almost complete spatial erosion of the structure, transforming the stonework into undercut sculptural relief. Panels of relief sculpture, capped by pinnacles, obscure the sides and fronts of the corner piers. Openwork tracery in the gables over the three portals overlaps the stringcourse behind them. Tall openings with tracery in the towers flank the central rose window, itself set into a large pointed arch with stained glass in the residual areas. Stained glass fills the tympana over the doors replacing the traditional sculpture. The traditional portal sculpture now resides in the gables above, reducing them to sculptural filigree. A horizontal frieze with the gallery of kings caps the ensemble. It contains gigantic statues in architectural niches that cover the gable of the nave and tie together the two towers, perhaps the work of Robert de Coucy between 1290 and 1311. Completion of the top story of the towers did not occur until between 1406 and 1428.

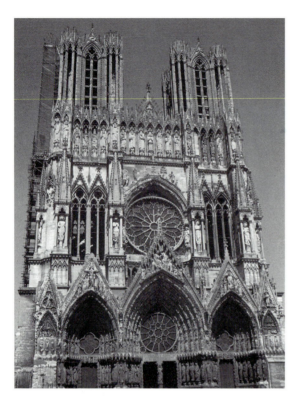

14.23 Reims Cathedral: facade, begun circa 1230–87 and later. (R. G. Calkins.)

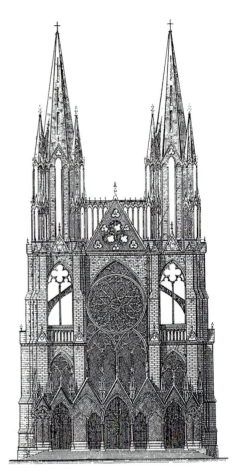

14.24 Reims, Saint-Niçaise (destroyed eighteenth century), 1231–60: facade. (After an engraving by N. de Son, 1625.)

Saint-Niçaise at Reims (fig. 14.24), built between 1231 and 1260 by Hugh Libergier and unfortunately destroyed in the eighteenth century, manifested the final development of the Gothic facade, in a style known as Rayonnant that occurred before the advent of the flamboyant Gothic (both discussed in the next chapters). Seven gables ran across the lower story, overlapping elements above, and all of the tympana and the whole west wall of the nave became stained glass.

Construction of the last of the great thirteenth-century Gothic cathedrals in France, **Amiens**, began in 1220 after a fire of 1218 that largely destroyed a previous Romanesque building (fig. 14.18, *right*; figs. 14.25–14.26). As at Reims, we know the architects of Amiens: Robert de Luzarches laid out the basic plan, starting from the west front, but including the lower levels of the choir around a small remaining church dedicated to St. Firmin, an early bishop of Amiens. This building was not torn down until the last possible moment to provide a worshiping space as long as possible until the new

nave was sufficiently completed. By 1247 most of the new nave and the apse, ambulatory and radiating chapels of the choir had been completed. After a hiatus because of the lack of funds, Thomas de Cormont and then his son, Regnault de Cormont, worked on the clerestory level of the choir in the later 1250s, also making repairs above the triforium near the crossing after the townspeople set fire to the church in 1258 during a populist uprising. The cathedral was completed by 1269. Originally two aisles flanked the nave but modifications between 1293 and 1375 resulted in deepening the pier buttresses and adding exterior chapels to each side.

Amiens constitutes the most balanced plan of the mature Gothic cathedrals (fig. 14.18, *right*), seven bays of the nave and five of the choir place the transept almost in the middle. The compact and uni-

fied exterior mass of the building further reflects this balanced arrangement. As in most of the previous Gothic cathedrals, the radial chapels gently undulate around the ambulatory with only a slightly projecting axial chapel similar to that at Reims. Unlike earlier multitowered buildings, however, Amiens's plan called only for twin facade towers.

Amiens stands among the tallest and most steeply proportioned of the mature Gothic cathedrals, fourteen feet higher than Reims (fig. 14.25): 139 feet high and 48 feet wide, the height of the nave equals 2.9 times its width. The nave arcade, at sixty feet, measures almost as high as the barrel vault of the nave at Conques. Stephen Murray has shown that the layout of the building strictly follows the 5:3 proportions of the golden section and that the crossing square, 100 royal feet (110 Amiens feet) to a side, generates the dimensions of the structure.[11] The three-story elevation and the use of *piliers cantonnés*

and four-part vaults covering wider, almost square bays, all essentially follow the Chartres model, but with important refinements. As at Chartres, the capitals of the nave supports are graduated according to their dimensions: the capital of the main cylindrical pier measures three times the height of those of the attached shafts, with the exception of the nave shaft that continues through the abacus, all the way through the decorative frieze at the triforium level, the stringcourse at the sill of the clerestory, to the cluster of capitals at the springing of the vaults.

Amiens's broad bays allow wider, more elaborate clerestory windows than those at Reims. Two pairs of lancets, each pair surmounted by a rose cluster under an encompassing arch and crowning rose, double the bar tracery formula developed at Reims. The linkage of the triforium and clerestory levels develops further, for a thin shaft connects the mullion between pairs of lancets to the sill of the trifo-

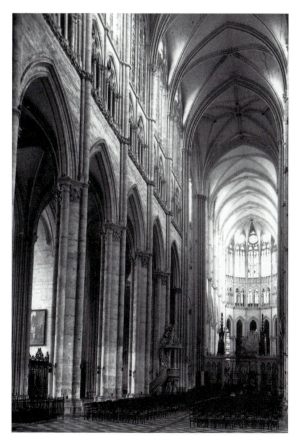

14.25 Amiens Cathedral: nave, 1220–47. (R. G. Calkins.)

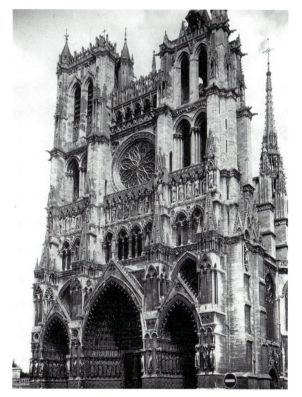

14.26 Amiens Cathedral: facade, 1220–36. (R. G. Calkins.)

rium, repeated by colonettes on each side that rise to the formeret. This linkage reinforces the unity of the clerestory and triforium, for their combined height equals the height of the nave arcade. The repetitive linear accents and the continuity of the bundled shafts further emphasize the verticality of the interior. The enhancement of the linkage between stories in the elevation leads directly to the evolution of the Rayonnant phase of Gothic in the choir completed by Thomas de Cormont and his son Regnault de Cormont between 1258 and 1269 (see chapter 16).

The facade of Amiens (fig. 14.26), laid out at the beginning of its construction in 1220 and complete to above the rose by 1236, incorporated devices used at Laon and Notre-Dame de Paris, but in more subtle and unified ways. A pronounced projecting porch with triple portals and gables ties into the fabric behind by deep pier buttresses and pinnacles that mask the difference of their frontal planes. The delicate openwork arcade across the entire facade creates spatial penetration restrained by the horizontal, corrugated texture of the sculptures in niches in the gallery of kings. The flamboyant rose, dating from 1500, replaces an earlier one. Large openings through the towers flank the rose and reiterate the higher openings into the belfry, completed on the south in 1366 and on the north in 1402. The entire facade is reduced to delicate sculptural relief with verticals of the pier buttresses broken into collections of colonettes, tabernacles, and pinnacles and balanced by delicate horizontal friezes of arcades and sculpture. Viollet-le-Duc added the connecting arcade and tracery in the nineteenth century.

These mature Gothic cathedrals manifest a refinement of the Gothic style in France. Dominated by the influence of Chartres, Reims and Amiens further developed its design, adhering to the *piliers cantonnés,* three-story elevation, four-part rib vaults, and prevalence of pointed arches. Nevertheless, within their relatively homogenous effect, they show considerable variety in design and structural solutions, increasing the height of their naves, linking triforium and clerestory levels, elaborating bar tracery windows, and thinning flying buttresses. Further, equally incremental refinements led to the Rayonnant phase that became the preferred style of the Court of St. Louis. In the meantime, however, the Gothic style was adapted later, and with distinctive variations elsewhere in Europe.

15

REGIONAL GOTHIC STYLES

In England, Germany, and Italy, the Gothic style developed later than in France: in England it began in the 1160s; in Germany after 1211; and in Italy after 1228. In these countries Gothic architecture evolved slowly out of a mix of regional traditions and local interpretations of imported elements. Incorporating many of the standard features of the Gothic, such as the rib vault and pointed arch, local builders used them in different ways resulting in distinctive regional variations.

ENGLAND

In England, the Gothic style began sporadically in various regions of the island, spurred by continued English associations with France. As with the fusion of Anglo-Saxon and Norman architecture, French Gothic influences resulted in variations that combined to form a distinctive English style. In the north of England, strong French Cistercian influences affected the details of the major constructions of the mid-twelfth century. Elements of the choir of Ripon in Yorkshire, built from about 1160 to 1170, only remotely reflect the early Gothic style in France. Ripon has a three-story elevation, originally with an attic gallery (now glazed) above the nave arcade and retention of the Norman thick wall with clerestory passage. French Cistercian influences resulted in the substitution of cluster piers (com-

posed of bundled small cylindrical shafts) rather than the cylindrical columns of early French Gothic or the *piliers cantonnés* of Chartrain style. Out of this beginning grew an elegant school of English Cistercian Gothic, exemplified by Fountains Abbey, Rievaulx, and Byland Abbeys in Yorkshire, all of the late twelfth century.

In the southeast, the destruction by fire of the choir of **Canterbury Cathedral** in 1174 permitted bringing together diverse English and French elements in a new synthesis, much as at Saint-Denis, resulting in a new English style. Canterbury already had a preeminence in the English Church, for St. Augustine, sent to Anglo-Saxon England by Pope Gregory in 597, dedicated this first cathedral to the Holy Savior (the dedication was changed in 813 to Christ Church). The usual disasters occurred: the Anglo-Saxon structure burned in 1067 and a Romanesque building replaced it, with a single transept and staggered chapels in echelon flanking the choir (fig. 15.1, *left*), built under Lanfranc, a Norman from Caen. A second transept and a huge new choir with three rectangular chapels appended to the curve of the ambulatory was begun under Prior Ernulf (1096–1113) in 1096 and finished under St. Anselm in 1130. The resulting two-transept plan resembled that of Cluny III, just as its earlier version and other Anglo-Norman churches reflected the echelon plan of the Benedictine Abbey

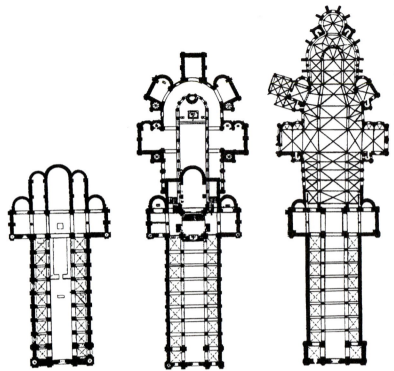

15.1 Canterbury Cathedral plans, *Left to Right:* Lanfranc's church, 1067–93; St. Anselm's church, 1093–1174; with choir of William of Sens and William the Englishman, 1174–84.

of Cluny II before 1089. Portions of the exterior wall of this construction still survive, massive blocks of masonry decorated with typical Anglo-Norman interlocking arcades and round-headed windows. Thomas Becket was murdered in a transept of this choir on December 29, 1170. This martyrdom immediately led to a popular cult devoted to his relics, even before his canonization in 1173. Perhaps in just retribution, a fire began in the town of Canterbury in September 1174, and lodged sparks in the roof of the cathedral. According to a twelfth-century chronicle by Gervaise of Canterbury, the sparks smoldered for several days before bursting into flame and destroying the choir.

Some parts of the building survived: the Romanesque nave with cylindrical columns; the transept ends with eastern chapels; a Norman hall crypt; and a shell of surrounding peripheral Romanesque chapels. But the fire essentially gutted the choir. After consulting several builders who recommended the destruction of the remaining choir because the masonry had been severely damaged, the canons engaged a French architect, William of Sens, "skilled in masonry and engineering," who at

first suggested repairing the remaining structure. As work progressed, however, it became apparent that most of the previous choir had to be torn down and rebuilt within the exterior walls of Anselm's choir. According to Gervaise, work progressed on the choir (fig. 15.2) from the remaining Romanesque nave eastward to the west piers of the east transept by 1177 and to its east piers by 1178. Unfortunately, in 1178 William of Sens fell from the scaffolding and was seriously injured. He attempted to direct the construction from his sickbed, but soon had to give up and return to France. By that time, he had probably completed the elevation and vault of the choir through the east transept crossing, and had the elevation of the next area, the presbytery beyond the east transept, completed to the level of the clerestory sill. He may even have planned the Trinity chapel and the apsidal chapel known as the "Corona" to house the severed scalp of St. Thomas à Becket.

Gervaise of Canterbury notes that William of Sens's reconstruction of the choir created "a new style," showing his recognition that the Gothic style was in fact innovative and therefore distinguishable from the Romanesque, in contrast with Abbot

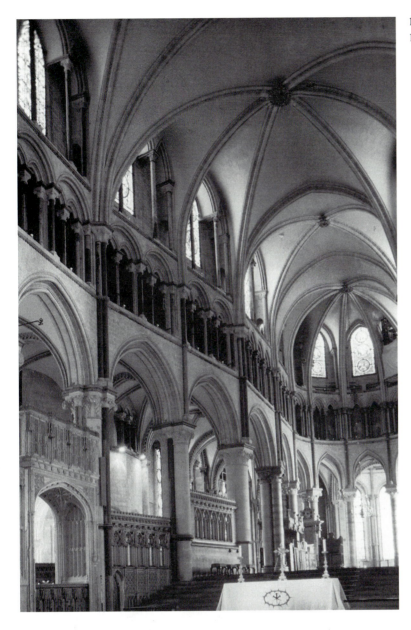

15.2 Canterbury Cathedral: choir, 1174–circa 1184. (R. G. Calkins.)

Suger's comments about his "new" construction at Saint-Denis, merely meaning that it was recent. William of Sens provided two bays of the liturgical choir with sexpartite vaults of the same height as the vault of the surviving Romanesque nave, but springing from the same level as the gallery arcades. Alternate octagonal and round piers respond to the vaulting system. A gallery with two sets of paired arches opens into the attic space above the aisle on the north side, as at Sens; on the south they opened into a vaulted gallery with exterior windows.

William of Sens buttressed the forces generated by the vaults with triangular spur walls that project above the low roof of the south gallery to abut the exterior clerestory wall between the windows. As a concession to the Anglo-Norman tradition, his clerestory had a wall passage. He also added decorative shafts of dark polished limestone, called "Purbeck marble," a tradition imported by masons from the Franco-Belgian border area around Arras, Cambrai, Valenciennes, and Tournai. Dark single and triple shafts rise from the abacus of the main piers,

and clusters of them support the gallery arcades, creating a dark horizontal band at that level. These shafts surround the main piers of the crossing of the east transept, and just beyond in the bottom arcade of the Trinity Chapel, William of Sens used the paired cylindrical columns of Sens Cathedral, alternating with single cylindrical ones but adding Purbeck marble shafts to them.

When William of Sens had to return to France, William the Englishman completed the vaults of the presbytery, the outer transept bays, the Eastern Crypt (1179–80), the Trinity Chapel (1181–84), and the Corona. William the Englishman retained the six part vaults of the first two bays of the presbytery but used a four-part vault next to the terminal bay with radiating ribs at the end of the horseshoe-shaped Trinity Chapel. He varied details of the elevation, doubling the clerestory windows in each bay, and substituting a triforium with uniform arcades for the attic gallery. He retained the use of Purbeck marble shafts, but varied their arrangement, clustering some around the crossing piers of the east transept. He also placed rudimentary flying buttresses against the clerestory wall in the form of thin arches above the gallery roof (fig. 15.3), probably about 1184. However, he retained arched diaphragm walls within the gallery that bore the real thrusts of the vaults.

Meanwhile in the southwest, the Gothic Cathedral of St. Andrew's at **Wells,** begun about 1200 (fig. 15.4) reflects the English predilection for length, as at St. Alban's, Ely, and Peterborough. Wells was extended even further with later additions of a second transept, a retrochoir, and a lady chapel in the fourteenth century. The nave elevation breaks with Continental traditions. Although it has a four-part vault and a three-story elevation, the details and emphasis differ entirely. Multiple archivolts corrugate the sharply pointed nave arcades and continue into twenty-four shafts engaged on the compound piers so complex they totally obscure their basic cores. Except in the last bay of the transepts, Wells abandons clusters of shafts linking stories together. Above a pronounced stringcourse, a heavy band of gallery arcades opens into the attic roof above the aisle. Beneath this roof, undercover buttresses, segments of pointed arches, abut the nave and transept walls (fig. 15.3). Above another strong horizontal stringcourse, a tall clerestory almost equal in height to the nave arcade contains

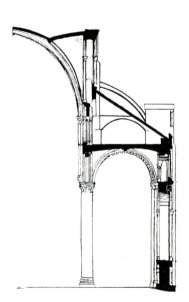
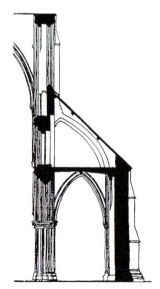
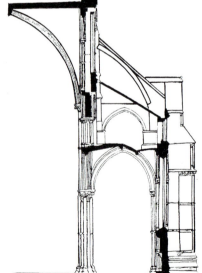

15.3 Sections: *Left to Right:* Canterbury, choir, 1174–circa 1184; Wells, transept, circa 1200–25; Lincoln, nave, 1192–80.

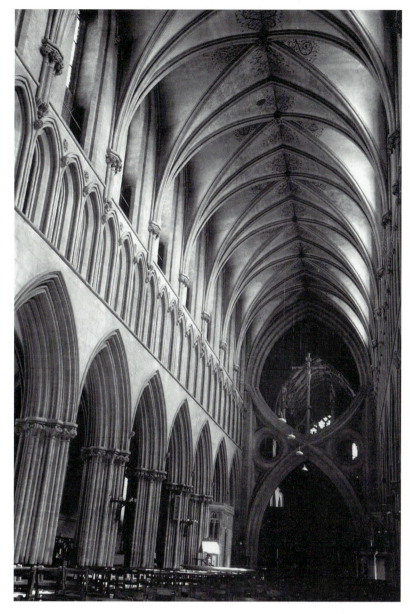

15.4 Wells Cathedral: nave interior, circa 1200–25. (R. G. Calkins.)

the traditional thick wall with wall passage. The vaults spring from a short cluster of shafts perched on corbels unceremoniously pinched between the intersecting curves of the gallery arcades. The persistent decorative linearity of colonettes and archivolts prevent any tectonic statement of structure. So many archivolts exist in the nave arcades that they collide at a sharp angle above the piers, as do the arches of the gallery arcade above. They make no vertical connections between stories; rather, the nave wall reads as a series of differently textured horizontal layers, repeated in the steady corrugation of the gallery level, that accentuate the length of the building. Wells thus develops the strong horizontality occurring at Southwell Minster and elsewhere in Romanesque England in the twelfth century in a Gothic idiom. The massive scissorlike arches abutting the crossing piers were built in the fourteenth century as added supports for the lantern tower above.

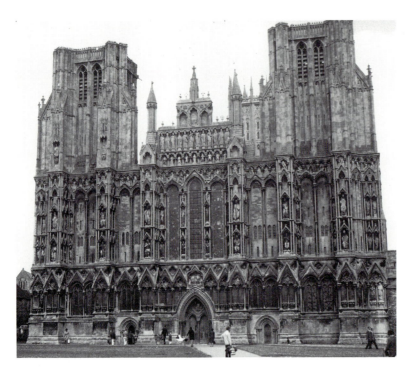

15.5 Wells Cathedral: facade, circa 1225–40. (R. G. Calkins.)

The great screening frontispiece of the west facade was built between 1220 and 1240 (fig. 15.5). This facade differs completely from those found on the Continent, consisting of a wide fabric completely covered with decorative arcades and niches with sculpture evenly spread across the pier buttresses of the towers and wall surfaces rather than concentrated around the portals. Its form may derive from the Anglo-Norman Romanesque interpretations of screen facades of Poitivan and Angevin Romanesque buildings.

Salisbury Cathedral, dominated by its massive, tall, early fourteenth-century tower (404 feet), follows the English tradition. With its extreme length, double transept, and square chancel with rectangular ambulatory, it manifests the purest form of early English Gothic (figs. 15.6, 17.1, *left*). Although its construction coincided with that of Amiens Cathedral (1220–1270), its exterior and interior effects are completely different. As at Wells, the facade of Salisbury creates a simple screenlike frontispiece tacked onto the front of the building, but substitutes flanking square stair turrets for Wells's tall twin towers. Here, as at Wells, decorative arcading and relief sculpture emphasize the pla-

narity of the facade by their even placement across the fabric.

In the interior (fig. 15.6), the east transept and choir of Salisbury, proportionally scaled down, constitutes a church within a church serving as the canons' choir. This liturgical space is further differentiated by eight shafts around its main supports. Before it, a tall lantern originally lit the main crossing as at Laon, before the construction of the crossing spire. In the nave (fig. 15.6) almost square bays with four-part vaulting cap the three-story elevation of a nave arcade on cylindrical columns; an attic gallery above a pronounced sill; and triple lancets in the clerestory with wall passage.

The varied colored and textured effects of Purbeck marble shafts differentiate the levels of the elevation and emphasize horizontality rather than verticality. Tall cylindrical nave columns have four dark shafts placed at their cardinal points, creating a salt-and-pepper effect, topped by a totally white band that corresponds to the archivolts and spandrels between the nave arches. In the gallery, an intense clustering of the dark Purbeck marble colonnades above a strong stringcourse creates a dark horizontal band. With single dark shafts rising

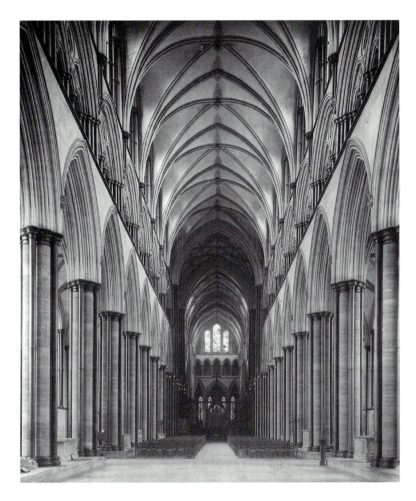

15.6 Salisbury Cathedral: nave, 1220–66. (Foto Marburg/Art Resource, N.Y.)

through the spandrels of the gallery arcade to the clerestory, and then another mix of dark colonettes and white wall in the clerestory area, the final effect results in five pronounced horizontal bands defined by gradations of color down the length of the nave.

GERMANY

In Germany, meanwhile, the Gothic had a more tentative start at the Abbey Church of **St. George at Limburg an der Lahn** (figs. 15.7–15.9). Although it was built between 1211 and 1235, and thus contemporary with Reims, its interior resembles more those of the early Gothic buildings in France. Limburg is a vigorous transitional building with the seven-towered format like Laon, presenting a massive but picturesque silhouette, appropriate for its

crowning position over the town and the winding Lahn valley. Exterior details, although garishly accentuated with ocher and yellow paint since World War II, reveal a mixture of round and pointed arches. The "helm" roofs on the towers that allow for pointed gables on each of their faces derive from a German Romanesque tradition, as do the decorative eaves arcades and arched corbel tables.

The solidity of the exterior, however, contrasts with the muscular and energetic space-holding interior, a remarkable combination of sturdiness and openness. Its four-story elevation resembles that of Laon and Noyon, crowned by domical six-part vaults and responded to by alternating supports of massive compound and intermediate square piers. Alternating single and clustered shafts rise through the ample gallery level and triforium to the spring-

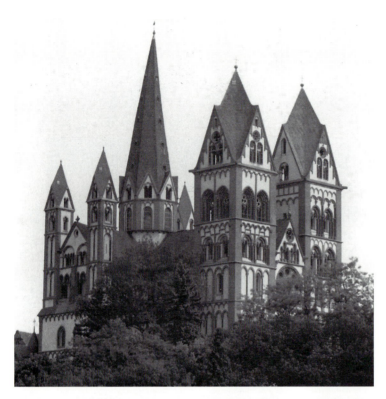

15.7 Limburg an der Lahn, St. George, circa 1211–35: view. (R. G. Calkins.)

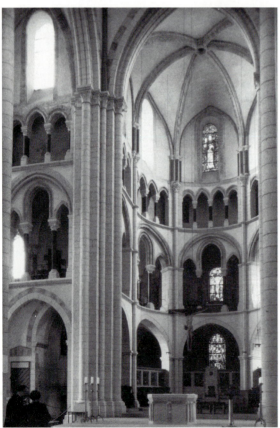

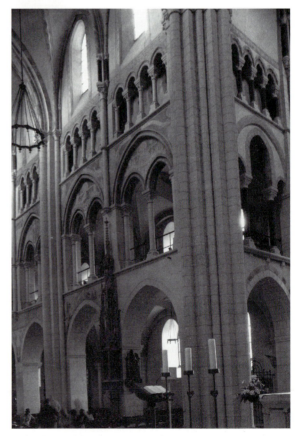

15.8 Limburg an der Lahn, St. George, circa 1211–35: choir interior. (R. G. Calkins.)

15.9 Limburg an der Lahn, St. George, circa 1211–35: nave elevation. (R. G. Calkins.)

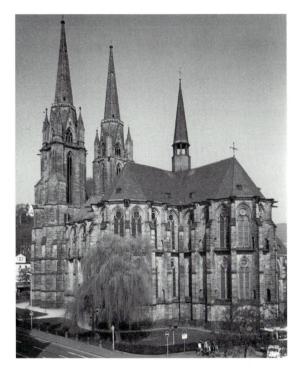

15.10 Marburg, St. Elizabeth, 1235–83: choir exterior. (R. G. Calkins.)

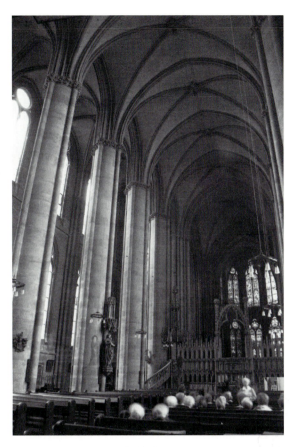

15.11 Marburg, St. Elizabeth: nave interior, 1235–83. (R. G. Calkins.)

ing of the vaults. Slightly pointed clerestory lancets penetrate massive walls. The choir in particular, where dark columns emphasize the voids of the gallery and triforium arcades, presents an especially vigorous and open interior.

When the mature Gothic arrived in Germany at **St. Elizabeth at Marburg** (figs. 15.10–15.11), it manifested itself in a remarkable combination of the hall church format and a refined, austere Gothic vocabulary. Begun in 1235 and completed by 1283, most scholars consider St. Elizabeth the work of a German architect familiar with the cathedrals at Soissons and Reims. For instance, the form of the bar tracery windows and the device of wrapping the capitals of naturalistic foliage around the tall cylindrical piers and their engaged shafts reflect the *piliers cantonnés* at Reims. Nevertheless, the plan, with trefoil arrangement of a rounded apse and transepts, repeats the formula found at Tournai, Noyon, and in Romanesque churches at Cologne. The exterior is unified and compact, pulled together and tidy as a result of the interior organization. The facade with

its twin towers, creates a reduced, even sterilized, version of the twin-towered facades of French cathedrals of this period, without their sculpted portals and open tracery arcades.

The nave and the aisles of St. Elizabeth are of equal height, forming a hall church that became the source of many later German variations. Because the nave arcade rises to the level of the springing of the vault and the aisles have two levels of bar tracery windows, patterned after Reims, light floods into the interior. The visibility of the aisles from the nave, screened by the slender nave columns, creates a unified interior space. As a consequence, the exterior consists of two levels of identical windows and stepped-out pier buttresses penetrated with small openings on the upper level, creating a relatively uniform, though slightly recessed wall surface. At Marburg, the Germans captured the essence of Gothic skeletonization, developing a new delicacy

and lightness of form that they then developed in new directions.

ITALY

In Italy the Gothic style also arrived late, combining with strong indigenous influences that dramatically changed its character.[1] At **S. Francesco at Assisi** (figs. 15.12–15.13, 15.20, *left*), perched on a mas-

sive abutment on the side of Monte Ricco, a two-story church was begun in 1228 to house the remains of St. Francis who was canonized in that year, but had died two years earlier. The basilica may have been substantially complete by 1239 but its consecration did not occur until 1253. S. Francesco forms a two-story, aisleless building with single nave and projecting transepts and single apse beyond on both levels. Heavy semicircular turrets

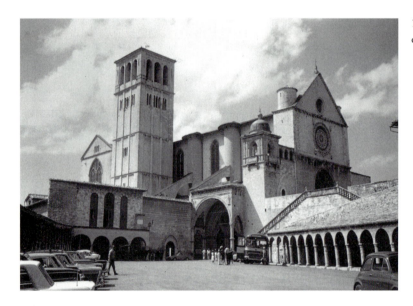

15.12 Assisi, S. Francesco, 1228–53: exterior from southeast. (R. G. Calkins.)

15.13 Assisi, S. Francesco, 1228–53: upper church, nave interior. (Alinari/Art Resource, N.Y.)

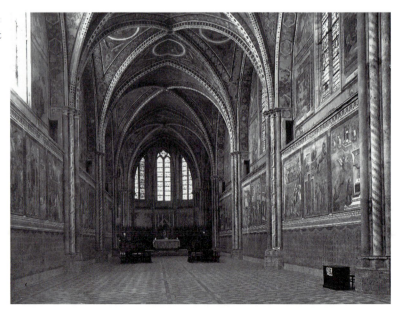

serve as exterior buttresses. The plain, blocklike exterior manifests a Romanesque character. Only thin paired lancet windows with pointed arches visible between the buttresses give a hint of Gothic detailing on the exterior.

The plain, mural character of the interior essentially follows the dominant effect of early Christian basilicas as it continued through the Romanesque, as at S. Angelo in Formis (fig. 11.7), but basic, subdued elements of Gothic structure begin to articulate it. Instead of the timber roofs of these earlier buildings, Assisi used rib vaults extending over square bays in both the upper and lower churches. In the Lower Church, the low domical rib vaults with massive diagonal ribs of square profile form semicircular arches like those of S. Ambrogio in Milan (fig. 11.20). In the upper church (fig. 15.13), the vaults reach higher but still have a domical form. The diagonal ribs became relatively lighter with round profiles, though still semicircular. Only the transverse arches separating the bays have pointed arches. These ribs and arches spring only slightly above a walkway at the foot of the clerestory level, responded to by clusters of five thin colonettes. But the shafts engage against a wall, and they, the ribs, and the arches are all painted with designs that reduce their structural

statement to a decorative one. Perhaps one could classify the nave wall as a two-story elevation, but it consists only of a flat surface on the lower level and a recessed tympanum-like lunette penetrated by a narrow lancet window above. The heavy arch encircling the recessed clerestory wall emphasizes its murality. All of the walls are painted, either with picture cycles, or along the dado, with simulated hanging tapestries that merely reassert their surfaces. Thus, the nave appears unified and spacious, its subdivisions barely discernible. It is horizontally rather than vertically oriented and bounded by decorative planes. The Italians had little interest in articulating the skeletal nature of the bays.

The great cathedral at **Siena** (fig. 15.14, *left*; fig. 15.15), begun perhaps about 1226 and virtually completed by 1264, achieved a totally different effect. The three-aisled building has a wide transept surmounted by a huge hexagonal dome and a square chancel at the end of the choir. Marble veneer with dark horizontal stripes sheathes the exterior, continuing the decorative planarity of Pisan and Tuscan buildings. The facade constitutes a mere marble frontispiece in rich decorative relief. Giovanni Pisano added large statues in tabernacles to the piers of the facade about 1300. Embedded in the plan, but

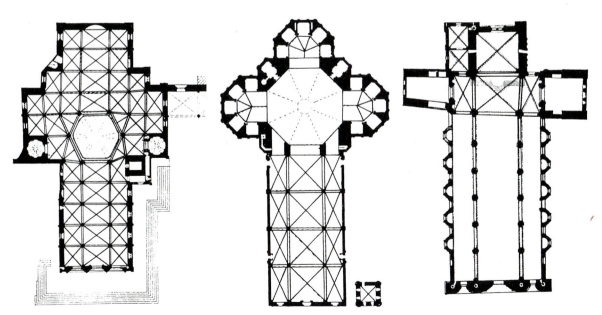

15.14 Plans, *Left to Right:* Siena Cathedral, circa 1226–64; Florence Cathedral, begun circa 1294, revised 1357 and 1366; Orvieto Cathedral, begun 1290. (After Dehio and Bezold.)

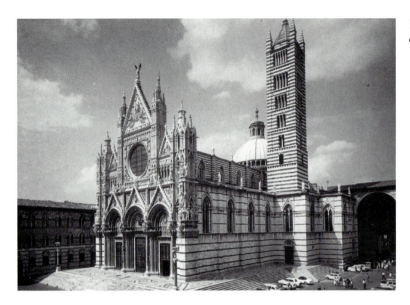

15.15 Siena Cathedral, circa 1226–64: exterior. (R. G. Calkins.)

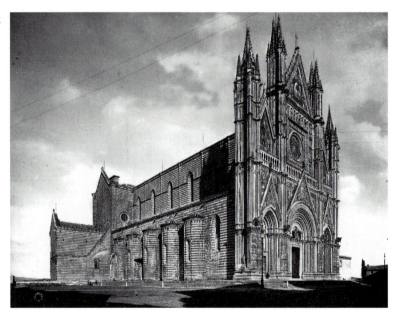

15.16 Orvieto Cathedral, begun 1290; exterior. (Alinari/Art Resource, N.Y.)

detached from the clerestory rises a tall semide-tached square campanile, reflecting the earlier Italian tradition of detached bell towers.

The interior (fig. 15.17), with its two-story elevation of nave arcade and clerestory, continues the decorative tradition found in earlier Tuscan buildings. Dark horizontal stripes decorate the walls and massive compound piers. A heavy sculpted frieze emphasizes the horizontal sill of the clerestory. The thick ribs and arches of the vaults, square in profile, form painted arcs of ornament. Four-part rib vaults cover square bays in the nave and transverse arches are round rather than pointed, accentuating cubic units of space. The only pointed arches occur in the longitudinal arches over the clerestory windows. Thus, again, the structure emphasizes horizontality rather than verticality and decorative linearity rather than structural veracity.

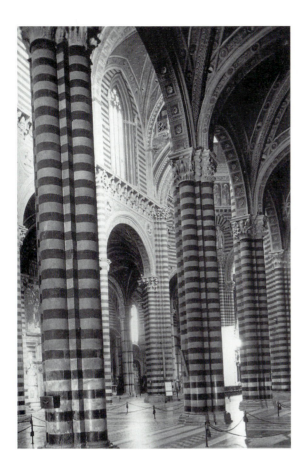

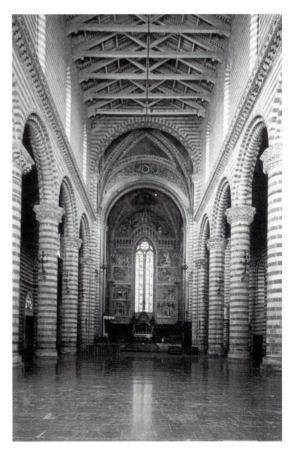

15.17 Siena Cathedral, circa 1226–64: nave, vaulted 1256–60. (R. G. Calkins.)

In 1339 the Commune of Siena decided, perhaps in competition with ambitious plans for expansion of the cathedral in rival Florence, to build a huge addition, turning the existing building into a mere transept of a vastly larger structure. The Sienese built only part of the new facade and the east nave arcade. The resulting incomplete structure serves as the Museo del Opera del Duomo housing Duccio's *Maestà* altarpiece. Work halted in the face of buttressing difficulties, declining prosperity, and then the outbreak of the plague in 1348.

The cathedral in the hill town of **Orvieto** (fig. 15.14, *right*; figs. 15.16, 15.18) follows the Sienese tradition of decorated vaults in the crossing and choir but abandons the rib vaults for a timber truss roof in the nave, intentionally emulating the early Christian basilica of S. Maria Maggiore in Rome. Decorative marble veneer with the dark horizontal stripes again covers all exterior and interior wall surfaces and piers of Orvieto. Round arches, a strong horizontal cornice, and horizontal stripes dominate the two-

15.18 Orvieto Cathedral, begun 1290: nave. (R. G. Calkins.)

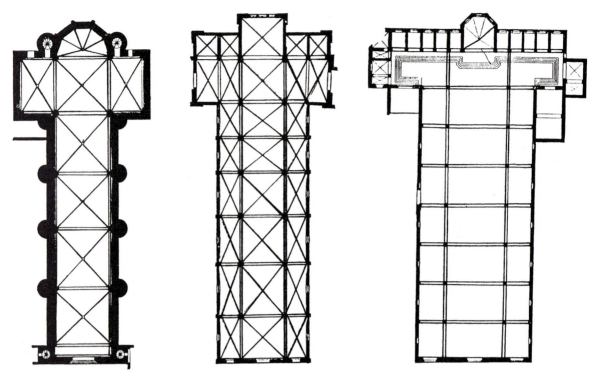

15.19 Plans: *Left to Right:* Assisi, S. Francesco, Upper church, 1228–53 (After Kleinschmidt); Florence, S. Maria Novella, begun 1279 (After Dehio and Bezold); S. Croce, by Arnolfo di Cambio (?), begun 1294/95 (After W. Paatz).

story elevation of the interior. The facade with pictorial mosaics in the gables and on wall surfaces, a flat frontispiece, has the form, planarity, and coloristic richness of a painted triptych. Marble latticework surrounds the filigree of the rose, and Lorenzo Maitani applied shallow, busy sculpted narrative reliefs to the lower pier buttresses between 1310 and 1330. The exterior aisle walls with their series of semicircular projections contain small chapels recalling the semicircular buttresses along the exterior of S. Francesco at Assisi (fig. 15.12).

The Florentines broke with these decorative, atectonic traditions in favor of other perceived requirements. At **S. Maria Novella** (fig. 15.19, *center*; fig. 15.20), founded by the Mendicant order of the Dominicans in 1279, the plan consisted of a simple three-aisled church with transept and four echelon chapels at the east end, flanking a square chancel. In the tradition of S. Miniato al Monti, application of a marble veneer facade began in 1310 but it remained unfinished until Alberti finally completed it in 1470. In the nave (fig. 15.20), decidedly pointed transverse arches and diagonal ribs support domical rib vaults over square bays. Decorated ribs and dark compound piers with shafts contrasting with white walls boldly articulate the defining elements of the bay. S. Francesco in Bologna first used this structural system between 1236 and 1250 in a slightly heavier form. S. Maria Novella, however, introduced a new openness and logical clarity of design: high, wide nave arcades open into aisles that extend over two-thirds the height of the nave, giving it the airiness and amplitude of a hall church, with good visibility and acoustics admirably suited to its function as a preaching church. The height of the nave arcade leaves only room for lunette-shaped clerestory walls and small oculi for windows.

Arnolfo di Cambio reputedly designed **S. Croce** in Florence, the Franciscan counterpart of S. Maria Novella, about 1294. This church serves its intended function as a preaching interior equally well. Perhaps in keeping with the Franciscans' closer adherence to the vow of poverty and avoidance of ostentation, the three-aisled church is simply roofed

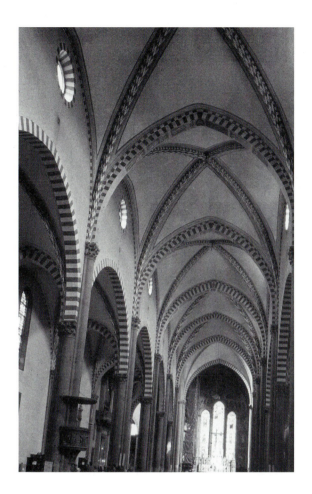

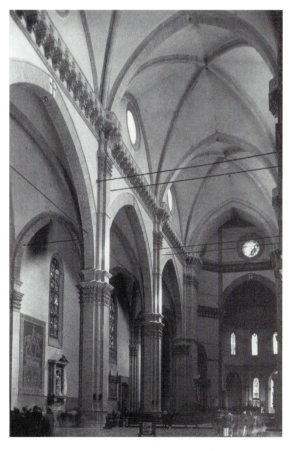

15.20 Florence, S. Maria Novella, begun 1279: nave. (R. G. Calkins.)

with timber trusses, the only vaulting occurring in the choir and multiple-echelon chapels along the east side of the transept (fig. 15.19, *right*; fig. 15.22). Wide, slightly pointed nave arcades supported on octagonal piers provide access to the high aisles and again create an effect of spatial unity approaching that of a hall church. A strong, corbelled cornice emphasizes the horizontality and length of the building, essentially a fourteenth-century re-evocation of the planar walls and atectonic space of the Early Christian basilica.

The **Cathedral of Florence** (fig. 15.14, *center*; fig. 15.21), S. Maria del Fiore, repeats on a larger scale the essential characteristics of S. Maria Novella: three aisles, domical rib vaults over square bays, and an emphasis of the structural elements in dark stone against white walls and vaults. Begun in 1296 by

15.21 Florence, Duomo, begun circa 1294, revised 1357 and 1366: nave interior. (R. G. Calkins.)

Arnolfo di Cambio, a timber roof may originally have been intended. Continued controversies and revisions surrounded the original plan. Francesco Talenti redesigned a trilobed east end in the 1350s, then a consortium of advisors vastly expanded it in 1366, and Brunelleschi again redesigned and completed the east end including its huge octagonal dome in the fifteenth century. Giotto, as Capomaestro del Duomo, designed the detached bell tower in 1334 that was eventually built almost according to his plans. A marble veneer facade, reflecting the earlier Tuscan tradition of polychomed sheathing, was applied in the nineteenth century. Inside Sta Maria, slender compound piers and wide nave arcades create an openness similar to that of S. Maria Novella. As at Siena and Orvieto, a heavy cornice divides the area of the slightly pointed nave arcade and the clerestory with a small oculus above, contributing to the horizontal effect of the interior.

When the Gothic appeared in Venice in the fourteenth century, it occurred as a variation of the above churches. The three-aisled structure of **S. Maria Gloriosa dei Frari** (fig. 15.23), begun by the Franciscans in the 1330s, has wooden domical rib vaults covering square bays with eastern transepts and four echelon chapels flanking the choir—like those at S. Maria Novella in Florence. The simple exterior of brick reflects the straightforward arrangement of interior spaces, like those in early Christian basilicas. The tall cylindrical piers, wide slightly pointed nave arcade, and high aisles again create a unified and open interior. Dark shafts, ribs, and

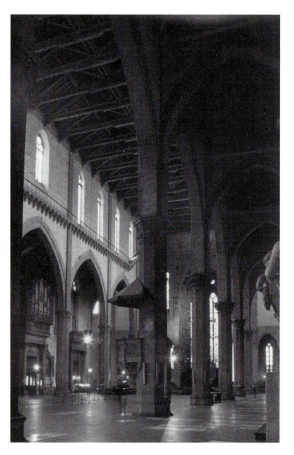

15.22 Florence, S. Croce, begun 1294/95: nave from aisle. (R. G. Calkins.)

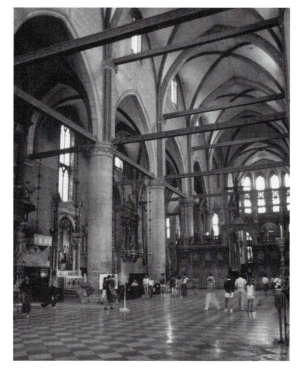

15.23 Venice, S. Maria Gloriosa dei Frari, begun 1330s: nave interior. (R. G. Calkins.)

arches contrast with light surfaces. The Venetians abandoned the horizontal cornices of Florence and Siena, but the presence of longitudinal and lateral timber tie beams spanning the aisles, nave, and nave arcades mitigate the potential verticality of the bays: the two ranges of tie beams in the nave were necessary, for external flying buttresses were not possible. The church is built on piles sunk into to the mud of the lagoon and this system would not have provided them adequate stability. In the late fourteenth century apse, the double tier of traceried windows reduce the seven-faceted wall to a diaphanous latticework similar to St. Elizabeth at Marburg. Very similar in plan, construction, and effect is SS. Giovanni e Paolo, begun about 1333 by the Dominicans. Both buildings carry the Venetian development of the Gothic skeleton to its fullest potential.

Although these Florentine and Venetian buildings most closely reflect the skeletal bays of the French Gothic, their interior openness, allowing for good visibility and acoustics, was not achieved in the French counterparts. The Venetians replaced the French logic of structural relationships with a new delicacy and lightness of walls and supports, thereby retaining the thinness and planarity of the Italian tradition stemming from the early Christian basilica. Elsewhere in Italy, this planarity was emphasized by the decorative veneer applied to the exteriors and interiors of some buildings. The English continued their penchant for horizontality, even in their adaptations of the Gothic style, emphasized the colored accents of Purbeck marble shafts, and the Germans found their own strength in adapting the new style to the hall church format.

16

THE RAYONNANT STYLE
IN FRANCE AND
EUROPEAN IMITATIONS

The earliest manifestation of the Gothic architectural style appeared at Saint-Denis; its ultimate refinement, called the Rayonnant Style (after *rayonner,* the French word meaning to radiate light) also first developed at Saint-Denis, but about a hundred years later. The Rayonnant does not represent a major transition in structure or style but the final resolution of design relationships and structural solutions that architects like Jean d'Orbais and Robert de Luzarches had incrementally fine tuned throughout the first half of the thirteenth century. The resulting phase of Gothic embodied the full realization of the logic generated by the vaulting system, and an elegance and lightness of structure that became synonymous with the Capetian Court in France and was emulated throughout Europe.

After about 1160, **Saint-Denis** had been left with a massive two-tower westwork, an early Gothic choir, perhaps part of a north transept, and an intervening Carolingian basilica (fig. 13.6). By 1231, Abbot Suger's choir showed signs of structural weakness, so sturdier columns replaced the inner row separating the aisles and hemicycle of the choir. The upper stories were also rebuilt with a new configuration of windows: stained glass appears behind a glazed triforium and high elaborate bar tracery windows with multiple lancets occur in the clerestory. These windows replaced the twelfth-century attic gallery and simple lancet windows in the original

design (fig. 13.9, *top*). At this time, flying buttresses were either added or rebuilt to abut the upper external wall. The resulting new elevation and uniform four-part vault system over rectangular bays in the choir were repeated throughout the new nave after 1235 (fig. 16.1), replacing the old Carolingian one.

These modifications represent a significant advance in Gothic architectural design. The visual linkage of the clerestory and triforium level constitutes the final logical refinement achieved in this elevation. Windows penetrate both levels, and bundled shafts link the mullions and arches of the windows above to rhythmic subdivisions of the triforium arcades below. At Saint-Denis, these linear linkages that Robert de Luzarches boldly stated at Amiens combine with the glazed triforium. Likewise, the main piers, which consist of a square core with shafts on each face corresponding to the layered archivolts of the nave arcades, now also contain a bundle of three shafts responding to the converging diagonal ribs and the transverse arches of the vaults above. These shafts descend uninterrupted through clerestory and triforium levels to the bases of the compound piers at the floor level. The logic of the supports for the vaulted canopy thus extends throughout the building's entire height. In addition, the delicacy of the structural members, slender, multiple linear accents, reinforces the linking and overlapping verticality of stories. The lowered roof over the aisle, bare-

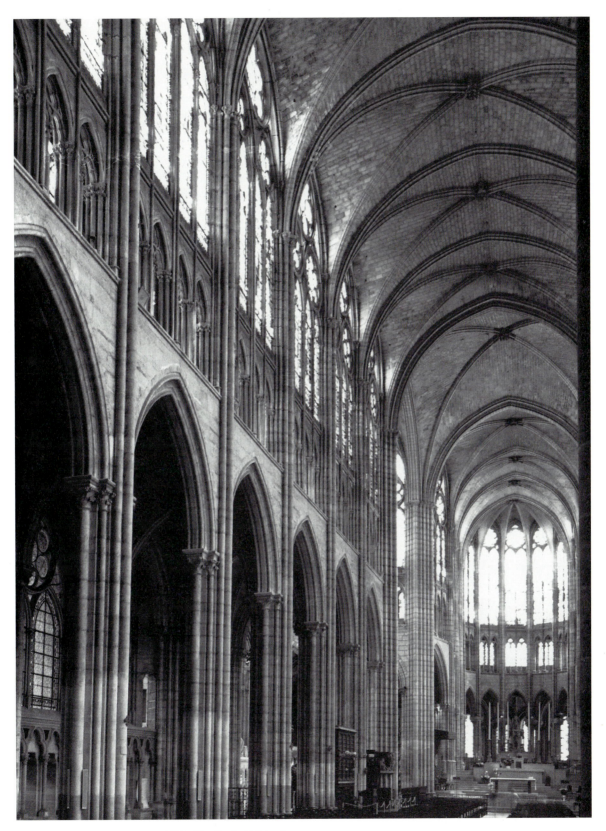

16.1 Saint-Denis: nave interior, 1235–80. (R. G. Calkins.)

ly sloping to the outside, made the glazed triforium possible at Saint-Denis; elsewhere, as at the choir of Amiens, conical roofs over surrounding chapels free up the wall surface for additional windows.

A variation of this Rayonnant system appears in the **choir of Amiens Cathedral**. Although Robert de Luzarches laid out the choir at Amiens cathedral around the remains of the old church of Saint-Firmin, Thomas de Cormont and his son Regnault de Cormont completed the elevation of the choir, mostly after a fire of 1258 and before 1269. On the exterior (fig. 16.2), radial chapels, undulating about the apse and placed between pier buttresses continue the unified plan begun at Saint-Denis. Conical roofs cap the chapels, freeing up the triforium wall to contain stained glass. The choir's exterior exhibits another feature of the Rayonnant style. Thin, planar gables, punctured by tracery, project above the balustrade of the roof and terminate in pinnacles—a further development of the device

of overlapping and linking levels of the building. Similar ornamented gables embrace pairs of cusped arches on the interior of the glazed triforium.

The use of diaphanous tracery buttresses (fig. 16.3) also distinguishes the Rayonnant exterior, creating a further thinning out of the forms that began to appear on the east sides of the transepts and around the choir at Chartres (fig. 14.7) where heavy arched spans of nave buttresses eroded into minimalist, taut, harp-string arcades around its choir. At Amiens, bar tracery arcades within the buttress take on a purely decorative quality between the lower arch of a single course of stones and the upper straight diagonal strut that serves as a wind brace. The unified exterior mass of the chevet, encrusted by thin, penetrated gables, dissolved buttresses, and the delicate filigree of pinnacles, is reduced to a decorative, insubstantial latticework.

Within the choir of Amiens (fig. 16.4), delicate forms also prevail, linking clerestory and triforium by light from windows in both levels, and by linear

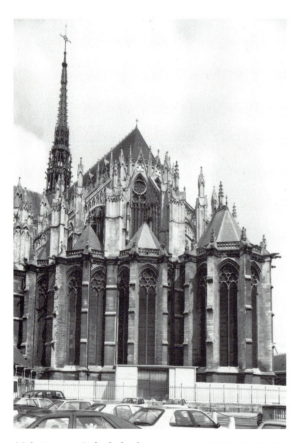

16.2 Amiens Cathedral: choir exterior, 1258–69. (R. G. Calkins.)

16.3 Amiens Cathedral: choir buttresses, 1258–69. (R. G. Calkins.)

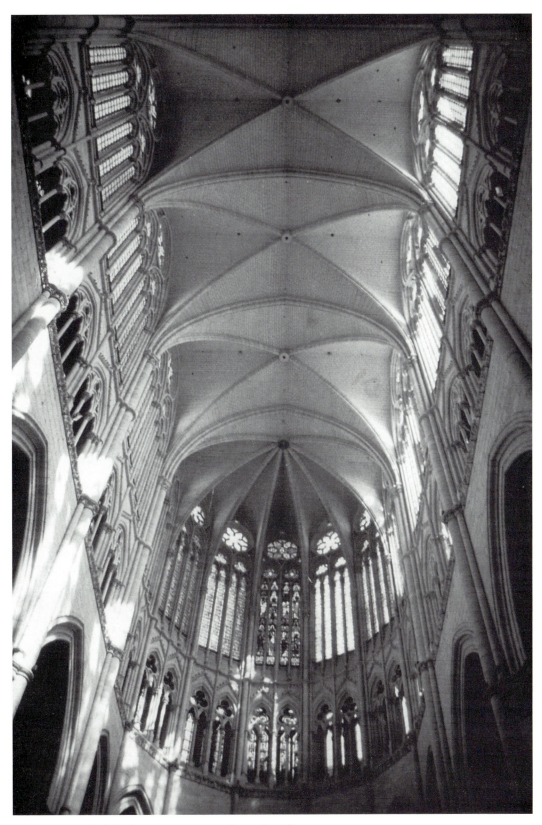

16.4 Amiens Cathedral: choir interior, 1258–69. (R. G. Calkins.)

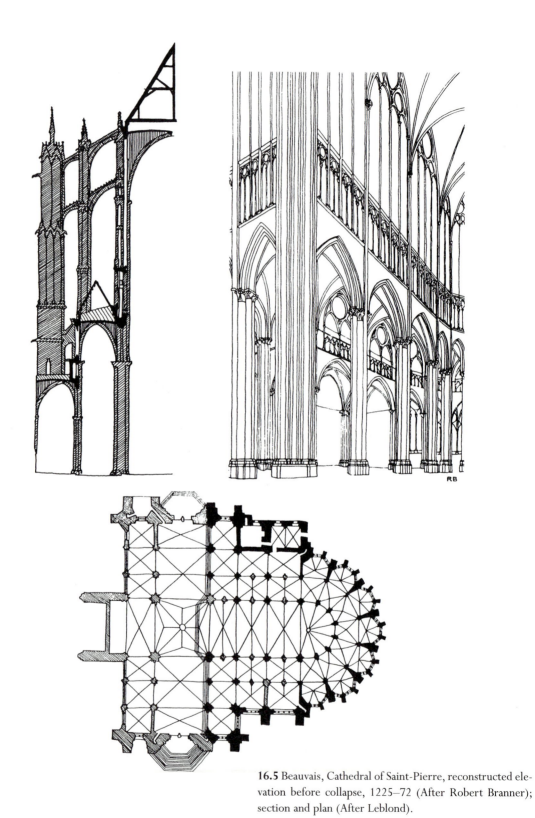

16.5 Beauvais, Cathedral of Saint-Pierre, reconstructed elevation before collapse, 1225–72 (After Robert Branner); section and plan (After Leblond).

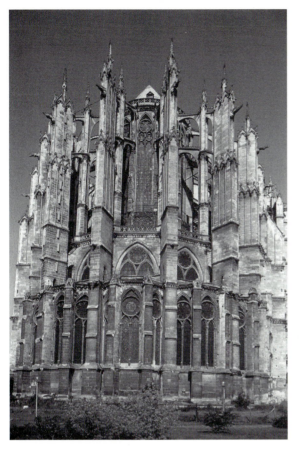

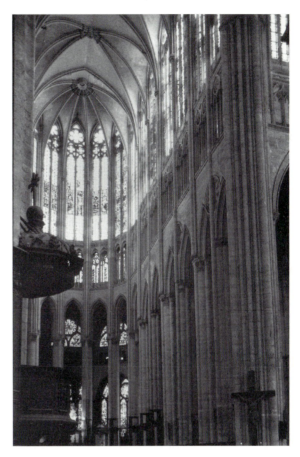

16.6 Beauvais, Cathedral of Saint-Pierre, 1225–72: choir exterior. (R. G. Calkins.)

16.7 Beauvais, Cathedral of Saint-Pierre, 1225–72 and after 1284: choir interior. (R. G. Calkins.)

accents of mullions continuing through the sill of the clerestory to the top of the gables over the tracery of the triforium level. Two tall aisles of equal height on each side of the choir continue out of the east side of the transepts to provide a spaciousness that complements its increased lightness and inexorable verticality.

At **Beauvais Cathedral** (figs. 16.5–16.7), which would have been the ultimate Rayonnant Cathedral, ambitious plans of the bishops and builders finally exceeded the structural requirements of the Gothic building. Only the choir and transepts of Beauvais were built, and then with many difficulties, resulting in a massive but truncated stump of the intended plan. The remains of a low three-aisled tenth-century basilican structure known as the "Basse Oeuvre" still occupies the area where the five-aisled nave of the Gothic Cathedral was to be built. Stephen Murray believes the planning and groundbreaking for

the Gothic structure began as early as 1225 according to a grandiose scheme of Bishop Miles of Nanteuil. Like Amiens, Beauvais would have consisted of two bays in the choir, flanked by double aisles before a hemicycle with single ambulatory. Like Bourges, the inner aisle is considerably higher than the outer one and has its own triforium and squat clerestory. An aisled transept (the eastern aisle of which doubles as a third bay of the choir); and six bays of the nave would have projected three bays beyond the Basse Oeuvre, perhaps requiring the demolition of the twin-towered gateway to the Episcopal palace.[1] Murray believes that construction began in the transepts under Bishop Miles (1225–32), progressed to and included the vaults of the ambulatory between 1238 and the 1240s under Bishop Robert de Cressonac, and at least to the vaults and buttresses of the choir under Bishop William of Grez in the 1250's and 1260s.

Originally four-part rib vaults covered rectangular bays in the choir. Thin arching flying buttresses around the choir and apse extended from deep pier buttresses to thin intermediate piers built above the columns between the two aisles, and above the inner edges of the walls dividing the radial chapels, a scheme also used on the choirs of Reims and Amiens. The effect of the height and proportions, even in the truncated interior, is remarkable: at 158 feet high Beauvais stands the tallest of the Gothic cathedrals (almost twenty feet higher than Amiens, forty feet higher than Chartres). The central vessel measures forty-five feet wide, yielding a proportion of height to width of 1:3.5, by far the steepest of the cathedrals of its era. Episcopal and civic pride and competition may have motivated builders to build Gothic cathedrals higher and higher in the thirteenth century, particularly at Beauvais: Bishop Miles of Nanteuil claimed to owe allegiance only to St. Peter, the patron saint of his cathedral, and was involved in antiroyalist intrigues against Blanche of Castille that led to his downfall. However, symbolism may also have played a role: the height of Beauvais measured 144 royal feet, a reference to the height of the wall of the celestial city of Jerusalem (144 cubits) recounted by St. John in his Apocalyptic vision (Apocalypse 21:17). Amiens reflects the same symbolism, but since it measures 144 shorter Amiens feet, it is lower.

The elevation reflects the Rayonnant design with tall clerestory windows and glazed triforium but with additional squat clerestory windows and a triforium in the inner aisle and ambulatory, reminiscent of Bourges Cathedral. Even in its present state, the interior structure appears reduced to minimal skeletal components. However, in its original configuration as reconstructed by Robert Branner (fig. 16.5), three fewer piers on each side of the choir, and tall, large openings into the aisles, resulted in an area so spacious, that the effect of lateral expansiveness would have been unrivaled even by Bourges.

The choir vaults of Beauvais collapsed in 1284, and repairs continued as late as 1337. The collapse has been attributed to settling foundations and the inadequacy of the structural supports relative to their height. Robert Mark has determined, however, as he did in earlier studies of Chartres and Bourges, that the force of the wind worked on the upper reaches of the building, eventually twisting and cracking one or more of the thin intermediate piers, causing them to collapse with the flying buttresses and the vaults they supported.[2] Mark calculated that the wind load exerted on a surface varies as the square of the wind speed, which itself increases with the height of the building. At Beauvais, he figured that the tensile stress caused by the wind exceeded ten times the tensile strength of the lime mortar binding the masonry. Cracks may have appeared for some time earlier, and perhaps a particularly severe storm caused the final collapse.

When the choir was rebuilt (fig. 16.7), the four piers next to the crossing were replaced by thicker ones than those around the chevet, indicating that this was the damaged area. In the choir, three extra intermediate piers augmented the aisle arcade: the outlines of the original arches still appear, intersected by the additional shaft that rises to a transverse rib of a six-part vault substituted for the earlier four-part one. The builders inserted similar additional piers in the openings between the inner and outer aisle, and five-part or six-part vaults were placed over the inner aisle.

Eventually, in the sixteenth century, Martin Chambiges directed construction of the flamboyant transept facades until his death in 1532.[3] Chambiges had also designed the transepts of Sens Cathedral and the west towers at Troyes Cathedral. Between 1563 and 1569, a huge crossing tower with masonry lantern and wooden spire 150 meters high (497 feet) was built, but without the stabilizing support of any bays of the nave to the west. The crossing piers began to rotate and lean outward, and arches and vaults began to crack. In 1573 the tower collapsed toward the northeast, to judge from the evidence of later repairs. Rebuilding of the first bay of the choir took place in 1575, and some crossing piers and the vaults of the transepts were rebuilt between 1577 and 1580. Crossing piers were rebuilt where necessary, but this time using the convex and concave moldings of the flamboyant style on the southeast pier, unceremoniously capping the top of an earlier compound cluster of cylindrical shafts. By 1600, builders abandoned plans to vault the first bay of the nave. Instead, they placed a timber vault there and simply screened off the nave opening.

Beauvais's problems are not yet over. Between 1992 and 1994, extensive wooden braces and reinforcing centering were inserted in the interior. Two sets of triangular wooden braces, an upper one and a lower one, extend between the four piers beyond the crossing in each transept. Their arrangement

prevents the piers from buckling inward and falling outward. Huge wooden raking buttresses and reinforcing centering in the outer arcades brace the northeast crossing pier of the thirteenth century, significantly, next to two transept piers that the collapse of the tower destroyed. In addition, electronic sensors monitor the stresses on some of the pier buttresses around the chevet.

The final resolution of the Rayonnant style in its reduction of structure to a skeleton and the ultimate takeover of the walls by stained glass occurs at the **Sainte-Chapelle** in Paris (figs. 16.8–16.10). Saint Louis (Louis IX, 1226–70) began construction in 1242 and had the structure consecrated in 1248 as a magnificent architectural reliquary to house a major collection of relics, including the crown of

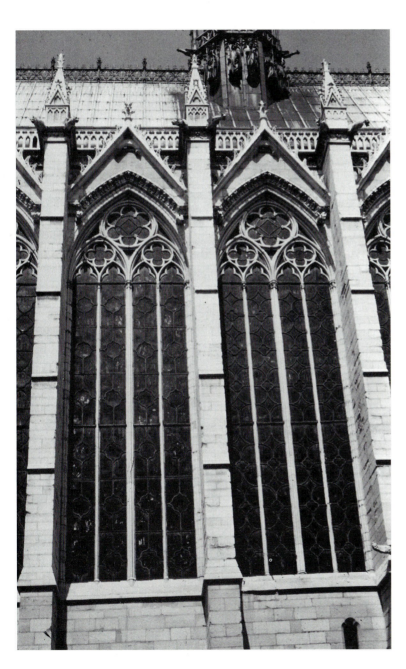

16.8 Paris, Sainte-Chapelle, 1242–48: exterior elevation. (R. G. Calkins.)

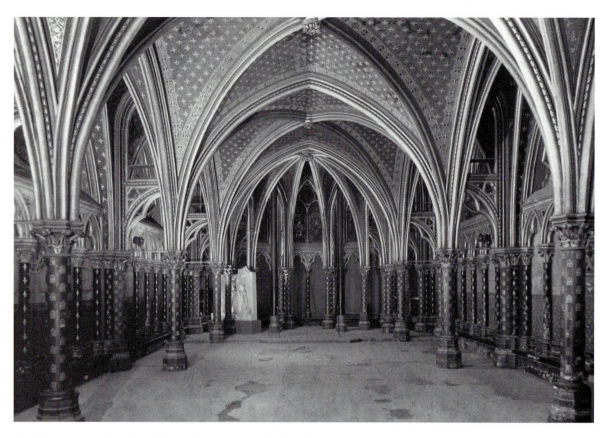

16.9 Paris, Sainte-Chapelle, 1242–48: lower chapel. (R. G. Calkins.)

thorns, part of the true cross, and the iron of the lance that he had obtained in 1239 from his cousin, Beaudoin II, emperor of Constantinople. Built next to Louis's royal palace, the Sainte-Chapelle consists of two levels, a lower chapel for the servants of the royal household, and the upper tall reliquary chapel.

The exterior displays a compact but delicate structure, the sides and apse corrugated by the projecting edges of gently stepped-out pier buttresses without flying buttresses, the upper walls reduced to forty-foot-high sheets of glass capped by gables overlapping the balustrade around the roof (fig. 16.8). The windows show the next step in the evolution of the bar tracery window from Reims: a doubling of the number of lancets with twin lancets separated by extremely thin stone mullions with a small rose beneath an enclosing arch and paired with an identical twin, all beneath

another tracery rose above the two. Robert Branner demonstrated many affinities with the details of the tracery in the choir of Amiens, suggesting that it was Thomas de Cormont who built the Sainte-Chapelle. As in other Rayonnant buildings, gables over the windows project above the balustrade along the edge of the roof.

On the interior, the two chapels give the Sainte-Chapelle the effect of a reliquary casket covered in gold and enamel. The lower chapel (fig. 16.9), dedicated to the Virgin, has a nave with four-part rib vaults twenty-one feet high flanked by equally high but narrow aisles, constituting a minihall church. Horizontal struts bridge the aisles to buttress the inner rows of columns. The upper chapel (fig. 16.10), on a level with the royal suite in the adjacent palace, contains an elaborate ciborium to display the relics. This space is surrounded by 6,450 square feet of stained glass. Statues of the Apostles (now mostly

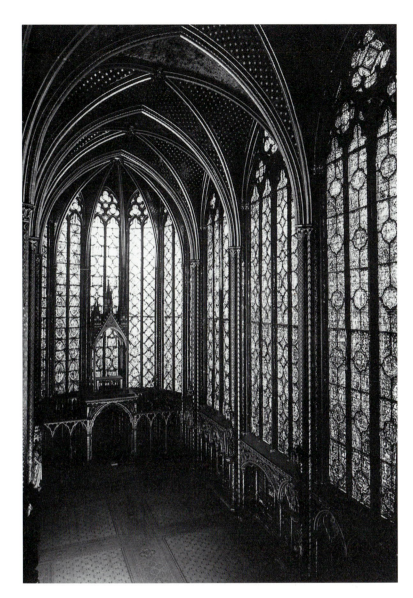

16.10 Paris, Sainte-Chapelle, 1242–48: upper chapel. (Giraudon/Art Resource, N.Y.)

replaced) engaged against each cluster of shafts link the lower part of the wall, a dado with interlocking blind arcades, to the upper just below the sill of the windows. Brilliant gold, blue, and red paint completely adorn the interiors of both upper and lower chapels: gilded tracery, decorative enamel-like designs on the shafts and ribs, actual inset enamels in the walls, and painted blue vaults with gold stars all give these spaces the effect of being inside a lavishly wrought metalwork reliquary. The vast expanse of glass in the upper chapel, the thin decorative struc-

tural elements, and the seemingly insubstantial starry vault reduce this chapel to a jeweled cage of red and blue glass.

A further manifestation of the Rayonnant style occurred at the small parish church of **Saint-Urbain** at Troyes (figs. 16.11–16.12), commissioned by Pope Urban IV to commemorate his birthplace. Although construction of Saint-Urbain began in 1262, a fire in 1266 required extensive renovations. By the end of the thirteenth century the building from the choir through three bays of the

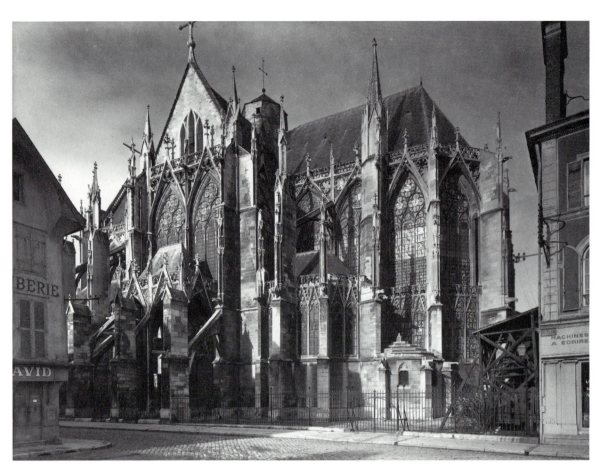

16.11 Troyes, Saint-Urbain, 1262–70: choir exterior. (Foto Marburg/Art Resource, N.Y.)

nave and the lower story of the facade were completed; two west bays of the nave stood complete by the consecration in 1386, but the upper stories of the facade were not built until 1902. The compact plan has two chapels in echelon flanking the triple-faceted apse (fig. 17.15, *center*). The exterior of the chevet (fig. 16.11) shows a plethora of decorative tracery gables overlapping the balustrade around the roof. A double tier of windows linked by delicate tracery occupies the entire elevation of the apse. Inside the choir, they totally dematerialize the wall (fig. 16.12) even beyond the manner found at St. Elizabeth at Marburg and in S. Maria Gloriosa dei Frari in Venice.

With its formulation in the nave of Saint-Denis and in the Sainte-Chapelle, the Rayonnant style became the Gothic form emulated across Europe. Robert Branner labeled it the "Court Style of Saint Louis."[4] It served as the basis for building designs in England, Germany, and Spain.

When Henry III commissioned Henry de Reyns to rebuild the east end of Westminster Abbey in the 1240s as a shrine for the remains of Edward the Confessor, he invoked elements from the French Coronation Cathedral of Reims, the Royal Pantheon of Saint-Denis, and the decorative richness of a reliquary shrine like that of the Sainte-Chapelle.

The elevation of the resulting choir of **Westminster Abbey** (fig. 16.13), with its incorporation of traditional English elements, an attic gallery above the aisle arcade and a use of dark Purbeck marble for the main supports and their attached shafts, however, differs from French Rayonnant elevations. Nevertheless, Henry de Reyns emulated the French plan, with an ambulatory and four radiating polygonal chapels (the axial one was replaced with the later Henry VII chapel). He abandoned the traditional English clerestory wall passage, and adopted the vertical proportioning of the

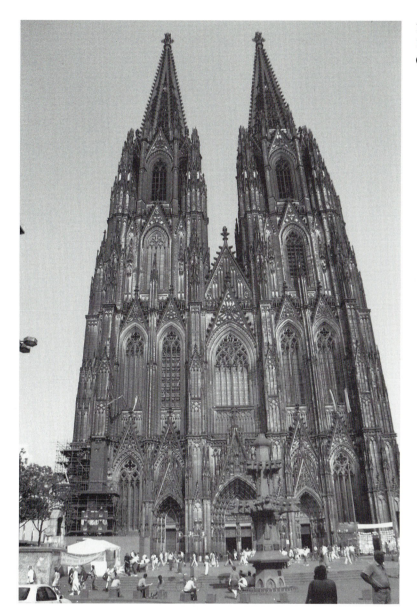

16.16 Cologne Cathedal: facade, circa 1300–1473 and nineteenth century. (R. G. Calkins.)

tions and bar tracery patterns of the clerestory windows from the Sainte-Chapelle.[5] The plan constitutes the most compact Gothic design: a five-aisled nave and choir with the transepts almost at a midpoint between the choir and nave, and a unified undulating cluster of seven radiating chapels around the ambulatory. Statues of the Apostles, Christ, and the Virgin stand on corbels and under architectural canopies against the shafts of the choir reiterating the placement of the statues of the apostles at the Sainte-Chapelle.

The completion and consecration of the choir occurred in 1322, the east walls of the transepts were built, and then construction lagged. Michael Parler began work on the facade around 1350, but not until 1473 did the south tower reach the level of the belfry. By 1560, work had ceased altogether. As a result, late medieval views of the building, as on Hans Memling's **Shrine of St. Ursula,** show the massive bulk of the choir, an empty notch in the position of the nave, and the stump of the south tower with a huge crane.

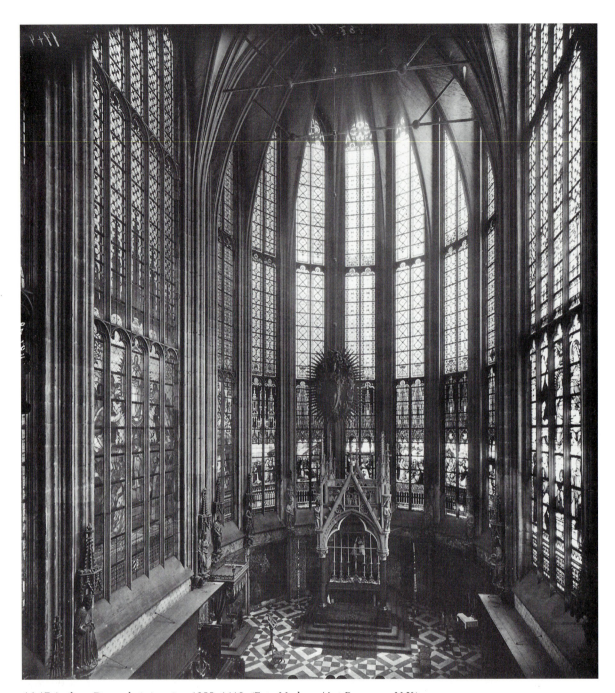

16.17 Aachen, Dom: choir interior, 1355–1410. (Foto Marburg/Art Resource, N.Y.)

Not until the middle of the nineteenth century, with the restoration of the archbishopric to Cologne (it had been removed to Aachen during the French occupation of Cologne in the early nineteenth century), the discovery of the original plans, and a renewed interest in the Gothic style during the Gothic revival promulgated by the literati across Europe, did construction begin again, starting in 1842 with completion in 1880. The nineteenth-century nave adheres closely to the design of the medieval choir and therefore gives the interior a rare homogeneity. Even the statuary engaged against

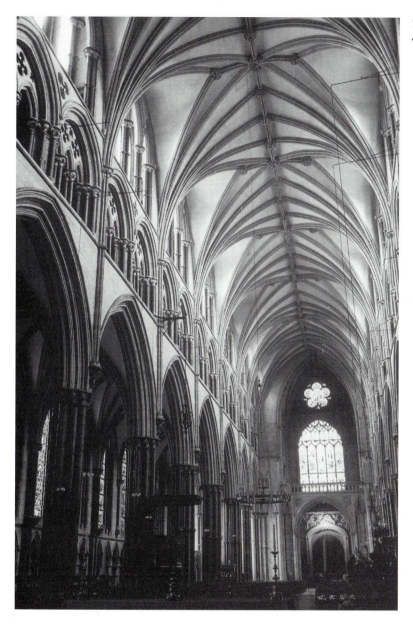

17.3 Lincoln, Cathedral: nave toward west, 1239–50. (R. G. Calkins.)

innovation found in the original vaults, or constitute a new invention thought to provide greater rigidity to the crossing piers. In any event, the new vaults used a longitudinal ridge rib that runs along the crown of the vault intersecting the diagonal ribs. The introduction of additional ribs, tiercerons, that define the angled transverse vaults from the clerestory windows and converge at points dividing the ridge rib of each bay into thirds represents a new decorative device. Because these elements, ribs, tiercerons, and transverse arches all have the same

profile and visual weight, the integrity of individual bays dissolves in the profusion of linear accents. The most readable part of the vault becomes the "diamond"-shaped surface uniting contiguous bays and obscuring their divisions.

However, the most remarkable feature of this new choir is the curious angling of the clerestory vaults and the odd lozenge of cells between them that cuts diagonally across each bay. Dubbed the "crazy vaults," they and their linear accentuation by ribs and tiercerons may derive from a scheme used in the pre-

vious apse. Excavations have revealed that Lincoln had a flat-ended trapezoidal apse terminated by a hexagonal chapel, probably emulating Becket's Corona at Canterbury. The odd trapezoidal bays may have necessitated the addition of tiercerons possibly providing a source for the form of the choir vaults.[1]

During the reconstruction of the nave of Lincoln between 1239 and 1250 (fig. 17.3), and of a second, eastern choir, the retrochoir, between 1256 and 1270, the asymmetrical form used in the crazy vaults was made symmetrical so that the vaults from the clerestory meet at the ridge rib. The tiercerons are retained, and in addition, transverse ridge ribs partially intrude into the clerestory vaults with their own tiercerons. As a result, the visual integrity of the bay disappears and the cells, adjacent bays and patterns of linear accents increase the unifying effect. These innovations, with the continued use of the dark accents of Purbeck marble shafts articulating horizontal bands of the elevation, emphasize the length of the building and obscure the architectonic logic.

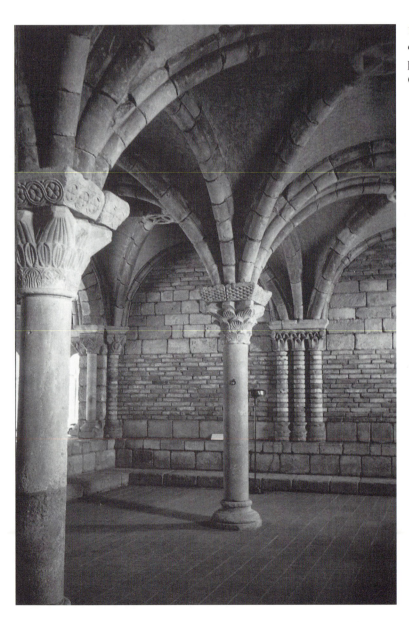

17.4 Pontault chapter house, twelfth century: re-erected at New York, Metropolitan Museum of Art, The Cloisters. (R. G. Calkins.)

The perfection of the centralized chapter house represents another particularly English development that occurred at Lincoln. The chapter house was a meeting room for monks of a monastic community, and it became a distinctive feature of English monastic cathedrals. Such structures had also appeared in Romanesque France, although they usually consisted of two-aisled rectangular spaces with a row of central columns upon which eight heavy arches and diagonal ribs from the surrounding bays converged. The twelfth-century chapter houses at Fontenay, and the reconstructed one from **Pontault** now at The Cloisters in New York (fig. 17.4) provide French examples of this format. At Worcester Cathedral, the bottom story of a circular Anglo-Norman chapter house of about 1110 to 1115 survives, complete with interlocking blind arcades, but the upper vaulting and central pier were replaced about 1400. At Lincoln, a decagonal chapter house was built about

1220 for the community of secular canons (fig. 17.1).[2] Twenty ribs converge on a central pier surrounded by a cluster of colonnetts, while five ribs descend to each of the ten wall supports. The delicate chapter house at **Westminster Abbey** (fig. 17.5), completed by Henry de Reyns by 1254, follows the same scheme: an octagon with sixteen ribs radiating out, umbrella-like, from an exceedingly slender central column to the eight sides. At the crown of the vault alternate ribs branch out from bosses into tiercerons that define the vaults leading to the large bar tracery windows. This structure probably served as the model for a similar, equally fragile, chapter house at Salisbury, built around 1265 (fig. 17.1). At **Wells** (fig. 17.6), a more vigorous version, built between 1303 and 1309, carried the umbrella effect to the extreme: thirty-two ribs radiate from a thick central column completely obscured by multiple shafts that meet the ribs from

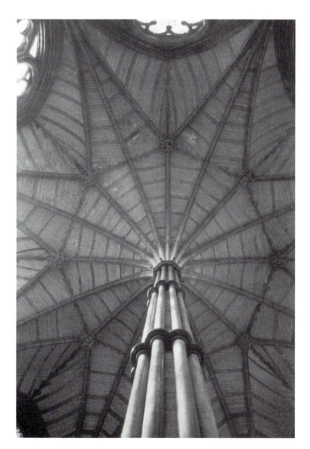

17.5 London, Westminster Abbey, chapter house, by 1254. (R. G. Calkins.)

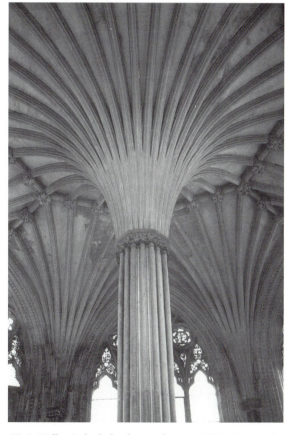

17.6 Wells Cathedral, chapter house, 1303–09. (R. G. Calkins.)

the eight walls at an intermediate ridge rib around the crown of the annular vault.

The conoid effect of converging ribs, both on the central pier and in the angles of the outer walls of these chapter houses, paralleled a similar effect that occurred with the proliferation of tiercerons in the vaults of English cathedrals after Lincoln. **Exeter Cathedral** (figs. 17.1, 17.7), a Gothic building sandwiched between two Norman towers and replacing an earlier Anglo-Norman structure demonstrates an extreme variation of this new vaulting system. Construction of the choir began about 1288, the nave vaulting occurred between 1303 and 1308, and the building was completed around 1370. The exceedingly lengthy structure has the longest continuous ridge rib in England, uninterrupted between the facade and chancel. Transverse ridge ribs between the clerestory windows intersect it at every bay, and these, accompanied by tiercerons in the clerestory vaults as well as a multitude of tiercerons springing across the nave, create a bundle of rising lines that totally obscure the

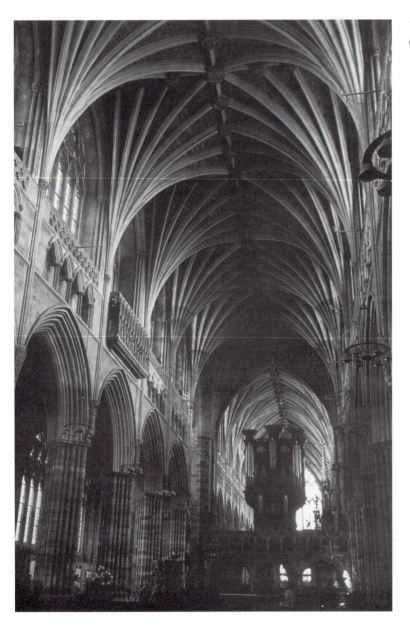

17.7 Exeter Cathedral: nave, 1303–08. (R. G. Calkins.)

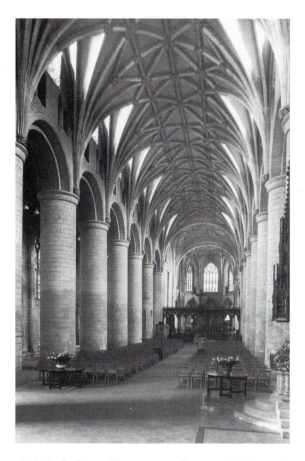

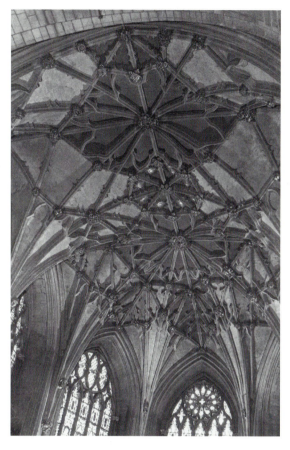

17.8 Tewkesbury Abbey: nave vaults, circa 1330. (R. G. Calkins.)

17.9 Tewkesbury Abbey: choir vaults, second quarter of fourteenth century. (R. G. Calkins.)

visual integrity of the bay. At first glance, these bundles of tiercerons appear to assume the conoid form of a fan vault, but in fact the planes of the nave and clerestory vault cells remain flat: transverse pointed vaults penetrate the longitudinal pointed vault of the nave, and each retain their identity. The use of sculpted bosses further enhances the decorative effect of this linear articulation of the vault by hiding the intersections of various members. In some English Gothic buildings, sculpted bosses took the form of entertaining grotesques, the architectural equivalent of drolleries in the margins of medieval manuscripts and misericords under the seats of late medieval choir stalls.

At **Tewkesbury Abbey,** in the West Country near Gloucester, Hereford, and Worcester, the original Norman construction still manifests itself in massive Romanesque cylindrical piers in the lower

elevation, but the nave vaults were replaced about 1330 with a further elaboration of the English vaulting style (fig. 17.8). Here, Tierceron vaults evolved into lierne vaults, named after the connecting ribs between various tiercerons, tying them together. Three parallel longitudinal ribs define the upper third of a barrel vault continuing the length of the nave, partially penetrated from the sides by vaults from the Norman clerestory windows. Tiercerons rise from above the nave supports to meet the ribs interconnected by additional ribs, the liernes, creating subsidiary geometric patterns resembling stars on the surface of the vault. These lierne vaults at Tewkesbury elaborate a system used in the east end of Wells Cathedral about 1320 and developed to a remarkable degree in the domical vault of the Lady Chapel at Wells. A similar lierne vault occurs in a fourteenth-century vault over a Norman nave at

Norwich Cathedral. In these cases, the lierne vaults state the decorative unity of the entire vaulted surface rather than the structural integrity of individual bay canopies. In the naves of Tewkesbury and Norwich, they emphasize the longitudinal space. Sometimes these elements are painted, and the rich decorative ensemble of painting, filigree tracery, and sculpture lend to this phase of English Gothic the name "decorated style."

An increased profusion of liernes occurs in the choir of Tewkesbury Abbey (fig. 17.9), dating from slightly later in the second quarter of the fourteenth century. Here, the liernes sprout cusps like those occurring on the arches of bar tracery windows, and form a series of complicated flower patterns, a further elaboration of the nave vaults. Such embellishments were to be developed even further in the vaulting of late-fifteenth-century German churches.

The ultimate proliferation of additional elements, tiercerons, and liernes occurs in the choir of **Gloucester Cathedral** that received a perpendicular style overlay of thin mullions and delicate tracery applied to a Norman elevation beginning in 1331 (fig. 17.10). A light barrel vault covers the choir, penetrated to one-third of its span on each side by the clerestory vaults over tall windows. Dense intersecting liernes, tiercerons, ribs, and ridge ribs weave a spiderweb, completely covering this surface. Again three parallel ridge ribs run along the middle third of the continuous vault. A decorative hovering canopy results without any visual statement of support or thrust.

The development of fan vaulting may evolve logically from the effect of clustered tiercerons as they exist in the nave at Exeter. The fan vault also simplified the construction of the vault because all of the ribs had the same curvature rather than the varied curves of tiercerons. A conoid volume rises from the wall surface with a semicircular boundary at the top. This form of vaulting may have first appeared in

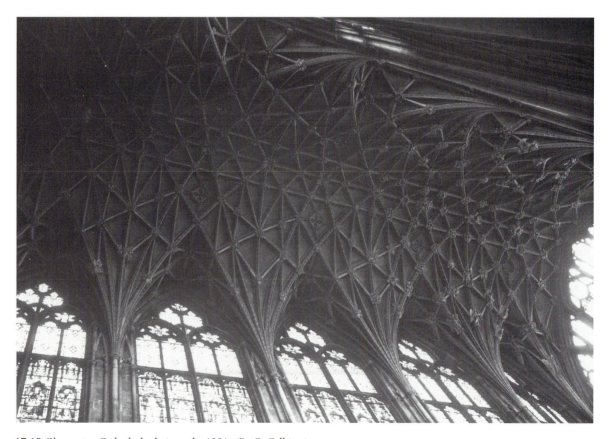

17.10 Gloucester Cathedral: choir vault, 1331. (R. G. Calkins.)

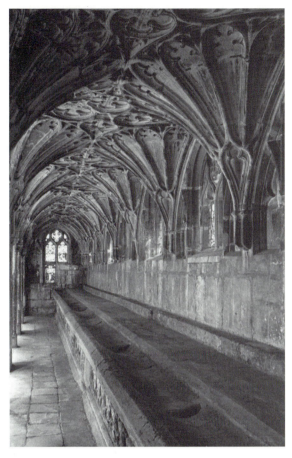

17.11 Gloucester Cathedral: cloister vault, begun circa 1351. (R. G. Calkins.)

London about 1292 at St. Stephen's Chapel, Westminster, now destroyed, and in a chapter house for Old St. Paul's of 1332, also destroyed. The earliest surviving example begun about 1351 appears in the cloister walks of Gloucester Cathedral (fig. 17.11). Here the ribs no longer form structural members, but simply exist as decorative ridges in relief, integral with the masonry of the conoid section behind them, and forming intricate interlocking flamboyant tracery patterns. These vaults look best over square bays, allowing for a full semicircular sweep of the upper circumference of the cone; in a rectangular bay, the cones collide. Fan vaults obscure the visual integrity of the bay because one perceives the entirety of opposite semicircular cones rising from the wall, each occupying a quarter of adjacent bays. Fan vaults produced a series of undulating, spreading canopies down the length of the cloister walk. The transverse retrochoir of **Peterborough** of 1496 to 1519, referred to as the "New Building," uses this device (fig. 17.12). Fan vaults traverse rectangular bays, causing the cones to collide with each other and reducing their full canopy to segmental curves. This also reduces the size of the flat, lozenge-shaped area in the center of the vault between their circumferences. Unlike Gloucester, transverse arches are present, but having equal visual weight as the spreading tracery ribs, they are barely discernible.

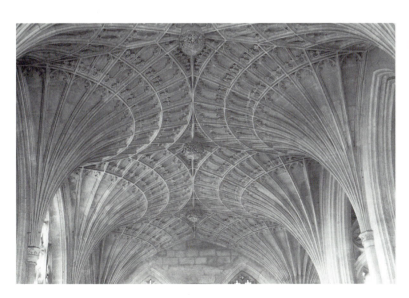

17.12 Peterborough Cathedral: "New Building" vaults, 1496–1519. (R. G. Calkins.)

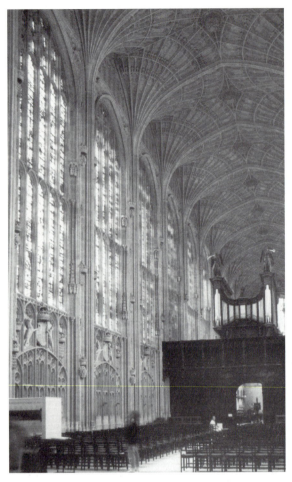

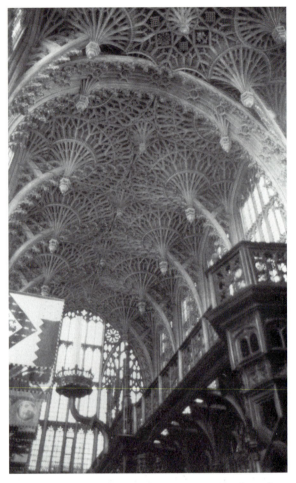

17.13 Cambridge, Kings College Chapel: interior, 1512. (R. G. Calkins.)

17.14 Westminster Abbey, Henry VII Chapel: vaults, 1503–19. (R. G. Calkins.)

The fan vaults at Gloucester and Peterborough extend over moderately sized spaces; however, at **Kings College Chapel** in Cambridge, dating from 1512, John Wastrell used them over the entire span of the aisleless nave and choir (fig. 17.13). He also restated the integrity of the bays: pronounced transverse arches demarcate them and interrupt the curvatures of the fans and the dense filigree pattern along the entire canopy formed by the ribs.

Pendant vaults with hanging pinnacles may have developed from late Gothic timber construction, but the late Gothic builders integrated these forms with the fan vault. At the Divinity School at Oxford of about 1479, William Orchard placed two hanging

cones with multiple ribs and liernes, separated by a ridge rib, in each bay.[3] In the vault of the Cathedral at Oxford (1478–1503) pendants hang from transverse arches that curve down away from the vault and end in hanging decorative finials. The **Henry VII Chapel,** built between 1503 and 1519 (fig. 17.14), carries this device to the extreme. Small fans spread upward from between the windows and below them, highly decorated transverse arches spring immediately away from the wall and then intersect the vault, at which point additional elaborate tracery cones with heavy finials descend. This creates a bewildering profusion of decorative stalactites and lacelike ornament that totally obscures the structure behind it.

FRANCE: THE FLAMBOYANT STYLE

Meanwhile, in France, tracery used in windows and balustrades and the profiles of moldings and shafts also became more decorative. Reverse curves in the tracery flowed into flamelike forms from which the flamboyant style gets its name, and reverse curves also appeared in the moldings, producing concave and convex surfaces that frequently meet in knife-sharp edges.

At the small monastic church of **La Trinité at Vendôme** (figs. 17.15, *left*; figs. 17.16–17.17) the transition from the Rayonnant to the Flamboyant style becomes easily discernible. In the choir of 1306 to 1318 and the first four bays of the nave of 1342 to 1357, the Rayonnant style prevails with glazed triforium with quatrefoil motifs in its balustrade and cusped pointed tracery arches in the clerestory windows above. Continuous bundles of round shafts rise unbroken from the base of the first

two eastern piers in the nave through a band of capitals to the springing of the vaults. Although the next two piers retain sculpted capitals, rising shafts with flat edges and sharp angles, evincing a transitional phase, intersect them. Flamboyant tracery appears in the balustrade of the glazed triforium.

As the nave arcade progressed westward (ca. 1450–1507), the rounded profiles of the archivolts became shallow and concave with sharp edges, and in the sixth and seventh bays the archivolts flow from the piers into the arches without interruption by foliate capitals. The nave shafts became shallower, with sharper, more linear forms.

The facade, completed by 1507 (fig. 17.17), possibly by Jean de Beauce, who designed the north tower of the Chartres facade, is filled with lattice-work flamboyant tracery masking wall surfaces and dissolving the central gable as it projects into the area of the large tracery window above. Following the lead of Reims Cathedral and Saint-Niçaise, flam-

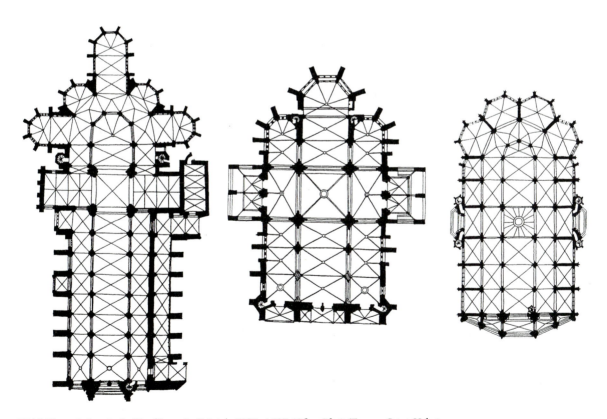

17.15 Plans, *Left to Right:* Vendôme, La Trinité, 1306–1507 (After Plat); Troyes, Saint-Urbain, 1262–1386 (After Salet); Rouen, Saint-Maclou, 1434–1514 (After de Lasteyrie).

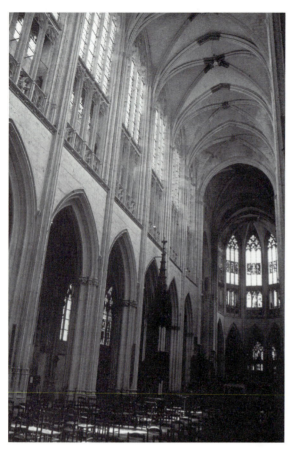

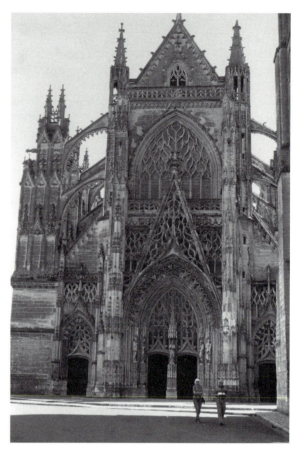

17.16 Vendôme, La Trinité, nave and choir, 1348–1357. (R. G. Calkins.)

17.17 Vendôme, La Trinité: facade, by 1507. (R. G. Calkins.)

boyant tracery and stained glass entirely fill the tympana above the portals. The effect is one of total dematerialization of the fabric—even more remarkable in contrast with the flanking sturdy twelfth-century tower.

An extreme manifestation of the flamboyant facade exists in the west front of the small parish church of **Saint-Maclou in Rouen** (fig. 17.19). This church was begun by Pierre Robin between 1434 and 1470 and Amboise Havel added the flamboyant facade between 1500 and 1514. Havel's three-faceted porch projects from the fabric, divided into five arches with openwork flamboyant tracery gables that penetrate a diaphanous balustrade above. Delicate tracery buttresses abut the nave, and the whole surface, eroded but projecting outward becomes an elaborate, flickering filigree of knitted stone.

Robin's nave and choir reveal the epitome of the flamboyant elevation (fig. 17.18). The height of the clerestory and triforium, linked by multiple mullions, approximates that of the nave arcade. Nave shafts, consisting of multiple undulating and sharp-edged elements rise unbroken to the vaults and the piers continue unbroken into the archivolts of the nave arcade, creating a unifying upward flow of linear accents.

The refinement and subtlety of such delicately etched lines of flamboyant elevations coincide with the increased amount of light that enters these buildings. By the fourteenth century, the prevailing taste in stained glass had changed: large areas of white glass dominated the windows, only highlighted by touches of yellow stain representing architectural canopies over lightly colored figures against a small colored ground. These windows permit a

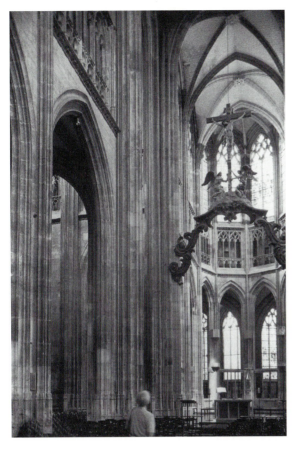

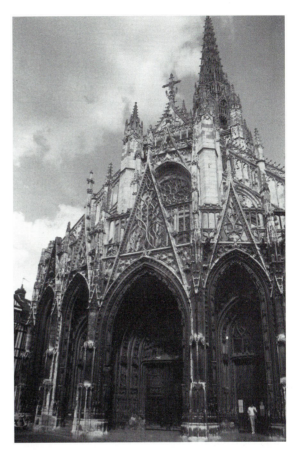

17.18 Rouen, Saint-Maclou: nave interior, 1434–70. (R. G. Calkins.)

17.19 Rouen, Saint-Maclou: facade, 1500–14. (R. G. Calkins.)

stronger, harsher light to play over the architectural details, emphasizing the sharp lines and modulating the convex and concave surfaces. Such fine architectural detailing would not have been readily noticeable in the purple-dark interior of the nave of Chartres Cathedral. But at Vendôme and Saint-Maclou, this new taste in these light-transmitting windows emphasized the brittle precision of detail and virtuosity of the craftsmanship.

SPAIN: NEW VARIATIONS

In Spain, a few builders followed precedents established in France, deriving inspiration from Bourges as at Toledo or from the Rayonnant style, as at León (see chapter 16). However, the builders of the most spectacular and innovative Gothic structures in Spain turned away from French sources and developed directions of their own that defy categorization. For instance, **Seville Cathedral** (fig. 17.20), the largest Gothic building in Europe, begun in 1402 on the site of a great mosque, used a two-story elevation. Like Toledo, it used the five-aisled plan, but omitted the triforium and placed a balustraded walkway before the clerestory windows.

In Catalonia, in northeastern Spain, strong Cistercian, Dominican, and Franciscan presences introduced an austere style and a penchant for good interior visibility. Thus in Barcelona, the capital of Catalonia, the **Cathedral** (figs. 17.21–17.22), begun by Jaime Fabre de Mallorca in 1298, used exceedingly high aisles and ambulatory flanked by tall compartmentalized chapels (the nave and choir were not completed until the fifteenth century). In the nave, a compartmentalized vaulted gallery above these chapels opens into the aisles. Above, a narrow-

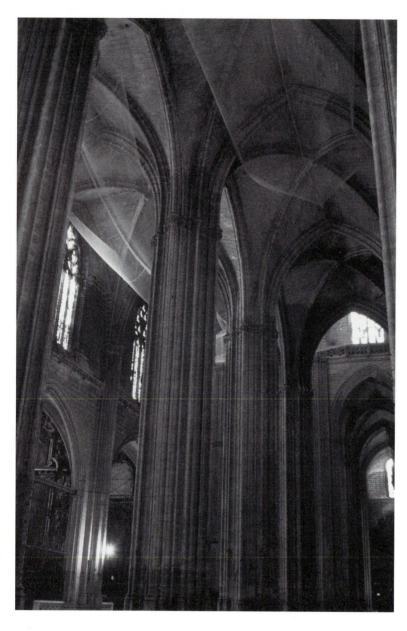

band triforium and a clerestory with small rose windows tucked up under the curvature of the vaults tops the elevated nave arcades. The interior space flows between the slender compound piers rivaling the open effect of Bourges and the developing German hall churches.

Santa Maria del Mar in Barcelona, built between 1328 and 1383 (fig. 17.23), uses this formula even more dramatically, where deeply plunging ribs and arches converge on tall octagonal piers and nave arcades as wide as the nave itself enhance the hall-church effect. The builders retained the clerestory rose, but abandoned the triforium. Three tall narrow chapels off each aisle bay with large windows above dematerialize the aisle wall and extend the interior spaciousness.

The Cathedral of **Palma de Mallorca,** begun in 1306 (figs. 17.24–17.25), demonstrates the extreme

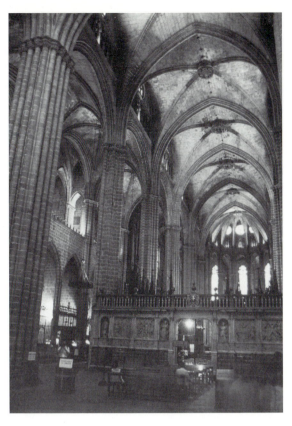

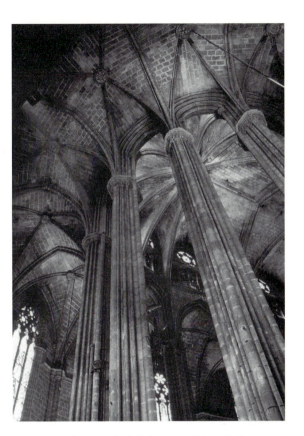

17.21 Barcelona Cathedral, begun 1298: nave interior. (R. G. Calkins.)

17.22 Barcelona Cathedral, begun 1298: ambulatory and choir vaults. (R. G. Calkins.)

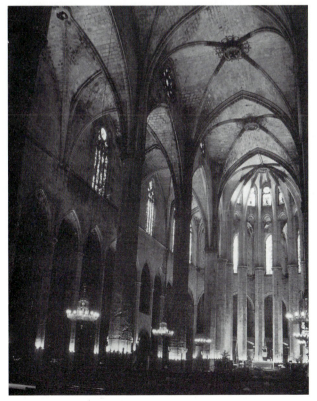

17.23 Barcelona, Santa Maria del Mar, 1328–83: nave interior. (R. G. Calkins.)

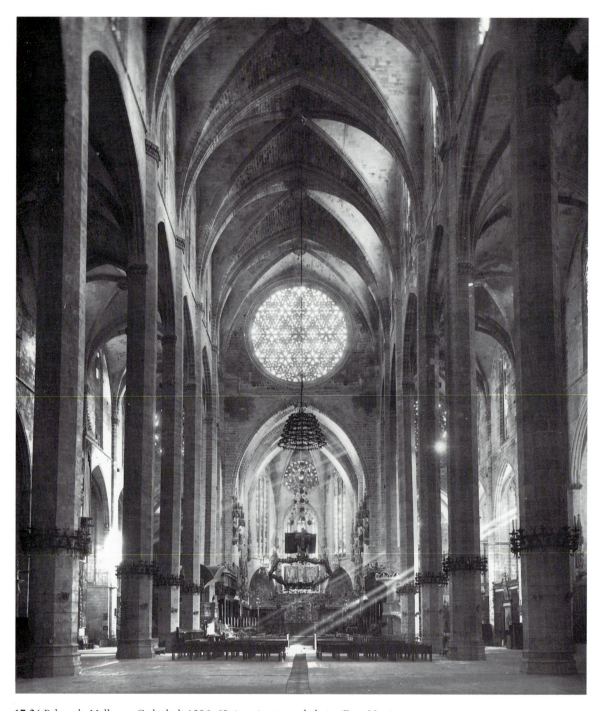

17.24 Palma de Mallorca, Cathedral, 1306–60: interior toward choir. (Foto Mas.)

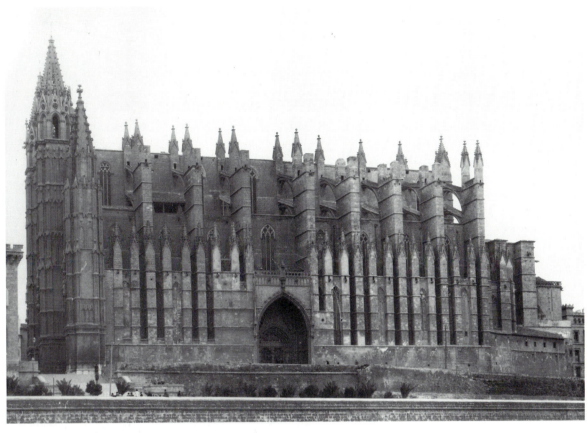

17.25 Palma de Mallorca, Cathedral, 1306–60: exterior. (Foto Mas.)

manifestation of this style. High aisles, slender, elegant octagonal piers, and a heightened nave (raised to 144.4 feet [44 meters] in 1360) give the interior a remarkable expansiveness. Tall clerestory windows over the nave arcade, without a triforium, and the triplet of large rose windows in the wall above the lower choir and its ambulatory illuminate the interior. Massive pier buttress along the outside, almost tripled along the level of the flanking chapels, give the exterior a corrugated, clifflike appearance.

ITALY: AN INTERPRETATION OF NORTHERN SUGGESTIONS

In Italy, Gian Galeazzo Visconti, the duke of Lombardy, expressed his grandiose pretensions by commissioning the cathedral at Milan, begun in 1386. With its proximity to France, **Milan Cathedral** (fig. 17.26–17.28) reflects its northern counterparts more closely than any other Italian structure. The exterior, though exotic, misleads,

however, as the multitude of pinnacles with sculptures, latticework, crossing spire, and facade all date from the eighteenth and nineteenth centuries. Nevertheless, the trifaceted apse with huge flamboyant tracery windows in different configurations and myriad thin shafts and multiple blind arcades and gables reflect the original intention.

The original plan called for a nave and four aisles, a slightly projecting transept, and a choir with a three-faceted apse and ambulatory. Repeating the staggered section of Bourges, Milan Cathedral's inner aisles rise much higher than the outer ones. According to surviving documents, a consortium of foreign and Italian architects planned the cathedral between 1389 and 1440. They designed its section to approximate an equilateral triangle. Controversy was rife over whether symbolic ideal proportions or structural necessity should determine the dimensions of the building.[4] Eventually a scheme was adopted by which the total height (eighty-four bracia) equaled three times the height of the springing

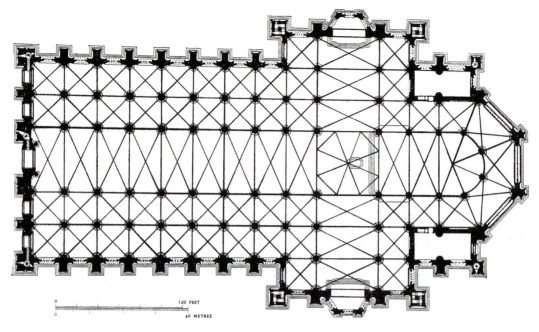

17.26 Milan Cathedral, begun 1386: plan. (After Dehio and Bezold.)

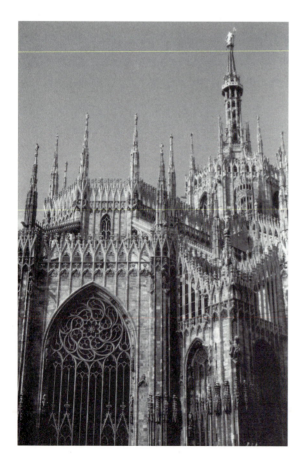

17.27 Milan Cathedral, begun 1386: apse exterior. (R. G. Calkins.)

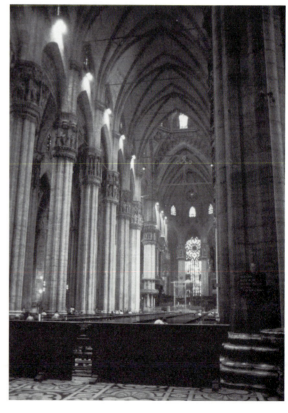

17.28 Milan Cathedral, begun 1386: nave interior. (R. G. Calkins.)

of the vault of the outer aisle (twenty-six bracia), twice the height of the springing of the inner aisle (forty-two bracia), and 1.5 times the height of the springing of the nave vault (fifty-six bracia). Despite the disagreement of the northerners in the consortium, particularly Johann von Freiburg in 1391 and Jean Mignot in 1400, and the latter's accusations of sloppy craftsmanship, the building as envisaged and finally constructed by the Italians still stands.

The nave reaches almost as high as Beauvais: just less than 157 feet. The high inner aisles of the interior work like those at Bourges, establishing the effect of a spacious hall-church, while the reduced clerestory level provides minimal light through a few small oculus windows. Remarkable rows of monolithic compound piers dominate the interior, capped by huge capitals with life-sized figures in architectural niches, perhaps planned from the beginning, as representations of them appear in manuscripts illuminated by Giovannini de' Grassi, Capomaestro of the Opera del Duomo between 1389 and 1399. These capitals create a pronounced horizontal band down the length of the nave. With the verticality and openness of its interior, the robustness of piers and shafts, and the sharply pointed transverse arches and diagonal ribs, Milan Cathedral emanates the most distinctly northern feeling of any Italian Gothic building.

GERMANY, PRUSSIA, BOHEMIA: NET VAULTS AND CELLULAR VAULTS

In Germany, the development of late Gothic styles branched out in new directions based on the hall church form, which became prevalent throughout the region. Transepts and crossings were frequently abandoned, and with increasing frequency decorative vaulting systems were adapted to their naves and choirs, all contributing to a remarkable effect of unified interior space.

The **Wiesenkirche at Soest** (fig. 17.29) in Westphalia provides a superb example of a German late Gothic hall church built for the mendicant orders. Erected in 1331, the church consists of a nave and aisles with only three bays each creating an almost cubic interior and an undulating triple apse flooded with light from tall, narrow windows practically the height of the walls. Slender columns with pear-shaped moldings flow uninterrupted upward into the aisle arcades and the ribs of the vault, a German variant of similar French flamboyant style.

The compactness of the interior space, openness of the nave arcades and delicate screening effect of the columns emphasize its spatial unity.

In the late fourteenth century, some late Gothic cathedrals in regions dominated by the German influence adapted a new vaulting style. Prague, the capital of Bohemia and of the Holy Roman Empire after the coronation of Charles IV of Bohemia in 1349, enjoyed the benefits of imperial patronage, and thanks to the efforts of members of the Parler family, developed its own distinctive Bohemian Gothic style. The Cathedral of **St. Vitus at Prague** (fig. 17.30, *left*; fig. 17.31), with a choir designed by Matthew of Arras between 1333 and 1352, and continued by Peter Parler between 1356 and 1385, used the Rayonnant elevation with glazed triforium and large clerestory windows. Parler also incorporated a new decorative vaulting system, essentially using parallel tiercerons and liernes, to create a mesh of intersecting diagonal ribs. Perhaps ultimately derived from the thirteenth-century inspiration of Lincoln Cathedral, variations of this geometric network appeared in Prussia and spread across northern Germany beginning in the late thirteenth century: at the Cistercian Abbey of Pelplin in 1276 and at Kulmsee in 1286.[5] Peter Parler's father, Heinrich Parler, is reputed to have placed similar vaults over the nave of the Heiligkreutzkirche at Schwäbish Gmünd beginning in 1317, and perhaps he, or his son Peter, multiplied them into a dense network in the choir about 1351 (fig. 17.30, *right*).

In the net vaults (*Netzgewölbe*) at Prague, the beginnings of transverse arches rise only to divide into two diagonal ribs a third of the way across the vault, forming interlocking diamond patterns. This net vault continues in the later nave. The lower clerestory and triforium arcade slant inward to enclose the shafts rising to the vaults, creating a rhythmic undulation of the wall that emphasizes the divisions of the lower bay and its supports. (On the transverse walls of the triforium behind these projections, Peter Parler placed sculpted busts of the Bohemian nobility and a self portrait.) However, the net vaults above, without continuous transverse arches to interrupt the longitudinal flow, emphasize the unity of the textured canopy over the entire length of the space, as in the choir at Gloucester, rather than a division into articulated bays.

The exterior of the compact chevet (fig. 17.32), undulates with faceted chapels topped by conical roofs between deep pier buttresses textured with

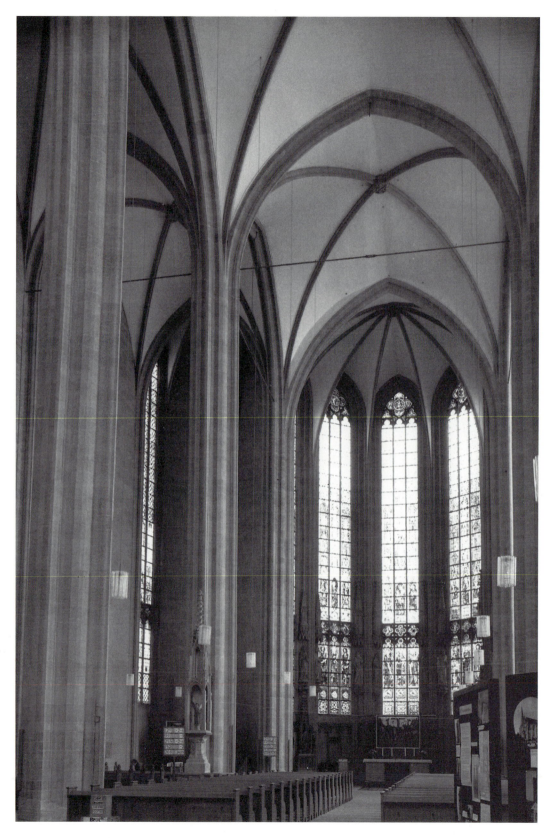

17.29 Soest, Wiesenkirche, 1331: interior. (R. G. Calkins.)

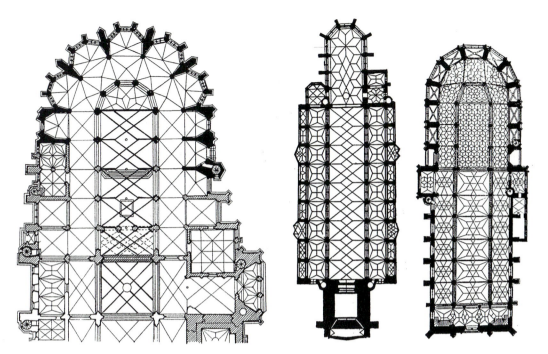

17.30 Plans, *Left to Right:* Prague, St. Vitus, choir, 1333–85; Landshut, Martinskirche, 1390–1432; Schwäbish Gmünd, Heiligkreutzkirche, 1317–51. (After Dehio and Bezold.)

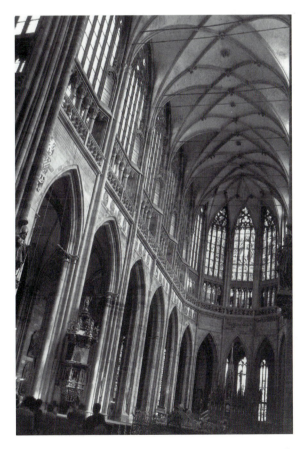

17.31 Prague, St. Vitus, choir interior, 1333–85. (R. G. Calkins.)

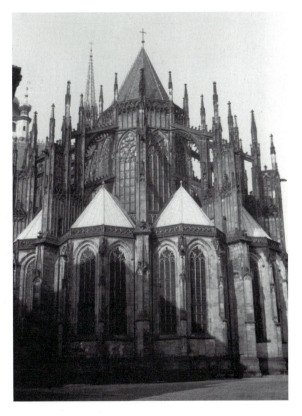

17.32 Prague, St. Vitus, choir exterior, 1333–85. (R. G. Calkins.)

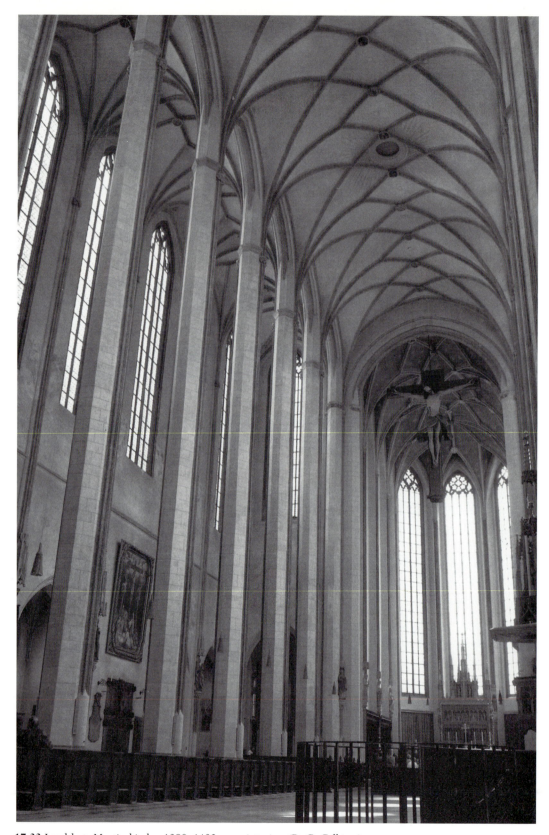

17.33 Landshut, Martinskirche, 1390–1432: nave interior. (R. G. Calkins.)

blind tracery, and flying buttresses rising through intermediate piers. In keeping with the late Gothic German style, a multitude of thin mullions in the windows and in relief on the pier buttresses emphasize the verticality of the exterior. This is a continuation of the harp-string effect designed in the fourteenth century for the facades of Cologne and Strasbourg Cathedrals (compare figs. 16.16, 19.5). Although the foundations of St. Vitus's nave were laid in 1392, and Peter Parler's sons, Wenzel Parler and his brother, Johann, worked on the tower on the south transept from 1396, the nave and west facade remained incomplete until the nineteenth century.

The hall church prevailed throughout Germany in fairly standard form, but new vaulting systems were adapted to it. At the **Martinskirche at Landshut** (fig. 17.30, *center;* fig. 17.33) in Bavaria, built between 1390 and 1432 by Hans von Burghausen, significant refinements occur in its supports and vaulting. Remarkably slender octagonal piers abandon engaged shafts and undulating moldings, although

the traditional tall aisles and nave remain essentially unchanged. Hans von Burghausen incorporated net vaults similar to those at St. Vitus, so that multiple lines of sight past the tall screening columns echo the interlocking diagonal patterns of the net vault. In the choir, the design becomes even more complex, with tiercerons springing from the transverse arch into a star pattern at the turn of the apse. As in earlier English counterparts, the network of these liernes and tiercerons emphasizes the decorative unity of the canopy throughout the length of the nave.

German net vaults became increasing complex throughout the fifteenth century. This process began as early as 1351 with the dense net vaults designed by Heinrich Parler for the choir of the Heiligkreutzkirche in Schwäbish Gmund (fig. 17.30, *right*). Nicolaus Eseler placed varied the patterns over several bays in the harmonious nave of St. George at Dinkelsbühl between 1448 and 1492 (fig. 17.34, *left*).

At the **Lorenzkirche in Nürnberg** (fig. 17.34, *center;* figs. 17.35–17.36) between 1439 and 1459, Konrad Heinzelmann added a choir to a nave of

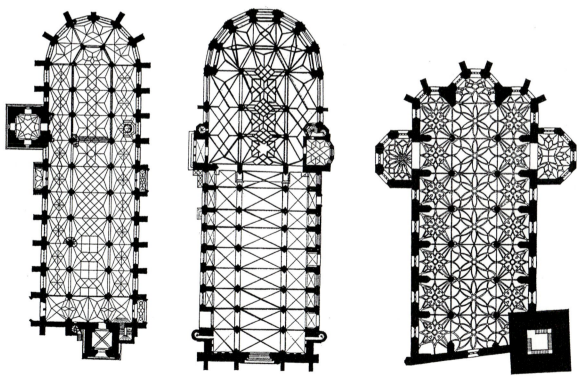

17.34 Plans, *Left to Right:* Dinkelsbühl, St. George, 1448–92; Nürnberg, Lorenzkirche, circa 1390, 1439–72; Annaberg-Bucholz, St. Anne, 1499–1522. (After Dehio and Bezold.)

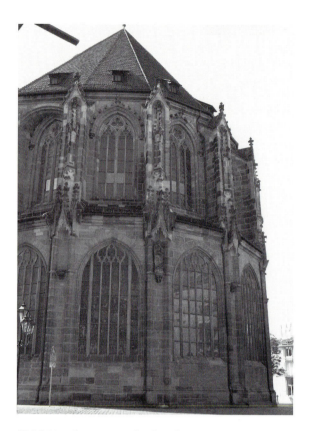

17.35 Nürnberg, Lorenzkirche: choir exterior, 1439–59. (R. G. Calkins.)

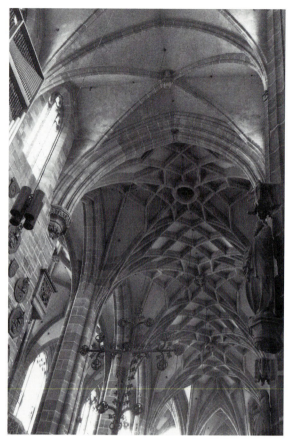

17.36 Nürnberg, Lorenzkirche: choir vaults, 1439–72. (R. G. Calkins.)

about 1390, using the hall church form with ambulatory and aisles as high as the choir vault. He omitted radial chapels, placing, instead narrow niches around the circumference with decorative balustrades above to break the vertical emphasis. As a result the exterior consists of a uniform, slightly faceted, tall hemicycle with two ranges of windows, the clerestory only slightly set back as at St. Elizabeth at Marburg. These windows create a light and spacious interior.

Konrad Roriczer added intricate net vaults to the choir of the Lorenzkirche between 1459 and 1472 (fig. 17.36). They consist of diagonal ribs continuing across the choir that are totally obscured by the profusion of intersecting tiercerons and liernes. Although the diagonal ribs rise from hexagonal piers, their grooved profiles now emerge smoothly from the surface and some ribs spring from a facet on the side of the pier, not from the side facing their trajectory. Architectonic relationships thus became

negated in the interest of interweaving decorative effects.

At **St. Anne at Annaberg-Bucholz** in Saxony (fig. 17.34, *right*; fig. 17.37), a small, delicate hall church begun in 1499 and completed in 1522, abandoned the geometric precision of the net vaults of the Lorenzkirche. Here, the ribs form reversing curves of flamboyant tracery and result in a flowing succession of floral patterns along the slightly undulating vaults down the nave.[6] The octagonal piers have concave facets and the curving ribs now loop around them from their springing point on an opposite side. Narrow chapels ring the aisles, topped by balconies looking out into the central space. The exuberant, delicate, light-filled interior was a celebration of the newfound wealth of the town with the opening of silver mines in the area in 1492. Its interior contrasts sharply with the massive unadorned block of brick masonry that constitutes its exterior.

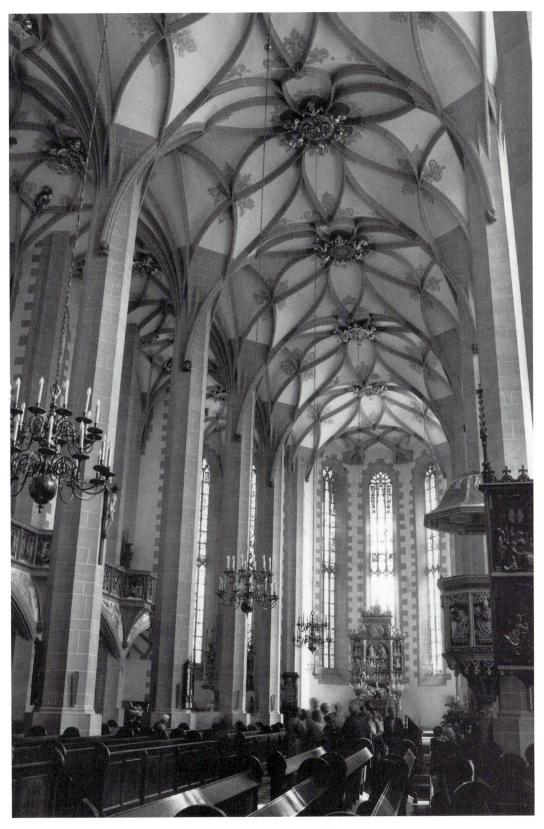

17.37 Annaberg-Bucholz, St. Anne, 1499–1522: interior. (R. G. Calkins.)

Benedict Rieth, another innovative Bohemian architect, used a similar, but lighter, more open design between 1487 and 1502 in the **Vladislav Hall** in the Hradcany Castle in Prague (fig. 17.38). This large, rectangular room served as a tournament hall. The ribs form large floral designs in the crown of the vault, emanating from curving ribs that spring from the sides of engaged piers along the walls and cut through each other as they rise in different directions. Some of these ribs simply end, like stumps, in the middle of the vault. Wrought-iron tension bars spanned the hall, stabilizing the walls. In the passage of the **Rider's Corridor** (fig. 17.39) that leads to this chamber, a profusion of curving and broken ribs intersect each other and end abruptly in the middle of the vault. Similar forms also occur in the sacristy at Annaberg of 1519 to 1522.

Analogous late Gothic exuberance occurs in the parish church of **St. Barbara at Kutná Hora** (sometimes referred to by its German name, Kuttenberg). In a choir begun by Johann Parler, Peter Parler's son, about 1388 and vaulted by Mathias Rajsek between 1489 and 1499 (figs. 17.40–17.41), Rajsek used net vaults above a clerestory and glazed triforium. However, in the nave completed in 1512, Benedict Rieth abandoned the triforium for a wide, light gallery. The gallery supports rise from the sill with no connection with the piers of the aisle arcade below. The floral rib design reflects that at Annaberg, with ribs curving around behind their supports, springing not from a shaft, but from a concavity. Similar ribs from the gallery vaults intersect those of the nave, and curve to the front of the pier as though to claim possession of it for their own system. An ultimate extreme of such floral patterning occurs in a small parish church at Kotschach in Austria of 1516, where a rich texture of wandering and intertwining stucco ten-

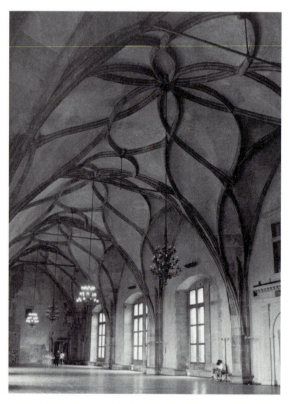

17.38 Prague, Hradcany Castle, Vladislav Hall, 1487–1502. (R. G. Calkins.)

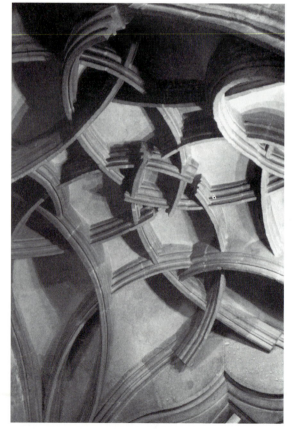

17.39 Prague, Hradcany Castle, Rider's Corridor, ribs, 1487–1502. (R. G. Calkins.)

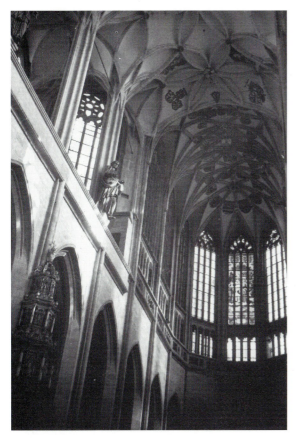

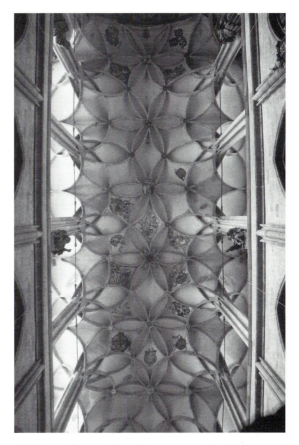

17.40 Kutná Hora, St. Barbara: nave and choir, begun 1388, 1489–99, 1512. (R. G. Calkins.)

17.41 Kutná Hora, St. Barbara: nave vaults, 1512. (R. G. Calkins.)

drils terminating in trefoil buds grows over the smoothly undulating canopy of the vault.[7]

The net vaults and floral designs formed the German equivalent of the English lierne vaults, but Bohemian and German architects also developed free-hanging autonomous ribs and pendants as their variation of the English pendant vaults. Peter Parler used a pendant hanging from freely descending ribs in the sacristy of Prague Cathedral by 1362, and detached flying ribs to the tiercerons in his south transept porch by 1368 (fig. 17.42).[8] A heavier version of Parler's sacristy pendant occurs in a side aisle at Annaberg of about 1500. Simple variants of flying ribs, forming autonomous rectilinear patterns occur at St. Leonard in Frankfurt and at Langenstein near Kassel, and proliferate in Vienna and Nürnberg.[9] More elaborate forms of flying ribs occur in the **Schlosskapelle at Meissenheim** (fig. 17.43) of the early sixteenth century where curving ribs break away from the central vault surface and project

downward in a free-hanging net of flamboyant tracery. The most extreme forms of these free-hanging ribs occur in a series of narrow side chapels dating from between 1509 and 1524 flanking the aisles of the Frauenkirche at **Ingolstadt** (fig. 17.44). Here, Erhard Heidenreich used autonomous ribbing that resembles a tangle of scaly, budding twigs, and even some like strings of hanging sausages.

Similar autonomous tracery pendants also appear in late Gothic French churches, usually restricted to individual vaults of small chapels. Examples occur at Saint-Étienne at Beauvais, and at Noyon and Senlis Cathedrals. The most remarkable example, attributed to the Jacquot brothers between 1494 and 1560, forms a hanging gilded crown under the vault of the Lady Chapel in the church of **Saints-Gervaise-et-Protais** in Paris (fig. 17.45). At Meissenheim and Ingolstadt, these elaborations were commissioned for private chapels by nobles or wealthy burghers, reflecting not only contemporary taste, but appropri-

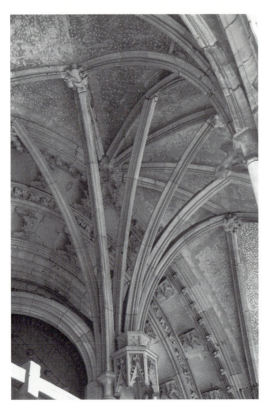

17.42 Prague, St. Vitus, south transept porch: vault with autonomous ribs, 1368. (R. G. Calkins.)

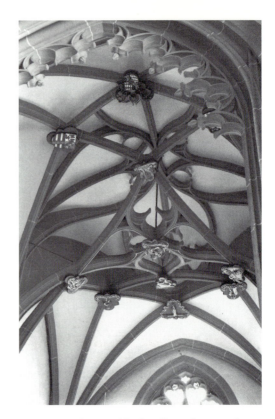

17.43 Meissenheim, Schlosskapelle, early sixteenth century: chapel vault with autonomous ribs. (R. G. Calkins.)

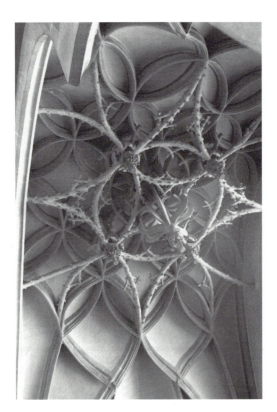

17.44 Ingolstadt, Parish Church: side chapel with autonomous ribs, 1509–24. (R. G. Calkins.)

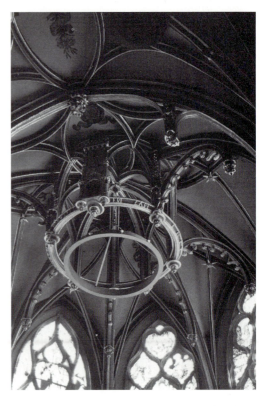

17.45 Paris, Saints-Gervaise-et-Protais: Lady Chapel vault with autonomous ribs, 1494–1560. (R. G. Calkins.)

ate, perhaps even competitive, designations of familial status. In the sacristy at St. Vitus, and at Saints-Gervais-et-Protais, they provided appropriate embellishments of special sanctified spaces.

One last variation of vaulting forms evolved in northern Germany in the late fifteenth century, developing from a rejection of rib vaults and a return to variations on the groin vault. This development is significant because it represents first a major contribution evolving out of secular architecture that was then adopted in numerous ecclesiastical buildings, and second, the last exuberant manipulation of the northern late Gothic before taste favored more sober Italianate Renaissance forms. Begun in Saxony, this form of vaulting became particularly prevalent in eastern Germany, the Baltic regions under the influence of the Hanseatic League, and in Bohemia.

Arnold von Westfalen receives credit for this last innovative phase of late German vaulting. In 1471 the

Margrave Albrecht of Saxony commissioned Arnold von Westfalen to build a castle, the **Albrechtsberg,** adjacent to the thirteenth-century cathedral of Meissen. In one of its principal rooms, the **Kirchensaal** (fig. 17.46), Arnold built huge inverted pyramids rising from short stocky piers, articulated by sharply molded ribs, but then folded the cells of the vaults between the ribs with extra creases and groins. The result constitutes the beginning of the cellular vault (*Zellengewölbe,* also known as diamond vaults, star vaults, or crystalline vaults) that exploits the principle of the groin vault to its exponential limits. He used multifaceted thin shells of brick to form folded planes that were then stuccoed and whitewashed to emphasize their prismatic quality. In an upper chapel of about 1480, he abandoned the ribs altogether and multiplied the convex and concave creases forming star patterns in the middle of the vault and tapering to corrugated cones at their

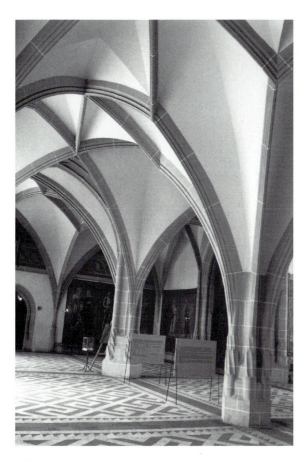

17.46 Meissen, Albrechtsburg: Kirchensaal vaults, begun 1471. (R. G. Calkins.)

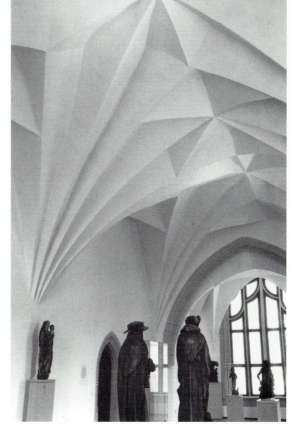

17.47 Meissen, Albrechtsburg: upper chapel vault, circa 1480. (R. G. Calkins.)

springing from the wall (fig. 17.47).[10] Simplified variants of this pristine vaulting style, using larger segments and deeper projections and indentations, occurs in the cloister of the cathedral next door of 1491 (fig. 17.48), and in the cloister of the Franciscan church at Bechyně in Bohemia. Thus Arnold and his followers achieved starkly modern and exciting effects that precociously anticipate the angled planes of ferroconcrete used by Felix Candela in his Santa Maria Miraculosa in Mexico City of 1954.

This vaulting system rapidly became popular in secular buildings as display pieces in entrance halls of burgher houses, public staircases and state rooms, as at the Albrechtsburg. The entryway to a former **burgher house in Annaberg-Bucholz** (fig. 17.49) Saxony (now the library) of about 1500, contains small repetitive parallel ridges cutting diagonally across the hall, forming faceted diamondlike patterns similar to those of the net vaults of St. Vitus and

Landschut. An elaborated variant appears above the first flight of the stairway leading upstairs. The style spread to the Austro-Bohemian border, where in the **Greinburg** (fig. 17.50) at Grein on the Danube (ca. 1488–93) perhaps a Bohemian builder multiplied the intersecting diagonals across a rectangular reception hall on the ground floor rather than an elongated entrance hall. The most elaborate manifestations occurred, however, at **Slavonice** (figs. 17.51–17.52) in Bohemia. Two burgher houses of about 1500, almost facing each other across the market square, contain entrance halls that vied with each other for the most extraordinary pendant variations of the cellular vault: hanging corrugated cones descend from star and floral patterns. No doubt they achieved their purpose, to impress the visitor.

Cellular vaults also appear in ecclesiastical buildings. The entrance-hall format used over small spans was adapted to the **cloister walks at Meissen**

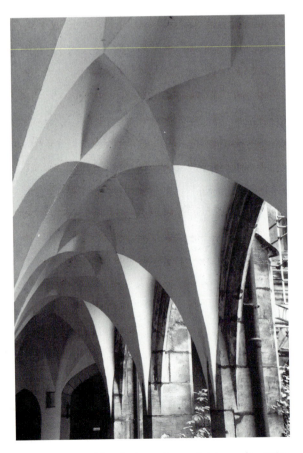

17.48 Meissen, Albrechtsburg, Dom: cloister vaults, 1491. (R. G. Calkins.)

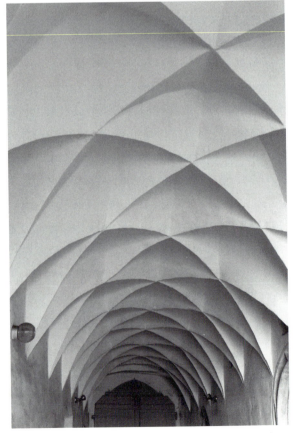

17.49 Annaberg-Bucholz, burgher house (now library), circa 1500: entrance hall vault. (R. G. Calkins.)

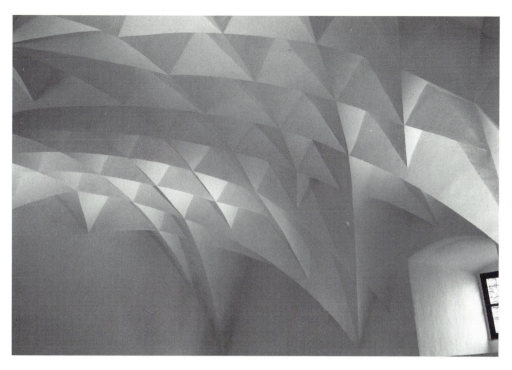

17.50 Grein, Austria, Greinburg: reception hall vault, 1488–93. (R. G. Calkins.)

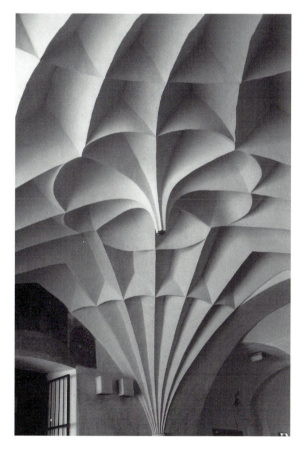

17.51 Slavonice (Bohemia), burgher house, circa 1500: entrance hall vault. (R. G. Calkins.)

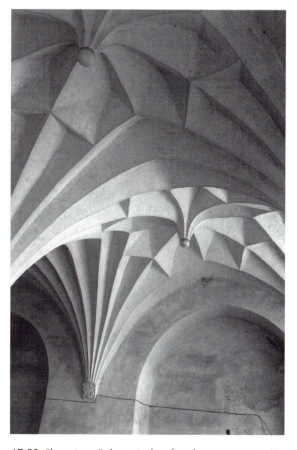

17.52 Slavonice (Bohemia), burgher house, circa 1500: entrance hall vault. (R. G. Calkins.)

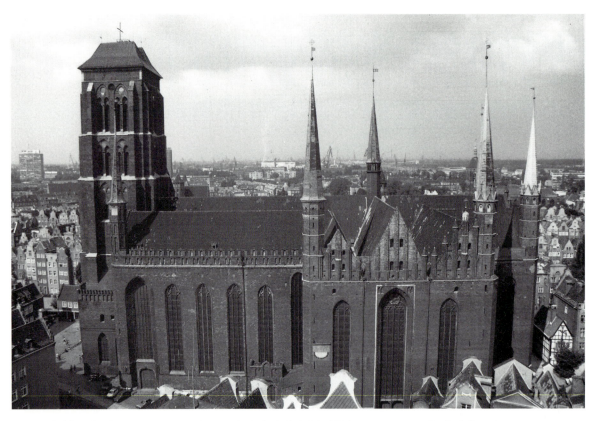

17.53 Gdańsk, Poland (Danzig, Prussia), St. Mary's Cathedral, 1343–1502: exterior view. (R. G. Calkins.)

(fig. 17.48) and at Bechyně in Bohemia. But additional uses also relate to a distinctive manner of building that prevailed in northern Germany and Poland. Particularly around the shores of the Baltic and in towns that belonged to the international commercial cartel known as the Hanseatic League that had been thriving since the twelfth century, ecclesiastical and secular buildings sprang up as an expression the growing power of the mercantile burgher class. In these northern regions, because of the lack of good building stone, brick dominated as the customary building material. These Gothic brick structures, (*Backsteingotik*), ecclesiastical and secular, have a distinctive exterior appearance, with the warm colored surfaces of facades of brick often elaborated with relief decoration of engaged mullions, elaborate blind tracery, and stepped gables.

Exteriors were usually massive, as manifested by the **Cathedral of St. Mary's at Gdańsk** (figs. 17.53–17.55) in Poland (formerly Danzig in Prussia). A huge west tower dominates the immense block of brick masonry alleviated by repetitive tall narrow windows. But the present building, begun in 1343 to replace a small thirteenth-century structure, went through several stages of construction. Building continued through two campaigns resulting in a huge structure with low aisles flanking the nave by 1400, and a three-aisled hall church configuration for the transept and choir by 1466. Between 1484 and 1502, the aisles were raised to the height of the nave and covered with elaborate cellular vaults, funded by competitive subscription by the town's wealthy burghers.

In such brick Gothic buildings, the construction of multifaceted thin shells of brick was a strong and efficient means of spanning narrow spaces. Used in cloister walks, cellular vaults sometimes migrated to the aisles of churches whose naves contain elaborate net vaults or ribbed floral patterns, as in St. Mary's, Gdańsk (figs. 17.54–17.55). When the cathedral was converted to a hall church, master Heinrich Hetzel built myriad crumpled facets, sharp groins, and angled indentations forming cellular vaults above the aisles, contrasting with the earlier dense net vaulting under

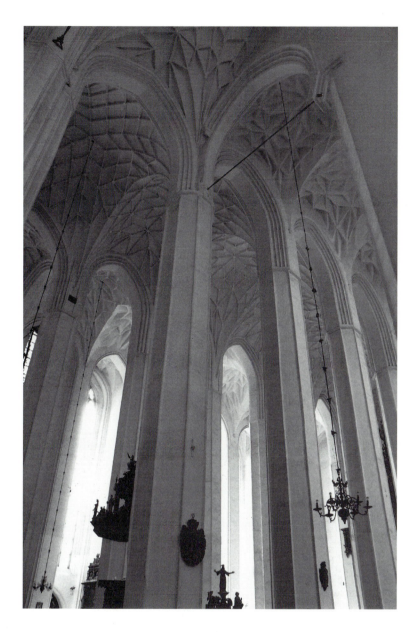

17.54 Gdańsk, Poland (Danzig, Prussia), St. Mary's Cathedral, 1343–1502, restored: nave and aisles. (R. G. Calkins.)

shallow saucer-shaped domes of the nave. Such elaborations in the aisles reflect the funding by competitive burghers, for cellular vaulting was *the* fashionable style of the moment, as indicated by its use in a secular context, discussed above. Although 40 percent destroyed during World War II, the cathedral has been restored with its shimmering, subtle whitewashed interior.

The cathedral of Gdańsk adapted the cellular vaults to the high vaults of a large hall church, but smaller structures used them just as effectively. In the parish church at **Morag,** Poland (Mohrungen,

Prussia) (fig. 17.56) of about 1515, elaborate star-patterned cellular vaults cover the side aisles in contrast to a very simple variant in the nave. And at **St. Catherine** in Gdańsk (fig. 17.57), about 1500, even more complex star patterns in the aisles contrast with the brick ribs of the net vaults in the nave—perhaps intended as appropriately embellished canopies over altars dedicated to revered saints.

Occasionally, cellular vaults constituted the preferred fashionable statement as in the naves at churches at Soběslav and Bechyně in Bohemia. In

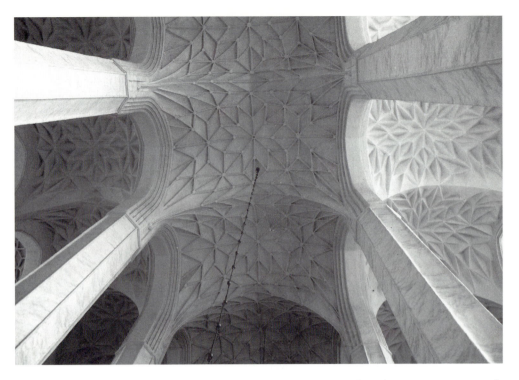

17.55 Gdańsk, Poland (Danzig, Prussia), St. Mary's Cathedral: nave and aisle vaults, 1484–1502, restored. (R. G. Calkins.)

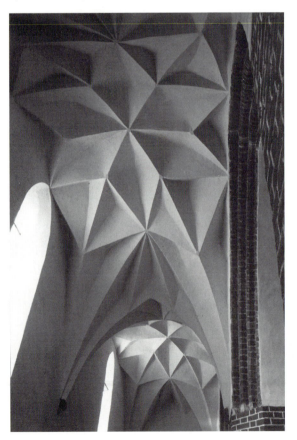

17.56 Morag, Poland (Mohrungen, Prussia), parish church: south aisle vaults, circa 1515. (R. G. Calkins.)

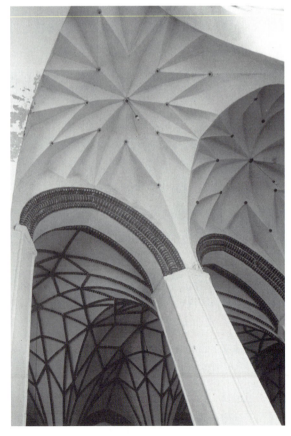

17.57 Gdańsk, Poland (Danzig, Prussia), St. Catherine, circa 1500, restored: aisle and nave vaults. (R. G. Calkins.)

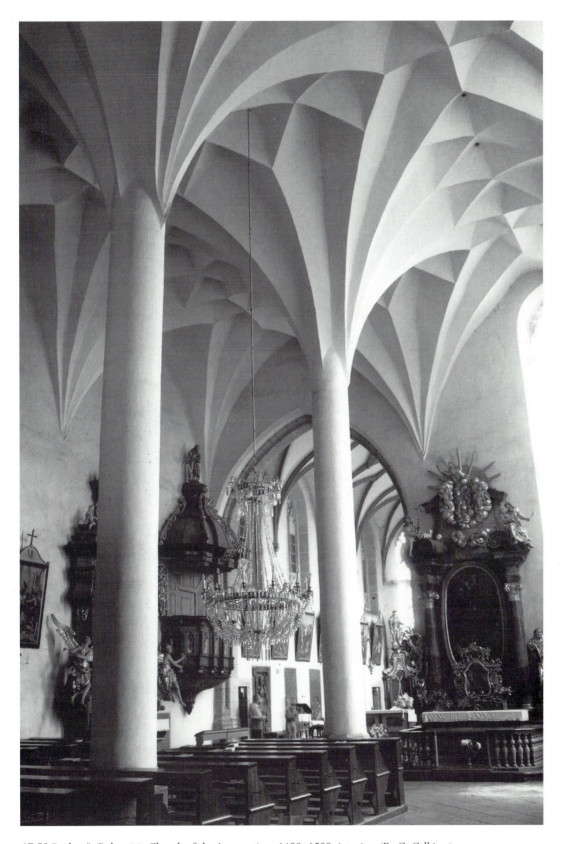

17.58 Bechyně (Bohemia), Church of the Assumption, 1490–1500: interior. (R. G. Calkins.)

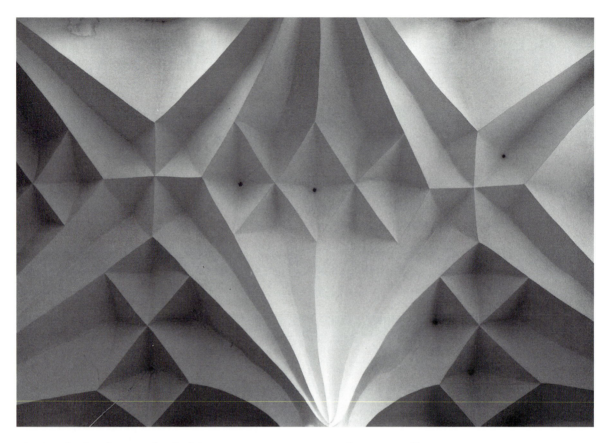

17.59 Bechyně (Bohemia), Church of the Assumption, 1490–1500: vaults. (R. G. Calkins.)

Bechyně, the Šternberk family brought Franciscan monks to the town in 1490 and expanded for them the monastery church of the **Assumption of the Virgin** (figs. 17.58–17.59). To a choir with simple net vaulting they added an elegant two-aisled nave with cones of cellular vaults rising from cylindrical columns down the middle. Emerging from these columns, groins rise in multifaceted cones and divide into intricate indented patterns, three-dimensional variations of the designs formed by the ribs of earlier net vaults.

An indication of a change from a fashionable statement to an increasing iconographic role of these vaults as befitting crowning canopies over especially important or sacred spaces can be found the chapter house at Bechyně, where the main chamber contains a simple cellular vault, but the niche intended for the abbot's chair was even more elaborated. A complex multifaceted canopy also appears above the sanctuary of the **Church of the Transfiguration at Tábor** (fig. 17.60) of about the same date. The final confirmation of this use appears in the Church of **St. Bridgit in Gdańsk** of about 1500 (fig. 17.61). Its nave, like that of the adjacent Church of St. Catherine, is decorated with net vaults of brick ribs forming geometric and floral patterns in which the warm color of the bricks contrasts sharply with the white vault surfaces. But the baptistery and sanctuary of St. Bridgit contain cellular vaults rivaling in complexity those of the aisles of the cathedral, elaborate canopies befitting the sanctity of the liturgical functions performed beneath them.

These decorative tours de force did not lend themselves to grandiose and monumental architec-

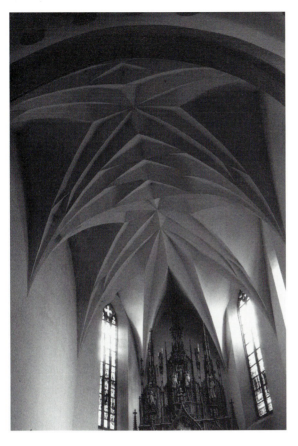

17.60 Tábor, Church of the Transfiguration, choir vaults, 1440–1512. (R. G. Calkins.)

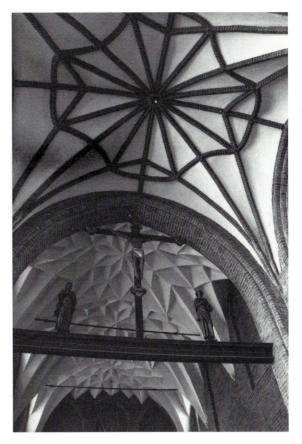

17.61 Gdańsk, Poland (Danzig, Prussia), St. Bridgit, circa 1500, restored: nave and sanctuary vaults. (R. G. Calkins.)

ture, and they occurred primarily in small spaces and private chapels commissioned by private patronage. They also mark the last innovative phase of the Gothic style. Although construction of Gothic buildings continued in northern Europe into the six-

teenth century, the influence of the Italian Renaissance became stronger, tastes changed, and English, French, and German regional variations of Renaissance architecture increasingly supplanted their variations of the Gothic style.

18

SECULAR ARCHITECTURE IN THE MIDDLE AGES

The many remarkable innovations in form and structure we have examined throughout the Middle Ages occurred primarily in religious buildings. Their form was largely dictated by the developing liturgical requirements of Christianity, such as processional spaces, centralized martyria, and radiating chapels, while their size and structural solutions were encouraged by the wealthy patronage of the church, royalty, or Holy Roman Empire. Individuals with power and wealth built palaces and castles, but until the late Middle Ages, the emphasis was often more on defensive capabilities than on structural or aesthetic innovations. Secular architecture built for the more ordinary strata of society often remained less grandiose in scale and followed traditional regional building practices. The primary purpose of their buildings was to provide shelter and protection for the inhabitants, and the resources for their financing were limited. Such buildings consisted of domestic structures, farm buildings, and small houses in villages of which only a relatively few medieval examples have survived.

The earliest domestic structures, whether in villages or rural sites in northern Europe, usually consisted of wattle and daub constructions with thatched roofs, or lean-to pole constructions, as at Ezinge (fig. 5.7, *top*), of which very few archaeological traces remain. With the perfection of half-timber construction, using timber beams to brace walls of ruble masonry, more permanent structures evolved, and this type of construction is believed to have prevailed in the ancillary buildings of the monastery at St. Gall (fig. 5.4). Combinations of such materials remained the standard construction of rural and town buildings throughout northern Europe into the nineteenth century. Later examples of such buildings survive throughout northern Europe, as in **Colmar** in Alsace (fig. 18.1). In Italy, buildings of coursed rubble were prevalent, sometimes multistoried, as at Gubbio, reflecting their heritage from the many-story *insulae* prevalent in Roman cities, such as those surviving at Ostia (fig. 2.1).

The fragmentation of political power after the disintegration of the Roman Empire, and in spite of some reconsolidation under the Carolingian and Ottonian Empires, led to the formation of localized centers of military power. Numerous armed principalities arose, and an intricate series of shifting allegiances became the basis of the feudal system. The protection the local lord could offer his subjects, in return for their crops or their manpower, was essential to this system, so strongholds were erected in almost every community. These castles developed sophisticated defensive systems in the twelfth through the fourteenth centuries before they eventually evolved into the elaborate hunting lodges and garden pavilions that were the Renaissance châteaux.

18.1 Colmar, half-timbered houses. (R. G. Calkins.)

The tradition of building fortified cities and erecting fortresses to protect them predates the origins of written history. Fortifications protected the inhabitants and keep out marauders, whether by moat, dike, and palisade systems in relatively flat areas, or massive perimeter walls surrounding an enclave on raised ground to make it more inaccessible. The Romans formalized the layout of the military camp, using a rectangular plan with a perimeter wall, entrance gates protected by flanking heavy square towers, and an interior grid system based on two main intersecting streets, the Decumanus and Cardo. The remains of a camp at Timgad in Algeria manifests such a plan, and this plan provided the basis for Diocletian's palace complex at Spalato (present-day Split) built on the Adriatic Coast about A.D. 300 (fig. 1.11). St. Louis imitated this plan at Aigues Mortes in Provence, erected between 1248 and 1272 as an embarkation point for the Seventh Crusade. The fortified camp also became the source

of inspiration for the layout of small fortified grid-system towns known as *bastide* towns in southern France during the Middle Ages.

It became the practice in any such fortified complex to build a final stronghold, a massive square or round tower called a keep, to which defending forces could retreat and try to last out a protracted siege. Usually built by local nobles, they dotted the European landscape as both safe havens and expressions of their feudal power. Eleventh-century keeps survive at Loches, Caen, and the Tower of London—surrounded by later walls—similar to the square keep at **Beaugency** on the Loire (fig. 18.2). Many twelfth-century variations also survive: the octagonal tower of the Tour de César at Provins, southeast of Paris, sits atop a mound encircled by a wall. These towers were usually multistoried to provide a high vantage point over the surrounding countryside. Groin or rib vaults, in the manner of church architecture, usually covered the lower rooms, timber ceilings the upper stories. A

18.2 Beaugency, castle keep, eleventh century. (R. G. Calkins.)

well for drinking water would usually be situated within the fortifications, sometimes even within the keep. With massively thick walls, these keeps were built for strength, and they therefore rarely received decorative embellishment: they had none of the opulence and comfort associated with later castles.

As the twelfth century progressed, the form of these castles became increasingly complex, with their various components conforming to the irregularities of their site. **Dover Castle** (fig. 18.3), begun in the second half of the twelfth century under Henry II, has a square keep at the highest point, surrounded by two concentric wandering walls with offset gates to slow people entering by constantly forcing them to change direction beneath the towering battlements. The crusader castle at **Krak des Chevaliers** (fig. 18.4) in Syria exemplifies one of the most

sophisticated examples of this form of fortification. Built on a hilltop twenty-one hundred feet above the surrounding plain, it expanded on an Arabic fortification originating from 1031. Crusaders and Arabs alternately occupied the fortification in the early years of the twelfth century. Ceded to the Hospitalers in 1143, Krak des Chevaliers then withstood several more Arab sieges until it was finally conquered by them in 1271. The present ruined complex consists of an inside circle of high walls, towers, and courtyard (bailey) of the twelfth century with an extensive outside perimeter wall with boldly projecting towers of the thirteenth century.

With variations, such sophisticated concentric fortifications around a central stronghold, and requiring changes in direction for access and providing multiple layers of defense, repeated all over

18.3 Dover Castle, twelfth century: air view. (RCHME © Crown copyright.)

18.4 Krak des Chevaliers, twelfth century: view. (Courtesy of Peter I. Kuniholm.)

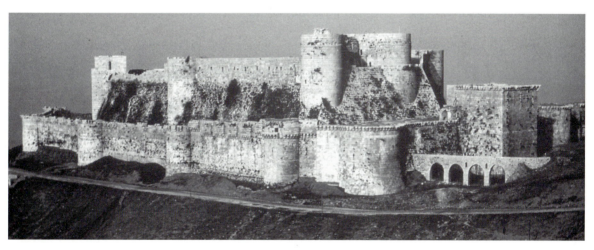

Europe throughout the later Middle Ages. Perhaps some of these castles, with their exotic silhouettes of turrets and towers were also intended as symbols of prowess and invincibility, although such statements were secondary to their physical security. The towering castle of **Karlštein** (fig. 18.5) on a pinnacle of rock west of Prague in Bohemia offers a superb fourteenth century example. Matthew of Arras designed it between 1348 and 1357 for the emperor Charles IV as a fortified reliquary and treasury for the crown jewels of the Holy Roman Empire. Reflecting its function as reliquary in the manner of St. Louis's

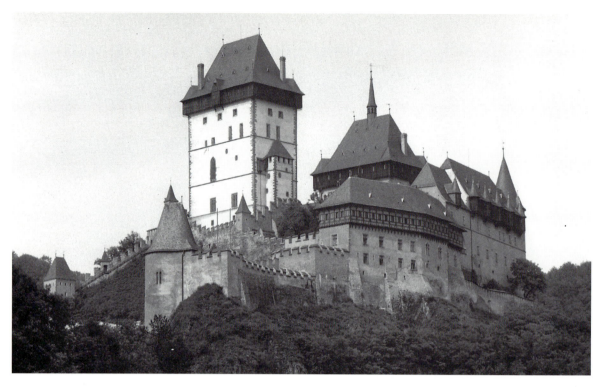

18.5 Karlštein, 1348–57: view. (R. G. Calkins.)

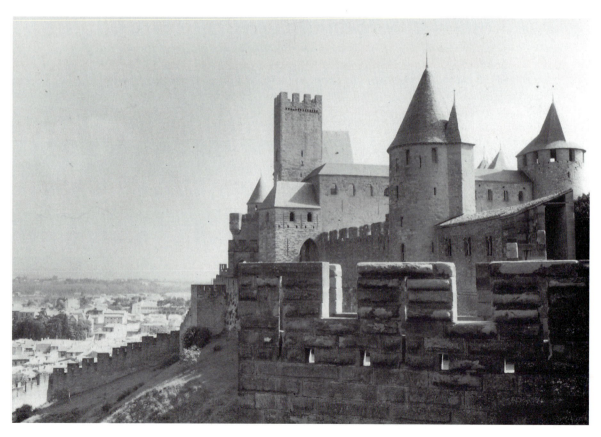

18.6 Carcassonne, thirteenth century: castle and barbican. (R. G. Calkins.)

Sainte-Chapelle, master Theodoric, and perhaps Tomasso da Modena, lavishly decorated the interior with frescoes. Some chambers, especially the chapel, have inlays of multicolored stones like settings of semiprecious jewels on a gold reliquary casket.

Such a complex could expand to envelop a whole town, as at the thirteenth-century town of **Carcassonne** (fig. 18.6) (restored by Viollet-le-Duc in the nineteenth century). Here double walls surround the irregular site, the offset gateways slow the entrance of visitors, and a massive castle and keep set against the wall at the steepest point of the escarpment provided a walled escape corridor, or barbican, leading down the hill. Other walled towns survive at Avila in Spain, Rothenburg on the Tauber in Germany, and Dubrovnik on the Dalmatian coast.

With the resurgence of the agricultural economy in Europe, perhaps beginning around A.D. 1000, and the increase in trade, partly spurred by the crusades and the pilgrimages in the twelfth century, villages became towns, and towns became cities. These growing urban centers became powerful economic and political forces in their own right, increasingly independent of the feudal lords. Under the burgeoning mercantile economy, larger urban dwellings were adapted to contain shops, and specific buildings were erected as market halls and guild halls of specific trades.

Houses of the mercantile class in these urban environments, depending on local building traditions, might have been like the half-timbered buildings in Colmar (fig. 18.1), or more substantial stone structures such as several surviving Romanesque houses at **Cluny** (figs. 18.7, 18.8, *left*). An ample arch opened into the shop area on the ground floor. Next to it a small door led to stairs accessing the main living quarters on the second story (*le premier*

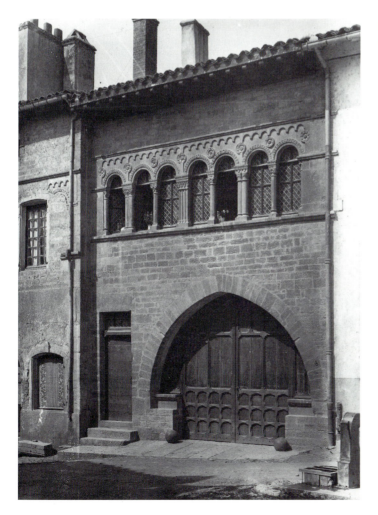

18.7 Cluny, Romanesque house, after 1159: facade. (© CNMHS.)

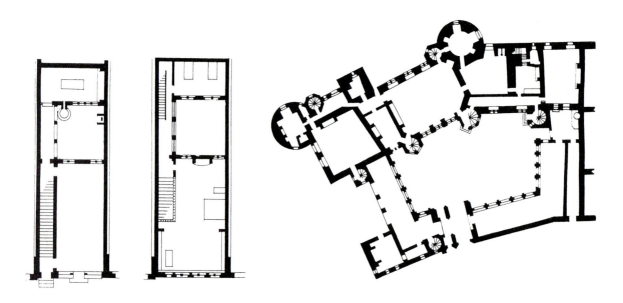

18.8 *Left:* Cluny, Romanesque house, after 1159: plan. (After Viollet-le-Duc.) *Right:* Bourges, Hôtel de Jacques Coeur, 1443–51: plan. (After Viollet-le-Duc.)

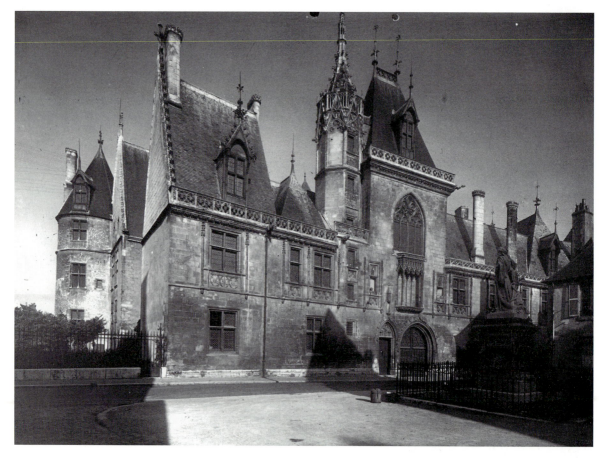

18.9 Bourges, Palais de Jacques Coeur, 1443–51: exterior facade. (© CNMHS.)

étage, piano nobile, erste Stock in French, Italian, and German respectively). The decorative windows on this story provided light to the main living room above the shop, behind which was an open court-yard. A kitchen on the ground floor and a bedroom above received light from the courtyard.

An elaborate variation of the town house was built by Jacques Coeur, treasurer to Charles VII and an immensely wealthy importer of spices and tex-tiles from the Near East, between 1443 and 1451 in Bourges. He received special permission to built it upon a section of the town ramparts. Although the bottom story facing the street of the **Palais de Jacques Coeur** (fig. 18.8, *right*; figs. 18.9–18.10) is relatively severe with only a few square mullioned windows and a carriage and pedestrian entrance, the upper story contains rich blind tracery work, more windows, and a tracery pavilion above the entrance. The facade with hexagonal stair tower overlooking the interior courtyard was even more elaborately decorated and opened up with windows. An open loggia around three sides of the courtyard provided shelter and space for Jacques Coeur's agents to sell their wares. The rooms provided every convenience known to the fifteenth century including an interior bathroom and even a sauna.

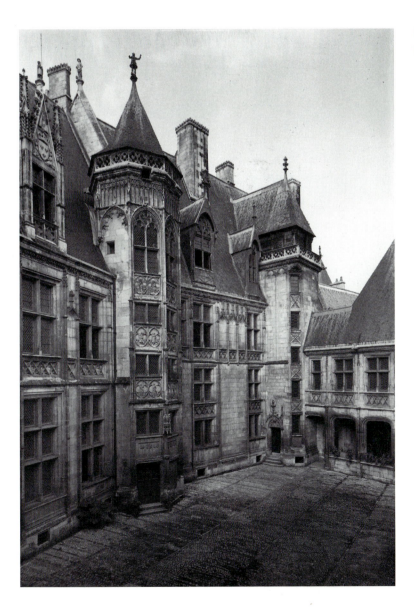

18.10 Bourges, Palais de Jacques Coeur, 1443–51: courtyard. (© CNMHS.)

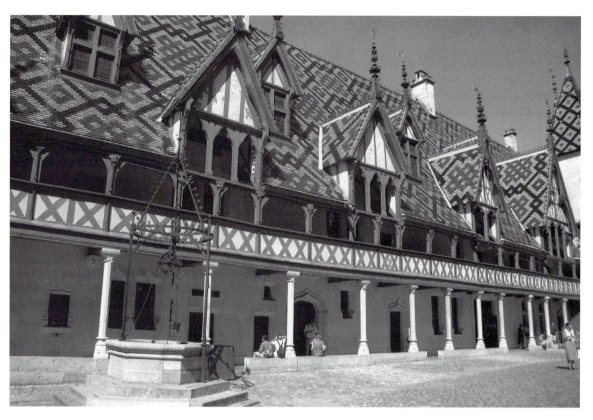

18.11 Beaune, Hôtel-Dieu, begun 1443: courtyard. (R. G. Calkins.)

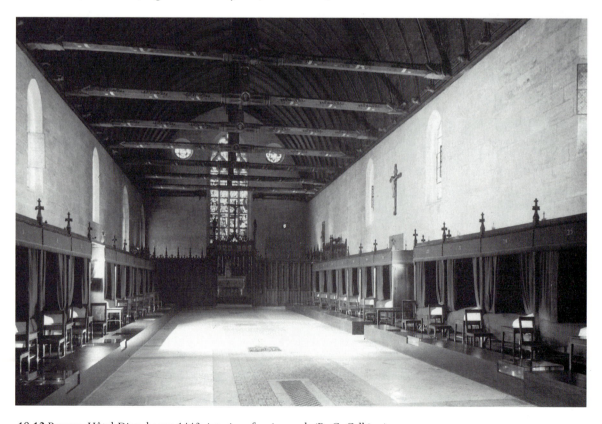

18.12 Beaune, Hôtel-Dieu, begun 1443: interior of main ward. (R. G. Calkins.)

Sometimes, however, elaborate structures were created for the public good. Nicolas Rolin, the chancellor to Philip the Good, duke of Burgundy, founded the **Hôtel-Dieu,** a hospital, in Beaune in 1443 (figs. 18.11–18.12). During much of the Middle Ages, the sick were cared for in monastic communities or by religious orders, such as the Augustinian foundation at Isenheim in Alsace, for which Matthias Grünewald's famous altarpiece was painted at the beginning of the sixteenth century. National groups of crusading knights created orders and founded hospitals for pilgrims in the Holy Land, the most famous being the Hospitalers and the Order of the Teutonic Knights in Jerusalem.

Nicolas Rolin's Hôtel-Dieu was a secular foundation, although it was run by nuns. Like the Palais de Jacques Coeur, it offers a severe facade to the outside world, but its interior courtyard, surrounded by two stories of loggias providing sheltered access to the various wards, and dominated by decorative tile roof, provides a light, open, colorful environment. A large ward for the poor, now magnificently restored

and roofed with a timber barrel vault stabilized by horizontal timber ties beams, contains rows of tester beds along the walls with curtains to provide privacy. During the fifteenth century, an altar at the end of this chamber supported Roger van der Weyden's Last Judgment Altarpiece, commissioned for the hospital by Rolin. The other rooms of the complex contained a kitchen, a pharmacy, a room reserved for nobility, and a special infirmary for those near death.

With the exponential growth in the size, population, and prosperity of medieval cities in the Gothic period, public spaces and market buildings for commerce became especially important. Open city squares often provided space for fairs and markets, but covered market halls, open on the sides, were also prevalent. Both remain common features of European towns today. A fifteenth-century **market hall at Méréville** in France consists of a simple post and lintel system with longitudinal and transverse tie beams, but with the addition of arching autonomous timber brackets to stabilize the structure (fig. 18.13). It has open sides and ends to allow

18.13 Méréville (Essonne), France, market hall, fifteenth century: interior. (Getty Research Institute, Resource Collections, Walter Horn Papers.)

18.14 Florence, Ponte Vecchio. (R. G. Calkins.)

easy access. Such timber roofs frequently covered early market halls and often replicated the form of timber truss work that had been used in rural structures such as barns through the ages (fig. 5.6).

In some major cities divided by rivers, as in London, Paris, and Florence, bridges served as important commercial thoroughfares. With houses and shops corbelled out over the water and lining the passageway, shopkeepers had access to a continual flow of prospective customers. London Bridge and the Pont-Neuf in Paris used to have this configuration; the **Ponte Vecchio** (fig. 18.14) in Florence provides the only surviving example. In the medieval tradition, artistic activities still prevail on some of these bridges today, as on Peter Parler's Charles Bridge over the Moldau in Prague, and on the modern Pont-des-Arts in Paris.

Sometimes trade or craft guilds manifested their commercial prowess by erecting imposing buildings on a main urban square, such as the monumental **Halle in Bruges** (fig. 18.15), the guild hall and market of the cloth makers. Built between 1230 and

1300, its 260-foot-high tower dominates the city. The Orsanmichele in Florence, built originally as an open corn market in 1337, and later converted into a chapel, became the object of artistic competition among the major Florentine trade guilds. During the early fifteenth century they vied with each other to commission statues of saints from the major early Renaissance sculptors Jacopo della Quercia, Nanni di Banco, Ghiberti, and Donatello to fill architectural niches on its otherwise plain exterior.

Urbanization also brought about not only the need for city government, but frequently a concern for its good administration. In keeping with this growing civic awareness, the city fathers built urban squares and town halls, providing a secular focus for the town in addition to the religious focus around the cathedral or the major parish church. The uses of these buildings were vastly different from the ecclesiastical ones, containing council chambers, courtrooms and large rooms for ceremonial functions, and they therefore required different architectural forms, without need for the large vaulted proces-

18.15 Bruges, Halle, 1230–1300: view. (R. G. Calkins.)

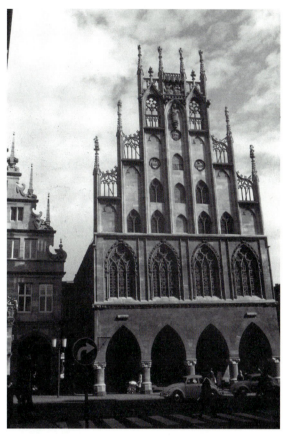

18.16 Münster, Rathaus, fourteenth century: facade. (R. G. Calkins.)

sional interiors of Romanesque and Gothic church-es. Nevertheless, architectural symbolism, which had played a large role in Roman civic structures and spaces, and which was adapted to a Christian con-text in medieval churches, took new forms as expressions of civic or commercial pride. But such structures only became prevalent after the later thir-teenth century in the city states of Italy and the mer-cantile centers of the Hanseatic league in the north.

The town hall became a vehicle for the expres-sion of civic pride in both northern and southern Europe. The commercial cities associated with the Hanseatic League, mostly ports bordering the North Sea and the Baltic, erected elaborate buildings with distinctive *backsteingotik* facades. At Lübeck, two wings of the Rathaus (town hall), linked to the Cloth Merchant's Hall (Tuchhalle), faced two sides of a large Marktplatz, with a decorative frontispiece of brick adorned with turrets, pinnacles, vertical pilasters, blind arcades, and ornamental openings. A large council chamber (Burgershaftssaal) occupied the main floor above the ground floor arcade where

merchants' booths stood on market days. An even more elaborate brickwork facade, with its gable penetrated by decorative openings and projecting above the rest of the building, was built at Stralsund in the late fourteenth century. At **Münster** (fig. 18.16) in Westphalia, the fourteenth-century Rathaus has an elaborate stone frontispiece pierced with intricate Gothic tracery projecting above the roof line like the false front of a movie set. In these buildings, a Ratskeller (literally the cellar of the town hall) usually stored beer and wine, as the municipalities had a monopoly in the sale of these commodities. The Ratskeller tradition survives today in Germany, where one can often dine and drink in the town hall basement.

The magnificent medieval town halls in Italy directly reflected the independence and pride of the often competing city states. An early example, the

massive, austere, and intimidating **Palazzo del Popolo** (fig. 18.17) of Orvieto of about 1250, stands as a brutal mass built on a gigantic arcade; however, a huge ceremonial staircase ascends at one end to the main story with its council chamber, providing the opportunity for ceremonial entrances and also expressing a modicum of accessibility to the ruling powers. Large tracery windows opening into the council chamber alleviate the severity of the facade.

As these buildings demonstrated civic pride, their form expressed a distillation of civic and artistic attitudes. For instance, nowhere is inter-city state rivalry in Italy more boldly stated than in a comparison of the Palazzo Vecchio of Florence, begun in 1299, and the **Palazzo Pubblico in Siena** (fig. 18.18) begun in 1298. Exceedingly tall towers surmount both structures and both face on their own large urban squares. However, the svelte elegance of the Palazzo Pubblico in Siena that serves as an appropriate backdrop to the Palio, a medieval festival still practiced in the piazza before it, contrasts with the vigor and strength of the Palazzo Vecchio in Florence. Both buildings, and their counterparts in many other Italian city states, manifest a new civic

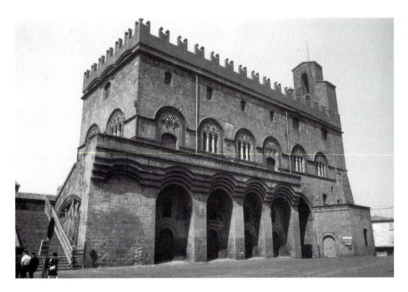

18.17 Orvieto, Palazzo del Popolo, circa 1250: facade. (R. G. Calkins.)

18.18 Siena: Palazzo Pubblico and Piazza del Campo, begun 1298. (R. G. Calkins.)

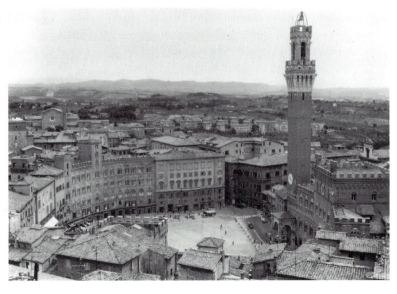

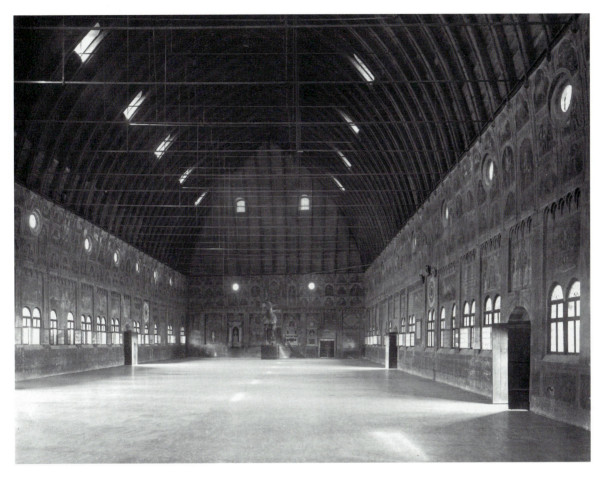

18.19 Padua, Palazzo della Ragione, 1306: interior. (Alinari/Art Resource, N.Y.)

awareness and a burgeoning secular spirit in the late Middle Ages.

Public or ceremonial meeting rooms in town halls and palaces frequently used various forms of timber truss construction, such a the wooden barrel vault in the ward of the poor at Beaune. An immense similar example dating from the twelfth and thirteenth centuries spans a large ceremonial hall in the **Palazzo della Ragione in Padua** (fig. 18.19) of 1306. Here the walls are stabilized with horizontal iron tie beams.

As the stone rib vaults of the Gothic period invited elaboration and proliferation of additional members, so did timber roof construction in the many market halls, tithe barns, and large public chambers. In the **Great Hall at Winchester** (1235–36) (fig. 18.20), wooden brackets supporting delicate tracery brace the tie beams and the roof is canted upward to

approximate the effect of a pointed barrel vault. Late medieval builders in England used variations of these timber construction techniques and developed hammer-beam truss work, as in the roof by Hugh Herland for the **Great Hall at Westminster** (fig. 18.21; 1393–1400). Even more innovative elaborations occur in timber roofs created for many small English parish churches, as at St. Paul's in Needham Market, Suffolk (1443–51), where the elaborate decoration of the Westminster Great Hall is transported into an ecclesiastical context.[1]

The development of civic and commercial complexes in the Gothic period, and their increased importance in the urban landscape in the north and in Italy, expressed the new concerns of an increasingly secularized society. They reflect a greater balance between the religious and secular spheres, a change of attitude about the absolute preeminence

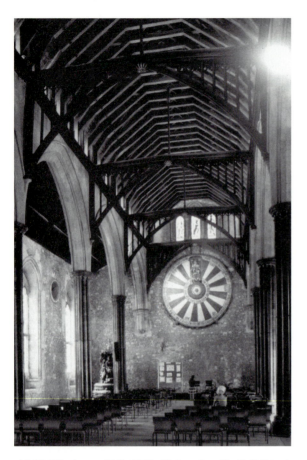

18.20 Winchester Hall, 1235–36: interior. (R. G. Calkins.)

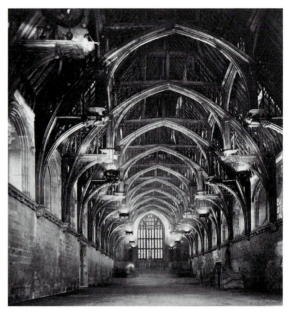

18.21 London, Westminster Hall, 1393–1400: interior. (RCHME © Crown copyright.)

of religion in people's lives that sets the stage for the ascendence of the humanism of the Renaissance. The patrons remained the same—papal, ecclesiastical, imperial, royal, and noble—but now with the addition of a wealthy mercantile class that could also afford modest architectural projects. While religious buildings remained a major vehicle for innovations in design, form and structure through the Renaissance and baroque periods, this expanded patronage also commissioned a wide range of urban spaces, civic buildings, palaces, and gardens, thus encouraging their share of architectural invention.

19

MEDIEVAL BUILDERS AND BUILDING PRACTICES

The process of building the immense structures of the Middle Ages—whether cathedrals, castles, parish churches, or humble dwellings—required the skills of many kinds of craftsmen. Many would have been lay laborers, even for the construction of monasteries and churches. However, frequently in the building of monastic communities during the early Middle Ages, the monks themselves not only planned the layout, designed the structures, and directed the construction, but also did the work. Many documents have survived, particularly from the late Middle Ages, that give a glimpse of building practices, contractual agreements, and the role of individual craftsmen for individual building sites, and these have been summarized in various modern writings on the subject. This is a rich and complex topic, for which the following discussion merely provides a brief overview.

The first step would have been the selection, clearing, and leveling of the site of the proposed building or complex. Depending on the nature of the building, an appropriately concerned abbot, bishop, noble, king, or emperor would have selected the site. The factors affecting the choice would have included any combination of the following: a long-standing tradition of perceived sanctity of the site (Chartres, Saint-Denis); the presence of a previous building for which this was to be a replacement (Reims, Amiens); its location next to an imperial or royal complex (Aachen, Sainte-Chapelle); and if it were a monastery, its proximity to arable or graze-able land (Fontenay), and possibly its defensibility (Saint-Martin-du-Canigou). In the case of the building of Salisbury Cathedral, Bishop Richard Poore obtained permission from the pope to move the seat of his bishopric from a decrepit building on a cramped hilltop at Old Sarum to a virgin site to build a new cathedral.

The labor force largely consisted of stone cutters who extracted the stones from quarries. As tools improved—a function of increasingly sophisticated metallurgy that produced harder chisels and the stone saw during the Romanesque period—walls of irregular small field stones, rubble, or reused Roman bricks were first replaced by hammer dressed stones and then by carefully cut and shaped ashlar blocks that were mined from hillsides or open pits. The mason's marks often found on blocks of stone in many medieval buildings may belong to the stone cutters, who were probably paid by the piece, identifying their work in the same way as the *peccia* marks found in manuscripts identified the work of the scribes who copied sections of the text. The stone cutters may also have worked as the masons who actually laid the stones in courses and erected the building, working alternate shifts at the quarry and on the site, but this is not certain. It seems unlikely that these identification marks would

belong to the actual builders, unless they finished shaping the stones, because the stones would have been stockpiled in the building yard until used and since five faces of the block are embedded in the masonry, many of these marks may be hidden. Later in the Middle Ages, however, such masons' marks were adopted as identifying monograms by architects in charge.

The stones were either transported by cart or by barge. While water transportation would have been the easiest and cheapest method, not every site had adequate water access. Barges could have carried stone to Notre-Dame de Paris on the Île-de-la-Cité, but the stones still had to be carted to the river from the quarry. Water transportation would certainly have played only a minor role at many sites since Laon, Chartres, and Amiens all sit on top of hills well above small, shallow streams that could have floated barges laden with stone only some distance away. In any event, whether it was the oxen presumably memorialized on the towers of Laon Cathedral, or the throngs of the devout described in Abbot Haimon's hyperbolic letter that described the "Cult of Carts" involved in bringing material for the construction of the north tower of Chartres Cathedral in 1134, in the end, the blocks of stone had to be dragged overland to the actual site.

The quality of the stone affected what could be done with it. Soft chalk would be susceptible to crumbling and would be useless for sculptural detail. A form of *calcaire grossie* was best for it would harden when exposed to air and would hold sharp edges appropriate for fine architectural decoration. The hardest stone, *lucastre,* would be durable, but shatters easily.[1] Availability of good stone restricted the durability of the building and quality of its detail, and sometimes better stone had to be imported from great distances when the necessary quality was lacking locally. Some of the stone for Chartres may have come from the Paris region, more than thirty miles away, with no connecting waterways.

The finished courses of stone of the completed building still testify to the skill of the masons, but an army of unseen craftsmen whose work does not remain, without whose help nothing could have been constructed, was also necessary: the carpenters. Massive amounts of timber were needed for centering in vaulted buildings to hold up arches, ribs, and cells, and the arcs of flying buttresses until the mortar had cured, as well as the timbers for the

trusses of gabled timber roofs, whether the buildings were vaulted or not. Above the vaults, and under the roof of Notre-Dame de Paris, vestiges of "la forêt," the original thirteenth-century roof timbers still remain, and similar medieval carpentry, with interlocking joints fixed with pegs, can be found above the radial chapels at Chartres and above the vault of the chapter house at Laon. Extensive centering would have been necessary to support the barrel vaults of Romanesque churches under construction, but the use of transverse arches, dividing the nave into bays, may have allowed the vaulting to progress a bay at a time, and permitted the repeated reuse of the centering and scaffolding. Sets of forms for the arches, ribs and flying buttresses of the Gothic cathedrals, once assembled, could have been reused many times for these elements of identical bays. Templates of shaped planks were necessary for the carving of moldings of ribs, shafts, and tracery. They were cut according to designs laid out on a tracing floor. Since neither saw mills nor band saws existed, every piece of wood had to shaped by hand: trees were sawn lengthwise and then smoothed with an adze to form beams; other pieces were reduced to thin planks by adze and plane before being cut into appropriate shapes for the templates.

The carpenters may also have been responsible for the construction of the necessary scaffolding, ladders, and wattle ramps known as *withies* that enabled the masons to ascend to the working area. However, the scaffolding and centering did not always have to be built from the ground up, for it was often supported on beams set into putlog holes, many of which still appear in the fabric of medieval buildings, or wedged into the ridges and ledges of the existing elevation. Builders hoisted materials by means of ropes and pulleys, sometimes wound up on great wheels erected in the rafters, such as one surviving at Mont-Saint-Michel.

For carving decorative moldings, string courses, capitals, ribs, and tracery, stone cutters may also have doubled as sculptors, although talented specialists in sculpture would undoubtedly have carved figurative reliefs, statues, and intricate foliate and zoomorphic decorations of corbels, capitals, and portals. Statues for portal sculptures may have been carved in the sculptors' shed, and then put in place, as at Reims, or they may have been carved from blocks already in situ, a practice used on the contemporary Cathedral of St. John the Divine in New York City.

The person responsible for the ultimate design of any molding, tracery, configuration of ribs and arches, and indeed, the entire building, would have been the master mason, the medieval equivalent of the modern architect.[2] His role as chief designer is indicated by medieval representations of master masons with their tools of the trade: the set square and a pair of dividers. In the early Middle Ages, he is for us an elusive figure, for even if we know his name, we know virtually nothing about him. The names of some architects are recorded throughout history, in the preantique and antique worlds, as well as the early Middle Ages. The Roman architect Vitruvius (ca. 90–20 B.C.), in his *Ten Books of Architecture,* described the ideal qualifications of the architect and the procedures by which he should operate. Thanks to Procopius, we know a little bit about Anthemios of Tralles and Isidorus of Miletus. The chronicles of Cluny mention Hézelon of Liège as the builder of Cluny III with the inspirational help of a vision beheld by the monk Gunzo. Gervaise of Canterbury gave us a precise account of the activities of William of Sens and William the Englishman at Canterbury. Building accounts and tax roles record the names of others. A labyrinth on the pavement of Reims Cathedral (now destroyed) recorded the names of Jean d'Orbais, Jean de Loup, Gaucher de Reims, and Bernard de Soissons, but controversy prevails over the exact time span and chronology that they were in charge and what they actually accomplished. But we know nothing of the architects who worked with Abbot Suger on the designs for the west front and choir at Saint-Denis, nor the architect responsible for the rebuilding of Chartres after the fire of 1194.

As the Gothic period progressed and the names of renowned master builders became more prevalent, the aura of their reputations increased, and their status became legendary. In the 1261, the Dominican Nicolas de Biard's reference to master masons, who "with rod and glove in hand, say to the others, 'Cut the stone in this fashion . . .' yet they receive greater pay," inferred that they never got their own hands dirty.[3] Nevertheless, they would have had to work their way up through an apprenticeship system for years doing those very tasks before assuming a head position. By the end of the Middle Ages, the master mason belonged to a mason's guild or lodge, a term derived from the stone cutter's shed next to the building site, and adhered to strict regulations or ordinances concerning his training and activities. The earliest mention of

a mason's lodge occurs in 1258, but the extent and nature of this tradition before then is unclear.[4]

By the fifteenth century, families of architects had set up virtual architectural dynasties in various regions of Europe. The activities of three generations of the Vertue family were recorded in England between 1475 and 1527, with Robert Senior working at Westminster Abbey in 1475. He was appointed master mason to the king in 1499, and designed the Henry VII chapel by 1506. Various branches of the Parler family were renowned in Germany. The most famous member, Peter Parler, completed the choir of St. Vitus Cathedral between 1356 and 1385 and built the Charles Bridge in Prague in 1357 under Charles IV. His father, Heinrich the Elder, designed the choir of the Heiligkreutzkirche in Schwäbish Gmund in 1351. Peter's son, Johann IV, designed the choir of the collegiate church at Kutná Hora in 1388. Peter's brother, Johann III, worked on the choir of the Minster of Freiburg-im-Breisgau in 1354. Johann III's son, Michael II von Freiburg, worked on the facade of Strasbourg Cathedral about 1365. A Heinrich Parler from Ulm, from another branch of the family, consulted in the discussions of the building of Milan Cathedral in 1392. And this is only a partial list of the family and its activities.[5] While all of these architects followed the prevailing styles of their day, they by no means reflected a homogeneous "school" of architecture, developing instead their own individual repertoires of motifs and details.

The growing renown of individual architects in the thirteenth century, and continuing through to the end of the Middle Ages, appears to have encouraged each master mason to become distinctive in some way. This tendency may be partly responsible for the progressive fine-tuning of the design elements in the elevations of French early and mature Gothic cathedrals leading to the final resolution in the Rayonnant nave of Saint-Denis. Certainly the cumulative increase in the knowledge of statics won through experience, and the growing sophistication of stone cutting and vaulting techniques, accounted for thinner ribs, cells, and buttresses; but their linear articulation and the manipulation of responds to vaulting systems became exercises in design, with each architect looking over a previous solution and "tweaking" it according to his own developing aesthetic and taste. The cult of artistic individuality in the modern sense may not yet have asserted itself, but master masons in the later Middle Ages were fast approaching the role of the prima donna, as evi-

denced in the vituperative squabbles between northern and Italian architects over how Milan Cathedral should be built.

Present over all of this activity was the taste and personality of the patron. The degree of his involvement and of his meddling in the design process is rarely evident. Renaud of Mouçon, bishop of Chartres, was strongly urged by Cardinal Melior of Pisa to rebuild the cathedral after the fire of 1194, and he and members of the chapter donated a large part of their incomes for three years to the construction of the new cathedral. One can be certain that they hovered around the chantier, agreeing that the new church should be built on the foundations of the old after the fire of 1194, especially since they were spared the expense of digging new foundations. But how much did they have to do with the subtle changes of design that resulted in its new synthesis of Gothic form? We know from Gervaise of Canterbury about the resistance of the canons to the total removal of the damaged choir after the fire of 1174 and how the wily William of Sens finally persuaded them that all had to be demolished except Anselm's shell. But how much interaction was there between them over William's use of six-part vaulting and Purbeck marble shafts?

One suspects an increasing pride and fierce competition between bishops and perhaps between master masons in the construction of French Gothic cathedrals that resulted in the rejection of some designs in favor of others, and that this competitive spirit may partly be responsible for pushing the height of their buildings to the limit at Beauvais, but we have no proof. Abbot Suger had been deeply involved in planning the iconography of his stained-glass windows and bronze doors, even composing verses for them. One can therefore envisage him constantly peering over the shoulder of his now anonymous second master mason, prodding him not to place walls between the chapels in the choir, as he had in the crypt, so that he would achieve maximum traffic flow, and perhaps urging him to place the largest possible windows in the radial chapels. Where the demands of the patron, his economic resources, and the flexibility and inventiveness of the master mason coincided, as at Saint-Denis, we have a solution that uses elements that had all be used previously elsewhere, but which, in their combination, transcends the sum of its ingredient parts.

Financing was a major factor in the construction of these buildings, for when it was not available,

construction stopped.[6] The bishop and canons of Chartres donated part of their incomes to the reconstruction of their cathedral in 1194. The bishop of Notre-Dame in Paris had access to the income from productive vineyards on the left bank. Abbot Suger made the collection of income from his dependencies more efficient, and also before Louis VII left on a crusade, had access to royal patronage. The bishops of Reims and Amiens taxed the wealthy merchants, with resulting uprisings and stoppages of work. The bishop of Reims also sold special indulgences to raise money. Some of the stained-glass windows at Chartres were financed by nobility, including Blanche of Castille, and it is believed that many the various trade guilds of the town funded others. This view has been questioned, but in any case, the funds would have paid for the windows, not the fabric of the building.[7] At Chartres, relics were paraded through the surrounding countryside from 1214 to 1216 to revive flagging financial interest. Towers were particularly susceptible to the vagaries of funding, for their visibility made them as much a statement of civic as well as ecclesiastical pride, and it was often the support of the mercantile class that brought them to completion and its refusal to contribute that prevented them from being built. Thus conflicts between the clergy and the townspeople at Chartres, Reims, and Amiens often brought construction to a halt. For all to proceed smoothly, harmonious relationships had to be maintained between the chapter, the bourgeoisie, the nobility and the royalty, often a difficult equilibrium to achieve and maintain.

Many medieval buildings were laid out according to a simple geometric grid or proportional schema. The medieval master mason used the most basic of tools: a right angle, a compass, a straight edge, a measuring rod of some predetermined length (royal foot, local foot, or *bracia*), and a string with which either to rotate diagonals of a predetermined square, or to serve as a plumb line to check the verticality of the walls.

As a result, the basic layout of the building and its relative proportions were all easily arrived at and projected by simple means: the most common device would be to repeat the square of the crossing area for the dimensions of the transepts and choir, and multiply it by an appropriate factor for the length of the nave.

More subtle relationships could be achieved by rotating the diagonal of the square by means of a

string to achieve a rectangle whose length is the $\sqrt{2}$, or rotating the diagonal of half a square to achieve a rectangle based on the golden section in which a smaller part is to the greater as the greater is to the whole. While such mathematical permutations may seem obscure, they were described in Vitruvius's *Ten Books of Architecture,* known throughout the Middle Ages. For medieval builders, Vitruvius's descriptions of ideal forms derived from simple geometric figures, based on Plato's *Philebus,* became the source for generating the proportional systems they employed. Indeed, builders through the ages have recognized that structures organized according to these relationships reflect universal aesthetic principles that are pleasing and empathetically harmonious. Thus, basic geometric relationships, projected by simple means, produce proportions that in turn relate to the mathematics of musical harmonies, and as such were thought to reflect the divine harmonies of the universe. Such a concept is embodied in the miniature in the Chronicles of Cluny that shows the aged monk Gunzo (fig. 19.1) having a vision of Saints Peter, Paul, and Stephen (to whom Cluny was dedicated) demonstrating to him how to lay out and rotate these diagonals, implying that the resulting proportions were divinely inspired. It is appropriate that the image of God creating the universe, which became popular in the thirteenth century when many of the major French cathedrals were under construction, shows him as the master architect (fig. 19.2), with dividers, separating out the heaven, earth, sun, moon, and stars in just proportions, ordering "all things in measure, number and weight" (Wisdom 11:21).

From the mathematical proportioning of the plan and elevation evolved a predilection for numerical symbolism that would have been apparent to the medieval beholder. The eight-sided plans of early baptisteries symbolized the eight days between Christ's entry into Jerusalem and his Resurrection. Abbot Suger wrote that the twelve columns around his choir stood for the Twelve Apostles, and the

19.1 Gunzo's Dream, *History of Cluny,* circa 1190. (Drawing by Kenneth Conant after Paris, Bibliothèque Nationale, Ms. lat. 17716, fol. 43r.)

19.2 God as Master Architect of the Universe, *Bible Moralisée,* circa 1250. (Vienna, Österreichische Nationalbibliothek, Cod. 2554, fol. 1v.)

twelve in the ambulatory for the minor prophets. The triplet of windows in the west facade of Chartres or in the clerestory of Saint-Remi at Reims, as well as its three-story elevation, or the triple portals at Saint-Denis and Chartres, were obvious references to the Trinity. Numerical symbolism is a rich topic; however, like that of geometric permutations, it is subject to frequent abuses, since every number has some symbolic value. For the best reading of the intended symbolism, one needs to depend on the medieval sources, such as Abbot Suger, Rupert of Deutz, or Durandus, who nevertheless indulged in their own excesses.

Symbolic form also added to the significance of these structures. The pedimented arch had imperial and therefore authoritative connotations in late antique and early Christian art and architecture. Westworks in Carolingian, Ottonian, and Romanesque buildings may have had the same implications. The ubiquitous cruciform plan symbolized the cross upon which Christ was crucified. Vaults, domes, and consequently their supporting members evoked the dome of heaven, a continuation of the cosmic significance of domes in antiquity. They also invoked the dome of the Holy Sepulchre in Jerusalem, known throughout the Middle Ages, and therefore imparted funerary connotations and the implication of ultimate resurrection and salvation. *Spoilia*, reused architectural elements taken from earlier buildings, such as columns, capitals and friezes, stated continuity with the past, as in the importation of classical columns to Cluny, or the reuse and even copying of Merovingian columns and capitals at Saint-Denis. All of these devices, combined with plan, structure, and exterior silhouette, resulted in churches that were an expression of continuity, of reverence for the sanctity of the site and of a terrestrial manifestation of the heavenly city of Jerusalem.

The process of formulating a design and then producing working drawings also remains obscure. Models of wood, clay, or wax may have been made by the master mason to show what the proposed building would look like, but only some from Renaissance architects have survived. Undoubtedly, the master builder made sketches on sheets of parchment, a slate, or planks of a drafting table, but eventually they were worked out in full-sized patterns on a tracing floor: incised lines for rose windows survive on the crypt floor of Bourges, for arches and tracery on the floor of an aisle at Lyons, on the floor above the chapter house at York, and elsewhere.

With the exception of a few scattered fragments, no architectural plans or drawings from before the thirteenth century have come down to us. The earliest surviving compendium of such drawings is the portfolio of drawings by Villard de Honnecourt dating from approximately 1225 to 1250. Some scholars consider Villard to have been an architect active in France, perhaps at Cambrai and Reims, but we have no indication of his having built a single building, and his drawings of carpentry betray a lack of understanding of standard practices. Carl Barnes showed that the notebook is a group of diverse scraps of parchment assembled and ordered well after the drawings were made, with notations by Villard and later owners, much as we might compile an annotated scrapbook of memorabilia.[8] Whether an architect, metalworker, or just gentleman dilettante and traveler, Villard had a keen interest in architectural details—as well as everything else around him. His drawings depict everything from a lion and a porcupine, which he claims to have drawn "from life," to figures clothed in the classicizing drapery of the style of Nicholas of Verdun, to diagrams of how to draw figures and animals, to variations on plans for chevets with radial chapels for Cistercian churches, to drawings of actual buildings: an unknown clock tower, a west facade tower at Laon with its oxen, and elevations and sections of Reims. The drawings of Reims are remarkable (fig. 19.3), as they are the earliest surviving evidence of a concern for relating the interior and exterior elevations of chapels and of the nave wall, in the latter case, side by side in a single drawing. That Villard made this analysis shows that questions of architectural design and relationships were prevalent by the early thirteenth century, especially if Villard were not a practicing architect. In turn, similar drawings were most probably made after other existing monuments by traveling masons to serve as sources of inspiration for their own buildings elsewhere. It was probably by means of such "model books" that many of the innovative devices in architecture and art were disseminated across Europe throughout the Middle Ages.

The earliest surviving manifestations of architects working out complete designs in advance date from the fourteenth century and later. The seventeen-foot drawing of the facade of Cologne of about 1300, two competition drawings for the facade at Orvieto, the drawings of the Campanile of Florence Cathedral by Giotto, of the facade of Strasbourg cathedral, per-

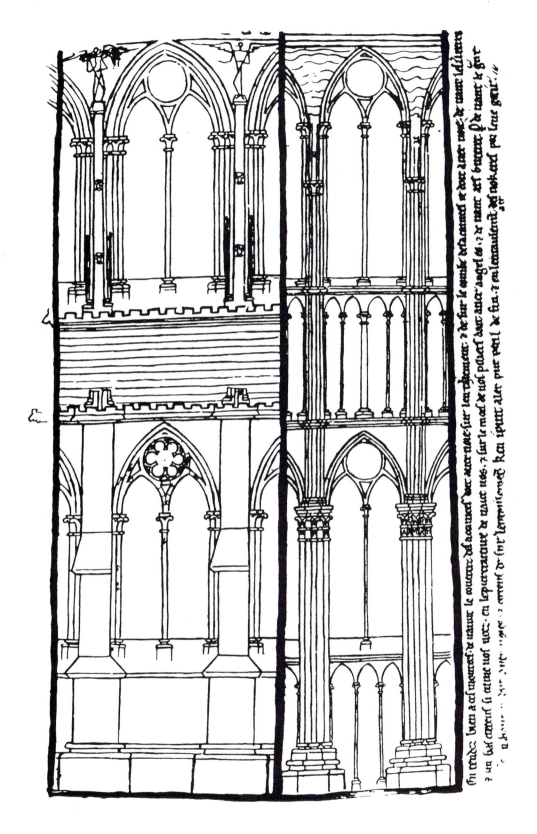

19.3 Villard de Honnecourt, drawing of interior and exterior elevation of Reims, circa 1225–50. (J. B. Lassus after Paris, Bibliothèque Nationale, Ms. fr. 19093, fol. 31v.)

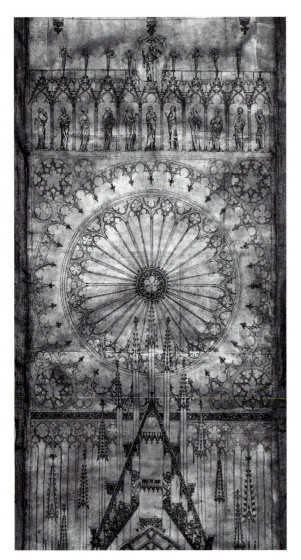

19.4 Drawing for Strasbourg facade by Michael de Fribourg, circa 1365. (Musée de l'Oeuvre Notre Dame de Strasbourg.)

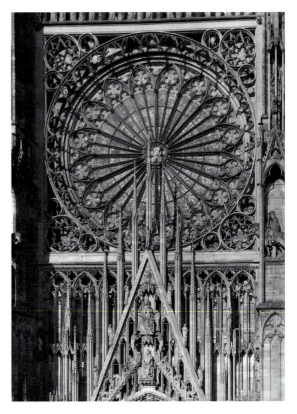

19.5 Strasbourg Cathedral: facade, late fourteenth century. (© CNMHS.)

haps by Michael of Freiburg circa 1365 (fig. 19.4), and of the tower of Ulm Cathedral by Hans Niesenberger of 1462 are rare surviving vestiges of a planned design before the creation of working drawings; these designs were in fact adhered to fairly closely (fig. 19.5).

This interest in the perfection of design for its own sake was combined with new concerns in the Renaissance. Brunelleschi and Serlio paid considerable attention to recording the features of existing monuments, especially of the archaeological remains of ancient Rome. Alberti revived the architectural theories of Vitruvius and wrote further elaborations on them. These concerns led to the deliberate return to classical forms in architecture, cloaked in new humanistic symbolism, and a further development of preparatory specifications, drawings and models, as for the competition for the dome of Florence Cathedral. All of these ingredients combined to yield a new Renaissance architecture, vastly different in details, form, associations, and intent from the churches and castles of the Middle Ages.

Notes

Chapter 1

1. For diagrams and a concise description, see Leland M. Roth, *Understanding Architecture: Its Elements, History and Meaning* (New York: HarperCollins Publishers, Icon Books, 1993), 22–27.

Chapter 2

1. See André Grabar, *Christian Iconography. A Study of its Origins* (Princeton: Princeton University Press, 1968).

2. Richard Krautheimer, *Early Christian and Byzantine Architecture, Pelican History of Art,* 3rd ed. (Harmondsworth and New York: Penguin Books, 1979), 40–41.

3. Kenneth J. Conant, *Carolingian and Romanesque Architecture 800–1200, The Pelican History of Art* (Harmondsworth and New York: Penguin Books, 1978), 40–41.

4. Based on the excavations conducted by David J. Stanley: "New Discoveries at Santa Costanza," *Dumbarton Oaks Papers* 48 (1994), 257–61.

5. Krautheimer, *Early Christian and Byzantine Architecture,* 90.

6. For illustrations, see Krautheimer, *Early Christian and Byzantine Architecture,* 90, plates 43 A and B.

Chapter 3

1. The following quotes have been rearranged for effectiveness. Reprinted by permission of the publishers and the Loeb Classical Library from Precopius's complete account of Haghia Sophia: *Procopius: the Buildings,* Vol. VII, translated by B. Dewing (Cambridge, Mass.: Harvard University Press, 1940), 11–33.

Chapter 4

1. For surveys of Byzantine architecture in these regions, see Krautheimer, *Early Christian and Byzantine Architecture;* Cyril Mango, *Byzantine Architecture* (New York: Harry N. Abrams, 1976); and William L. MacDonald, *Early Christian and Byzantine Architecture* (New York: George Braziller, 1962).

2. For the arrangement of mosaics in Byzantine churches, see Otto Demus, *Byzantine Mosaic Decoration: Aspects of Monumental Art in Byzantium* (London: Routledge & Kegan Paul, 1953).

3. For Armenian architecture, see J. Strzygowski, *Die Baukunst Armenier und Europa* (Vienna, 1918); S. der Nersessian, *Armenia and the Byzantine Empire* (Cambridge, Mass.: Harvard University Press, 1945); and G. de Francovich, ed. *Architettura medievale Armena* (Rome, 1968).

CHAPTER 5

1. Liam de Paor questioned the St. Patrick legends in *Saint Patrick's World: The Christian Culture of Ireland's Apostolic Age—Translations and Commentaries* (Dublin: Four Courts Press, 1993).

2. Walter Horn and Ernest Born, *The Plan of St. Gall: A Study of the Architecture and Economy of, and Life in, a Paradigmatic Carolingian Monastery* (Berkeley: University of California Press, 1979). For a summary, see Lorna Price, *The Plan of St. Gall in Brief* (Berkeley: University of California Press, 1982). For a review of the study by Horn and Born, see Warren Sanderson in *Speculum* 60/3 (July 1985), 615–32.

3. Josef Strzygowski, *Early Church Art in Northern Europe* (London: B. T. Batsford, 1928); Walter Horn, "On the Origins of the Bay System," *Journal of the Society of Architectural Historians* 17/2 (1958), 2–22.

4. See the section on "Secular Architecture" by Philip Dixon in *The Making of England: Anglo-Saxon Art and Culture, AD 600–900,* Leslie Webster and Janet Backhouse, eds. (London: The British Museum, 1991), 67–70.

5. For medieval timber-truss market halls and barns, see Malcolm Kirk, *Silent Spaces: The Last of the Great Aisled Barns* (Boston and New York: Little Brown and Co., 1994).

CHAPTER 6

1. Jean Hubert, J. Porcher, and W. F. Volbach, *The Carolingian Renaissance* (New York: George Braziller, 1970), 343.

2. A tenth-century *Miracula S. Maximini* stated that Germigny-des-Prés was built like the palatine chapel at Aachen: quoted in Richard Krautheimer, "Introduction to an Iconography of Medieval Architecture," reprinted in Richard Krautheimer, *Studies in Early Christian, Medieval, and Renaissance Art* (New York: New York University Press, 1968), 116. Krautheimer's article explores the medieval attitude toward architectural copies.

3. Richard Krautheimer, "The Carolingian Revival of Early Christian Architecture," *The Art Bulletin* 24 (1942), 1–38.

4. Considerable controversy remains over the exact size and many of the details of the Carolingian church. Disagreements concern whether the cloister was trian-

gular or square, whether the crossing towers were square or round, and the exact function of the westwork: see references listed under Centula in the bibliography.

5. Archaeological evidence suggests that this space, and therefore perhaps the space above, was octagonal: Bernard, Honoré, "D'Hariulphe à Effmann, à la lumière des récents fouilles de Saint-Riquier," *Actes du 95ᵉ Congrès National des Sociétés Savantes,* Section d'archéologie et d'histoire de l'art (Reims, 1970), 219–35.

6. The function of the westwork has provoked considerable discussion: for a start, see Carol Heitz, *Recherches sur les rapports entre architecture et liturgie à l'époque carolingienne.* Bibliothèque Générale de l'École Pratique des Hautes Études, VIᵉ Section (Paris: S.E.V.P.E.N, 1963); H. Reinhardt and E. Fels, "Étude sur les églises-porches carolingiennes et leur survivance dans l'art roman," *Bulletin monumental* 92 (1933), 331–65; 96 (1937), 425–69; and Vallery-Radot, J., "Notes sur les chapelles hautes dédiées à Saint-Michel," *Bulletin monumental* 88 (1929), 453–78.

CHAPTER 7

1. Jean Bony, *French Gothic Architecture of the 12th and 13th Centuries* (Berkeley: University of California Press, 1983), 82–83.

2. Groin vaults span the choir of La Trinité at Caen, completed by 1066, but they are neither as high nor as wide as Speyer. For La Trinité, see chapter 12.

CHAPTER 8

1. Visigothic horseshoe arches also appeared at San Fructuoso de Montelius at Braga in Portugal and San Pedro de Nave, both of the seventh century: see Pedro de Palol, *Arte Hispanico de la Epoca Visigoda* (Barcelona: Ediciones Poligrafa, 1968), figs. 56 and 57, and passim.

Muslim horseshoe arches began to appear in the early eighth century. A hint of a horseshoe arch occurs in the arcaded court of the Great Mosque of Damascus of about 706: see Richard Ettinghausen and Oleg Grabar, *Art and Architecture of Islam 650–1250,* The Pelican History of Art (Harmondsworth and New York: Penguin Books, 1987), figs. 13 and 14. Distinct horseshoe arches appeared in the *mihrab* of the Great Mosque of Kairovan of 836–75, and abounded in the arcades of the Mosque at Córdoba from 736 and in its *maksurah* and *mihrab* of 987.

Visigothic and Muslim horseshoe arches may derive from different geometries, but their effect is similar. Generally, Muslim horseshoe arches are based on a circle and extend beyond the semicircle. Visigothic horseshoe arches, on the other hand, are sometimes only semicircles with inward projections at the bottom of the intrados, inner curve, and occasionally have an elongated extrados, outer curve.

CHAPTER 9

1. Quoted from Elizabeth Holt, *A Documentary History of Art,* Vol. 1 (Garden City, New York: Doubleday Anchor Books, 1957), 18.

2. Henri Focillon, *L'An Mil* (Paris: Armand Colin, 1952).

3. Henri Focillon, *The Art of the West in the Middle Ages: Romanesque Art,* trans. D. King (New York: Phaidon, 1963), 17–58.

4. For an illustration of S. Mariá de Vilabertrán, see Pedro de Palol, *Early Medieval Art in Spain* (New York: Harry N Abrams, Inc., 1966), fig. 171.

5. For illustrations, see de Palol, *Early Medieval Art in Spain,* figs. 56–57.

6. E. C. Ferni related S. Vicente to the Bodrum Cami in Constantinople in "St Vincent at Cardona and the Mediterranean Dimension of First Romanesque Architecture," in *Studies in Medieval Art and Architecture Presented to Peter Lasko,* eds. David Buckton and T. A. Heslop (London: Alan Sutton, Publishers, 1994), 24–35.

7. See Kenneth J. Conant, *Carolingian and Romanesque Architecture,* fig. 205.

CHAPTER 10

1. Early Muslim examples of slightly pointed arches appear at the Great Mosque of Damascus by 706, on a gate at Raqqa about 772, at the Jawsaq al-Khaqani Palace at Samarra in 836–37, on the Nilometer at Fustat in 861, and in the mosque of Ibn Tulun at Fustat by 879; a pointed barrel vault was used in an entrance hall at Ukhaydir, circa 778.

2. See Annie Shaver-Crandall and Paula Gerson, *The Pilgrim's Guide to Santiago de Compostela: A Gazetteer* (London: Harvey Millar Publishers, 1995), which contains a commentary, an English translation of the *Guide,* and an illustrated gazetteer.

3. For a discussion of this object, see Jean Taralon, *Treasures of the Churches of France* (New York: George Braziller, 1966), 295.

4. Abadie used these motifs for his design of the Sacré-Coeur, built on the Butte-de-Montmartre in Paris between 1876 and 1910.

5. Anglo-Norman variations of the screen facade appear on English Romanesque buildings such as Castle Acre, Bury St. Edmunds, and Malmesbury, and then on English Gothic cathedrals: St. Alban's, Wells, Salisbury, and Lincoln (for the Gothic manifestations, see chapter 15).

6. See Whitney Stoddard, *Art and Architecture in Medieval France,* Icon Editions (New York: Harper & Row, 1972), 85–90; figs. 118–21.

CHAPTER 11

1. For early Muslim antecedents, see chapter 10, note 1.

2. For an illustration, see Otto Demus, *Byzantine Mosaic Decoration,* plate 45.

3. For illustrations of these two churches, see Heinrich Decker, *Romanesque Art in Italy* (New York: Harry N. Abrams, 1960) plates 148–49, 151.

4. Interlocking arches occur in the decoration of the exterior portals of the great Mosque of Córdoba of the tenth century and on the exterior of the Bab Mardum mosque in Toledo of circa 1000.

5. Sant' Ambrogio was once thought to contain the first structural rib vaults: see Conant, *Carolingian and Romanesque Architecture,* 391–95 for discussion and previous bibliography. For Durham Cathedral, see chapter 12.

CHAPTER 12

1. For a reconstruction drawing of the interior of Jumièges, see Jean Bony, *French Gothic Architecture,* fig. 75.

2. Jean Bony, "La technique normande du mur épais à l'époque romane," *Bulletin Monumental,* 98 (1939), 153–88.

3. John James, "The Rib Vaults of Durham Cathedral," Gesta 22 (1983), 135–46. See also Jean Bony, "Le projet premier de Durham: voûtement partiel ou voûtement total," *Urbanisme et architecture, études écrits et publiées en l'honneur de Pierre Lavedan* (Paris, 1954), 41–49.

4. Stephen Gardner, "The Nave Galleries of Durham Cathedral," *The Art Bulletin* 64 (December 1982), 564–78.

CHAPTER 13

1. See chapter 10, note 1.

2. Christopher Wilson, *The Gothic Cathedral* (London and New York: Thames and Hudson, 1990), 41–42.

3. From Suger's *De Administratione,* translated in Erwin Panofsky, *Abbot Suger on the Abbey Church of St.-Denis and its Art Treasures* (Princeton: Princeton University Press: 1979), 49.

4. Stephen Gardner, "Two Campaigns in Suger's Western Block," *The Art Bulletin* 66 (December 1984), 574–87. For the full account of the building of the abbey from its Merovingian beginnings, see Sumner McKnight Crosby, *The Royal Abbey of Saint-Denis from Its Beginnings to the Death of Suger, 475–1151,* edited and completed by Pamela Z. Blum (New Haven: Yale University Press, 1987). See also William Clark, "Suger's Church at Saint-Denis: The State of Research," in *Abbot Suger and Saint-Denis, A Symposium,* edited by Paula Lieber Gerson (New York: Metropolitan Museum of New York, 1986), 105–30.

5. Jean Bony, *Gothic Architecture,* figs. 54–55, 57.

6. Panofsky, *Abbot Suger,* 75.

7. Wilson, *The Gothic Cathedral,* 41–42.

8. For Suger's complete text, see Panofsky, *Abbot Suger.*

9. See Bony, *Gothic Architecture,* fig. 52; and *idem,* "What Possible Sources for the Chevet of Saint-Denis?" in Gerson, ed., *Abbot Suger and Saint-Denis,* 131–43. Wilson, in *The Gothic Cathedral,* suggests that Abbot Suger's accounts are a defense of his elaborate expenditures on the doors, windows, and liturgical objects for his abbey. I find it difficult to believe, given the apparent magnitude of Abbot Suger's ego, that if he had recognized the innovative quality of what he had caused to be created, he would have refrained from extolling its innovative qualities.

10. For a conjectural reconstruction of the elevation of Sens, see Bony, *Gothic Architecture,* fig. 96.

11. For the exterior of the nave of Tournai Cathedral, see Bony, *Gothic Architecture,* fig. 158.

12. Wilson, *The Gothic Cathedral,* 59–60.

13. See Bony, *Gothic Architecture,* figs. 163, 165, 180, 181, 183.

14. See Bony, *Gothic Architecture,* fig. 134.

15. Robert Mark, *Experiments in Gothic Architecture* (Cambridge, Mass.: MIT Press, 1982).

16. William Clark and Robert Mark, "The First Flying Buttress: A New Reconstruction of the Nave of Notre-Dame de Paris," *The Art Bulletin* 66 (March 1984), 47–64.

17. For Champeaux, see Bony, *Gothic Architecture,* fig. 175.

18. Whitney Stoddard, *Art and Architecture in Medieval France,* fig. 197.

CHAPTER 14

1. William Clark, "Gothic Architecture" in *Medieval France, An Encyclopedia,* William W. Kibler and Grover A. Zinn, eds. (New York and London: Garland Publishing, Inc., 1995), 400–05.

2. For a discussion of the growing design mentality, see Charles M. Radding and William Clark, *Medieval Architecture, Medieval Learning: Builders and Masters in the Age of Romanesque and Gothic* (New Haven and London: Yale University Press, 1992).

3. This popularly accepted hypothesis has been questioned by Jane Williams, *Bread, Wine and Money: The Windows of the Trades at Chartres Cathedral* (Chicago: The University of Chicago Press, 1993).

4. The width-to-height proportion at Sens is 1:1.95; Laon 1:2.25. However, Noyon is 1:2.55; Notre-Dame de Paris 1:2.74.

5. Carl Barnes, "The Documentation for Notre-Dame de Soissons," *Gesta* 15 (1976), 61–70; *idem,* "The Twelfth Century Transept of Soissons Cathedral: The Missing Sources for Chartres?" *Journal of the Society of Architectural Historians* 28 (1969), 9–25.

6. Robert Mark, *Experiments in Gothic Architecture* (Cambridge, Mass.: MIT Press, 1982).

7. Barbara Abou-el-Haj, "The Urban Setting for Late Medieval Church Building: Reims and its Cathedral between 1210 and 1240," *Art History* 11/1 (March 1988), 17–41.

8. For this controversy, see the following: Robert Branner "The Labyrinth of Reims Cathedral, *Journal of*

the *Society of Architectural Historians* 21 (1962), 18–25; *idem,* Jean d'Orbais and the Cathedral of Reims," *The Art Bulletin* 43 (1961), 131–33; *idem,* "Historical Aspects of the Reconstruction of Reims Cathedral 1210–1241," *Speculum* 36 (1961), 23–37; *idem,* "The North Transept and the first West Façades of Reims Cathedral," *Zeitschrift für Kunstgeschichte* 24 (1961), 220–41; Henri Deneux, "Chronologie des maîtres d'oeuvre de la cathédrale de Reims," *Bulletin de la société national des antiquaires de France* (1920), 196–200; and Jean-Pierre Ravaux, "Les compagnes de construction de la cathédral de Reims de Reims au XIIIᵉ siècle," *Bulletin Monumental* 137 (1979), 7–66.

9. For the labyrinth in which the names of the four main architects were recorded, see Robert Branner, "The Labyrinth of Reims Cathedral," *Journal of the Society of Architectural Historians* 21 (1962), 18–25. A different reading of the labyrinth evidence by Deneux yielded an almost reversed chronology: Gaucher de Reims (1211–19), Jean de Loup (1219–35), Jean d'Orbais (1235–55), and Bernard de Soissons (1255–90): see Henri Deneux, "Chronologie des maîtres d'oeuvre de la cathédrale de Reims," *Bulletin de la société national des antiquaires de France* (1920), 196–200, a view in part accepted by Richard Hamann-MacLean and Ise Schusseler, *Die Kathedrale von Reims,* Vol I, *Die Achitektur* (Stuttgart: Franz Steiner Verlag, 1993). For additional campaigns of construction, see Jean-Pierre Ravaux, "Les compagnes de construction de la cathédral de Reims de Reims au XIIIᵉ siècle," *Bulletin Monumental* 137 (1979), 79.

10. Villard de Honnecourt is generally though to have been an architect, but in fact we know nothing about him except for the evidence of his "notebook." For a discussion of the controversy and the drawings by Villard, see the following publications of Carl Barnes: *Villard de Honnecourt, the Artist and his Drawings,* G. K. Hall Annotated Bibliographies (New York, 1982); "The Drapery-Rendering Technique of Villard de Honnecourt," *Gesta* 20/1 (1981), 199–206; "The Codicology of the Portfolio of Villard de Honnecourt (Paris, Bibliothèque Nationale, MS. Fr. 19093)," *Scriptorium* 42/1 (1988), 20–48; and "A Note on the Bibliographic Terminology in the Portfolio of Villard de Honnecourt," *Manuscripta* 31 (1987), 71–76. Whatever his actual status and profession, Villard has left us a collection of the oldest surviving analytical architectural drawings that reveal a developed sense of design, as when he compares the inside and outside elevations of the choir chapels and the nave at Reims (fig. 19.3).

11. Stephen Murray and J. Adiss, "Plan and Space at Amiens Cathedral," *Journal of the Society of Architectural Historians* 49 (1990), 44–66.

CHAPTER 15

1. For a more detailed account of the developments of Italian Gothic architecture, see John White, *Art and Architecture in Italy, 1250 to 1499, Pelican History of Art* (Baltimore: Penguin Books, 1966), 3–38, 159–200, 317–58. For an important reassessment, see Marvin Trachtenberg, "Gothic Italian 'Gothic': Toward a Redefinition," *Journal of the Society of Architectural Historians* 50 (March 1991), 22–27.

CHAPTER 16

1. Stephen Murray, *Beauvais Cathedral, Architecture of Transcendence* (Princeton: Princeton University Press, 1989).

2. Robert Mark, *Light, Wind, and Structure: The Mystery of the Master Builders,* New Liberal Arts Series (New York: McGraw Hill Publishing Company, 1990), 128–35.

3. See Stephen Murray, *Building Troyes Cathedral, The Late Gothic Campaigns* (Bloomington and Indianapolis: Indiana University Press, 1987), 87–109.

4. Robert Branner, *The Court Style of Saint Louis,* (London: Zwemmer, 1965).

5. Wilson, *The Gothic Cathedral,* 124–26.

CHAPTER 17

1. Peter Kidson, "St. Hugh's Choir," *Medieval Art and Architecture at Lincoln Cathedral. British Archaeological Association, Conference Transactions.* 1982, 8 (Lincoln, 1986), 29–42.

2. For illustrations of the chapter houses at Worcester and Lincoln, see Geoffry Webb, *Architecture in Britain in the Middle Ages, The Pelican History of Art* (Harmondsworth and New York: Penguin Books, 1965), plates 58 A and B.

3. See Webb, *Architecture in Britain in the Middle Ages,* plate 178 A.

4. For an examination of this controversy, see James S. Ackerman, "'Ars sine Scientia nihil est . . .", *The Art Bulletin* 31 (1949), 84 ff. For a summary of the arguments, see White, *Art and Architecture in Italy,* 336–50.

5. Karl Heinz Clasen, *Deutsche Gewölbe der Spätgotik,* (Berlin, 1961), 27–34.

6. For a discussion of the curved rib system, see James Ackland, *Medieval Structure: the Gothic Vault* (Toronto: Toronto University Press, 1972), 200–09.

7. For an illustration, see Karl Heinz Clasen, *Deutsche Gewölbe der Spätgotik,* fig. 222.

8. This development may have begun with the autonomous braces across the aisle of the Sainte-Chapelle of 1242–48 (fig. 16.9), and flying ribs in the vault of the Berkeley Chapel in Bristol Cathedral of circa 1300–10: see Pevsner, *An Outline of European Architecture* (Harmondsworth, Penguin Books, 6th Jubilee edition, 1960), fig. 170.

9. See Paul Frankl, *Gothic Architecture,* plates 112 A and B, 164 A and B, and Clasen, *Deutsche Gewölbe der Spätgotik,* figs. 140–42.

10. Antecedents for these vaults may be found in the faceted surfaces, stepped out squinches, and prismatic or honeycomb pendentives found in Muslim architecture, as at Isfahan in the Masjid-Jami as early as the twelfth century or in the Madressah Bibi Quasem (1340), and at Bursa, Turkey, in the Mosque of Murad I (1365–85): see Jean Bony, *The Decorated Style: Gothic Architecture Transformed 1250–1350* (Ithaca, N.Y.: Cornell University Press, 1979), fig. 287, and James Ackland, *Medieval Structure,* 221 ff. Closer to home, the Alhambra at Granada has many chambers with elaborate honeycombed ceilings, but early cellular vaults use larger faceted planes. A more appropriate antecedent may have been the extrasharp creases in the cells of some four-part vaults as early as the 1330s, as in the Wiesenkirche in Soest (fig. 17.29).

Chapter 18

1. For English parish churches see Colin Platt, *The Parish Church of Medieval England* (London: Seker and Warburg, 1981).

Chapter 19

1. See John James, "An Investigation into the Uneven Distribution of Early Gothic Churches in the Paris Basin, 1140–1240," *The Art Bulletin* 66 (March 1984), 15–46.

2. The term *architect* was not used as we know it in the Middle Ages: see N. Pevsner, "The Term 'Architect' in the Middle Ages," *Speculum* 17 (1942), 549–62). The subject of the medieval master builder/architect is a complex one, but for a good introduction to the subject, the reader should consult the following: Jean Gimpel, *The Cathedral Builders,* Teresa Waugh, trans. (New York: Harper and Row, 1984); John Harvey, *The Medieval Architect* (London: Wayland Publishers:1972); Nicola Coldstream, *Masons and Sculptors,* Medieval Craftsmen (Toronto and Buffalo, University of Toronto Press: 1991); and for the masons's lodges, Paul Frankl, *The Gothic Literary Sources and Interpretations through the Ages* (Princeton: Princeton University Press: 1960), 1–234.

3. Nicolas de Biard, quoted in Jean Bony, *French Gothic Architecture of the 12th and 13th Centuries,* 358.

4. For an overview of the literature on masons' lodges, see Paul Frankl, *The Gothic. Literary Sources,* 110–58.

5. For the Parler Family, see Louis Grodecki, *Gothic Architecture* (New York: Harry N. Abrams, 1977), 305–6; A. Legner, ed., *Die Parler und der schöne Stil 1350–1400,* 5 vols. (Cologne: Schnütgen Museum, 1978).

6. For a discussion of the funding see Henry Kraus, *Gold Was their Mortar: The Economics of Cathedral Building* (London, Henley, and Boston: Routledge & Kegan Paul, 1979).

7. See Jane Williams, *Bread, Wine and Money: The Windows of the trades at Chartres Cathedral* (Chicago: The University of Chicago Press, 1993).

8. Carl Barnes, *Villard de Honnecourt, the Architect and His Drawings. A Critical Bibliography,* Reference Publications in Art History (Boston: G. K. Hall and Co., 1982).

BIBLIOGRAPHY

GENERAL SURVEYS AND BACKGROUND

Adams, Henry. *Mont-Saint-Michel and Chartres.* New York: Collier Books, 1963.

Bishop, Morris. *The Middle Ages.* New York: American Heritage Press, 1970.

Bucher, Francois. "Micro-architecture as the "Idea" of Gothic Theory and Style," *Gesta* 15 (1976), 71–89.

Busch, Harald, and Bernd Lohse, eds. *Gothic Europe.* London: B. T. Batsford, 1959.

Calkins, Robert. *Monuments of Medieval Art.* Ithaca: Cornell Univeristy Press: 1989.

Conant, Kenneth J. *Carolingian and Romanesque Archtecture 800–1200.* The Pelican History of Art. Harmondsworth and New York: Penguin Books, 1978.

Crossley, P. "Medieval Architecture and Meaning: the Limits of Iconography." *The Burlington Magazine* 130 (1988), 116–21.

Dehio, Georg., and G. von Bezold. *Die kirchliche Baukunst des Abendlandes.* 2 vols., 5 atlases. Stuttgart: A. Bergströsser, 1887–1901.

Duby, George. *The Age of the Cathedrals: Art and Society 980–1420.* Chicago: University of Chicago Press, 1981.

Ettinghausen, Richard, and Oleg Grabar. *Art and Achitecture of Islam 650–1250.* The Pelican History of Art. Harmondsworth and New York: Penguin Books, 1987.

Fletcher, B. A. *History of Architecture on the Comparative Method.* 19th ed. London: Butterworths, 1987.

Focillon, Henri. *The Art of the West in the Middle Ages.* Jean Bony, ed. Vol I: *Romanesque Art;* Vol II: *Gothic Art.* London: Phaidon, 1963.

Gall, Ernst, Olive Cook, trans. *Cathedrals and Abbey Churches of the Rhine.* New York: Harry N. Abrams, Inc., 1963.

Holt, Elizabeth, ed. *A Documentary History of Art.* Vol. I. New York: Doubleday Anchor Books, 1957.

Kidson, Peter, Peter Murray, and Paul Thompson. *A History of English Architecture.* Harmondsworth and New York: Penguin Books, 1965, 13–151.

Kostof, Spiro, with revisions by Greg Castillo. *A History of Architecture: Settings and Rituals.* New York, Oxford: Oxford University Press, 1995.

Krautheimer, Richard. "Introduction to an 'Iconography of Medieval Architecture.'" *Journal of the Warburg and Courtauld Institutes* 5 (1942), 1–33.

Neale, J. M., and B. Webb. *William Durandus, Bishop of Mende, on the Symbolism of Churches and Church Ornaments.* London, 1843.

Pevsner, Nicholas. *An Outline of European Architecture.* Baltimore and Harmondsworth: Pelican Books, 1963, 1–171.

Porter, Arthur K. *Medieval Architecture: Its Origins and Development.* 2 vols. New York: The Baker and Taylor Company, 1909.

Power, Eileen. *Medieval People.* New York: Barnes and Noble, Inc., 1924.

Radding, Charles M., and William Clark. *Medieval Architecture, Medieval Learning: Builders and Masters in the Age of Romanesque and Gothic.* New Haven and London: Yale University Press, 1992.

Stoddard, Whitney. *Art and Architecture in Medieval France.* New York: Harper and Row, 1972.

Trachtenberg, Marevin, and I. Hyman. *Architecture: From Prehistory to Post Modernism / The Western Tradition.* Englewood Cliffs: Prentice Hall, 1986.

Webb, Geoffrey. *Architecture in Britain in the Middle Ages. The Pelican History of Art.* Harmondsworth and New York: Peguin Books, 1965.

1. Classical Antecedents

Bianchi Bandinelli, R. *Rome, the Late Empire.* P. Green, trans. New York: George Braziller, 1971.

Brilliant, Richard. *Roman Art from the Republic to Constantine.* London: Phaidon, 1974.

Brown, Frank E. *Roman Architecture.* New York: George Braziller, 1961.

Collart, P., and P. Coupel. *L'autel monumental de Baalbek.* Paris, 1951.

De Fine Licht, K. *The Rotunda in Rome: A Study of Hadrian's Pantheon.* Copenhagen: Nordisk Forlag, 1968.

Kähler, H. *Das Fortunaheiligtum von Palestrina Praeneste.* Saarbrucken, 1958.

———. *Hadrian und seine Villa bei Tivoli.* Berlin, 1950.

MacDonald, William. *The Architecture of the Roman Empire: An Introductory Study.* New Haven and London: Yale University Press, 1965.

Smith, E. B. *The Dome.* Princeton: Princeton University Press, 1950.

Swift, Emerson H. *Roman Sources of Christian Art.* New York: Columbia University Press, 1951.

Ward-Perkins, J. B. *Roman Imperial Architecture. The Pelican History of Art.* Harmondsworth and New York: Penguin Books, 1981.

———. *Roman Architecture.* New York: Harry N. Abrams, 1977.

Wilkes, J. J. *Diocletian's Palace, Split: Residence of a Retired Roman Emperor. Exeter:* Short Run Press, Ltd., 1993.

2. Early Christian Buildings to A.D. 500

Butler, H. C. *Architecture and Other Arts,* Publication of an American Archaeological Expedition to Syria in 1899–1900. New York: Century, 1903.

———. *Ancient Architecture in Syria.* Sect. A.: *Southern Syria;* Sect. B.: *Northern Syria.* Publication of the Princeton University Archaeological Expeditions to Syria in 1904–5 and 1909, Div. II. 2 pts. Leiden: E. J. Brill, 1919–20.

———. *Early Churches in Syria.* Princeton, N.J.: Published for the Department of Art and Archaeology of Princeton University, 1929.

Coüasnon, Charles. *Church of the Holy Sepulchre in Jerusalem.* J. P. B. and C. Ross, trans. London: Oxford University Press, 1974.

Davis-Weyer, Caecilia. *Early Medieval Art 300–1150. Sources and Documents.* Engelwood Cliffs: Prentice-Hall, 1971.

Gerkan, A. von. *Spätantike und Byzance (Neue Beiträge zur Kunstgeschichte des 1. Jahrhunderts).* Baden-Baden, 1952.

Grabar, André. *Christian Iconography. A Study of its Origins.* Princeton: Princeton University Press, 1968.

———. *Martyrium* 2 vols. Paris: Collège de France, 1946.

Harvey, William. *Church of the Holy Sepulchre, Jerusalem: Structural Survey.* London: Oxford Unversity Press, 1935.

Krautheimer, Richard. *Early Christian and Byzantine Architecture.* 3rd ed. *The Pelican History of Art.* Harmondsworth and New York: Peguin Books, 1979.

———. *Corpus basilicarum Christianarum Romae. The Early Christian Basilicas of Rome (IV–IX Cent.).* 5 vols. Città del Vaticano: Pontificio istituto di archeologia cristiana, 1937.

Lassus, J. *Sanctuaires chrétiens de Syrie.* Paris: P. Geuthner, 1947.

MacDonald, William L. *Early Christian and Byzantine Architecture.* New York: George Braziller, 1962.

Mango, Cyril. *Byzantine Architecture.* New York: Harry N. Abrams, 1976.

Milburn, Robert. *Early Christian Art and Architecture.* Berkley: University of California Press, 1988.

Rostovtzeff, M. I. *Dura Europas and Its Art.* Oxford, 1938

Sanderson, Warren. *Early Christian Buildings. A Graphic Introduction.* Montreal and Lake Champlain, N.Y.: Astrion Publishing, 1993.

Stanley, David J. "New Discoveries at Santa Costanza." *Dumbarton Oaks Papers* 48 (1994), 257–61.

Volbach, Wolfgang F. *Early Christian Art.* New York: Harry N. Abrams, Inc., 1961.

3. Justinian's Buildings

Mathews, Thomas F. *Early Churches of Constantinople: Architecture and Liturgy.* University Park, Penn.: Pennsylvania State University Press, 1971.

Milligen, A. van. *Byzantine Churches in Constantinople: Their History and Architecture.* London: Macmillan, 1912.

Procopius. *Buildings.* H. B. Dewing, trans. Vol. 7. The Loeb Classical Library. Cambridge: Harvard University Press, 1940.

Haghia Sophia

Conant, Kenneth J. "The First Dome of St. Sophia and its Rebuilding," *Bulletin of the Byzantine Institute* 1 (1946), 71–78.

Kähler, H. *Haghia Sophia,* trans., E. Childs. New York: Praeger, 1967.

Mainstone, Rowland. *Haghia Sophia: Architecture, Structure and Liturgy of Justinian's Great Church.* New York: Thames and Hudson, 1988.

Mark, Robert, and A. Cakmak. *Haghia Sophia: From the Age of Justinian to the Present.* New York: Cambridge University Press, 1992.

Mark, Robert. *Light, Wind and Structure: The Mystery of the Master Builders.* Cambridge: Cambridge University Press, 1990.

Schneider, A. M. *Die Haghia Sophia zu Konstantinopel.* Berlin, 1939

Swift, Emerson, *Haghia Sophia.* New York: Columbia University Press, 1940.

S. Vitale, Ravenna

Bovini, Giuseppe. *San Vitale, Ravenna.* Milan: Silvanan Editoriale d'arte, 1956.

von Simson, Otto. *Sacred Fortress: Byzantine Art and Statecraft in Ravenna.* Chicago: University of Chicago Press, 1948.

4. Later Byzantine Variations

Demus, O. *The Church of San Marco in Venice.* Washington, D.C.: Dumbarton Oaks Research Library and Collection, 1960.

———. *Byzantine Mosaic Decoration.* London: Routledge and Kegan Paul, 1953.

Diehl, C., M. Le Tourneau, and H. Saladin. *Les Monuments chrétiens de Salonique,* 2 vols. Paris: E. Leroux, 1918

de Francovich, Geza., ed. *Architettura medievale Armena.* Rome: De Luca, 1968.

Hörmann, H. *Forschungen in Ephesos.* Vol 4, pt 3. Öster-reichisches Archäologisches Institut, Vienna. Baden bei Wein: Rudolf M. Roher, 1951.

Krautheimer, Richard. *Early Christian and Byzantine Architecture,* 3rd ed. The Pelican History of Art.

Harmondsworth and New York: Penguin Books, 1979.

der Nersessian, S., *Armenia and the Byzantine Empire.* Cambridge: Harvard University Press, 1947.

Soteriou, G. A. *Hi Basiliki tou Hagiou Dimitriou.* 2 vols. Bibliotheke tes en Athenais Archaiologikes Hetaireias, No. 34. Athens: 1952.

Strzygowski, Josef. *Die Baukunst Armenier und Europa.* Vienna: A. Schroll and Co., 1918.

5. Early Monasticism and Northern Traditions

Monasticism

Braunfels, W. *Monasteries of Western Europe: The Architecture of the Orders.* A. Laing, trans. Princeton: Princeton University Press, 1973.

Dixon, Philip. "Secular Architecture." *The Making of England: Anglo-Saxon Art and Culture, AD 600–900.* eds., Leslie Webster and Janet Backhouse. London: The British Museum, 1991, 67–70.

Eschapasse, M. *L'Architecture Bénédictine en Europe.* Paris: 1963.

Horn, W., and E. Born. *The Plan of St. Gall: A Study of the Architectecture and Economy of, and Life in a Paradigmatic Carolingian Monastery.* Berkeley: University of California Press, 1979.

Horn, W., E. Born, Jenny Marshall, and Grellen Rourke. *The Forgotten Hermitage of Skellig Michael.* Berkeley: University of California Press, 1990.

de Paor, Liam. *Saint Patrick's World: The Christian Culture of Ireland's Apostolic Age—Translations and Commentaries.* Dublin: Four Courts Press, 1993.

Price, Lorna. *The Plan of St. Gall in Brief.* Berkeley: University of California Press, 1982.

Rusconi, Arturo Jahn. *Monte Cassino.* Bergamo: Istituto italiano d'arte grafiche, 1929.

von Schlosser, J. *Die Abandändische Klosteranlage des frühen Mittelalters.* Vienna: 1889.

Willard, H. M. "A Project for the Graphic Reconstruction of the Romanesque Abbey at Monte Cassino," *Speculum* 10 (April 1935), 144–46.

Timber Construction

Brugge, A. *Norwegian Stave Churches.* Ragnar Christopherson, trans. Oslo: 1953.

Dietrichson, L. *De norske stavkirker.* Copenhagen: A. Cammermeyer, 1892.

Horn, W. "On the Origins of the Medieval Bay System," *Journal of the Society of Architectural Historians* 17/2 (1958), 2–22.

Kirk, Malcolm. *Silent Space: The Last of the Great Aisled Barns.* Boston, New York, Toronto: Little Brown and Co., 1994.

Strzygowski, Josef. *Early Church Art in Northern Europe.* London: B. T. Batsford, Ltd., 1928.

Merovingian France

Eygun, F. "Le baptistère Saint-Jean à Poitiers." *Gallia* 22 (1964), 137 ff.

Hubert, Jean, Jean Porcher, and Wolfgang F. Volbach. *Europe of the Invasions.* New York: George Braziller, 1969.

6. Carolingian Assimilations and Innovations

Gall, E. *Karoliongische und ottonische Kirchen.* Deutsche Bauten, 17. Burg bei Magdeburg, 1930.

Hubert, Jean, J. Porcher, and W. F. Volbach. *The Carolingian Renaissance.* New York: George Braziller, 1970.

Jeannez-Audra, E. "L'Église carolingienne de Germigny-les-Prés." *Institut d'art et d'archéologie de l'Université de Paris, Travaux du groupe d'histoire de l'art.* 1928.

Krautheimer, R. "The Carolingian Revival of Early Christian Architecture." *The Art Bulletin* 24 (1942), 1–38.

Lebouteux, Pierre. "L'église de Saint-Philibert de Grandlieu: Les dates de construction." *Bulletin archéologique du Comité des travaux historique et scientifique,* n.s. 1–2 (1965–66: Paris 1968), 49–107.

Saalman, Howard. *Medieval Architecture.* New York: George Braziller, 1965.

Sanderson, Warren. *Carolingian Romanesque Buildings. A Graphic Introduction.* Montreal and Lake Champlain, N.Y.: Astrion Publishing, in press.

Aachen

Kleinbauer, E. "Charlemagne's Palace Chapel at Aachen and Its Copies." *Gesta* 4 (1965), 2–11

Schnitzler, Hermann. *Der Dom zu Aachen.* Düsseldorf: L. Schwann, 1950.

Centula

Achter, J. "Zur Rekonstruction der karolingischen Klosterkirche Centula." *Zeitschrift für Kunsgeschichte* 19 (1956), 133 ff.

Bernard, Honoré. "D'Hariulphe à Effmann, à la lumière des récents fouilles de Saint-Riquier." *Actes du 95e Congres National des Sociétés Savantes.* Section d'archéologie et d'histoire de l'art. Reims, 1970, 219–35.

Effmann, W. *Centula. St. Riquier. Eine Untersuchung zur Geschichte der kirchlichen Baukunst in der Karolingerzeit.* Münster in Westfalia: 1912.

Hubert, J. "Saint-Riquier et le monachisme bénédictine en Gaule à l'époque carolingienne." *Il Monachesimo nell'alto medioevo e la formazione della civilta occidentale.* Spoleto, 1957, 293–309.

Jansen, V. "Round or Square? The Axial Towers of the Abbey Church of St. Riquier." *Gesta* 21/2 (1983), 83–90.

Parsons, David. "The Pre-Romanesque Church of St-Riquier at Centula: The Documentary Evidence." *Journal of the British Archaeological Association,* 130 (1977), 21–51.

Corvey

Effmann, W. *Die Kirche bei Abtei Corvey.* Paderborn, 1929.

Rave, W. *Corvey.* Münster: Aschendorff, 1958.

St. Gall

Horn, Walter, and Ernest Born. *The Plan of St. Gall: A Study of the Architecture and Economy of, and Life in a Paradigmatic Carolingian Monastery.* Berkeley: University of California Press, 1979.

Price, Lorna. *The Plan of St. Gall in Brief.* Berkeley: University of California Press, 1982.

Westworks

Francastel, P. "À propos des églises-porches du carolingien au roman." *Mélanges d'histoire du moyen-age dédiés à la memoire de Louis Halphen.* Paris, 1950, 247–57.

Fuchs, A. "Zum Problem der Westwerke," *Karolingische und ottonische Kunst.* Wiesbaden, 1957, 109–17.

Heitz, Carol. *Recherches sur les rapports entre architecture et liturgie à l'époque carolingienne.* Bibliothèque Générale d'l'École Pratique des Hautes Études, VIᵉ Section. Paris: S.E.V.P.E.N, 1963.

Reinhardt, H., and E. Fels. "Étude sur les églises-porches carolingiennes et leur survivance dans l'art roman." *Bulletin monumental* 92 (1933), 331–65; 96 (1937), 425–69.

Vallery-Radot, J. "Notes sur les chapelles hautes dédiées à Saint-Michel." *Bulletin monumental* 88 (1929), 453–78.

7. Ottonian Continuations

Grodecki, Louis. *L'architecture ottonienne: au seuil de l'art roman.* Paris: A. Colin, 1958.

Horn, Walter. "On the Origins of the Medieval Bay System." *Journal of the Society of Architectural Historians* 17 (1958), 2–23.

Jantzen, H. *Ottonishe Kunst.* Munich: Ernesto Grassi, 1947.

Kautzsch, R. *Die romanische Dome am Rhein.* Leipzig: 1922.

Lange, O. *Ottonische und frühromanische Kirchen in Köln.* Coblenz: 1932.

Meyer-Barkhausen, W. *Das grosse Jahrhundert Kölnischer Kirchenbaukunst.* Cologne: 1952.

Hildesheim, St. Michaels

Beseler, Hastwig, and Hans Roggenkamp. *Die Michaelskirche in Hildesheim.* Berlin: Verlag Gebr. Mann, 1954.

Binding, Günther. *Bischof Bernward als Architekt der Michaelskirche in Hildesheim.* Köln: Abt. Architektur des Kunsthistorischen Instituts, 1987.

Tschan, Francis J. *St. Bernward of Hildesheim. Vol. 2 His Works of Art.* Notre Dame, Ind.: Notre Dame University Press, 1951, 351–452.

Speyer

Klimm, Franz. *Der Kaiserdom zu Speyer.* Speyer: Verlag Jaeger, 1953.

Krautzsch, R. "Der Dom zu Speyer." *Städeljahrbuch* (1921).

Kubach, H. E., and W. Haas. *Der Dom zu Speyer.* Kunstdenkmäler von Rheinland-Pfalz, 3 vols. Munich: 1972.

Lehmann, E. "Die Bedeutung des antikenschen Bauschmucks am Dom zu Speyer." *Zeitschrift für Kunstwissenschaft* 5 (1951), 1–16.

Reindardt, H. "Die Deutschen Kaiserdome des XI. Jahrh." *Baseler Zeitschrift* (1934).

Weindal, Philipp. *Der Dom zu Speyer.* Speyer: Gesamptherstellung Jaeger Druck GmbH, 1970.

8. Visigothic, Asturian, Muslim, and Mozarabic Beginnings in Spain

Arenas, José Fernández. *Mozarabic Architecture.* Greenwich, Conn.: New York Graphic Society, 1972.

Correa, Antonio Bonet. *Arte Pre-Romanico Asturiano.* Barcelona: Ediciones Poligrafa, 1967.

Dodds, Jerrilyn D. *Al Andalus: The Art of Islamic Spain.* New York: The Metropolitan Museum of Art, 1992.

———. *Architecture and Ideology in Early Medieval Spain.* University Park: Pennsylvania State University Press, 1990.

de Palol, Pedro. *Arte hispanico de la epoca Visigoda.* Barcelona: Ediciones Poligrafa, 1968.

de Palol, Pedro, and Max Hirmer. *Medieval Art in Spain.* New York: Harry N. Abrams, 1966.

Ferni, E. E. "St. Vincent at Cardona and the Mediterranean Dimension of First Romanesque Architecture." *Studies in Medieval Art and Architecture Presented to Peter Lasko,* ed. David Buckton and T. A. Heslop. London: Alan Sutton, Publishers, 1994, 24–35.

King, G. G. *Pre-Romanesque Churches of Spain.* Bryn Mawr Monographs 7. New York: 1924.

Lambert, E. "La croisée d'ogives dans l'architecture islamique." *Recherche* 1 (1939), 57–71.

Manzanares Rodriguez Mir., J. *Arte prerromanico asturiano. Sintesis de su arquitectura.* Oviedo, 1957.

Metropolitan Museum of Art. *The Art of Medieval Spain, A.D. 500–1200.* New York: Harry N. Abrams, Inc., 1993.

Moreno, Gómez. *Iglesias mozárabes. Arte español de los siglos IX al XI.* Junta para ampliación de estudios e investigaciones cientificas. Centro de Estudios Históricos. Madrid, 1919.

Schlunk, H. *Ars Hispaniae. Vol 2: Arte visigodo, arte asturiano.* Madrid: 1947.

Schlunk, H., and M. Berenguer. *La pintura mural asturiana de los siglos IX y X.* San Sebastian: 1957.

Whitehill, W. M. *Spanish Romanesque Architecture of the Eleventh Century.* Oxford: 1941.

9. Early Romanesque Solutions

Focillon, Henri. *L'An Mil.* Paris: Armand Colin, 1952.

Deshouilières, F. *Au debut de l'art roman: Les églises de l'onzième siècle en France.* Paris, n.d. (1929).

Gaillard, G. "Notes dur la date de quelques églises romanes espagnoles." *Bulletin Monumental* 104 (1945), 65–87.

Hubert, J. *L'art pre-roman.* Paris: Les Éditions d'art et d'histoire, 1938.

———. "L'église S. Michel-de-Cuxa et l'occidation des églises au moyen-âge," *Journal of the Society of Architectural Historians* 21 (1962), 163 ff.

Lesueur, F. "Saint-Martin de Tours et les origines de l'art roman." *Bulletin Monumental* 8 (1949), 7–84.

Porter, A. K. *Lombard Architecture.* 4 vols. New Haven: Yale University Press, 1915–17.

Plat, G. *L'art de bâtir en France, des Romans à l'an 1100, d'après les monuments anciens de la Touraine, de l'Anjou et du Vendômois.* Paris: Éditions d'Art et d'Histoire, 1939.

Puig i Cadafalch, J. *La Géographie et les origines du premier art roman.* Paris: 1935.

————. *Le premier art roman: l'architecture en Catalogne et dans l'occident méditerranéan aux Xᵉ et XIᵉ siècles.* Paris: Henri Laurens, 1928.

————. "L'architecture mozarabe dans les Pyrénées françaises, Saint-Michel de Cuxa," *Mémoires de l'Académie des Inscriptions et Belles Lettres* (1938), 1–43.

Rey, Raymond. *L'art roman et ses origines: archéologie pre-romane et romane.* Toulouse: Privat; Paris: H. Didier, 1945.

Rivoira, G. T. *Lombardic Architecture: Its Origin, Development, and Derivatives.* G. McN. Rushforth, trans. 2 vols. London: Heinemann, 1910; 2nd ed., Oxford: Clarendon Press, 1933.

Whitehill, A. M. *Spanish Romanesque Architecture of the Eleventh Century.* Oxford: 1941.

Vallery-Radot, J. *Saint-Philibert de Tournus.* Paris: L'Inventaire Monumental, 1959.

Viellard-Troikouroff, M. "La cathédrale de Clermont du Ve au XIIIe siècle." *Cahiers archéologiques* (1960), 199 ff.

Virey, Jean B. "Les dates de construction de Saint-Philibert de Tournus." *Bulletin Monumental* 62 (1903), 532 ff.

————. *St. Philibert de Tournus.* Paris: P. H. Laurens, 1932.

10. Romanesque Styles in France

Armi, Edson. *Masons and Sculptors in Romanesque Burgundy: The New Aesthetic of Cluny III.* 2 vols. University Park and London: Pennsylvania University Press, 1983.

Aubert, Marcel. *Cathédrales abbatiales, collegiales, prieures romans de France.* Paris: Arthaud, 1965.

————. *L'Église Saint-Sernin de Toulouse.* Paris: H. Laurens, 1933.

————. *L'Église de Conques.* Paris: H. Laurens, 1954.

Auriol, A., and R. Rey. *La Basilique Saint-Sernin de Toulouse.* Toulouse and Paris: 1930.

Bréhier, L. "L'origine des chevets à chapelles rayonnantes et la liturgie." *La vie et les art liturgiques* (1921).

Clapham, A. W. *Romanesque Architecture in Western Europe.* Oxford: Clarendon Press, 1936.

Conant, Kenneth J. "The Pointed Arch—Orient to Occident." *Palaeologia* 7 (1959), 267–70.

Deshouilières, F. *Éléments datés de l'art roman.* Paris: 1936.

Durliat, Marcel. *St. Sernin de Toulouse.* Toulouse: Éché, 1986.

Focillon, H. *The Art of the West in the Middle Ages: Romanesque Art.* trans., D. King. New York: Phaidon, 1963.

Héliot, P. *Du Carolingien au Gothique. L'Évolution de la plastique murale dans l'archituecture religieuse du nord-ouest de l'Europe (IXe au XIIIe siècle).* Paris: 1966.

Kubach, H. E. "Das Triforium. Ein Beitrag zur kunst-geschichtliche Raumkunde Europas im Mittelalter." *Zeitschrift für Kunstgeschichte* 5 (1953), 275 ff.

————. *Romanesque Architecture.* New York: Henry R. Abrams, Inc.: 1975.

Lambert, Elie. *Abbayes et cathédrales du Sud-Ouest.* Toulouse: Privat, 1958.

Lesueuer, F. "Saint-Martin de Tours et les origines de l'art roman." *Bulletin Monumental* 107 (1949), 7–84.

Melczer, William. *The Pilgrim's Guide to Santiago de Compostela.* New York: Italica Press, 1993.

Mortet, V. *Recueil des textes relatifs à l'histoire de l'architecture et à la condition des architectes en France au moyen-âge: XIᵉ-XIIᵉ siècles.* 2 vols. Paris: 1911–29.

Schaefer, H. "The Origins of the Two Tower Façade in Romanesque Architecture." *The Art Bulletin* 27 (1945), 85–108.

Shaver-Crandall, Annie, and Paula Gerson. *The Pilgrim's Guide to Santiago de Compostela: A Gazetteer.* London: Harvey Miller Publishers, 1995.

Sunderland, E. R. "Symbolic Numbers and Romanesque Church Plans." *Journal of the Society of Architectural Historians* 18 (1959), 94–103.

Vallery-Radot, J. *Églises romanes. Filiations et échanges d'influence.* Paris: 1931.

————. "Notes sur les chapelles hautes dédiées à Saint-Michel." *Bulletin Monumental* 86 (1927), 453 ff.

Virey, J. *Paray-le-Monial et les églises du Brionnais.* Paris: P. H. Laurens, 1962.

Auvergne

Bréhier, L. "Que faut-il entendre par le terme d'art roman auvergnat?" *Bulletin archéologique du Comité des Travaux Historiques* (1930–31)

Craplet, B. *Auvergne romane.* La Pierre-qui-Vire: Zodiaque: 1962.

de Rochemonteix, A. *Les Églises romanes de la Haute-Auvergne.* Paris: Réimpression F. de Nobele, 1966.

Cistercian

Aubert, Marcel. *L'architecture cistercienne en France.* 2 vols. 2nd ed. Paris: Vanoest, 1947.

Dimier, M. A., and J. Porcher. *L'art cistercien.* La Pierre-qui-Vire: Zodiaque, 1962.

Dimier, Fr. *Recueil de plans d'eglises cisterciennes.* 2 vols. Paris: Librarie d'Art Ancien et Moderne, 1949.

Cluny

Conant, Kenneth J. *Cluny: les églises et la maison du chef d'ordre.* Macon: Imprimerie Protat Frères, 1968.

Evans, Joan. *Monastic Life at Cluny, 910–1157*. Hamden, Conn: Archon Books, 1968.

—————. *The Romanesque Architecture of the Order of Cluny*. Cambridge: Cambridge University Press, 1938.

Périgueux

Crozet, R. *L'art roman en Poitou*. Paris: Henri Laurens, 1948.

Crozet, R., and others. *Poitou roman*. La Pierre-qui-Vire: Zodiaque, 1957.

Rey, R. *La Cathédrale de Cahors et les origines de l'architecture à coupoles d'Aquitaine*. Paris: 1925.

Roux, Chanoine J. *La Basilique St-Front de Périgueux*. Périgueux: 1919.

Secret, J. "La restauration de Saint-Front au XIXᵉ siècle." *Les monuments historiques de la France* (1956), 145-59.

Santiago de Compostela

Conant, Kenneth J. *The Early Architectural History of the Cathedral of Santiago de Compostela*. Cambridge: Harvard University Press, 1926.

Tours, Saint-Martin

Hersey, C. K. "The Church of Saint-Martin at Tours (903–1150)." *The Art Bulletin* 25 (1943), 1–39.

—————. "Current Research on the Church of Saint-Martin at Tours." *Journal of the Society of Architectural Historians* 7 (1948). 10–12.

Lessueur, F. "Saint-Martin de Tours." *Congrès archéologique de Tours* (1948), 9–28.

—————. "Saint-Martin de Tours et les origines de l'art roman." *Bulletin Monumental* 107 (1949), 7–84.

Vézelay

Deschamps, Paul, and François Harb. *Vézelay*. Paris: Editions TEL, nd.

Porïe, Charles, and M. E. Lefèvre-Pontalisy. *Vézelay*. Paris: Henri Laurens, n.d.

Salet, Francis, and Jean Adéhmar. *La Madeleine de Vézelay*. Melun, Libraire d'Argences, 1948.

11. Other Romanesque Variations: Germany and Italy

Anthony, E. W. *Early Florentine Architecture and Decoration*. Cambridge: Harvard University Press, 1927.

Bettini, S. *L'architettura di San Marco (Venezia)*. Padua: Tre Venezie, 1946.

Decker, Heinrich. *Romanesque Art in Italy*. New York: Harry N. Abrams, 1960.

di Stefano, G. *Monumenti della Sicilia normana*. Palermo: 1955.

Horn, Walter. "Romanesque Churches in Florence. A Study of their Chronology and Stylistic Decoration." *The Art Bulletin* 25 (1943), 112–131.

Krautheimer, Richard. "San Nicola in Bari und die apulische Architektur des 12. Jahrhunderts." *Wiener Jahrbuch für Kunstgeschichte* 9 (1934), 5 ff.

Krönig, W. *The Cathedral of Monreale*. Palermo: 1965.

Porter, A. K. *Lombard Architecture*. 4 vols. New Haven: Yale University Press, 1915–17.

—————. *The Construction of Lombard and Gothic Vaults*. New Haven: Yale University Press, 1911.

Ricci, C. *Romanesque Architecture in Italy*. London: W. Heinemann, 1925.

Rivoira, G. T. *Lombardic Architecture: Its Origin, Development, and Derivatives*. trans. G. McN. Rushforth. 2 vols. London: W. Heinemann, 1910; 2nd ed. Oxford: Clarendon Press, 1933.

Salmi. Mario. *L'architettura romanica in Toscana*. Milan and Rome: Bestitti e Tuninelli, 1927.

—————. *Églises romanes de Toscane*. Paris: Éditions des Deux Mondes, 1961.

Schwarz, H. M. "Die Baukunst Kalabriens und Siziliens im Zeitalter der Normannen." *Römisches Jahrbuch für Kunstgeschichte (1942–44)*, 1 ff.

Schettini, F. *La basilica di San Nicolo di Bari*. Bari: 1967.

Shearer, C. *The Renaissance of Architecture in Southern Italy*. Cambridge: W. Heffer, 1935.

12. Anglo-Saxon, Norman, and Anglo-Norman Romanesque

Anfray, M. *L'architecture normande*. Paris: Auguste Picard, 1939.

Bony, J. "Tewkesbury et Pershore, deux élevations à quatre étages de la fin du XIᵉ siècle." *Bulletin Monumental* 96 (1937)

—————. "La technique normande du mur épais à l'époque romane." *Bulletin Monumental* 98 (1939), 153–88.

Clapham, A. W. *English Romanesque Architecture Before the Conquest*. Oxford: The Clarendon Press, 1930.

—————. *English Romanesque Architecture After the Conquest*. Oxford: The Clarendon Press, 1934.

—————. *Romanesque Architecture in England*. London and New York: Longmans, Green, 1950.

Gout, P. *Mont-Saint-Michel, histoire de l'abbaye et de la ville, étude archéologique et architecturale des monuments*. Paris: 1910.

Hayward Gallery. *English Romanesque Art 1066–1200*. Exhibition Catalogue. London: Weidenfeld and Nicholson, 1984.

Heliot, P. "Les origines et les débuts de l'apside vitrée XI au XIII siècle." *Wallraf Richartz Jahrbuch* 30 (1968), 89–127.

Lambert, E. "Caen roman et gothique." *Bulletin de la Société des Antiquaires de Normandie* 43 (1935), 5–70.

Lefèvre-Pontalis, E. "Les influences normandes au XIᵉ et au XIIᵉ siècle dans le nord de la France." *Bulletin Monumental* 64 (1906), 3–37.

Liess, R. *Der frühromanische Kirchenbau des 11. Jahrhunderts in Normandie.* Munich: Fink, 1967.

Ruprich-Robert, V. *L'architecture normande au XIᵉ et XIIᵉ siècles.* 2 vols. Paris: Librairie des imprimeries réunies, 1894–98.

————. *L'église Ste-Trinité et l'église St-Étienne à Caen.* Caen: Hardel, 1864.

Taylor, Harrald. M. and Joan Taylor. *Anglo-Saxon Architecture.* 3 vols. Cambridge: Cambridge University Press, 1965–78.

Durham

Bilson, J. "Durham Cathedral: The Chronology of its Vaults." *Archaeological Journal* 89 (1922), 101–6.

Bony, J. "Le projet premier de Durham: voûtement partiel ou voûtement total." *Urbanisme et architecture, études écrits et publiées en l'honneur de Pierre Lavedan.* Paris, 1954, 41–49.

British Archaeological Association. *Medieval Art and Architecture at Durham Cathedral.* Leeds: W. S. Maney and Son, Ltd., 1980.

Gardner, Stephen. "The Nave Galleries of Durham Cathedral." *The Art Bulletin* 64 (December, 1982), 564–78.

James, John. "The Rib Vaults of Durham Cathedral." *Gesta* 22 (1983), 135–46.

Shipley, Debra. *Durham Cathedral.* London: Tauris Books, 1990.

13. Early Gothic in France

Ackland, James H. *Medieval Structure: the Gothic Vault.* Toronto: Toronto University Press, 1972.

Alexander, K. D. R. Mark, and J. F. Abel. "The Structural Behavior of Medieval Ribbed Vaulting." *Journal of the Society of Architectural Historians,* 36 (1977), 241–51.

Aubert, Marcel. *Les plus anciennes croisées d'ogives. Leur rôle dans la construction.* Paris: Auguste Picard, 1934.

Aubert, Marcel, and Simone Goubet. *Gothic Cathedrals of France and their Treasures.* London: Nicholas Kaye, Ltd. 1959.

Bilson, J. "The Beginnings of Gothic Architecture."

Journal of the Royal Institute of British Architects (1899) 6 (1901), 259–69; 289–319.

————. "Les voûtes d'ogives de Morienval." *Bulletin Monumental* 72 (1908), 484–510.

Boinet, Amédée. *Les églises parisiennes.* 2 vols. Paris: Les Éditions de Minuit, 1958–62.

Bony, J. French *Gothic Architecture of the 12th and 13th Centuries.* Berkeley: University of California Press, 1983.

————. "Diagonality and Centrality in Early Rib-vaulted Architecture." *Gesta* 15 (1976), 15–25.

Branner, Robert. *Gothic Architecture.* New York: George Braziller, 1961.

————. "Gothic Architecture 1160–80 and its Romanesque Sources." *Acts of 20th International Congress of the History of Art* 1. Princeton: Princeton University Press, 1963, 92–104.

Clark, William. "Gothic Architecture" in *Medieval France, An Encyclopedia.* William W. Kibler, Grover A. Zinn, eds. New York and London: Garland Publishing, Inc. 1995, 400–5.

de Lasteyerie, R. *L'architecture religieuse en France à l'époque gothique.* 2 vols. Paris: Auguste Picard, 1926.

Deshoulières, F. "L'église Saint-Pierre de Montmartre." *Bulletin Monumental* 71 (1913), 5–28.

Erlande-Brandenberg, Alain. *The Cathedral. The Social and Architectural Dynamics of Construction.* Cambridge Studies in the History of Architecture. Cambridge: Cambridge University Press, 1994.

Fitchen, J. "A Comment on the Function of the Upper Flying Buttresss in French Gothic Cathedrals." *Gazette des Beaux Arts* 97 (1955), 69–90.

Frankl, Paul. *The Gothic: Literary Sources.* Princeton: Princeton University Press, 1960, 3–237.

————. *Gothic Architecture,* The Pelican History of Art. Baltimore: Penguin Books, 1972

Frisch, Teresa. *Gothic Art 1140–c. 1450: Sources and Documents.* Englewood Cliffs, N.J.: Prentice-Hall, 1971.

Gall, Ernst. *Die gotische Baukunst in Frankreich und Deutschland.* Braunschweig: Klinhardt and Bierman, 1955.

————. *Niederrheinische und normänische Architektur im Zeitalter der Frühgotik.* Berlin: 1915.

Grodecki, Louis. *Gothic Architecture.* New York: Henry N. Abrams, Inc., 1977.

Gross, W. *Die abendländische Architektur um 1300.* Stuttgart: W. Kohlhammer, 1948.

————. *Gotik und Spätgotik.* Frankfurt am Main: Umschau Verlag, 1969.

Harvey, John H. *The Gothic World 1100–1600.* London and New York: B. T. Batsford, 1950.

Héliot, P. "Du Carolingien au gothique, l'évolution de la plastique murale dans l'architecture religieuse du nord-ouest de l'Europe (IXe–XIIIe siècle)." *Mémoires présentés par divers savants à l'Academie des inscriptions et belles lettres* 15/2 (1967), 1–140.

Henriet, J. "St.-Germer-de-Fly." *Bulletin Monumental* 143 (1985), 94–142.

Heyman, Jacques. "The Stone Skeleton." *International Journal of Solids and Structures* 2 (1966), 249–80.

Kimpel, Dieter, and Robert Suckale. *L'Architecture gothique en France 1130–1270.* Paris: Flammarion, 1990.

Kraus, Henry. *Gold was their Mortar: The Economics of Cathedral Building.* London and Boston: Routledge and Kegan Paul, 1979.

Lefèvre-Pontalis, Eugène A. "L'Église de Saint-Martin-des-Champs à Paris." *Congrès archéologique de France* 32 (1919: Paris), 106–26.

Mâle, Émile. *The Gothic Image.* New York: Harper, 1951.

Mark, Robert. *Experiments in Gothic Architecture.* Cambridge: MIT Press, 1982.

———. "Gothic Cathedrals and Structural Rationalism." *Transactions of the New York Academy of Sciences* 2nd ser. 33 (1971), 607–24.

Mussat, A. *Le style gothique de l'Ouest de la France (XIIème-XIIIème siècles).* Paris: A. et J. Picard, 1963.

———. *La cathédrale du Mans.* Paris: Berger-Levrault, about 1981.

Panofsky, Erwin. *Gothic Architecture and Scholasticism.* New York: New American Library, 1976.

Pope, Arthur U. "Possible Iranian Contributions to the Beginning of Gothic Architecture." *Beiträge zur Geschichte Asiens, In memoriam Ernst Diez.* O. Aslanapa, ed. Istanbul: 1963, 1–29.

Prache, A. "Les arc-boutants au XIIᵉ siècle." *Gesta* 15 (1976), 31–42.

———. *St-Remi de Reims. L'oeuvre de Pierre de Celle et sa place dans l'architecture gothique.* Bibliothèque de la Société français de l'Archéologie, 8. Geneva: 1978).

Raguin, Virginia C. Kathryn Brush, and Peter Draper, eds. *Artistic Integration in Gothic Buildings.* Toronto: University of Toronto Press, 1995.

Rey, Raymond. *L'art gothique du Midi de la France.* Paris: H. Laurens, 1934.

von Simson, Otto Georg. *The Gothic Cathedral: Origins of Gothic Architecture and the Medieval Concept of Order.* Princeton: Princeton University Press, 1956.

Swaan, Wim. *The Gothic Cathedral.* New York: Park Lane, 1984.

Summerson, John. "An Interpretation of the Gothic." *Heavenly Mansions.* New York: W. W. Norton, 1963), 1–28.

Taylor, W., and Robert Mark. "The Technology of Transition: Sexpartite to Quadripartite Vaulting in High Gothic Architecture." *The Art Bulletin* 54 (1982), 579–87.

Verlet, Hélène. "Les batiments monastiques de l'abbaye de Saint-Germain-des-Prés." *Paris et Île-de-France* 9 (1957-58), 9–68.

Wagner-Rieger, Renate. *Die italienische Baukunst zu Beginn der Gotik.* 2 vols. Graz: H. Böhlaus, 1956–57.

Wilson, Christopher. *The Gothic Cathedral: The Architecture of the Great Church 1130–1530.* London, Thames and Hudson, 1992.

Worringer, Wilhelm. *Form in Gothic.* New York: Schocken, 1927.

Angers Cathedral

Farcy, Louis de. *Monographie de la cathédrale d'Angers.* 4 vols. Angers: Josselin, 1901–10.

Laon

Adenauer, H. *Die Kathedrale von Laon.* Düsseldorf: 1934.

Broche, Lucien. *La cathédrale de Laon.* Paris: H. Laurens, 1926.

Clark, William W., and R. King. *Laon Cathedral.* London: Harvey Miller Publishers, 1983.

Héliot, P. "Le chevet de la cathédrale de Laon, ses antécédents français et ses suites." *Gazette des Beaux Arts* 6th ser. 79 (1972), 193–214.

Lambert, E. "La cathédrale de Laon." *Gazette des Beaux-Arts* 68 (1926), 361–84.

Noyon

Seymour, Charles, Jr. *Notre-Dame of Noyon in the Twelfth Century. A study in the Early Development of Gothic Architecture.* New Haven: Yale University Press, 1939.

Paris, Notre-Dame

Aubert, Marcel. *Notre-Dame de Paris, sa place dans l'histoire de l'architecture du XIIème au XIV siècle.* Paris: H. Laurens, 1909.

Bruzelius, C. A. "The Construction of Notre-Dame in Paris." *The Art Bulletin* 69 (1987), 540–69.

Clark, William, and Robert Mark. "The First Flying Buttress: A New Reconstruction of the Nave of Notre Dame de Paris." *The Art Bulletin* 66 (March 1984), 47–64.

Tempko, Allan. *Notre Dame of Paris.* New York: Viking Press, 1959.

Saint-Denis

Bony, J. "What Possible Sources for the Chevet of Saint-Denis?" *Abbot Suger and Saint-Denis, A Symposium.* Paula Lieber Gerson, ed. New York: Metropolitan Museum of New York, 1986, 131–43.

Bruzelius, Caroline. *The 13th-Century Church at St-Denis.* New Haven: Yale University Press, 1985.

Clark, William. "Suger's Church at Saint-Denis: The State of Research." *Abbot Suger and Saint-Denis, A Symposium.* Paula Lieber Gerson, ed. New York: Metropolitan Museum of New York, 1986, 105–30.

Crosby, Sumner McK. *The Royal Abbey of Saint-Denis: From its Beginnings to the Death of Suger.* Pamela S. Blum, ed. New Haven: Yale University Press, 1987.

Gardner, S. "Two Campaigns in Suger's Western Block at St-Denis." *The Art Bulletin* 66 (1984), 574–87.

Gerson, Paula, ed. *Abbot Suger and St-Denis: A Symposium.* New York: Metropolitan Museum of Art, 1986.

Metropolitan Museum of Art, The Cloisters. *The Royal Abbey of St. Denis in the Time of Abbot Suger.* Exhibition Catalogue. New York: Metropolitan Museum of Art, 1981.

Panofsky, Erwin. *Abbot Suger on the Abbey Church of St. Denis and its Art Treasures.* Princeton: Princeton University Press, 1979.

Rudolph, Conrad. *Artistic Change at Saint-Denis; Abbot Suger's Program and the Early Twelfth Century Controversy over Art.* Princeton: Princeton University Press, 1990.

Sens Cathedral

Bégule, Lucien. *La cathédrale de Sens. Son architecture, son décor.* Lyon: 1929.

Chartraire, Eugène. *La cathédrale de Sens.* Paris: H. Laurens, 1930.

Deschamps, Paul. *La cathédrale de Sens.* Paris: Éditions "Tel," 1943.

Henriet, J. "La cathédrale de St-Étienne de Sens." *Bulletin Monumental* 140 (1982), 81–174.

Salet, Francis. "La cathédrale de Sens et sa place dans l'histoire de l'architecture médiévale." *Comptes-rendus de l'Académie des inscriptions et belles-lettres* (1955), 182–87.

Tournai

Héliot, P. " La cathédrale de Tournai et l'architecture du moyen âge." *Revue belge d'archéologie et d'histoire de l'art* 31–33 (1962–64), 3–139.

Rolland, P. "Chronologie de la cathédrale de Tournai." *Revue belge d'archéologie et d'histoire de l'art* 4 (1934), 103 ff; 225 ff.

———. "La cathédrale de Tournai et les courants architecturaux." *Revue belge d'archéologie et d'histoire de l'art* 9 (1937), 229 ff.

———. "La technique normande du mur évidé et l'architecture scaldienne." *Revue belge d'archéologie et d'histoire de l'art* 10 (1940), 169–88.

Warichez, J. *La cathédrale de Tournai.* Brussels: 1935.

14. Thirteenth-Century Gothic in France

James, John. "An Investigation into the Uneven Distribution of Early Gothic Churches in the Paris Basin, 1140–1240." *The Art Bulletin* 66 (March 1984), 15–46.

Jantzen, Hans. *High Gothic: the Classic Cathedrals of Chartres, Reims and Amiens.* New York: Pantheon Books, 1962.

Kunze, H. *Das Fassadenproblem der französischen Früh-und Hochgotik.* Leipzig: 1912.

Murray, Stephen. *Building Troyes Cathedral: the Late Gothic Campaigns.* Bloomington: University of Indiana Press, 1987.

Amiens

Durand, G. *Monographie de l'église Notre Dame, cathédrale d'Amiens* 3 vols. Amiens and Paris: 1901–03.

Murray, Stephen. *Notre-Dame, Cathedral of Amiens: The Power of Change in Gothic.* New York: Cambridge University Press, 1995.

Murray, Stephen, and J. Adiss. "Plan and Space at Amiens Cathedral." *Journal of the Society of Architectural Historians* 49 (1990), 44–66.

Bourges

Branner, Robert. *The Cathedral of Bourges and its place in Gothic Architecture.* Cambridge: MIT Press, 1989.

Gauchery, R. C. Gauchery-Grodecki. *Saint-Étiennne de Bourges.* Paris: 1959.

Wolfe, Maury I., and Robert Mark. "Gothic Cathedral Buttressing: The Experiment at Bourges and Its Influence." *Journal of the Society of Architectural Historians* 33 (1974), 17–27.

Chartres

Barnes, Carl. "Medieval Church Construction and the 'Cult of Carts.'" Unpublished typescript of paper given at Kalamazoo (May 1972).

Bony, J. "The Resistance to Chartres in Early Thirteenth Century Architecture." *Journal of the British Archaeological Association* 20/21 (1957–58), 35–52.

Branner, Robert. *Chartres Cathedral*. New York: W. W. Norton, 1969.

Fels, Étienne. "Die Grabung an der Fassade der Kathedrale von Chartres." *Kunstchronik* 8 (1955), 149–51.

Frankl, Paul. "The Chronology of Chartres Cathedral." *The Art Bulletin* 39 (1957), 33–47.

———. "Reconsiderations on the Chronology of Chartres Cathedral." *The Art Bulletin* 43 (1961), 51–58.

Grodecki, L. "Chronologie de la cathédrale de Chartres." *Bulletin Monumental* 116 (1958), 91–119.

———. "The Transept Portals of Chartres Cathedral: The Date of their Construction According to Archeologial Data." *The Art Bulletin* 33 (1951), 156–64.

Henderson, George. *Chartres*. The Architect and Society. Harmondsworth and New York: Pelican Books, 1968.

Hilberry, H. "The Cathedral at Chartres in 1030." *Speculum* 34 (1959), 561–72.

James, John. *Chartres: the Masons who Built a Legend*. London and Boston: Routledge and Kegan, 1982.

———. *Chartres, les constructeurs*. Dooralong, Victoria: Mandorla Publications, 1978.

Mâle, Émile. *Chartres*. New York: Harper and Row, 1983.

Miller, Malcolm. *Chartres Cathedral*. London: Pitkin Pictorials, Ltd., 1985.

van der Meulen, J. "Histoire de la construction de la cathédrale Notre-Dame de Chartres après 1194." *Bulletin de la Société Archéologique d'Eure-et-Loir* 18 (1965), 5–126.

———. *Biographie der Kathedrale*. Cologne: 1984.

Reims

Abou-el-Haj, Barbara. "The Urban Setting for Late Medieval Church Building: Reims and its Cathedral between 1210 and 1240." *Art History* 11/1 (March 1988), 17–41.

Branner, Robert. "The Labyrinth of Reims Cathedral," *Journal of the Society of Architectural Historians* 21 (1962), 18–25.

———. Jean d'Orbais and the Cathedral of Reims." *The Art Bulletin* 43 (1961), 131–33.

———. "Historical Aspects of the Reconstruction of Reims Cathedral 1210–1241." *Speculum* 36 (1961), 23–37.

———. "The North Transept and the First West Façades of Reims Cathedral." *Zeitschrift für Kunstgeschichte* 24 (1961), 220–41.

Deneux, Henri. "Chronologie des maîtres d'oeuvre de la cathédrale de Reims." *Bulletin de la société national des antiquaires de France* 63 (1920), 196–200.

Deschamps, Paul. *La cathédrale de Reims*. Paris: Éditions "Tel," 1937.

Hamann-MacLean, Richard, and Ise Schusseler. *Die Kathedrale von Reims,* Vol I, *Die Achitektur*. Stuttgart: Franz Steiner Verlag, 1993.

Ravaux, Jean-Pierre. "Les compagnes de construction de la cathédral de Reims au XIIe siècle." *Bulletin Monumental* 137 (1979), 7–66.

Reinhardt, Hans. *La cathédrale de Reims: son histoire, son architecture, sa sculpture, ses vitraux*. Paris, Presses Universitaires de France, 1963.

Soissons

Barnes, Carl. "The Cathedral of Chartres and the Architect of Soissons." *Journal of the Society of Architectural Historians* 22/2 (1963), 63–74.

———. "The Documentation for Notre Dame de Soissons." *Gesta* 15 (1976), 61–70.

———. "The Twelfth Century Transept of Soissons Cathedral: The Missing Sources for Chartres?" *Journal of the Society of Architectural Historians* 28 (1969), 9–25.

Lefevre-Pontalis, E. *L'architecture religieuse dans l'ancien diocèse de Soissons au XIème et au XIIème siècle*. 3 vols. Paris: 1894.

———. "Cathédrale de Soissons." *Congrès archéologique de France: Reims* 78 (1911), 318–37.

15. REGIONAL GOTHIC STYLES

England

Alexander, Jonathan, and Paul Binski, eds. *Age of Chivalry: Art in Plantagenet England 1200–1400*. Exhibition Catalogue, Royal Academy of Arts, London. London: Weidenfeld and Nicholson, 1987.

Bony, J. "French influences on the Origins of English Gothic Architecture." *Journal of the Warburg and Courtauld Institutes* 12 (1949), 1–15.

Draper, P. "Recherches récentes sur l'architecture dans les îles britanniques à la fin de l'époque romane et au début du Gothique." *Bulletin Monumental* 144 (1986), 305–28.

Hearn, M. F. *Ripon Minster and the Beginnings of the Gothic Style in England. Transaction of the American Philosophical Society* 73, pt. 6 (1983), 1–196.

———. "The Rectangular Ambulatory in English Medieval Architecture." *Journal of the Society of Architectural Historians* 30 (1971), 187–208.

Canterbury

Collison, Patrick, Nigel Ramsey, and Margaret Sparks. *A History of Canterbury Cathedral*. New York: Oxford University Press, 1995.

Willis, R. *The Architectural History of Canterbury Cathedral*. London: Longman and Co., 1845. Reprinted in R. Willis, *Architectural History of Some English Cathedrals* vol. 1. Chicheley: 1972.

Woodman, Francis. *The Architectural History of Canterbury Cathedral*. London: Routledge and Kegan Paul, 1981.

Salisbury

Cocke, Thomas, and Peter Kidson. *Salisbury Cathedral: Perpsectives on the Architectural History*. Royal Commission on the Historical Monuments of England. London: HMSO, 1993.

Spring, Roy. *Salisbury Cathedral*. London: Unwin Myman, 1987.

Wells Cathedral

Bilson, J. "Notes on the Earlier Architectural History of Wells Cathedral." *Archeological Journal* 85 (1928), 23–68.

Colchester, L. S. ed. *Wells Cathedral. A History*. Shepton Mallet: Open Books, 1982.

Italy

Argan, G. C. *L'archittettura italiana del Duecento e Trecento*. Bari: Dedalo, 1978.

Bierbach, K. *Die holzgedeckten Franziskaner-und Dominikanerkirchen in Umbrien und Toscana*. Berlin, 1908.

Decker, Heinrich. *Gotik in Italien*. Vienna: A. Schroll, 1964.

Paatz, W. E. *Die Kirchen von Florenz. Ein kunstgeschichtliches Handbuch* 6 vols. Frankfurt am Main: V. Klostermann: 1940–54.

Romanini, Angiola Maria. *L'architettura gotica in Lombardia*. Milan: Ceschina, 1964.

Trachtenberg, M. "Gothic Italian 'Gothic': Toward a Redefinition." *Journal of the Society of Architectural Historians* 50 (1991), 22–37.

Wagner-Rieger, R. *Die italienische Baukunst zu Beginn der Gotik*. Graz: Böhlaus, 1956–57.

White, John. *Art and Architecture in Italy, 1250 to 1499*. Pelican History of Art. Baltimore: Penguin Books, 1966.

Assisi, S. Francesco

Chiarelli, Renzo. *Assisi and the Basilica of San Francesco*. Florence: Bonechi, 1975.

Hertein, E. *Die Basilika San Francesco in Assisi. Gestalt, Bedeutung, Herkunft*. Munich: 1964.

Kleinschmidt, Beda. *Die Basilika S. Francesco in Assisi*. 3 vols. Berlin: Verlag für Kunstwissenschaft, 1915–28.

Nessi, Silvestro. *La Basilica di S. Francesco in Assisi e la sua documentazione storica*. Assisi: Casa Editrice Francescana, 1982.

Poeschke, Joachim. *Die Kirche San Francesco in Assisi und ihre Wandmalereien*. Munich: Hirmer, 1985.

Schöne, W. "Studien zur Oberkirche von Assisi." *Festschrift Kurt Bauch (1957)*, 50–116.

Florence, Cathedral of S. Maria del Fiore

Saalman, H. "S. Maria del Fiore: 1294–1418." *The Art Bulletin* 46 (1964), 478–500.

Toker, F. "Florence Cathedral: the Design Stage." *The Art Bulletin* 60 (1978), 214–31.

———. "Arnolfo's S. Maria del Fiore: a Working Hypothesis." *Journal of the Society of Architectural Historians* 42 (1983), 101–20.

Orvieto

Bonelli, R. *Il Duomo di Orvieto e l'architettura italiana del Duecento e Trecento*. Rome: Officina, 1972.

Carli, Enzo. *Il Duomo di Orvieto*. Rome: Istituto poligrafico dello Stato, Libreria dello Stato, 1965.

Siena Cathedral

Pietramellara, Carla. *Il Duomo di Siena: evoluzione dalle origini alla fin del Trecento*. Florence: Edam, 1980.

Ploeg, Kees van der. *Art, Architecture and Liturgy: Siena Cathedral in the Middle Ages*. Groningen: Forsten, 1993.

Germany

Gross, Werner. "Die Hochgotik im deutschen Kirchenbau." *Marburger Jahrbuch für Kunstwissenschaft* 7 (1933), 290–346.

Hempel, Eberhard. *Geschichte der deutschen Baukunst*. Munich: F. Bruckmann, 1949.

Krönig, W. "Hallenkirche in Mittelitalien." *Kunstgeschichtliches Jahrbuch der Bibliotheka Hertziana* 2 (1938), 1-142.

Rose, Hans. *Die Baukunst der Zisterziener*. Munich: 1916.

Rosemann, Heinz R. "Die westfälische Hallenkirchen in der ersten Hälfte des 13. Jahrhunderts." *Zeitschrift für Kunstgeschichte* 1 (1932), 203–27.

Limburg an der Lahn, St. George

Gall, Ernst. "Sankt-Georg in Limburg-an-der-Lahn und die nordfranzösische Frühgotik." *Festschrift für Adolf Goldschmidt.* Leipzig: 1923, 7–24.

Marburg, Elizabethkirche

Dinkler-von Schubert, Erika. *Die Elizabethkirche zu Marburg.* Marburg: Watzenhausen, Trauvetter und Fischer, 1974.

Hamann, R. W. Kästner. *Die Elizabethkirche zu Marburg.* Marburg: 1929.

Leppin, Eberhard. *Die Elizabethkirche in Marburg an der Lahn.* Die Blaue Bücher. Königstein im Taunus: Karl Langewiesche Nachfolger Hans Köster, 1980.

Michler, Jürgen. *Die Elizabethkirche zu Marburg in ihrer ursprunglischen Farbigkeit.* Marburg: N. G. Elwert, 1984.

16. The Rayonnant Style in France and European Imitations

Bideault, Maryse, and C. Lautier. "Saint-Nicaise de Reims. Chronologie et nouvelles remarques sur l'architecture." *Bulletin Monumental* 135 (1977), 295–330.

Branner, Robert. "Paris and the Origins of Rayonnant Gothic Architecture down to 1240." *The Art Bulletin* 44 (1962), 39–51.

————. *St. Louis and the Court Style in Gothic Architecture.* London: A. Zwemmer, Ltd.: 1985.

————. "Westminster Abbey and the French Court Style." *Journal of the Society of Architectural Historians* 23 (1964), 3–18.

Beauvais

Branner, Robert. "Le maître de la cathédrale de Beauvais." *Art de France* 2 (1962), 78–92.

Leblond, Victor. *La cathédrale de Beauvais.* Paris: 1933.

Murray, Stephen. *Beauvais Cathedral: the Architecture of Transcendence.* Princeton: Princeton University Press, 1989.

————. "The Collapse of 1284 at Beauvais Cathedral." *Acta* 3 (1976), 17–44.

Wolfe, Maury I., and Robert Mark. "The Collapse of the Vaults of Beauvais Cathedral in 1284." *Speculum* 51 (1976), 462–76.

Cologne

Clemen, P. *Der Dom zu Köln.* Dusseldorf: 1937.

Kunst, H. J. "Der Domchor zu Köln und die hochgotische Kirchenarchitektur in Norddeutschland." *Niederdeutsche Beiträge zur Kunstgeschichte* 8 (1969), 9–40.

Meyer-Barkausen, W. *Das grosse Jahrhundert kölnischer Kirchenbaukunst 1150 bis 1250.* Cologne: 1952.

Rode, Herbert. *Der Kölner Kathedral.* Augsburg: Verlag Josef Hannesschläger, 1968.

Wolff, Arnold. *The Cathedral of Cologne.* Stuttgart: Verlag Müller und Schindler, 1974.

Paris, Sainte-Chapelle

Bottineau, Yves. *Notre Dame de Paris et la Sainte-Chapelle.* Paris: Arthaud, 1966.

Grodecki, Louis. *La Sainte-Chapelle.* Paris: La Caisse Nationale des Monuments Historiques et des Sites, 1975.

Hacker-Suck, I. "La Sainte-Chapelle et les chapelles palatines du Moyen Age en France." *Cahiers Archéologiques* 12 (1962), 217–57.

Troyes, Saint-Urbain

Davis, M. T. "On the Threshold of Flamboyant: The Second Campaign of Construction of St. Urbain, Troyes." *Speculum* 59 (1984), 847–84.

Salet, F. "Saint-Urbain de Troyes." *Congrès Archéologique* 113 (1955), 9–28.

17. Late Gothic Elaborations and Innovations

Bialostocki, Jan. "Late Gothic: Disagreements about the Concept." *Journal of the British Archaeological Association,* 3rd. ser. 29 (1966), 76–105.

England

Bock, Henning. *Der Decorated Style Untersuchungeen zur englischen Kathedralarchitektur der ersten Hälfte des 14. Jahrhunderts.* Heidelberg: C. Winter, 1962.

Bony, J. *The English Decorated Style: Gothic Architecture Transformed, 1250–1350.* Ithaca, N.Y.: Cornell University Press, 1979.

Braun, Hugh. *Parish Churches: Their Architectural Development in England.* London: Faber, 1970.

Coldstream, Nicola. *The Decorated Style.* London: British Museum Press, 1995.

Cook, George Henry. *The English Medieval Parish Church.* London: Phoenix House, 1955.

Cox, J. Charles. *The Parish Churches of England.* New York: C. Scribner's Sons, 1941.

Crossley, Peter. "Wells, the West Country, and Central European Late Gothic." *British Archaeological Association, Conference Transactions, Wells and Glastonbury 1978* (1981), 81–109.

Draper, P. "The Sequence and Dating of the Decorated Work at Wells." *British Archaeological Association, Conference Transactions, Wells and Glastonbury 1978* (1981), 18–29.

Enlart, C. "Origine anglaise du style gothique flamboyant." *Bulletin Monumental* 70 (1906), 38–81.

Harvey, John H. *The Perpindicular Style: 1330–1485.* London: B. T. Batsford, 1978.

Leedy, W. C. *Fan Vaulting: As Study of Form, Technology and Meaning.* Santa Monica, Calif.: Arts and Architecture Press, 1980.

Platt, Colin. *The Parish Church of Medieval England.* London: Seker and Warburg, 1981.

King's College Chapel, Cambridge

Tibbs, Rodney. *King's College Chapel, Cambridge: The Story and the Renovation.* Lavenham: Terence Dalton, 1970.

Woodman, Francis. *The Architectural History of King's College Chapel.* London: Routledge and Kegan Paul, 1986.

Lincoln

Frankl, Paul. "The Crazy Vaults of Lincoln Cathedral." *The Art Bulletin* 35 (1953), 95–107.

———. "Lincoln Cathedral." *The Art Bulletin* 44 (1962), 29–37.

Kendrick, A. F. *The Cathedral Church of Lincoln: A History and Description of its Fabric and a List of Bishops.* London: G. Bell and Sons, Ltd., 1922.

Kidson, Peter. "St. Hugh's Choir." *Medieval Art and Architecture at Lincoln Cathedral. British Archaeological Association, Conference Transactions, 1982.* 8. Lincoln, 1986, 29–42.

———. "Architectural History," in *A History of Lincoln Minster,* ed. Dorothy Owen. Cambridge: Cambridge University Press, 1994.

Norsdtröm, F. "Peterborough, Lincoln, and the Science of Robert Grosseteste." *The Art Bulletin* 37 (1955), 241–72.

Owen, D. ed. *A History of Lincoln Cathedral.* Cambridge: Cambridge University Press, 1994.

Pevsner, N. "The Choir of Lincoln Cathedral." *Charlton Lectures on Art.* London: Oxford University Press, 1963.

France

Leblond, V. *L'église Saint-Étienne de Beauvais.* Petites Monographies des Grands Édifices de la France. Paris: Henri Laurens, 1929.

Murray, Stephen. "The Choir of St-Étienne de Beauvais." *Journal of the Society of Architectural Historians* 36 (1977), 111–21.

Plat, G. *L'Église de la Trinité de Vendôme.* Petites Monographies des Grands Édifices de la France. Paris: Henri Laurens, 1934.

Sanfaçon, R. *L'architecture flamboyante en France.* Québec: Les Presses de l'Université Laval, 1971.

Schürenberg, L. *Die kirchliche Baukunst Frankreichs zwischen 1270 und 1380.* Berlin: 1934.

Saint-Maclou, Rouen

Neagley, Linda. *The Parish Church of Saint-Maclou: A Study of Rouennais Flamboyant Architecture.* Bloomington: Indiana University Press: 1983.

———. "The Flamboyant Architecture of St.-Maclou, Rouen and the Development of a Style." *Journal of the Society of Architectural Historians* 47/4 (1988), 374–96.

———. "Elegant Simplicity: The Late Gothic Plan Design of St.-Maclou in Rouen." *The Art Bulletin* 74 (192), 394–423.

Germany and Bohemia

Burmeister, W. *Norddeutsche Backsteindome.* Berlin: 1938.

Clasen, Karl Heinz. *Deutsche Gewölbe der Spätgotik.* Berlin: Henchelverlag Kunst und Gesellschaft, 1961.

Fink, E. *Die gotischen Hallenkirche in Westfalen.* Emsdetten: 1934.

Fischer, F. W. *Die spätgotische Kirchenbaukunst am Mittelrhein.* Heidelberg: Friedhelm Wilhelm, 1962.

———. *Unser Bild von der deutschen spätgotischen Architektur des XV Jahrhunderts.* Heidelberg: C. Winter, 1964.

Gerstenberg, Kurt. *Deutsche Sondergotik. Eine Untersuchung über das wesen der späten Mittelalter.* Darmstadt: 1969.

Krautheimer, R. *Die Kirchen der Bettelorden in Deutschland.* Deutsche Beiträge zur Kunstwissenschaft. Cologne: F. J. Marcan, 1925.

Legner, A., ed. *Die Parler und der schöne Stil 1350–1400.* 5 vols. Cologne: Schnütgen Museum, 1978.

Reinhardt, H. *La cathédrale de Strasbourg.* Paris: 1972.

Renger-Patzsch, A. *Norddeutsche Backsteindome.* Berlin: 1930.

Ringshausen, G. "Die spätgotische Architektur in Deutschland unter besonderer Berückschtigung ihrer Beziehungen zu Burgund im Anfang des 15. Jahrhunderts." *Zeitschrift des deutschen Vereins für Kunstwissenschaft* 17/1–4 (1973), 63–78.

Schotes, P. *Spätgotische Einstützenkirchen und zweischiffige Hallenkirche im Rheinland.* Aachen: 1970.

Schulze, Konrad Werner. *Die Gewölbesystem in spätgotische Kirchenbau in Schwaben von 1450–1520.* Reutlingen, about 1940.

Stiehl, Otto Max. *Backsteingotik in Norddeutschland und Danemark.* Stuttgart: J. Hoffmann Verlag, 1923.

Zaske, Nikolaus. *Gotische Backsteinkirchen Norddeutschlands zwischen Elbe und Oder.* Leipzig: Koehler and Amelang, 1968.

Prague, St. Vitus

Bock, H. "Der Beginn spätgotischer Architektur in Prag (Peter Parler) und die Beziehungen zu England." *Wallraf Richaartz Jahrbuch* 23 (1961), 191–210.

Kletzl, O. *Peter Parler, der Dombaumeister zu Prag.* Leipzig: 1940.

Swoboda, K. M. *Peter Parler: der Baukünstler und Bildhauer.* Vienna: A. Schroll, 1943.

Italy

Milan

Ackerman, James. *Gothic Theory of Architecture at the Cathedral of Milan.* New York: Garland Publishing, 1949.

Bescapé, G. P. Mezzanotte. *Il Duomo di Milano.* Milan: 1965.

Cassi Ramelli, Antonio. *Luca Beltrami e il Duomo di Milano.* Milan: 1965.

Visitin, Luciano. *Il Duomo in Milano.* Milan: Mursia, 1986.

Spain

Blanch, M. *l'art gothique en Espagne.* Barcelona: 1972.

Durliat, M. *L'architecture espagnole.* Toulouse: Privat, 1966.

———. *Art catalan.* Paris: Arthaud, 1963.

Gudiol i Ricart, J. *La catedral de Toledo.* Madrid: 1948.

Harvey, John B. *The Cathedrals of Spain.* London: B. T. Batsford, 1957.

Lambert, Élie. *L'art gothique en Espagne aux XII^e et XIII^e siècles.* Paris: 1931.

Lampérezy Romea, Vicente. *Historia de la arquitectura cristiana española en la edad media.* 3rd ed. 3 vols. Madrid: 1930.

Lavedan, Pierre. *L'architecture gothique religieuse en Catalogne, Valence et Baléares* Paris: H. Laurens, 1935.

Torres Balbás, L. *Arqutectura gótica. Ars Hispaniae* 7. Madrid: Editorial Plus-Ultra, 1952.

Barcelona, Cathedral

Bassegoda y Amigó, B. *La catedral de Barcelona.* Barcelona: nd.

Durán Sanpere, A. "La cathédrale de Barcelone." *Congrès Archéologique. Catalogne* 117 (1959), 28–36.

Elías, F. *La catedral de Barcelona.* Barcelona: 1926.

Liaóno Martinez, Emma. *La catedral de Barcelona.* Madrid: Everest, 1983.

Barcelona, Santa Maria de la Mar

Bassegoda y Amigó, B. *Santa María de la Mar.* Barcelona: 1925.

Lavedan, P. "L'église Sainte-Marie-de-la-Mar à Barcelone." *Congrès Archéologique, Catalogne* 117 (1959), 75–83.

Palma de Mallorca, Cathedral

Durliat, M. *L'art dans le royaume de Majorque. Les débuts de l'art gothique en Roussillon, en Cerdagne, et aux Baléares.* Toulouse: Privat, 1962.

Rubio y Bellver, J. *La catedral de Mallorca.* Barcelona: 1922.

Seville, Cathedral

Falcon Márquez, T. *La catedral de Sevilla. Estudio arquitectónico.* Seville: 1980.

Gómez-Moreno, M. "La catedral de Sevilla." *Boletín de la Real Academia de la Historia* 92 (1928), 482–88.

18. SECULAR ARCHITECTURE IN THE MIDDLE AGES

Castles

Brown, R. A. *English Medieval Castles.* London: 1954.

Chierici, G. *Il palazzo italiano, dal secolo XI al secolo XIX.* 3 vols. Milan: 1952–57.

Deschamps, P. *Les Châteaux des croisés en Terre Sainte. Le Crac des Chevaliers.* Paris: P. Geuthner, 1934.

Fedden, R. *Crusader Castles.* London: 1950.

Pounds, N. J. G. *The Medieval Castle in England and Wales: A Social and Political History.* Cambridge: Cambridge University Press, 1990.

Reyerson, Kathryn, and Faye Powe, eds. *The Medieval Castle: Romance and Reality.* Medieval Studies at Minnesota 1. Dubuque, Iowa: Kendall/Hunt, 1994.

Troy, Sidney. *Castles: their Construction and History.* New York: Dover Publications, 1985.

Cities

Arslan, E. *Venezia gotica. L'architettura civile gotica veneziana.* Milan: Electra, 1970.

Braunfels, Wolfgang. *Mittelalterliche Stadtbaukunst in der Toskana.* Berlin: 1953.

———. *Abandländische Stadtbaukunst. Herrschaftsform und Baugestalt.* Cologne: DuMont Schauberg, 1976.

Carli, Enzo. *San Gimignano.* Milan: Electra, 1987.

Lavedan, Pierre. *L'urbanisme au moyen age.* Geneva: Droz, 1974.

Miller, Maureen. "From Episcopal to Communale Palaces: Palaces and Power in Northern Italy (1000–1250)," *Journal of the Society of Architectural Historians* 54/2 (1995).

Rodolico, F., and G. Marchini. *I Palazzi del popolo nei communi toscani del medio evo.* Milan: Electra editrice, 1962.

Saalman, H. *Medieval Cities.* New York, George Braziller: 1968.

Stiehl, O. *Das deuteche Rathaus im Mittelalter.* Leipzig: 1905.

Thurm, S. *Norddeutsche Backsteinbau, gotischen Backsteinhallen mit dreiapsidialem Chorschluss.* Berlin: 1935.

Florence, Palazzo Vecchio

Lensi, Alfredo. *Palazzo Vecchio.* Milan: Bestetti e Tumminelli, 1929.

Paul, J. *Der Palazzo Vecchio in Florenz, Ursprung und Bedeutung seiner Form.* Florence: L. S. Olschki, 1969.

Sinibaldi, Giulia. *Il Palazzo Vecchio di Firenze.* Rome: Istituto poligrafico dello Stato. Liberia, 1969.

19. MEDIEVAL BUILDERS AND BUILDING PRACTICES

Acland, James H. *Medieval Structure: the Gothic Vault.* Toronto: University of Toronto Press, 1972.

Bandmann, Günter. *Mittelalterliche Architektur als Bedeutungsträger.* Berlin: Verlag Gebr. Mann, 1951.

Barnes, Carl F. *Villard de Honnecourt, the Architect and his Drawings. A Critical Bibliography.* Boston: Garland, 1982.

Biget, J. L. "Recherches sur les financements des cathédrales du Midi au XIIIe siècle." *La naissance et l'essor du gothique méridional au XIIIe siècle.* Cahiers de Fanjeaux, 9. Toulouse: E. Privat, 1974.

Bowie, Theodore R. *The Sketchbook of Villard de Honnecourt.* Bloomington: Indiana University, 1959.

Branner, Robert. "Villard de Honnecourt, Reims and the Origin of Gothic Architectural Drawing." *Gazette des Beaux Arts* 61 (1963), 129–46.

Bucher, François. "Design in Gothic Architecture. A preliminary Assessment." *Journal of the Society of Architectural Historians* 27/1 (1968), 49–71.

———. "Review of *Die Gotischen Planrisse der Wiener Sammlungen* by Hans Koepf," *The Art Bulletin* 53 (1971), 113–15.

———. "Medieval Architectural Design Methods, 800–1560." *Gesta* 11 (1972), 37–51.

Colchester, L. S., and John H. Harvey. "The Wells Tracing Floor." *Archaeological Journal* 131 (1974), 210–14.

Coldstream, Nicola. *Masons and Sculptors,* Medieval Craftsmen. Toronto and Buffalo, University of Toronto Press: 1991.

du Colombier, Pierre. *Les Chantiers des cathédrales: ouvriers, architects, sculpteurs,* rev. ed. Paris: A. et J. Picard, 1953.

Fitchen, John. *Construction of Gothic Cathedrals: A Study of Medieval Vault Erection.* Oxford: Clarendon Press, 1961.

Frankl, Paul. *The Gothic: Literary Sources and Interpretations through the Ages.* Princeton: Princeton University Press: 1960), 1–234.

———. "The Secret of Medieval Masons." *Art Bulletin* 27 (1945), 46–60.

Gimpel, Jean. *The Cathedral Builders,* trans. Teresa Waugh. New York: Harper and Row, 1984.

Hahnloser, Hans. *Villard de Honnecourt.* Vienna: Anton Schroll, 1935.

Harvey, John. *The Master Builders: Architecture in the Middle Ages.* London: Thames and Hudson, 1971.

———. *The Medieval Architect.* London: Wayland Publishers, 1972.

Kimpel, D. "La sociogenèse de l'architect moderne," in X. Barral i Altet, ed. *Artistes, artisans et production artistique du Moyen Age,* I. Paris: Picard, 1986), 135–49.

Knoop, D., and G. P. Jones. *The Medieval Mason: An Economic History of English Stone Building in the Later Middle Ages and Early Modern Times,* 3rd ed. New York: Barnes and Noble, 1967.

Koepf, Hans. *Die Gotischen Planrisse der Wiener Sammlungen.* Vienna, Hermann Boeklaus Nachf: 1969.

Kostoff, Spiro, ed. *The Architect. Chapters in the History of the Profession.* New York: Oxford University Press, 1977.

Kraus, Henry. *Gold was their Mortar: The Economics of Cathdral Building.* London, Henley, and Boston: Routledge and Kegan Paul, 1929.

Kubler, G. "A Late Gothic Computation of Rib Vault Thrusts." *Gazette des Beaux Arts* 26 (1944), 135–48.

Lopez, Robert. "Economie et architecture médiévales, cela aurait-il tué ceci?" *Annales d'histoire économique et sociale* 7 (1952), 433–38.

Macauley, David. *Cathedral: The Story of Its Construction.* Boston: Houghton Mifflin Company, 1973.

Mark, Robert. *Experiments in Gothic Architecture.* Cambridge: MIT Press, 1982.

———. *High Gothic Structure: A Technological Reinterpretation.* Princeton: Princeton University Press, 1984.

———. *Light, Wind, and Structure: The Mysteries of the Master Builders.* New York, McGraw-Hill, 1990.

Mortet, V., and P. Deschamps. *Recueil de textes relatifs à l'histoire de l'architecture et à la condition des architects en France au moyen-âge, XII–XIII siècles* 2 vols. Paris: 1911–29.

Pevsner, Nicolaus. "The Term 'Architect' in the Middle Ages." *Speculum* 17 (1942), 549–62 .

———. "Terms of Architectural Planning in the Middle Ages." *Journal of the Warburg and Courtauld Institutes* (1952), 232–37.

Recht, Roland. *Les Batisseurs des Cathédrales Gothiques.* Strasbourg: Editions des Musées de la Ville de Strasbourg, 1989.

———. "Sur le dessin d'archtecture gothique." *Études d'art offerts à Louis Grodecki.* Paris: Ophrys, 1981, 167–79.

Shelby, Lon R. *Gothic Design Techniques: the Fifteenth-Century Design Booklets of Mathes Roriczer and Hans Schuttermayer.* Carbondale: Southern Illinois University Press, 1977.

———. "Medieval Masons' Templates." *Journal of the Society of Architectural Historians* 30/2 (1971), 140–54.

———. "Medieval Masons' Tools: I. The Level and the Plumb Rule." *Technology and Culture* 2 (1961), 127–30.

———. "Medieval Mason's Tools: II. Compass and Square." *Technology and Culture* 6 (1965), 236–248.

———. "The Geometrical Knowledge of Medieval Master Masons." *Speculum* 47 (1972), 395–421.

———. "The Practical Geometry of Medieval Masons." *Studies in Medieval Culture* 5 (1975), 133–44.

———. "The Education of Medieval English Master Masons." *Medieval Studies* 32 (1970), 1–26.

———. "The Role of the Master Mason in Medieval English Building." *Speculum* 39 (1964), 387–403.

Ward, C. *Medieval Church Vaulting.* Princeton: Princeton University Press, 1915.

White, Lynn. *Medieval Technology and Social Change.* London and New York: Oxford University Press, 1964.

Architectural Sculpture

Armi, Edson. *The "Headmaster" of Chartres Cathedral and the Origins of "Gothic" Sculpture.* University Park, Penn.: Pennsylvania State University Press, 1994.

Fassler, Margot. "Liturgy and Sacred History in the Twelfth Century Tympana at Chartres." *The Art Bulletin* 56 (September 1993), 499–520.

Katzenellenbogen, Adolf. *The Sculptural Programs of Chartres Cathedral: Christ, Mary, Ecclesia.* New York: W. W. Norton, 1964.

Lapeyre, P. *Des façades occidentales de Saint-Denis et de Chartres aux portails de Laon.* Paris, 1960.

Rickard, Marcia. "The Iconography of the Virgin Portal at Amiens." *Gesta* 22/2 (1983), 147–57.

Sauerlander, Willibald. *Gothic Sculpture of France, 1140–1270.* New York: Harry N. Abrams, 1973.

Stoddard, Whitney. *Sculptors of the West portals of Chartres Cathedral: Their origins in Romanesque and Their Role in Chartrain Sculpture.* New York: Norton, 1987.

———. *The West Portals of Saint-Denis and Chartres; Sculpture in the Ile de France from 1140 to 1190, Theory of Origins.* Cambridge: Harvard University Press, 1952.

Stained Glass

Aubert, Marcel. *Le Vitrail en France.* Paris: Larousse, 1946.

Cothren, Michael W. "The Iconography of Theophilus Windows in the First Half of the Thirteenth Century." *Speculum* 59/2 (April 1984), 308–41.

Grodecki, Louis. *Gothic Stained Glass, 1200–1300.* Ithaca, N.Y.: Cornell University Press, 1985.

Johnson, James R. *The Radiance of Chartres: Studies in the Early Sained Glass of the Cathedral.* New York: Random House, 1965.

———. "The Tree of Jesse Window: Laudes Regiae." *Speculum* 36 (1961), 1–22.

Williams, Jane. *Bread, Wine and Money: the Windows of the Trades at Chartres Cathedral.* Chicago: University of Chicago Press, 1993.

Index